THE MYSTIC NORTH

ROALD NASGAARD

THE MYSTIC
NORTH

SYMBOLIST LANDSCAPE PAINTING IN NORTHERN EUROPE AND NORTH AMERICA 1890–1940

ART GALLERY OF ONTARIO, Toronto, Canada 13 January to 11 March, 1984

CINCINNATI ART MUSEUM 31 March to 13 May, 1984

ASTRUP, NIKOLAI
(1880-1928) Norwegian

1 *Kollen*, 1906
oil on canvas 101 × 120 cm.
Rasmus Meyers Samlinger, Bergen, Norway

2 *Dusk in Spring*, c.1909
oil on canvas 98.2 × 106.2 cm.
Rasmus Meyers Samlinger, Bergen, Norway

CARMICHAEL, FRANKLIN
(1890-1945) Canadian

3 *Autumn Hillside*, 1920
oil on canvas 76.2 × 91.4 cm.
Gift from the J.S. McLean Collection on loan
to the Art Gallery of Ontario, Toronto from the
Ontario Heritage Foundation, 1970

CARR, EMILY
(1871-1945) Canadian

4 *Indian Church*, 1929
oil on canvas 108.6 × 68.9 cm.
Art Gallery of Ontario, Toronto, bequest of
Charles S. Band, 1970

5 *Above the Trees*, 1935
oil on panel 91.6 × 61 cm.
Vancouver Art Gallery, Vancouver, BC

6 *Overhead*, 1935-36
oil on panel 61 × 91.6 cm.
Vancouver Art Gallery, Vancouver, BC

7 *Old Tree at Dusk*, c.1936
oil on canvas 112 × 68.9 cm.
McMichael Canadian Collection,
Kleinburg, Ontario
Gift of Col. R.S. McLaughlin

8 *Study in Movement*, 1936
oil on canvas 68.6 × 111.8 cm.
Art Gallery of Ontario, Toronto

DOVE, ARTHUR
(1880-1946) American

9 *Waterfall*, 1925
oil on panel 25.4 × 20.3 cm.
Phillips Collection, Washington, DC

10 *Snow Thaw*, 1930
oil on canvas 45.7 × 61 cm.
Phillips Collection, Washington, DC

11 *Morning Sun*, 1935
oil on canvas 50.8 × 71.1 cm.
Phillips Collection, Washington, DC

12 *Red Sun*, 1935
oil on canvas 51.4 × 71.1 cm.
Phillips Collection, Washington, DC

13 *A Cross in the Tree*, 1935
oil on canvas 71.1 × 51.4 cm.
Terry Dintenfass Gallery, New York

PRINCE EUGEN
(1865-1947) Swedish

14 *Forest Clearing*, 1892
oil on canvas 76 × 45.5 cm.
Prins Eugens Waldemarsudde, Stockholm

15 *The Cloud*, 1895
oil on canvas 112 × 103 cm.
Göteborgs Konstmuseum, Göteborg, Sweden

16 *Summer Night, Tyresö*, 1895
oil on canvas 78 × 144 cm.
Nationalmuseum, Stockholm

17 *Still Water*, 1901
oil on canvas 142 × 178 cm.
Nationalmuseum, Stockholm

FJAESTAD, GUSTAF
(1868-1948) Swedish

18 *Winter Moonlight*, 1895
oil on canvas 100 × 134 cm.
Nationalmuseum, Stockholm

19 *Snow*, 1900
oil on canvas 99 × 141 cm.
Göteborgs Konstmuseum, Göteborg, Sweden

20 *Running Water*, 1906
oil on canvas 120 × 148 cm.
Thielska Galleriet, Stockholm

21 *Running Water*, 1906
woollen tapestry 203 × 312 cm.
Göteborgs Konstmuseum
Göteborg, Sweden

GALLEN-KALLELA, AKSELI
(1865-1931) Finnish

22 *Lake in the Wilderness*, 1892
oil on canvas 72 × 51 cm.
Gösta Serlachius Fine Arts Foundation, Mänttä,
Finland

23 *Waterfall at Mäntykoski*, 1892-94
oil on canvas 270 × 156 cm.
Jorma Gallen-Kallela Family Collection, Helsinki

24 *Great Black Woodpecker*, 1893
gouache on paper 144 × 89 cm.
K.O. Donner, Helsinki

25 *Kullervo's Curse*, 1899
oil on canvas 186 × 105 cm.
Art Museum of the Ateneum, Collection Antell,
Helsinki

26 *Broken Pine*, 1906-08
oil on canvas 124 × 137 cm.
Private Collection

27 *Autumn*, 1902
(a study for the frescos in the Juselius
Mausoleum Chapel at Pori, 1903)
tempera on canvas 77 × 143 cm.
Sigrid Juselius Foundation, Helsinki

28 *Winter*, 1902
(a study for the frescos in the Juselius
Mausoleum Chapel at Pori, 1903)
tempera on canvas 76 × 144 cm.
Art Museum of the Ateneum, Collection Antell,
Helsinki

29 *The Lynx's Den*, 1906
oil on canvas 40 × 30.5 cm.
Gösta Serlachius Fine Arts Foundation,
Mänttä, Finland

HALONEN, PEKKA
(1865-1933) Finnish

30 *Wilderness*, 1899
oil on canvas 110 × 55.5 cm.
Turku Art Museum, Turku, Finland

31 *Washing on Ice*, 1900
(commissioned for the Finnish Pavilion,
Universal Exposition, Paris, 1900)
oil on canvas 125 × 180 cm.
Art Museum of the Ateneum, Collection Antell,
Helsinki

32 *The Lynx Hunter*, 1900
(commissioned for the Finnish Pavilion,
Universal Exposition, Paris, 1900)
oil on canvas 125 × 180 cm.
Art Museum of the Ateneum,
Collection Antell,
Helsinki

HAMMERSHOI, VILHELM
(1864-1916) Danish

33 *Sunshine and Shower, Lake Gentofte*, 1902
oil on canvas 83 × 78 cm.
Private Collection

34 *The Buildings of the East Asia Company*, 1902
oil on canvas 158 × 166 cm.
Private Collection

HARRIS, LAWREN S.
(1885-1970) Canadian

35 *Snow II*, c.1916
oil on canvas 120.3 × 127.3 cm.
National Gallery of Canada,
Ottawa

36 *Aura Lee Lake, Algonquin Park*, 1916
oil on board 26.7 × 35.6 cm.
Private Collection

37 *Snow*, c.1917
oil on canvas 69.7 × 109 cm.
McMichael Canadian Collection, Kleinburg,
Ontario
Gift of Mr. and Mrs. Keith MacIver

38 *Waterfall, Algoma*, 1918
oil on canvas 120.2 × 139.6 cm.
Art Gallery of Hamilton, Hamilton, Ontario
Gift of the Women's Committee, 1957

39 *Beaver Swamp, Algoma*, 1920
oil on canvas 120.7 × 141 cm.
Art Gallery of Ontario, Toronto
Gift of Ruth Massey Tovell in memory
of Harold Murchison Tovell, 1953

40 *Elevator Court, Halifax*, 1921
oil on canvas 96.5 × 112.1 cm.
Art Gallery of Ontario, Toronto
Gift from the Albert H. Robson
Memorial Subscription Fund, 1941

41 *Above Lake Superior*, c.1922
oil on canvas 121.9 × 152.4 cm.
Art Gallery of Ontario, Toronto
Gift from the Reuben and Kate
Leonard Canadian Fund, 1929

42 *Maligne Lake, Jasper Park*, 1924
oil on canvas 122.8 × 152.8 cm.
National Gallery of Canada, Ottawa

43 *Lake and Mountains*, 1927-8
oil on canvas 130.8 × 160.7 cm.
Art Gallery of Ontario, Toronto
Gift from the Fund of the T. Eaton Co.
Ltd. for Canadian Works of Art, 1948

HARTLEY, MARSDEN
(1877-1943) American

44 *Cosmos*, 1908-09
oil on panel 76.2 × 76.5 cm.
Columbus Museum of Art, Columbus, Ohio
Gift of Ferdinand Howald

45 *Paysage*, 1924
oil on canvas 80.9 × 80.9 cm.
Grey Art Gallery and Study Center,
New York University Art Collection
Gift of Leo M. Rogers, 1972

46 *Rock Doxology, Dogtown*, 1931
oil on board 47.5 × 61 cm.
Private Collection

47 *Garmisch-Partenkirchen*, 1933
oil on composition board 75.1 × 56.6 cm.
Mr. and Mrs. William J. Poplack,
Birmingham, Michigan

48 *Rising Wave, Indian Point, Georgetown, Maine*,
1937-38
oil on board 55.9 × 71.1 cm.
Edward Joseph Gallagher III
Memorial Collection,
Baltimore Museum of Art

49 *Wood Lot, Maine Woods*, 1938
oil on panel 71.1 × 55.9 cm.
Phillips Collection, Washington, DC

50 *Mount Katahdin, Autumn No. 1*, 1939-40
oil on canvas 76.2 × 101.6 cm.
F.M. Hall Collection
Sheldon Memorial Art Gallery
University of Nebraska-Lincoln

HESSELBOM, OTTO
(1848-1913) Swedish

51 *Our Country, Motif from Dalsland*, 1902
oil on canvas 126 × 248 cm.
Nationalmuseum, Stockholm

HODLER, FERDINAND
(1853-1918) Swiss

52 *Autumn Evening*, 1892
oil on canvas 100 × 130 cm.
Musée d'art et d'histoire,
Neuchâtel, Switzerland

53 *Eiger, Mönch and Jungfrau above a Sea of Mist*,
1908
oil on canvas 67.5 × 91.5 cm.
Musée Jenisch, Vevey, Switzerland

54 *Lake Thun*, 1909
oil on canvas 67.3 × 92 cm.
Musée d'art et d'histoire, Geneva

55 *Breithorn*, 1911
oil on canvas 67 × 89.5 cm.
Kunstmuseum Lucerne, Lucerne, Switzerland
On permanent loan from the Bernhard Elgin-
Stiftung

56 *Mönch*, 1911
oil on canvas 88 × 66 cm.
Jacqueline and Max Kohler, Switzerland

57 *Sunset on Lake Geneva*, 1915
oil on canvas 61 × 90 cm.
Kunsthaus, Zürich

58 *Les Dents du Midi*, 1916
oil on canvas 64 × 88 cm.
Musée d'art et d'histoire, Neuchâtel, Switzerland

59 *Mountain Stream at Champéry*, 1916
oil on canvas 82 × 98 cm.
Germann Auktionshaus, Zürich

JACKSON, A.Y.
(1882-1974) Canadian

60 *Terre Sauvage*, 1913
oil on canvas 128.8 × 154.4 cm.
National Gallery of Canada, Ottawa

61 *October Morning, Algoma*, 1920
oil on canvas 123.2 × 154 cm.
Hart House Permanent Collection
University of Toronto, Toronto

JANSSON, EUGÈNE
(1862-1915) Swedish

62 *The Outskirts of the City*, 1899
oil on canvas 152 × 136 cm.
Nationalmuseum, Stockholm

63 *Nocturne*, 1901
oil on canvas 149 × 201 cm.
Thielska Galleriet, Stockholm

64 *Hornsgatan at Night*, 1902
oil on canvas 152 × 182 cm.
Nationalmuseum, Stockholm

KIRCHNER, ERNST LUDWIG
(1880-1938) German

65 *Sand Hills in Engadine*, 1917-18
oil on canvas 85.7 × 95.2 cm.
Museum of Modern Art, New York

66 *Forest Interior*, 1919-20
oil on canvas 120 × 90 cm.
Staatliche Museen Preussischer Kulturbesitz,
Nationalgalerie, Berlin.
Extended loan from a private collection

LISMER, ARTHUR
(1885-1969) Canadian

67 *Old Pine, McGregor Bay*, 1929
oil on canvas 82.5 × 102.2 cm.
Art Gallery of Ontario, Toronto
Bequest of Charles S. Band, 1970

MACDONALD, J.E.H.
(1873-1932) Canadian

68 *A Rapid in the North*, 1913
oil on canvas 51.4 × 72.1 cm.
Art Gallery of Hamilton, Hamilton, Ontario
Gift of the MacDonald Family, 1974

69 *Snow-Bound*, 1915
oil on canvas 51.1 × 76.5 cm.
National Gallery of Canada, Ottawa

70 *Leaves in the Brook*, 1919
oil on canvas 52.7 × 65 cm.
McMichael Canadian Collection
Kleinburg, Ontario
Gift of Dr. Arnold C. Mason

71 *Falls, Montreal River*, 1920
oil on canvas 121.9 × 153 cm.
Art Gallery of Ontario, Toronto

72 *Gleam on the Hills*, 1921
oil on canvas 81.5 × 87.1 cm.
National Gallery of Canada, Ottawa

MONDRIAN, PIET
(1872-1944) Dutch

73 *Woods*, 1898-1900
watercolour/gouache 45.3 × 56.7 cm.
Gemeentemuseum, The Hague

74 *Evening on the Gein*, 1907-08
oil on canvas 65 × 86 cm.
Gemeentemuseum, The Hague

75 *Evening Sky*, 1907-08
oil on paper, laid on canvas 64 × 74 cm.
J.P. Smid, Art Gallery Monet, Amsterdam

76 *Trees on the Gein, with Rising Moon*,
1908 (Toronto only)
oil on canvas 79 × 92.5 cm.
Gemeentemuseum, The Hague

77 *Sea after Sunset*, 1909
oil on canvas 41 × 76 cm.
Gemeentemuseum, The Hague

78 *Church at Zoutelande*, 1909-10
oil on canvas 90.7 × 62.2 cm.
Canadian Centre for Architecture, Montreal

79 *Dune IV*, 1909-10
oil on canvas 33 × 46 cm.
Gemeentemuseum, The Hague

80 *Dune VI*, 1909-10
oil on canvas 134 × 195 cm.
Gemeentemuseum, The Hague
On extended loan to Solomon R. Guggenheim
Museum, New York

MUNCH, EDVARD
(1863-1944) Norwegian

81 *Melancholy, The Yellow Boat*, 1891-92
oil on canvas 65.5 × 96 cm.
Nasjonalgalleriet, Oslo

82 *Train Smoke*, 1900
oil on canvas 84 × 109 cm.
Munch-museet, Oslo

83 *White Night*, 1901
oil on canvas 115.5 × 110.5 cm.
Nasjonalgalleriet, Oslo

84 *Forest*, 1903
oil on canvas 82.5 × 81.5 cm.
Munch-museet, Oslo

85 *Winter Landscape, Elgersburg*, 1906
oil on canvas 84 × 109 cm.
Munch-museet, Oslo

86 *The Sun II*, 1912
oil on canvas 163 × 205.5 cm.
Munch-museet, Oslo

87 *Winter, Kragerø*, 1915
oil on canvas 103 × 128 cm.
Nasjonalgalleriet, Oslo

NIELSEN, EJNAR
(1872-1956) Danish

88 *Landscape from Gjern, Jylland*, 1897
oil on canvas 110 × 220 cm.
Vejen Kunstmuseum, Vejen, Denmark

NORDSTRÖM, KARL
(1855-1923) Swedish

89 *Storm Clouds*, 1893
oil on canvas 72 × 80 cm.
Nationalmuseum, Stockholm

90 *Varberg Fort*, 1893
oil on canvas 62 × 88.5 cm.
Prins Eugens Waldemarsudde, Stockholm

91 *Hartippen, Tjörn*, 1897
oil on canvas 85.5 × 126 cm.
Göteborgs Konstmuseum,
Göteborg, Sweden

92 *Winter Night*, 1907
oil on canvas 128 × 173 cm.
Prins Eugens Waldemarsudde, Stockholm

O'KEEFFE, GEORGIA
(b. 1887) American

93 *Lake George*, 1922
oil on canvas 41.2 × 55.9 cm.
San Francisco Museum of Modern Art
Gift of Charlotte Mack

94 *Lake George Barns*, 1926
oil on canvas 53.7 × 81.3 cm.
Walker Art Center, Minneapolis
Gift of the T.B. Walker Foundation

95 *Red Hills and Sun, Lake George*, 1927
oil on canvas 68.6 × 81.3 cm.
Phillips Collection, Washington, DC

96 *East River from the Shelton*, 1927-28
oil on canvas 63.7 × 55.8 cm.
New Jersey State Museum Collection, Trenton,
New Jersey
Purchased by the Association for the Arts of the
New Jersey Museum with a Gift from Mary Lee
Johnson, 1972

97 *Cross by the Sea, Canada*, 1932
oil on canvas 91.4 × 61 cm.
Currier Gallery of Art
Manchester, New Hampshire

OSSLUND, HELMER
(1866-1938) Swedish

98 *Autumn Day, Fränsta*, 1898-99
oil on canvas 63 × 82 cm.
Private Collection

99 *Before the Storm, A Motif from Lapporten*, c.1907
oil on canvas 56 × 98 cm.
Private Collection

100 *Laplanders' Store*, c.1907
oil on canvas 33 × 43.5 cm.
Göteborgs Konstmuseum,
Göteborg, Sweden

101 *Autumn*, 1907
oil on canvas 110 × 200 cm.
Nationalmuseum, Stockholm

102 *Autumn Evening, Nordingrå*, 1910
oil on paper 66 × 97 cm.
Nationalmuseum, Stockholm

103 *Waterfall, Porjus*, 1915
oil on paper 55 × 127 cm.
Nationalmuseum, Stockholm

SOHLBERG, HARALD
(1869-1935) Norwegian

104 *Night Glow*, 1893
oil on canvas 79.5 × 62 cm.
Nasjonalgalleriet, Oslo

105 *Winter Night in Rondane*, 1901
oil on canvas 68 × 91 cm.
Hilmar Rekstens Samlinger,
Bergen, Norway

106 *Street in Røros*, 1903
oil on canvas 60.5 × 90.5 cm.
Nasjonalgalleriet, Oslo

107 *Night*, 1904
oil on canvas 113 × 134 cm.
Trøndelag Kunstgalleri, Trondheim, Norway

108 *Flower Meadow in the North*, 1905
oil on canvas 96 × 111 cm.
Nasjonalgalleriet, Oslo

109 *Fisherman's Cottage*, 1906
oil on canvas 109 × 94 cm.
Edward Byron Smith, Chicago

TACK, AUGUSTUS VINCENT
(1870-1949) American

110 *Storm*, 1920-23
oil on canvas mounted on construction board
94 × 121.9 cm.
Phillips Collection, Washington, DC

111 *Voice of Many Waters*, 1924
oil on canvas mounted on construction board
194.3 × 121.9 cm.
Phillips Collection, Washington, DC

112 *Flight*, c.1930
oil on canvas mounted on construction board
111.8 × 91.4 cm.
Phillips Collection, Washington, DC

THOMSON, TOM
(1877-1917) Canadian

113 *A Northern Lake*, 1912-13
oil on canvas 69.9 × 101 cm.
Art Gallery of Ontario
Gift of the Government of the Province of
Ontario, 1972

114 *Northern River*, 1915
oil on canvas 115.1 × 102 cm.
National Gallery of Canada, Ottawa

VALLOTTON, FELIX
(1865-1925) Swiss

115 *Le Breithorn*, 1892
woodcut on wove paper 25 × 36.8 cm.
Galerie Paul Vallotton, Lausanne, Switzerland

116 *Le Cervin*, 1892
woodcut on wove paper 25 × 32 cm.
Galerie Paul Vallotton, Lausanne, Switzerland

117 *Le Mont-Blanc*, 1892
woodcut on wove paper 37 × 25.5 cm.
Galerie Paul Vallotton, Lausanne, Switzerland

118 *Mont-Blanc*, 1892
woodcut on wove paper 25 × 32.5 cm.
Galerie Paul Vallotton, Lausanne, Switzerland

119 *Glacier du Rhône*, 1892
woodcut on wove paper 25 × 32.8 cm.
Galerie Paul Vallotton, Lausanne, Switzerland

120 *La Jungfrau*, 1892
woodcut on wove paper 25 × 32.7 cm.
Art Gallery of Ontario, Toronto

121 *Le Mont-Rose*, 1892
woodcut on wove paper 24.5 × 36.8 cm.
Galerie Paul Vallotton, Lausanne, Switzerland

VARLEY, F.H.
(1881-1969) Canadian

122 *The Cloud, Red Mountain*, c.1928
oil on canvas 86.8 × 102.2 cm.
Art Gallery of Ontario, Toronto
Bequest of Charles S. Band, 1970

123 *The Open Window*, 1932
oil on canvas 102.3 × 87 cm.
Hart House of Permanent Collection,
University of Toronto, Ontario

WESTERHOLM, VICTOR
(1860-1919) Finnish

124 *Ahvenanmaa* (Åland, 1909)
oil on canvas 200 × 263 cm.
Turku Art Museum, Turku, Finland

WILLUMSEN, JENS FERDINAND
(1863-1958) Danish

125 *Spanish Chestnuts, Ornamental Landscape
Composition*, 1891
oil on canvas and wood 96 × 95.5 cm.
J.F. Willumsens Museum, Frederikssund,
Denmark

126 *Study for Jotunheim*, 1892
watercolour over pencil on paper
29.9 × 35.4 cm.
Lolland-Falsters Kunstmuseum, Maribo,
Denmark

127 *Mountains under the Southern Sun*, 1902
oil on canvas 209 × 208 cm.
Thielska Galleriet, Stockholm

128 *Fear of Nature (After the Storm II)*, 1916
tempera on canvas 194 × 169 cm.
J.F. Willumsens Museum,
Frederikssund, Denmark

ROALD NASGAARD

THE MYSTIC
NORTH

SYMBOLIST LANDSCAPE PAINTING IN NORTHERN
EUROPE AND NORTH AMERICA 1890–1940

Published in association with the Art Gallery of Ontario by
UNIVERSITY OF TORONTO PRESS
Toronto Buffalo London

ISBN 0-8020-2530-7 (cloth) ISBN 0-8020-6544-9 (paper)

ITINERARY OF THE EXHIBITION

Art Gallery of Ontario, Toronto: 13 January to 11 March 1984
Cincinnati Art Museum: 31 March to 13 May 1984

Canadian Cataloguing in Publication Data

Nasgaard, Roald.
 The mystic North : symbolist landscape painting in Northern
Europe and North America, 1890–1940

Based on an exhibition held at the Art Gallery of Ontario, Toronto,
Ont., Jan. 13 – Mar. 11, 1984, and the Cincinnati Art Museum,
Cincinnati, Ohio, Mar. 31 – May 13, 1984.
Includes bibliographical references and index.
ISBN 0-8020-2530-7 (bound). – ISBN 0-8020-6544-9 (pbk.)

1. Landscape painting – 20th century – Europe, Northern –
Exhibitions. 2. Landscape painting – 20th century – Canada –
Exhibitions. 3. Landscape painting – 20th century – United States –
Exhibitions. 4. Symbolism in art – Europe, Northern – Exhibitions.
5. Symbolism in art – Canada – Exhibitions. 6. Symbolism in art –
United States – Exhibitions. I. Art Gallery of Ontario. II. Cincinnati
Art Museum. III. Title.

ND1349.6.N37 1983 758'.1 C83-099295-2

The Art Gallery of Ontario is funded by the Province of Ontario, the Ministry of
Citizenship and Culture of Canada, the Government of Canada through the National Museums
Corporation and the Canada Council, and the Municipality of Metropolitan Toronto.

CONTENTS

FOREWORD

This book, and the exhibition which it accompanies, seek to define a new historical synthesis based on the many common characteristics of landscape painting in northern Europe and North America between the 1890s and the Second World War. The exhibition is international in scope, and the latest of a number, including *The Sacred and Profane in Symbolist Art*, 1969, *Puvis de Chavannes and the Modern Tradition*, 1975, and *Vincent van Gogh and the Birth of Cloisonism*, 1981, that the Art Gallery of Ontario in Toronto has devoted to problems originating in late-nineteenth-century art.

Both book and exhibition refer to artists who are well known, but also bring into an international context some who remain little known and little discussed outside their own countries. The placing of the work of these latter artists in a broader perspective has special poignancy for the Art Gallery of Ontario in relation to the Canadian Group of Seven. The Gallery has shown and collected the Group's work for many years. The Group's first exhibition and subsequent official shows took place at the Gallery. Arthur Lismer was a significant contributor to the Gallery's education program, and A.Y. Jackson served on the Collection Committee. Though it has often been claimed that the Group developed independently of foreign influence, it was in a lecture at the Gallery in 1931 that J.E.H. MacDonald recalled the strong impressions Scandinavian art had made on both him and Lawren Harris at an exhibition in Buffalo in 1913. The Gallery is happy to provide the opportunity to consider in greater depth the relationships between Canadian and modern international developments.

Along with Roald Nasgaard, the author of the book and organizer of the exhibition, and on behalf of the Art Gallery of Ontario, I want to express heartfelt thanks to the many generous private and public lenders who have graciously entrusted so many important works, many of them national treasures, to the exhibition during its stay in Toronto and Cincinnati. The exhibition could not have taken place without the warm support and multiple loans of the following institutions, to which we are especially grateful: Art Museum of the Ateneum, Helsinki; Prins Eugens Waldemarsudde, Stockholm; Gemeentemuseum, The Hague; Göteborgs Konstmuseum, Göteborg, Sweden; Munch-museet, Oslo; Nasjonalgalleriet, Oslo; The National Gallery of Canada, Ottawa; Nationalmuseum, Stockholm; The Phillips Collection, Washington, DC; and Thielska Galleriet, Stockholm.

The many other lenders to whom we are most indebted are: The Baltimore Museum of Art; Canadian Centre for Architecture, Montreal; Columbus Museum of Art, Columbus, Ohio; The Currier Gallery of Art, Manchester, New Hampshire; Terry Dintenfass Gallery, New York; K.O. Donner, Helsinki; Jorma Gallen-Kallela Family Collection, Helsinki; Musée d'art et d'histoire, Geneva; Germann Auktionshaus, Zürich; Grey Art Gallery and Study Center, New York University Art Collection; The Solomon R. Guggenheim Museum, New York; Art Gallery of Hamilton, Hamilton, Ontario; Hart House, Uni-

versity of Toronto; Musée Jenisch, Vevey; Sigrid Juselius Foundation, Helsinki; Jacqueline and Max Kohler, Switzerland; Lolland-Falsters Kunstmuseum, Maribo, Denmark; Kunstmuseum (Bernhard Elgin-Foundation), Lucerne, Switzerland; The McMichael Canadian Collection, Kleinburg, Ontario; Rasmus Meyers Samlinger, Bergen, Norway; The Museum of Modern Art, New York; Musée d'art et d'histoire, Neuchâtel, Switzerland; New Jersey State Museum, Trenton, New Jersey; Nordiska Museet, Stockholm; Mr and Mrs William J. Poplack, Birmingham, Michigan; Hilmar Rekstens Samlinger, Bergen, Norway; San Francisco Museum of Modern Art; The Gösta Serlachius Fine Arts Foundation, Mänttä, Finland; F.M. Hall Collection, Sheldon Memorial Art Gallery, University of Nebraska–Lincoln; J.P. Smid, Art Gallery Monet, Amsterdam; Edward Byron Smith, Chicago; Staatliche Museen Preussischer Kulturbesitz, Nationalgalerie, Berlin; Trøndelag Kunstgalleri, Trondheim, Norway; Turku Art Museum, Turku, Finland; Galerie Paul Vallotton, Lausanne, Switzerland; Vancouver Art Gallery, Vancouver, BC; Vejen Kunstmuseum; Walker Art Center, Minneapolis; J.F. Willumsens Museum, Frederikssund; Kunsthaus, Zürich; and several lenders who wish to remain anonymous.

WILLIAM J. WITHROW
Director
Art Gallery of Ontario

PHOTO CREDITS

Numbers indicated below are illustration numbers:

Jörg P. Anders, Berlin: 158; Art Museum of the Ateneum, Helsinki: 19, 22, 24, 27, 28, 29, 30; The Baltimore Museum of Art: 141; Bildarchiv Preussischer Kulturbesitz, Berlin: 75; Lloyd Bloom, Hamilton: 107; Canadian Centre for Architecture, Montreal: 101; The Art Institute of Chicago: 34; Columbus Museum of Art: 136; Deutsche Fotothek, Dresden: 35; Prins Eugens Waldemarsudde, Stockholm: 18, 32, 36; Lolland-Falsters Kunstmuseum, Maribo, Denmark: 5; Bill Finney, Courrier Art Gallery of Art, Manchester, New Hampshire: 152; Gallen-Kallela Museum, Espoo, Finland: 25; Gemeentemuseum, The Hague: 95, 96, 97, 98, 100, 103; Musée d'art et d'histoire, Geneva: 80, 86; Germann Auktionshaus, Zürich: 93; Jim Gorman, Vancouver Art Gallery: 134; Göteborgs Konstmuseum: 16, 33, 37, 45, 46, 55; Carmelo Guadayno, Courtesy of the Solomon R. Guggenheim Museum, New York: 102; Art Gallery of Hamilton: 121; Helmuth Hansen, Frederikssund: 3; Hart House, University of Toronto: 124; Gottfried-Keller Foundation: 84; Kunsthistorisk Pladearkiv, Copenhagen: 62, 160; Kunstmuseum, Lucerne: 90; Norman Mackenzie Art Gallery, Regina: 111; The McMichael Canadian Collection, Kleinburg: 109, 119, 131; Rasmus Meyers Samlinger, Bergen, Norway: 1, 77, 78; The Minneapolis Institute of Arts: 15, 21, 26; Munch-museet, Oslo: 57, 59, 60, 61, 64; The Museum of Modern Art, New York: 157; The National Gallery of Canada, Ottawa: 104, 105, 108, 110, 113, 117, 122, 127; Nationalmuseum, Stockholm: 14, 17, 40, 41, 42, 44, 49, 50, 51, 54, 56; Musée d'art et d'histoire, Neuchâtel: 79; New Jersey State Museum, Trenton: 150; Sven Nilsson, Bromma, Sweden: 47, 48, 88; Nordiska Museet, Stockholm: 53; Jean Baer O'Gorman: 138; Larry Ostrom, Art Gallery of Ontario: 106, 112, 114, 116, 120, 123, 125, 126, 128, 129, 130, 132, 135; The Phillips Collection, Washington: 140, 143, 144, 145, 146, 149, 153, 154, 155; Eric Pollitzer, Hempstead, New York: 147; Hilmar Reksten Samlinger, Bergen: 69; Saltmarche Brothers, Toronto: 115; San Francisco Museum of Modern Art: 148; The Gösta Serlachius Fine Arts Foundation, Mänttä, Finland: 20, 31; Sheldon Memorial Art Gallery, University of Nebraska – Lincoln: 142; J.P. Smid, Art Gallery Monet, Amsterdam: 99; Statens Museum for Kunst, Copenhagen: 4; Stiftung Seebüll A. and E. Nolde: 156; Swiss Institute for Art Research, Zürich: 82, 83, 87, 91, 159; Esben H. Thorning, Aalborg: 161; Turku Art Museum: 43; O. Vaering, Oslo: 2, 23, 58, 65, 66, 67, 68, 70, 71, 72, 73, 118; Galerie Paul Vallotton, Lausanne: 7, 8, 9, 10, 11, 12, 13; Joël von Allmen, Neuchâtel; 92; Walker Art Center, Minneapolis: 151; Sarah Wells, New York: 137; J.F. Willumsens Museum, Frederikssund: 6; Liselotte Witzel, Essen: 81; Ole Woldbye, Kunstindustrimuseet, Copenhagen: 63; Robert Keziere, Vancouver Art Gallery: 133; Kunsthaus, Zürich: 85.

PREFACE

The thesis of this book, and of the exhibition on which it is based, originated almost fifteen years ago in my graduate research on J.F. Willumsen and the relationship of his work to French Symbolism. The thesis took on a transatlantic perspective because of the demonstrable connections between Scandinavian painting and the Group of Seven. This exhibition, bringing together for the first time the work of the Canadians and the Scandinavian work that had impressed them, offered the opportunity to explore more comprehensively the notion that there was indeed a body of northern Symbolist landscape painting with a common set of subjects, feelings, and structures.†

Several of the artists presented here are new to international audiences and have till now been considered primarily within their respective national contexts. The general framework of my thesis, however, owes a considerable debt to the work of others, especially that of the late Robert Goldwater and of Robert Rosenblum, whose ideas about the northern Romantic tradition I have been exposed to since student days at the Institute of Fine Arts, New York University. Because my research has involved the art of several nations, I have often had to rely on secondary sources. I am especially indebted to the insights into turn-of-the-century Scandinavian art contained in the work of Sixten Strömbom, Leif Østby, and Salme Sarajas-Korte, who speeded my work by making available prior to publication the Swedish translation of her book on early Finnish Symbolism.

In addition to the numerous generous lenders there are many people who assisted me in my research and in the organization of the exhibition. To them I am very grateful. For their recommendations, discussions, willingness to share ideas and information, assistance with difficult loans, and general support I would especially like to thank Jan Askeland, Director, Bergen Billedgalleri and Rasmus Meyers Samlinger, Bergen, Norway; Erik Bergh, Director, Turku Art Museum, Turku, Finland; Knut Berg, Director, and Magne Malmanger, Chief Curator, of Nasjonalgalleriet, Oslo; Per Bjurström, Director, Nils-Göran Hökby, and other staff at Nationalmuseum, Stockholm; Arne Eggum, Curator, Munch-museet, Oslo; Hanne Finsen, Director, Ordrupgaard, Copenhagen; Björn Fredlund, Director, Göteborgs Konstmuseum, Göteborg, Sweden; Aivi Gallen-Kallela, Helsinki; Barbara Haskell, Curator, The Whitney Museum of American Art, New York; Herbert Henkels, Curator, Gemeentemuseum, The Hague; Sharon L. Hirsh, Dickenson College, Carlisle, Pennsylvania; Oystein Hjort, University of Copenhagen; Trygve Huseby, Norwegian Consul-General, Toronto; Kerttu Kannas, Director, Gallen-Kallela Museum, Espoo, Finland; Dr Ernst-Gunther Koch, Consul-General, Federal Republic of Germany, Toronto; Christian Kremm, Curator, Kunsthaus, Zürich; Leila Krogh, Director, J.F. Willumsen Museum, Frederiks-

† An asterisk before a title in illustration captions and the index indicates a work included in the exhibition.

sund, Denmark; Martin Kunz, Kunstmuseum, Lucerne, Switzerland; Steingrim Laursen, Louisiana Museum, Humlebaek, Louisiana; Ulf Linde, Director, Thielska Galleriet, Stockholm; Bo Lindwall, Stockholm; Robert R. Littman, Director, Grey Art Gallery and Study Center, New York University; Willem de Looper, Curator, and Joseph Holbach, Registrar, Phillips Collection, Washington, DC; Leena Peltola, Curator, Art Museum of the Ateneum, Helsinki; Hans A. Lüthy, Director, and Lukas Gloor of the Swiss Institute for Art Research, Zürich; Maritta Pitkänen, Director, Museum of Gösta Serliachius Fine Arts Foundation, Mänttä, Finland; Dennis Reid, Curator of Canadian Historical Art, Art Gallery of Ontario, Toronto; Ulla Ryott, Stockholm; Edward Byron Smith, Chicago; Richard J. Wattenmaker, Director, Flint Institute of Arts, Flint, Michigan; Robert P. Welsh, University of Toronto; and Brent Wiggens, the Terry Dintenfass Gallery, New York.

For their patience and goodwill during the long period of the organization of the exhibition and the writing of this book, when I was too often absent from my other duties at the Art Gallery of Ontario, I am deeply indebted to those other staff members who had to fill in, from the Gallery's Director, William J. Withrow, and Norman Walford, Chief of Administration, to the many department heads and their staff who diligently and efficiently carried out the business of the Curatorial Branch. My thanks to Olga Davison, my assistant, on whose shoulders invariably fell the many organizational details, and to Pamela Vandenburg who ably filled in during her leave of absence; to Karen McKenzie, Head, Larry Pfaff, and the Library Staff for their enthusiastic support of my research; to Denise Bukowski, Head of Publications, and her staff and to the editors of University of Toronto Press for their work on the manuscript; and very especially to Karen Finlay, Assistant Curator, Exhibitions, who gave me invaluable assistance with basic research on the North American artists and prepared the majority of the bibliographies.

On a more personal note I am grateful to a number of friends who provided me with food, shelter, and convivial company during extended, often midwinter stays in Scandinavia or during my writing period in Canada. I want especially to single out Benedikte Groth in Copenhagen, Ulla Thorell in Odensala, Sweden, and Jane Davidson, Brucefield, Ontario. Finally I must pay tribute to my wife, Susan, who, despite the demands of her own work, found time to give me research assistance, especially with the Scandinavian material, and to read and reread and astutely criticize the text in its various draft stages.

RN
Toronto, August 1983

THE MYSTIC NORTH

The Northern Symbolist Landscape

The flow and ripple of water were beautifully painted by him, and shaded streams and stony rapids, and mottled rocks, and spotted birch trunks. We were so fond of these things ourselves that we couldn't but like the pictures, and we were well assured that no Swedish brook or river would speak a language unknown to us and that we would know our own snows and rivers better for Fjaestad's revelations.

They ... seemed to us true souvenirs of that mystic north round which we all revolve.

J.E.H. MacDonald[1]

In January 1913 two Canadian artists, J.E.H. MacDonald and Lawren Harris, took a train trip from Toronto to Buffalo to see a touring exhibition of contemporary Scandinavian art at the Albright Art Gallery. As they would recall later in life, "this turned out to be one of the most exciting and rewarding experiences either of us had."[2] What they discovered in the exhibition was a close correspondence between the spirit with which the northern Europeans looked at their native landscape and the way the Canadians, feeling themselves on the verge of new discoveries, wanted to paint their own north. As MacDonald remarked: "Except in minor points, the pictures might all have been Canadian, and we felt 'This is what we want to do with Canada.' "[3] In retrospect we may conclude that the Scandinavians taught MacDonald and Harris, and through them their colleagues in Toronto, three important lessons: they showed them how

to see, with fresh eyes, the unique aspects of their landscape, the vast wild and virgin wilderness that spread endlessly beyond the farmlands of southern Ontario; they provided artistic models for expressing both the physical and spiritual essence of the Canadian landscape; and they gave them enthusiasm and the conviction to take up their new artistic enterprise. In Harris's words, "From that time on we knew we were at the beginning of an all-engrossing adventure."[4]

The *Exhibition of Contemporary Scandinavian Art* which MacDonald and Harris saw toured the northeastern United States under the auspices of the American-Scandinavian Society.[5] It was conceived as an 'élite exhibition,' surveying the recent art of Norway, Sweden, and Denmark, and was undertaken in the hope of developing an American market for Nordic art.[6] Since it presented a representative selection of the art of each country, the exhibition inevitably had little stylistic focus, and it ranged freely across three generations of artists: the generation of Krogh, Werenskiold, Liljefors, and Zorn, who during the 1880s had proudly carried home from Düsseldorf and Paris their naturalistic lessons and applied them to indigenous subjects; the Symbolist generation – Munch, Willumsen, Hammershøi, Sohlberg, and Prince Eugen – who represented artistic innovation during the 1890s and, especially in Sweden, reinforced with mystical overtones the need to find subjects in their own land; and finally the youngest artists who, reacting to the national retrench-

ment of their predecessors, turned their eyes afresh to international developments and were attracted by Matisse and Cubism.

Reviewers of the exhibit and audiences in New York, Boston, and Chicago seem to have given most of their attention, favourable or not, to the middle generation, except for the work of Zorn. In the Oslo *Aftenposten* in April 1913 Zorn, Hammershøi, and Solberg were called the most popular artists, while Munch and Willumsen were considered the most difficult. Commenting on the relatively conservative character of the Scandinavian exhibition, the report added that, if the American public were finding Munch, Willumsen, and the younger Scandinavians difficult, then the Armory Show, which was about to open in Chicago, with works by van Gogh, Gauguin, Matisse, and Picasso, followed "by a long tail of 'Cubists' and 'Futurists,' ... will be still more difficult to deal with."[7]

That the Scandinavian exhibition should so excite Harris and MacDonald is a comment on their own limited and conservative artistic perspective. They were in fact indifferent to the modernist experiments of the younger Scandinavians. They admired the naturalistic pictures devoted to northern subjects, but their enthusiasm was reserved for the painters of the 1890s, especially Sohlberg, Fjaestad, and Hesselbom, who monumentalized and gave decorative form to their landscapes and implied the existence of unseen meanings behind the appearances of the wilderness subject matter. In the next few years MacDonald and Harris and several colleagues, working in close harmony, produced a succession of paintings which appeared to resuscitate the tradition of Scandinavian Symbolist landscape painting and breathe fresh life into it.

The general relationship between Scandinavian and Canadian painting is, of course, not so easily summarized. But the 1913 exhibition can help us isolate a period of landscape painting stretching twenty years back and thirty years into the future and linking northern Europe and northern North America. In Scandinavia, especially in Sweden, from about 1890 and in Canada after 1913 Symbolist landscape painting became the pre-eminent national style. Yet it is also possible to chart a broader and equally coherent configuration of landscape painting throughout the North on the basis of striking parallels in style and subject matter among many landscape painters, beginning with the generation born about 1860 and coming to maturity in the 1890s.

It may seem arbitrary to speak of landscape painting as a subject for independent study within the general phenomenon of Symbolism, which dominated art at the end of the last century. Landscape was at best a minor genre for Symbolist artists, or at least that is the impression received from the many books and catalogues on Symbolism published in the last decade and a half.[8] Article IV of the "Rules" of the Salon de la Rose + Croix, one of the most important public manifestations of Symbolism, explicitly rejected "all landscapes, except those composed in the manner of Poussin."[9] Occasionally French or Belgian Symbolists such as William Degouve de Nuncques or Lucien Lévy-Dhumer will lead us into silent parks bathed in evocative mauve twilight. On the whole, however, the movement is anthropocentric and symbol-oriented, indulging in suggestive images of legendary princesses, sphinxes, and other *femmes fatales*, accompanied by peacocks or unicorns or clutching exotic flowers. Although the Symbolists fully realized the dangers of an art based on literary allegory, they preferred figurative subjects because the rendering of human expressions, gestures, and situations could perhaps convey more specifically than landscape the poetic ideas and the occult and mystical experiences that preoccupied them.

The term *Symbolism* may have become too exclusively associated with the so-called decadent artists of the turn of the century during the revival, in the late 1960s and 1970s, of those innumerable peerers into the soul with their generally conservative and anti-modernist styles, at a time when modernism itself seemed to be losing its hegemony. Thus, for instance, Symbolism was identified as an "alternative tradition," of which Surrealism was a later manifestation.[10] This view was held especially by *littérateurs* with a preference for broad cultural approaches and a keener interest in movements as styles of life rather than as groupings of art. With the depreciation of artistic evaluation on visual and stylistic grounds the work of Redon, Moreau, Puvis de Chavannes, Gauguin,

Burne-Jones, Séon, Point, and Schwabe were grouped under the single ideological banner of Symbolism, with only cursory reference to their rather crucial differences in kind and quality. Formal innovators such as Gauguin found a place in this context primarily because of their mystical and exotic content.[11]

The Symbolists were often discussed in different terms from their contemporaries, subsequently dubbed the Post-Impressionists, who created a new pictorial style that would lay the foundations for the major modernist developments of the twentieth century. But there were crossovers; and if Symbolist apologists could only rarely accommodate van Gogh and Seurat, and never Cézanne, it was because of the energy, vitality, and sunlight in their work (incompatible with decadent day-dreaming), not because of a failure on their part to explore what Gauguin called "the mysterious centres of thought." That is the implication of Félix Fénéon's review of Sar Péladan's first Salon de la Rose + Croix in 1892, to the effect that three apples on a tablecloth by Cézanne contain more mystical value than all the exhibitors in Péladan's exhibition put together.[12]

The objectives of Symbolism and Post-Impressionism do, of course, inextricably overlap. Both evolved in reaction to the positivist and scientific attitudes of Naturalism, during the "crisis of the 1880s," when Impressionism seemed to have run its course, even for its originators, and when subjective tendencies increasingly infused the work of most artists, whatever the theoretical bases of their styles. Both categories account, therefore, not only for the younger generation's new interest in inner states of being, but for the stylistic reorientation taken even by the arch-Impressionist Monet in the direction of concentrated and reduced means. Rather than being transcribed as precisely studied segments of nature at a given moment, Monet's subjects – the poplars, cathedral facades, haystacks – were perceived with increased personal intensity and thereby transformed into timeless and unified wholes sustained more by inner vision than external reference.

In 1886 the Symbolist poet and critic Gustav Kahn, using as a foil Zola's definition of Naturalism formulated twenty years earlier, wrote: "Our art's essential aim is to objectify the subjective (the exteriorization of the idea), instead of subjectifying the objective (nature seen through a temperament)."[13] The programme of the Symbolist poets coincided with that of the painters, as expressed, for example, by Gauguin to his friend Emile Schuffenecker: "Don't copy nature too closely. Art is an abstraction; as you dream amid nature, extrapolate art from it and concentrate on what you will create as a result."[14] This bit of advice issued from Brittany in 1888 formulates what would become the rule of procedure for landscape artists throughout the North during the next decades.

It is precisely the capacity of Gauguin's own work to coexist in both Symbolist and Post-Impressionist groupings that suggests that their objectives do not fundamentally differ. In fact, a workable definition may better be found through a broader understanding of the subjective aims of Symbolism. The *allegorical* Symbolists, while inventing new esoteric subject matter, represent it in conventional styles and thus continue to parallel rather than fuse content and meaning; the *true* Symbolists do not so much search out new themes and subjects as invest the given ones with subjective and transcendental meaning. The latter achieve seamless continuity between external forms and states of inner feeling, freely transforming their subjects and reorganizing their forms and colours in the belief that meaning and form are inseparable. Their work is often called Synthetist, with the stress on their conviction that formal transformations of the subject matter can directly express meaning.[15] For these artists – the principal Symbolist–Post-Impressionists, namely Seurat, van Gogh, and Gauguin, as well as the Nabis in France and related Symbolist artists outside France, especially in northern Europe – the landscape continued to be a prime and sometimes exclusive subject.

Symbolist landscape painting in the North is unquestionably rooted in the stylistic principles of Synthetism, but it is more than an offshoot of French Synthetist Symbolism. It is also more than a mere sum of landscape paintings, executed in the North, which display Synthetist form or attempt to extract the supernatural from the natural motif. It begins to appear with surprising consistency between 1892 and 1894, across Scandinavia and in Switzerland. It emerges as a subjective and heroic approach to

landscape painting and contains such remarkable parallels of subject matter and stylistic solutions that one would speak of a school, were it not that most of the artists involved did not at this stage know each other's work. Some northern Symbolists sought to define their identity by crediting northern art with a spiritual profundity that French art, because of its preoccupation with technical facility, could not attain. Others insisted that there were inevitable differences between northern and southern art because they arise out of different climatic, topographical, and spiritual conditions.

The majority of the artists who participated in the development of northern Symbolist landscape painting had spent their formative years in Paris in the 1880s. Several became accomplished Naturalists or Impressionists, and by the end of the decade they were also gaining their first glimpse of the emerging alternatives to Naturalism: Neo-Impressionism, Cloisonism, Synthetism, and Symbolism. By the late 1880s they displayed a tendency to return home; it seemed implicit in Naturalism that its techniques be applied to the subject matter one knew best, one's native land. Some sought refuge at home when the artistic confusion of Paris in the early 1890s became too disruptive. Van Gogh died in 1890 and Seurat in 1891, and in March 1891 Gauguin departed for Tahiti, leaving behind a vacuum in advanced painting circles.

The breach was quickly filled, for better or worse, by the flamboyant Sar Péladan, who in March 1892 opened his much publicized Salon de la Rose + Croix, dedicated to Latinizing, mystical, and occultist art. While it remains unclear how much northern artists knew about avant-garde painting in Paris, Péladan's brand of spiritualizing and idealist aesthetics had short-lived appeal. The landscapists rejected exotic allegorical subject matter and returned home to brave barren promontories, impenetrable forests, and high mountain peaks in order to produce new work that depended on the cleansing effect of unspoiled wilderness. The journeys of some paralleled or were deliberate emulations of Gauguin's exploration of the harsh countryside of Brittany, or his pursuit of an imaginary paradise in the South Seas.

Gauguin, more than any other Post-Impressionist, was the spiritual father of many of the northern Symbolist landscape painters. Several of them had studied with Gauguin; some had seen his work in Paris or in Copenhagen, where his wife Mette lived. Only rarely, however, as in the Synthetist work of Willumsen, executed in France between 1890 and 1892, did a northern artist follow Gauguin's lead in giving priority to aesthetic values. Van Gogh's influence is also regularly discernible, but it was never singled out in the same way as Gauguin's. This is surprising because with their unshakeable roots in Naturalism, the northern painters, like Van Gogh, closely relied on nature as a source of inspiration and usually remained quite faithful to their original subject.

Because of its formal simplifications and concentrations, northern landscape painting is usefully described as Synthetist, although, because of its close identification of visual form and invisible content, it may also, and more generally, be called Symbolist. Scandinavian historians have called it Neo-Romantic, acknowledging the revival of pre-Naturalist affective and transcendental values and the resuscitation of the subject matter of earlier Romantic landscape painting. In the work of such artists as Dahl in Norway, Marcus Larsson in Sweden, and Calame and Diday in Switzerland that subject matter had survived longer – until the middle of the nineteenth century – in those northern countries than in France, England, or Germany.[16] Symbolist landscape painting from the end of the century rediscovered the compositional schemes, subjects, and philosophical attitudes of the very beginning of the century, especially those of Phillipp Otto Runge and Caspar David Friedrich, the latter an artist essentially forgotten and hidden from view during the 1890s. Thus the landscapists discussed here fit within Robert Rosenblum's reading of a "northern Romantic tradition" that spanned both the nineteenth and twentieth centuries.[17]

In Sweden and Finland especially Symbolist landscape painting became inextricably involved with local national and Romantic movements dedicated to expressing personal and patriotic feelings for the artist's countrymen and their natural surroundings. This concerted and almost programmatic application of an advanced style to native subject matter produced Sweden's and Finland's first truly national schools of painting. (Denmark had a

national tradition firmly established since the beginning of the nineteenth century, and in Norway the naturalist generation that had returned home from Paris in the mid-1880s had already associated its style with home-grown motifs. Outside Scandinavia Hodler broached Swiss national subjects only in large public commissions.) Throughout the North Symbolist yearnings for transcendental experience, coupled with Synthetist perception, opened doors to native wilderness scenery that Naturalism had ignored, but that quickly became established as the embodiment of national character.

Thomson and the Group of Seven, usually seen as Canada's first national school, could readily identify with Scandinavian Symbolist landscape painting when they came into contact with it two decades after its inception. In the United States, as a consequence of intensified isolationist attitudes after the First World War, advanced artists either were encouraged to play down their European-based Modernism or found that they could no longer sustain it. The intensified regionalism that resulted, expressed most insightfully by Hartley's commitment to New England and Nova Scotia, assumed many of the mystical trappings of Scandinavian national Romanticism.

With the exception of the work of Hodler, Munch, and Mondrian, very few of the paintings discussed here are known outside their respective national contexts. But in quality they at least equal and often surpass the work of many artists we are much more familiar with from the international Symbolist movement. North American viewers became familiar with some of these works only recently in the exhibition *Northern Light: Realism and Symbolism in Scandinavian Painting 1880–1910*.[18] Despite their relative obscurity, however, most of the artists who participated in the early stages of the formulation of the northern Symbolist landscape saw themselves as innovators building an art for the future. This ambition was tied up with the notion prevailing in Europe at the turn of the century, and underpinned by Theosophical thought, that a spiritual, cultural, and aesthetic renaissance would come from the North. But while spiritually and stylistically the northern landscapists subscribed to the Symbolist doctrine of correspondences and understood

something of the expressive capacity of plastic vocabulary, only one of its late practitioners, Mondrian, had the preconditions to move toward pure abstraction. In the United States during the 1920s and 1930s the situation was somewhat reversed: painters who had been innovatively conversant with the first stages of the development of abstraction either, like Dove and O'Keeffe, continued to draw from natural sources or, like Hartley, abandoned abstraction entirely for representational, if heroic, depictions of native subjects and communion with native landscapes.

Northern Symbolist landscape painting can be divided into two parts. The first phase was centred in Europe between 1890 and 1910 and had as its principal exponents Munch, Willumsen, Gallen-Kallela, Hodler, and Mondrian. (French art during the period was both the principal stylistic source for northern art and the foil against which it was defined.) The second phase, lasting from about 1910 to 1940, was centred in Canada and the United States, though the general features of the style had become common currency in Europe by then and could regularly be detected, especially in expressionist painting.

The artists referred to from both phases have dedicated a significant body of work to landscape painting. Those who do not have international reputations, such as Sohlberg in Norway, Nordström in Sweden, or the Group of Seven in Canada, were central and innovative figures in their own national contexts. Many of them worked primarily on the periphery of the Modernist tradition, but they also proved, as did the Scandinavian Naturalists of the 1880s, that a stylistic attitude, perhaps past its prime in its place of origin, could regain its original vigour when transported to a provincial context where it became rejuvenated as an avant-garde force.

The first phase of northern Symbolist landscape painting, with the prominent exception of Hodler, had run its innovative course by 1910. Then a younger generation, often despite the admonitions of its elders, rediscovered Paris and absorbed the lessons of Matisse and the Cubists. Some latecomers to this first phase, such as Osslund and Astrup, effectively adhered to its precepts well into the twentieth century, and for Mondrian a Symbolist approach to landscape served as a crucial transition between

his naturalist painting and his discovery of Cubism in 1911.

About 1910, however, the history of the development of northern Symbolist landscape painting jumps across the Atlantic to Canada and the United States, where artists drawn to their native landscapes reiterated many of the subjects and compositional schemes of the first, European phase, with the same intention of drawing higher meaning out of external nature. In the second phase it becomes difficult to account for the transmission, even to artistically conservative and isolated Canada, of artistic ideas that originated a decade or two earlier. By the very specific route of the Scandinavian exhibition in Buffalo in 1913, however, the painting of Canada's first concerted national movement, that of Thomson and the Group of Seven, can be described as a direct outgrowth of the first phase of northern Symbolist landscape painting. It was not simply a generalized response to lately received Post-Impressionist and Symbolist ideas and influences. Selectively viewed, the similarity between individual Scandinavian pictures and later Canadian ones often gives the impression of history repeating itself, a kind of sequential synchrony supported also by a Canadian appeal to patriotic and mystical motivations that parallel those of the northern Europeans at the turn of the century. Thus the Canadians, despite their originality within their own context, and their uncontestable vitality, invite classification as the final stage of nineteenth-century northern Romantic landscape painting. The vigour and optimism of their work has little to do with fin-de-siècle twilight, but unlike their American contemporaries they were little challenged by twentieth-century Modernist developments.

The late appearance of the northern Symbolist landscape modes in the United States requires a special explanation. The principal practitioners, Hartley, Dove, and O'Keeffe, were thoroughly immersed in the most recent modern European movements, much more so than most of the Scandinavians, with the exception of Munch and Willumsen, had been in Post-Impressionism. However, there is a parallel to the Scandinavian situation in the 1890s, where even the most ambitious artists, once cut off from the artistic centres and not immediately challenged by the fervour of advanced artistic ideas, had to discover a spiritual fountainhead for meaningful art in their own responses to the land they loved.

In the following chapters I shall attempt to describe a specific configuration of landscape painting that possesses an inner coherence based on a striving for the expression of affective or transcendental content through close communion with an intimately experienced landscape. While rooted in an older Romantic tradition, this landscape painting developed in direct reaction to Naturalism, the precepts of which were felt to exclude significant realms of spiritual experiences. Its language of expression, which also had parallels with earliest Romanticism, was adapted primarily from French Post-Impressionism, especially Gauguin's Synthetism. Northern painting, unlike French, however, shied away from pure aestheticism, saw art in the service of life, and consequently remained faithful to its subject to the point where it never really forsook its realist roots. The Symbolist landscape flourished in Scandinavia, in the Alps, on rugged and desolate coastlines, and in primeval forests because those who sought refuge in the unspoiled wilderness were able to re-establish contact with the primal sources of experience, the search for which was the special quest of Symbolist art.

From Naturalism to Symbolism

Close your bodily eye, so that you may see your picture first with the spiritual eye. Then bring to light of day that which you have seen in the darkness so that it may react upon others from the outside inwards.
Caspar David Friedrich[1]

Nature is not something that can be seen by the eye alone – it lies also within the soul, in pictures seen by the inner eye.
Edvard Munch[2]

Though the principles of Symbolism were being succinctly formulated by French poets as early as the mid-1880s and had been given painterly form by the end of the decade, the struggle of a younger generation against Naturalism in art and literature continued into the 1890s. This was especially true in northern Europe, not only because of its distance from Paris, but because Naturalism had been such a powerful liberating force during the 1880s, rendering obsolete the moribund academic teaching that had dominated local academies of art. Naturalism was associated with those artists who had defied academic authority and public displeasure in order to pursue a revolutionarily modern style, and their fight had often required the formation of independent artists' associations, the setting up of alternative exhibition spaces, and the establishment of schools run by artists.

Northern Symbolist landscape painting did not emerge as a movement with a sense of its own purpose or an inner coherence but was composed of a series of parallel developments arising in the work of artists working in various artistic and national contexts. It is thus a remarkable coincidence that the first paintings of this type appeared in a short period, between 1891 and 1894. They included Munch's *Melancholy, The Yellow Boat*, 1891–2 (no. 2); Sohlberg's *Night Glow*, 1893 (no. 66); Willumsen's *Jotunheim*, 1892–3 (no. 6); Nordström's *Storm Clouds*, 1893 (no. 14), and *Varberg Fort*, 1893 (no. 15); Prince Eugen's *Forest Clearing*, 1892 (no. 32); Gallen-Kallela's *Waterfall at Mäntykoski*, 1892–4 (no. 21), and *Great Black Woodpecker*, 1893 (no. 22); and Hodler's *Autumn Evening*, 1892 (no. 79). These works may seem a somewhat uneven group; some seem barely to have abandoned naturalistic mood painting, while others – those by Munch, Hodler, and Willumsen – have in their respective ways been severely abstracted. Each of these paintings, however, confirms the commitment to forge a new style that will overcome the limitations of Naturalism.

Whatever their stylistic disparities, the programme that lies behind these pictures can be seen in Munch's proclamation of 1890: "I paint not what I see but what I saw." Munch's motto, formulated before he had achieved his mature style of *Melancholy*, in turn echoes the call for an "art of memory" contained in an influential polemical article of 1889 entitled "The Field Study. The Picture. The Art of Memory" by the Danish art critic and historian Julius Lange. The article, which voices succinctly growing

doubts about the shortcomings of Naturalism as well as *plein air* painting, was widely read and commented on.[3] Andreas Aubert, the Norwegian critic, introduced Lange's ideas to Norway in 1890;[4] and the Swedish painter and critic Richard Bergh undoubtedly had them in mind in the 1890s when he defended the work of Nordström and Swedish national Romantic painting as an art of dreaming and longing.

In his article Lange observes that the sketch had come to be preferred over the picture finished in the studio because only the sketch could convey the radiance, freshness, and powerful flavour of the immediate experience sought in Impressionism. These evaporate all too swiftly and cannot be "cooked up" again in the studio. Does that mean, however, that art must satisfy itself by producing only Impressionist sketches, one after the other? If work in the field and work in the studio are incompatible according to Impressionist principles, is there another and different objective for which working in the studio is the right method? It is not a question of doing away with one method or the other, but rather of ensuring that one should not tyrannize the other. Certainly the servant should not tyrannize the master, and the master, in Lange's opinions, is work in the studio: "there should be room for that aspect of art which comes from inside, and this after all should also rule the whole."[5]

It was probably not clear to Lange what kind of art he anticipated as an alternative to Impressionism. (In a long note he draws attention to a number of anti-naturalistic principles of Japanese art derived from an eighteenth-century Japanese author who had just come to his attention.[6]) Study of the subject was not to be abandoned; on the contrary, the artist must know all the components of his art as well as a scientist does his. Naturalistic knowledge is an essential tool for the production of an art that comes from inside; knowledge is necessary to avoid dilletantism.

Lange stresses that he is not advocating a return to idealist or conventional or literary art; he wants rather to be the spokesman for "an Art of Memory." Art, he insists, is born not during the day when the light blinds the eye, when external surprises crowd out one another – that kind of art will have very short roots in the soul:

But in silence and darkness, or in any case while the outer eye is *not* looking, but the mind is left in peace to make its choices from what memory conceals, then images emerge to the inner eye, half clear, half obscured images from the fertile night of the unconscious life of the soul, its dark fruitful depth. It is the surprises which come from inside: one does not know oneself according to which laws they come, or where from; but there is that difference between them and those which come from outside, that we recognize them as our most trusted friends; they are after all only an expression for what we longed to see. It is that which has struck roots in us, which grows forth and which wants to come out and take on form and character.[7]

Lange's call for an art of memory, an art that reflects the desires and needs of the heart, strikes to the core of the Symbolist landscape that would emerge during the next few years.

The terms of the transition from Naturalism to Symbolism were not identical for all the artists, which explains the stylistic variety among the first Symbolist paintings of 1892–4. For many, however, an essential threshold to cross was moving from an increasingly subjective Naturalism, which depicted a mood that arose out of particular light and atmospheric effects in nature, to a freer stylistic approach that would willingly transform the natural motif in a formal way to make it convey a mood, feeling, or idea that originated in the heart, soul, and mind of the artist. The distinction may be subtle, but the transition represents the stylistic issues at stake in the early 1890s. It might initially be explored by contrasting two well-known works by Munch: *Inger on the Beach*, 1889 (no. 1), essentially a naturalistic mood painting, and *Melancholy, The Yellow Boat*, 1891–2 (no. 2), usually regarded as his first fully realized Symbolist landscape painting.

During the 1890s Munch rarely produced pure landscape paintings, and his subject matter was dedicated to the exploration of human psychology. During the years from his departure for Paris in 1889 to his final return to Norway in 1909 he returned home almost every summer; and throughout the 1890s most of his major paintings were executed at Aasgaardstrand, the forests, shoreline, and summer twilight of which are the unifying theme of "The Frieze of Life," on which he worked for most of

the decade. Because of the importance of the Norwegian landscape to this work he was compelled to deal with it in ways that parallel and illuminate those of his northern landscapist contemporaries.

The landscape settings of both *Inger on the Beach* and *Melancholy* are saturated in mood, but in *Inger on the Beach* the disposition of the female figure seated in profile on the rocks in the near foreground is essentially realistic;

and the scene, shrouded in the pale, shimmering twilight of the northern summer night, partakes of the conven-

1
Edvard Munch (1863–1944) Norwegian
Inger on the Beach, 1889
Oil on canvas. 126.4 × 161.7 cm
Rasmus Meyers Samlinger, Bergen, Norway

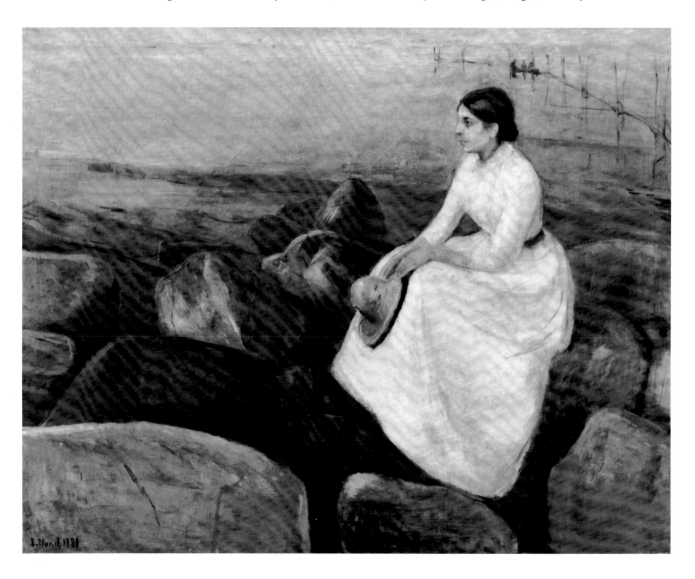

Edvard Munch (1863–1944) Norwegian
* *Melancholy, The Yellow Boat*, 1891–2
Oil on canvas. 65.5 × 96 cm
Nasjonalgalleriet, Oslo

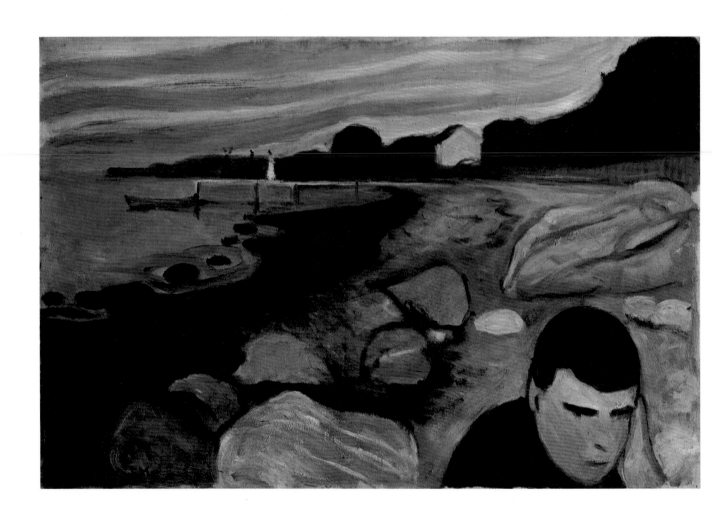

tions of Naturalist mood painting.[8] This type of landscape subject had become particularly popular in Norway in the summers of 1886 and 1887, when a group of Naturalist artists, tired of the glare of sunlight, shifted their attention to the more evocative softness of summer evening twilight. They remained faithful to the imperative of rendering sense impressions, but sought those times of day when nature could evoke a sense of mood. Their model was in part at least Puvis de Chavannes, and from him they learned to suppress finer details in favour of a broader rendering of form, to soften the effects of light, and to give a deeper ring to their tonalities in order to convey in stillness and silence something of the mystery of nature. During the 1880s the nationalistic appeal of the northern twilight was no insignificant motivation for these artists who came together on Christian Skredsvig's farm of Fleskum near Oslo. But it was the new poetic and musical intensity of their work that signaled it as prophetic of something in the air, not only in Norway, but throughout the North.[9]

Inger on the Beach, directly indebted to the Fleskum painters, underscores the singleness of its purpose both by the considerable formal simplifications that closely integrate landscape and female figure and by the pervasively lyrical atmosphere, which echoes the self-absorbed contemplativeness of her pose. The personal nature of Munch's handling of the figure and the intensity of the mood he describes push the painting to the brink of symbol. His method, however, if we correctly interpret his description in the "St Cloud Manifesto," composed the following winter in France as a programme for "The Frieze of Life," indicates that he is still a modified Naturalist. As he says, he would depict the scene as he had seen it, "but in a blue mist."[10] In *Night in St Cloud* (Nasjonalgalleriet, Oslo), executed in the winter of 1890, he shrouded in a blue haze the lonely, contemplative, and melancholy figure staring out of the window of his dark room to life outside, in a painting thought to express the artist's own mood after his father's death. The mood-inducing blue haze, which owes a great deal to Whistler, remains ubiquitous throughout northern landscape painting for at least a decade.

In *Melancholy* Munch rethinks the twilight seashore motif of *Inger on the Beach*. The development lies not merely in the greater fluidity and expressive character of the drawing, which is not content just to describe but has impregnated each element of nature with significance. The rendering of space, the disturbing rush from foreground to distance, fundamentally alters our relation to the scene by physically juxtaposing disparate spaces. The recessional sweep of the shoreline in a sharp curve from close-up foreground to the distant horizon line is continuous and uninterrupted in a way familiar from early Impressionism (see Claude Monet's *The Beach at Sainte-Adresse*, 1867, Metropolitan Museum of Art, New York). But the foreground is unexpectedly monumentalized and unnervingly close, making even more poignant the spatial rupture, across an empty middle ground, between the foreground rocks and abruptly truncated male figure and the three tiny figures on the wharf and yellow boat in the far distance. Near and far are no longer united within a continuous naturalistic space but have been separated into two quite disparate realms of existence, a space of physical being and another of yearning and reflection. The spatial schism is exacerbated by the decision to make the brooding foreground figure face out the front of the picture rather than toward the objects of his contemplation. The abrupt truncation also establishes a new relationship between the content of the picture and us the viewers, who have been crowed out of the foreground of the picture at the same time as our noses have been pushed up against it, depriving us of objective distancing.

In *Inger on the Beach* and *Night in St Cloud*, as in earlier Romantic painting, we are cast as observers of figures that might act as our surrogates, but that are nevertheless outside ouselves, performing in fully realized spaces, and we share their mood through the experience of empathy. In *Melancholy,* however, we have become fused with the protagonist and stand, without an intermediary, face to face with a structure of tensions, formal and psychological, that strikes us with the force of a personal mental projection.

The transformation of Munch's style from essentially Naturalist to Symbolist in this way is a model for similar transformations among his contemporaries. That Munch during the 1890s used landscape primarily as a setting for

the enactment of psychic dramas should not distract us from this. The figures in *Melancholy* are not essential to the establishment of the mood of the painting, and the tension-filled distance between the near and the far would be just as poignant without them. The figures give it a certain kind of specificity and anchor it within Munch's interest with psychic experience. The fact that this painting has had several titles – *Evening, Sad Evening, The Sorrow, Jealousy*, and *Melancholy*[11] – suggests the ambiguity of the moods of landscape paintings, which even the presence of figures does not dissipate without the introduction of extra-pictorial clues, such as those that have traditionally accompanied *Melancholy, The Yellow Boat*.[12]

The restructuring of pictorial space from the representational to the symbolic – a transformation from a space of potential physical access to one of purely visual entry – is one of the defining characteristics of northern Symbolist landscape, and one of the earliest. This process is, nevertheless, only one of the threads that must be followed before we can come to terms with our subject, because the development of stylistic solutions to "an art of memory" is intimately interwoven with other northern problems. In the early 1890s northern artists rediscovered the wilderness landscape as a place for spiritual revelation. The northern landscape itself, wilderness or not, its light and atmosphere, posed unanticipated problems for styles learned abroad. These issues in turn were not only discussed from the point of view of spiritual imperatives but were also assessed in relation to patriotic needs and analysed in terms of irreconcilable North-South dichotomies.

Wilderness and the Challenge of Gauguin: J.F. Willumsen

I met in the mountains the eternal and the everlasting which as a mirror image let me see and understand something of all that which moved me strongly. Here I gathered the strength to continue along the way which would lead me toward heights where the blue mysterious flower of art buds and unfolds in the sun.

J.F. Willumsen[1]

The development of northern Symbolist landscape painting in all its phases is closely connected with a specific kind of landscape. The art histories of the northern European countries were independent, had different roots, and were at different stages of development at the beginning of the 1890s, with Switzerland quite outside the otherwise predominantly Scandinavian orbit and "northern" primarily because of its mountainous terrain and the Germanic and Protestant component of its culture. All these countries, however, except Denmark, could boast of considerable tracts of unexplored wilderness, which for various reasons, patriotic or spiritual, it became imperative to explore. Jens Ferdinand Willumsen, Denmark's most powerful and problematic Symbolist, found his motifs in the Juras, the Alps, and finally in Norway. Similarly Piet Mondrian, when he abandoned Hague-school painting several years after the turn of the century, would find a comparable monumental motif after he turned his back on the cultured and cultivated Dutch countryside to face the infinite expanse of the ocean.

The development of Symbolist landscape painting con-sequently was linked with journeys by the northern artists into virgin forests, up steep mountain slopes, and generally into wild regions in search of an unspoilt wilderness paradise in which the tired soul could be reborn. This idea became a powerful underlying theme, which in Canada prevailed into the 1930s; Lawren Harris, fired by Theosophical ideas, revived mystical notions, prevalent in Europe in the 1890s, of the North as an ever-replenishing source of psychic strength and the location of the new cultural and spiritual renaissance. For Harris this would not only ensure that the art of the future would be produced on Canadian soil, but that Canadians, because they possessed the spirit of the North, would also be able to regenerate their southern neighbour, the United States. To the Americans, for whom such wilderness quests had had a special spiritual potency throughout the nineteenth century during the period of expansion into the West, the Canadian cult of the North might have seemed *déjà vu*. But even they were able to sustain or perhaps revive such ideas through the 1920s and 1930s, often with a strong regionalist focus, as in Marsden Hartley's work.

The idea of the journey into the wilderness also became, either immediately, or in later critical assessments, intimately associated with Gauguin's trip to Tahiti. His departure took place only a year before the sudden flourishing of northern Symbolist landscape painting, in the spring of 1891, and his rejection of a corrupt and doomed European culture took on considerable symbolic power. Thus Finnish artists undertook expeditions into the Finnish

Karelia initiated by Akseli Gallen-Kallela in 1891. Their trips, which produced paintings such as *Great Black Woodpecker* (no. 22), were undertaken in pursuit of simple and primitive pre-Christian forms of Finnish life, which the wild and sparsely populated forests presumably had preserved. This vision of a primal, unspoiled paradise, close to nature, was inspired by the Finnish national folk epic the *Kalevala*. The artists' search during the 1890s for the mythical world that the epic described in the deep forests of the Karelia caused the latter to be dubbed Finland's "domestic Tahiti."[2]

During this same period the Swedish painter Karl Nordström deserted Stockholm for a refuge in his native province on the west coast of Sweden, in a landscape harsh, barren, and windy. His move received a similar interpretation from critics, supported by the fact that his work, whatever his other influences, grew directly out of his experiences of Gauguin's work, which he had studied extensively in Copenhagen in 1892, when his friend and colleague Richard Bergh had acquired a Breton painting by Gauguin. Nordström was even able to call those weatherbeaten and unfriendly surroundings in which he produced *Storm Clouds* (no. 14) and *Varberg Fort* (no. 15) a "paradise" – "a paradise for nerves gone lax; a wilderness in which to preserve our [the Swedish artists'] health and strength."[3]

The notion of a wilderness paradise was, of course, not a paradoxical one at the end of the nineteenth century, when the earlier opposing concept of paradise and wilderness had become quite reconciled. This is especially true of the American wilderness which, because it was a place of solitude, untouched by man, was considered pregnant with divine association and a place where the mind could contemplate eternal things. The wilderness was, however, a new challenge for those parts of Europe where it still existed, although it seemed merely chaotic and monotonous until the key to its secrets was found. To probe these was important for two reasons. First, as in the United States much earlier, wilderness was the principal landscape characteristic that distinguished the northern countryside from the rest of Europe; and second, the mysterious and wild lands could be a sympathetic mirror for the vague longings of restless artistic souls. In addition, wilderness could be a site for the rediscovery of primal experience.

Though Gauguin's journey to the South Seas came to stand as a powerful symbolic model for northern artists' own expeditions into mountains and forests, their notion of a wilderness paradise, often both sunless and silent, stands in sharp contrast to Gauguin's expectations of Tahiti. Gauguin had described these with enthusiasm to Willumsen in a letter in the autumn of 1890 when he accounted in some detail for his intentions to go to the South Seas. Gauguin's earthly paradise was essentially a Romantic transplantation of the notion of the Golden Age such as his contemporaries might have imagined it from the paintings of Puvis de Chavannes, seen in conjunction with descriptions of the South Sea islands in travel books (by Pierre Loti) and what might be learned about them at the Universal Exposition in Paris in 1889. An official handbook at the exhibition seems to have provided Gauguin with the images he conveyed to Willumsen: "Out there ... beneath a winterless sky, on marvellously fertile soil, the Tahitian need only lift up his arms to pick his food; for that reason he never works." In Europe "men and women can satisfy their needs only by toiling without respite, while they suffer the pangs of cold and hunger, a prey to poverty"; the Tahitians, "on the contrary, are the happy inhabitants of the unknown paradises of Oceania and experience only the sweet things in life. For them, living means singing and loving." This South Seas paradise will be a refuge from a Europe where

3

Jens Ferdinand Willumsen (1863–1958) Danish

* *Spanish Chestnuts, Ornamental Landscape Composition*, 1891 "Decorative patterns based upon the vividly green and luxuriant Spanish chestnut. The pattern is continued in the mother-of-pearl-like rings formed in the lake by the rain. The frame is carved in such a way that it forms a continuation of the picture's pattern, shading off evenly toward the straight lines of the outer edge. The mottled green area below is merely a decorative contrast" (artist's commentary, 1892).

Oil on canvas and wood. 96 × 95.5 cm

J.F. Willumsens Museum, Frederikssund, Denmark

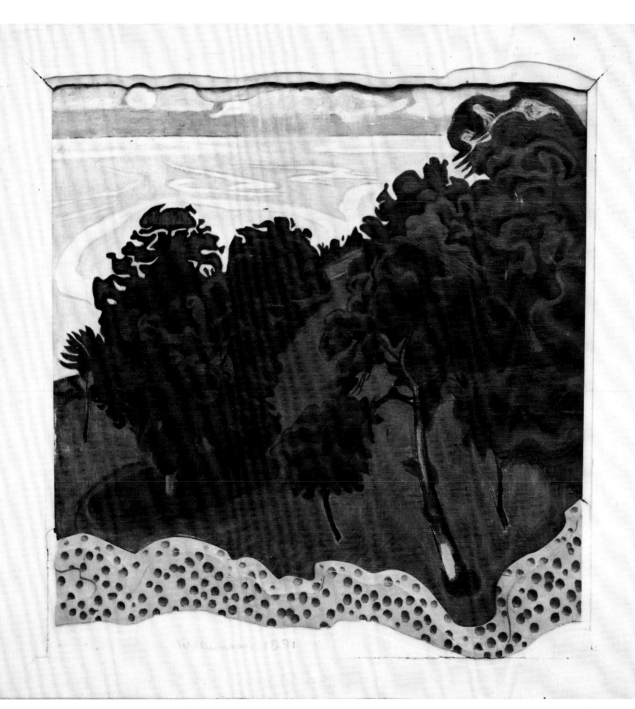

"terrible times are in store ... Where everything is rotten, men and arts alike."[4]

Gauguin's vision seems to have occupied Willumsen's mind for some time, and he radically restructured it, coming to terms with it in his monumental mountain winterscape *Jotunheim* during 1892–3 (no. 6), which illustrates dramatically how northern artists would transform Gauguin's winterless paradise into a winterbound northern one.

Jotunheim is one of the most remarkable Symbolist landscapes of the 1890s. The stylized bleak and barren landscape, with its snowclad mountains spread out panoramically somewhere below our own lofty position, is quite new in the history of art. The subject matter is not new: we are familiar with panoramic mountain scenery from Romantic painting in Europe and North America; but the viewpoint is, setting us aflight as disembodied spirits attending to a vision of sublime but forbidding majesty, which is perhaps more an idea than a place attainable by mere mortals.

Jotunheim summarizes many of the fundamental problems surrounding the development of northern Symbolist landscape painting, and does so better than any other contemporary work because its genesis is not tied to any particular national development. When Willumsen began the painting, he was smarting from the virulent critical reception of his Synthetist, Gauguin-influenced work. It was first shown in Copenhagen in Den frie Udstilling in 1891 and the spring of 1892, and reviewers had judged it incompatible with the Danish tradition. Despite the bitterness and loneliness of what consequently seemed to him exile from Denmark in Paris, he had at the same time begun to feel at odds with French artistic culture, and *Jotunheim*, by the time it was finally completed in 1893, had unwittingly become a kind of manifesto for the northern spirit.

Willumsen, who first went to Paris from Copenhagen in late 1888 as a dedicated Naturalist and emulator of Raffaëlli, had fully assimilated the decorative principles of Gauguin's style by the time the two artists met in Pont Aven in the summer of 1890. The encounter led to an exchange of letters and visits, as well as of works, during the following winter in Paris. Willumsen was a guest at the banquet that the Symbolists gave in Gauguin's honour on 23 March 1891, prior to his departure for Tahiti, and a week later Willumsen saw him on the train for Marseilles to catch his boat.[5]

Willumsen was powerfully drawn to Gauguin and welcomed his suggestion that the two of them were "un peu parents."[6] Yet the overwhelming personality of the Frenchman threatened the independence of Willumsen's own work, a problem brought home to him during the spring exhibition in Copenhagen, when his most recent work, already received with stormy miscomprehension, was also accused by a leading critic of being "an extremely cheap plagiarism of Gauguin."[7]

Willumsen sought afterwards to get Gauguin out of his system. In the summer of 1891 he decided not to return to Brittany, though it maintained its undiminished popularity for other former associates of Gauguin. Instead Willumsen opted for the Côte d'Or and the Jura Mountains, a choice that would not only introduce him to a new realm of subject matter but would also spur him to the level of awe-filled emotion at which much of his later work would be conducted.

The most important painting resulting from that summer was *Stonebreakers in a Fertile Mountain Region*, 1891–2 (no. 4), a polychromed wood relief with an inlaid gilded metal plate. It is not primarily a landscape, but it reveals Willumsen's ambivalence toward the vision of the Tahitian paradise that Gauguin conveyed in his letter of the preceding autumn. The commentary Willumsen wrote to accompany the picture when it was exhibited in Scandinavia in 1892 seems on the surface to echo Gauguin:

Men are quarrying stones from a mountain covered by a lush vegetation. They have to toil to earn their daily bread while the animals that live freely on the mountain easily find their food in the rich vegetation. In the winged and web-footed chamois

4
Jens Ferdinand Willumsen (1863–1958) Danish
Stonebreakers in a Fertile Mountain Region, 1891–2
Wood relief. 98 × 98 cm
Statens Museum for Kunst, Copenhagen

is an expression for the running, flying and swimming animals combined into one being.

The picture thus contains the opposition between freedom with its pride and joy of life and compulsive labour with its oppressive effect.

"The stonebreakers are not personified individually," Willumsen further tells us, because "it is the same human machine which works in all of them."[8]

Despite the clarity of intention, there is an ambiguity about the work. It is not a realistic rendering of daily toil such as one would have found in Naturalistic painting during the 1880s. The absorbed action of the workers, the neat, clean, Synthetist blue-and-white planes of their clothes, and the ritualistic rhythm of the sequence of their gestures can as easily be interpreted as a celebration of the dignity of labour in close harmony with natural sur-roundings. The workers belong stylistically with the forested mountain side, and the unexpectedly exotic and extravagant intruder is the gilded chamois, which, en route to the first Salon de la Rose + Croix, has briefly perched in the countryside to tempt the diligent and productive workers away to the Parisian world of Symbolist decadence.

Such a revisionist reading of Willumsen's stated intentions suggests both that he is subconsciously uneasy with Gauguin's vision of paradise and that he is in the process of turning it topsy-turvy, which he will in fact do in

5
Jens Ferdinand Willumsen (1863–1958) Danish
* *Study for Jotunheim*, 1892
Watercolour over pencil on paper. 29.9 × 35.4 cm
Lolland-Falsters Kunstmuseum, Maribo, Denmark

6

Jens Ferdinand Willumsen (1863–1958) Danish
Jotunheim, 1892–3
"The clouds drifted away and I found myself at the edge of
an abyss, looking over a mountainous landscape in the far
North, grim and harsh, covered by eternal snow and ice, a
world uninhabitable for human beings.

The symbolic figures in the relief were formed under the
influence of this grim atmosphere.

The figures on the left of the relief represent those who
steadfastly seek through learning and reason the link
between the infinitely great and the infinitely small. The

infinitely great is symbolized by a stellar nebula, the
infinitely small by microbes. The figure below is inspired;
the figure above is convinced of the true outcome of his
researches.

The right side of the relief is in contrast to the left
and represents the purposeless; below are two men, one
of whom is weaving a net which the other is as quickly
unravelling; in the centre a group of those who are
indifferent; above a figure representing chimeric dreams"
(artist's commentary, 1895).
Oil painted zinc and enamelled copper. 105 × 277 cm
J.F. Willumsens Museum, Frederikssund, Denmark

21

Jotunheim, the major work of the next two years. This work, or rather the landscape part of it, was conceived in Norway, which Willumsen was touring in the summer of 1892, just prior to setting up his one-man exhibition in Oslo in September.[9] In its breathtaking panoramic spectacle encompassing ice-cold fjords and the mightiest snowclad mountain peaks, the painting was the first monumental Scandinavian mountainscape since J.C. Dahl's, and one not matched in Norway until 1900 by Harald Sohlberg, and elsewhere until 1908 by Ferdinand Hodler.

Willumsen's journey northward in 1892 had been preceded by a journey up into the Juras in the summer of 1891. The account of his first confrontation with mountains reads like a restless, insatiable quest for new levels of experience attained only at the topmost point of the highest peak. He wrote from Paris to his friend the painter Johan Rohde on 17 November 1891:

It was the mountains this summer which formed my longing and desire ... I went from railway station to railway station, higher up into the mountains. It was the naked cliffs I sought ... In this searching way I reached the highest peaks of the Jura chain from which the land again descended towards Lake Geneva, but on the other side they could be seen again rising twice as high above the clouds with the long chain of yellow-white snowpeaks ... and with these naked tops and sides which I sought, this must stand for me as a desired, distant land which lay too far away to reach.[10]

The works that developed immediately out of that summer journey are relatively realistic mountain studies. Willumsen, considering them alongside his later, more stylized works, described them as pictures taken somewhere or other haphazardly with a colour camera, lying outside his otherwise continuing development.[11] Because, ironically, we know them today only from photographs, their quality is hard to judge, but their remarkable panoramic perspectives and their elimination of foreground *repoussoir* elements are important. Finished paintings, as opposed to various studies by Romantic painters, they are perhaps the first of their kind to establish so radical a spatial disjuncture between the spectator and the subject.

Each fall and winter in his Paris studio Willumsen would undertake a much more ambitious Synthetist approach to pure landscape. In such works as *Spanish Chestnuts, Ornamental Landscape Composition*, 1891 (no. 3), he attempted to develop a formal approach to expressive content. In the catalogues for his 1892 exhibitions in Copenhagen and Oslo he wrote: "One sees how I more and more have distanced myself from an illusionistic effect of nature, in order instead to offer an art which consists of its individual parts presented in various mutual relationships, so as to create effects on the soul analogous with those produced by architecture and music." In the painting itself, "the ornamental forms" are developed from the shape of the "dark green, luxuriant chestnut tree," and are continued in the pattern of the "mother-of-pearl-like" rings formed on the surface of the lake by the rain. The frame, furthermore, is carved so as to form a continuation of the picture's ornament, as a transition to the straight lines of the outer edges, whereas "the mottled green plane below is merely a decorative contrast."[12]

The landscape in *Spanish Chestnuts*, probably based on a motif from Lake Geneva, is perhaps the first pure Synthetist-Symbolist landscape executed by a northern artist, although Munch also was moving in the same direction, from "mood painting" to a more powerfully expressive interpretation of landscape. Both artists proceeded from Baudelaire's notion of *correspondances*, but, as Przybyszewski would soon argue, the colours and lines in Munch stood in direct connection to the most intimate movements of his soul,[13] so that the artist and the landscape became mystically united as one; Willumsen, in contrast, seems to have retained a personal distance, as if the making of decorative landscape composition is a matter of intellectualized stylization rather than affective transformation.

The stylistically more adventurous works that resulted from Willumsen's summer in the Juras, such as *Spanish Chestnuts* and *Stonebreakers*, confine themselves to the lower slopes of the mountain sides. Willumsen remained dissatisfied with the paintings that scanned the higher altitudes because, as he later explained in his memoirs, "my eyes were not yet attuned to grasp so immense a spectacle, and my hands did not know how to capture so strange a world of beauty."[14]

The quest for the irresistible mystery of the mountains was continued the following summer with treacherous climbs into even higher mountains in Norway. On one frightful occasion, as Willumsen would recollect in his memoirs, "the weather suddenly changed and great banks of fog rolled in from all sides, or rushed by. They were like evil spirits and I felt an ice cold terror inside me. I was filled with fear of the immensity of nature. Pieces of rock became alive and sought my life, and struck by panic I ... plunged into a run which became wilder and wilder," down from the frightening raw "black and white" colours, as they seemed up there, to the soft green ones below.[15] This late account is tainted with mythologizing interpretation, but it serves as testimony to the intensity with which northerners at the turn of the century experienced wild nature and attributed to it demonic and primeval forces.

In Paris in December 1892 Willumsen began a notebook in which he reflected on those powerful occurrences in the mountains.[16] His descriptions correspond closely to his painted rendering of the landscape. One frightening day on the mountainside he became lost in the fog, and when the fog lifted he found himself in a place he had never been before, on the edge of a steep cliff. In front of him he saw a world "covered in ice and snow which never melted ... a nature raw, brutally hard and craggy, untouched by man." But, as he concluded, "one learned from looking at it." He elaborates: "And in the far distance there was another view, this one of the very highest peaks protruding above the fog." These peaks "are so high that no one can reach them because the air is so thin and the cold so fierce and the way so far that those who set out will die halfways. One must be satisfied," he concludes, "with the sight of these peaks from down below."

So the journey into the northern mountains yields conclusions about the demonic nature of experience in high wild places and about the distant goals that rise magnificently before one's eyes but are accessible only to the eyes and to the longing for them. (Striving for them is as futile as Gauguin's pursuit of his dream in the South Seas.) Nevertheless, as Willumsen records in his notebook, there are lessons, even if they are unspecified, to be learned from having seen and confronted the awesome and distant peaks.

Jotunheim (no. 6) was originally planned simply as a decorative landscape modeled on those of the previous year. The 1892 notebook indicates that Willumsen carried out extensive studies so as to be correct in his depiction of natural phenomena. Nevertheless, and unlike the work of the previous summer in the Juras, the studies for *Jotunheim* are stylized and abstract (no. 5). The painting was not intended to represent any particular place or view but was conceived as a composite of many in order to capture an "intense and typical expression of the particular feeling one experiences in the mountains."[17] While formally the look of the 1891 landscapes was dictated by the rounded shapes of organic growth, the forms of *Jotunheim* are sharp and jagged like the cliffs and the peaks themselves, or crisply geometric like the icy crystalline reflections in the water. The colours are cold – white, black, and blue – relieved only by the warmer brown of the lower slopes in the foreground.

The painting was intended to stand alone as a pure landscape conveying its meaning through formal stylizations. Willumsen showed it that way in the Salon du Champ-de-Mars in 1893, but it apparently did not meet his expectations. A pure Synthetist landscape somehow did not afford him the range of expression demanded by his experiences in the mountains and the ideas they aroused. Several entries in the 1892 notebook discuss the importance of the "idea," which should be the subject of the work of art and must rise above the merely personal and speak in the interest of mankind in general. Over the next year Willumsen decided to add the frame with its lateral groupings of figures and the frieze of mountain peaks above.

If the painting did not easily yield Willumsen's intended content, the programme of the frame is also ambiguous and hard to decipher. If he felt the need to introduce figurative imagery in order to explain himself more precisely, he also wanted scrupulously to avoid using borrowed imagery or literary sources and insisted on inventing his own. But, as even his friends acknowledged, Willumsen's greatest strength was not a sharp intellect. As with the work exhibited in 1892, he provided an ex-

planatory text which, along with the 1892 notebook, makes it clear that his thinking originated in Gauguin's evocation of the joys of leisure in Tahiti and shows that he finally rejected Gauguin's paradise in favour of one based on quite opposing values.

The catalogue commentary from the first, 1895, exhibition of *Jotunheim* in its final version explains that the symbolic imagery of the relief was formed under the influence of the "mood of solemnity" of the mountain landscape.[18] The significance of this uninhabited world was revealed when the clouds suddenly parted to expose the highest unattainable peaks above the clouds. Up there, one learns from the notebook, the air is always pure and the atmosphere unchanging, and there the mystery of things resolves itself into clear and eternal laws. Below the clouds where the light, the weather, and the climate are constantly changing, men's temperaments are also constantly variable and "quick to joy or sorrow."

As the 1892 notebook also tells us, those who live among great mountains develop "a certain imperturbability in their behaviour, firm wills to ponder over the reality of things" and generally search for illumination. They always look "upwards and outwards" and are demanding in their work, in their quest of the "unchangeable infinitely large." Those who live under the shifting clouds, in a world of changes, "sun and rain, summer and winter, travel to north or south," become absorbed by "the practical needs of daily life"; they look "inwards and downwards" and seek "ease and happiness." Those who can attain the heights are "people who have grown up under difficult conditions whereby they have learned to become thoughtful," whereas those who live below are people from a "fertile region" who (shades of Gauguin), "wherever they turn or however they carry on, the lap of the earth provides for their needs."

The right and left panels thus come to stand respectively for the world above the clouds and the world below and become a kind of juxtaposition of folly and wisdom. The right side must be "loose and easy," says the notebook. It is lush and green (like Gauguin's Tahiti), and people are carefree, singing, and loving. But, admonishes Willumsen in his commentary, these people are "the indifferent," and their purposelessness is illustrated by the two men at the bottom, one of whom is weaving a net which the other is quickly undoing. In contrast, the left side, says the notebook, is "rulebound, mathematical and logical" and depicts four stern and solemn men absorbed in weaving another kind of net, a net of knowledge based on inspiration, research, and a determined will, which will unite "the infinitely small," represented by the microbes below, and "the infinitely great," the stellar nebula above, in pursuit of the truth, which one yearns for and which resides in the highest mountain peaks above the clouds. In the frieze of the frame, as if in apotheosis, the peaks have been lifted out of the physical world and are now touched by the golden rays of the sun.

Inspired by a sublime vision, Willumsen projects a quest for mystical truth based on hard work, diligence, and sacrifice. His belief in the character-moulding effect of the northern latitudes and his puritanical condemnation of a life of ease and pleasure not only sum up the belief in the recuperative values of the wilderness generally shared by our northern artists but also reiterate the northern belief in its moral superiority over southern countries. Later in the 1890s this attitude would occasionally translate into a belief also in the superiority of northern art, precisely because it stressed the ethical over the aesthetic.[19] The Swedish artist and critic Richard Bergh, writing during the 1890s in defence of the national Romantic attitude, echoed Willumsen's proscription of South Seas bliss when he remarked: "in the North art is not a product of happiness, but of longing."[20]

It was probably the tragedy of Willumsen's art that he could not realize his expressive objectives of *Jotunheim* in a pure Synthetist landscape and that he needed to venture into figurative allegory. In his subsequent work it was the Symbolist rather than the Synthetist aspect of his work he often emphasized, sometimes with bizarre results. Emil Hannover, a Danish critic and Willumsen's most sensitive interpreter and supporter, attributed the problem to Willumsen's wanting to be a thinker of significance, which he was not. Essential to his art was his capacity to feel "grandly and solemnly in the face of even the simple events of everyday life." But his feeling, to Hannover's mind, was essentially "devotional" in character. He has something of a "barbarian's or primitive

7
Félix Vallotton (1865–1925) Swiss
* *Le Mont-Blanc*, 1892
Woodcut on wove paper. 37 × 25.5 cm
Galerie Paul Vallotton, Lausanne, Switzerland

man's puzzled awe of the mystery of nature and existence, and there is in his art something of the puzzled way in which barbarians and primitive man have given this awe a pictorial or symbolic expression."[21] Hannover's insights parallel Aurier's description of Gauguin's work as "Platon plastiquement interprété par un sauvage de génie."

Through the airborne vantage point of *Jotunheim*, which renders uncertain both the artist's and the spectator's physical and spatial relations to the landscape, transforming it into something accessible to vision alone, Willumsen has underscored his intention to present us with an idealized mental projection. In its Synthetist simplification of natural phenomena, its frontality, and its rendering of space in a sequence of layers parallel to the picture surface, *Jotunheim*'s compositional type is closely related to those Symbolist landscapes that begin to emerge between 1892 and 1894, especially those of Gallen-Kallela, Nordström, and Sohlberg. More specifically, the way in

which Willumsen's painting treats mountain scenery prefigures an important subset within Symbolist landscape types.

Willumsen's synthesizing approach to depicting the Jotunheimen scenery evolved during 1891 and 1892 in the manner I have described, and was probably based on no preceding models, except his own Gauguin-related work. Nevertheless, and given Willumsen's usual receptivity to new ideas, one wonders whether there was some kind of intervention between the summers of 1891 and 1892 that aided him with the problem that, according to his memoirs, developed during his first confrontation with mountain scenery in the Alps. How was he to teach his eye "to grasp the immense spectacle," and his hand to "capture so strange a world of beauty," which lay spread out before him?

Like most of his contemporaries, French or otherwise, Willumsen would have been attentive to the compositional devices and the possibilities of simplification suggested by Japanese prints. In 1892, however, Félix Vallotton, a member of the Nabis better known for his prints of domestic interiors, street scenes, and portrait subjects, executed a number of woodcuts that present Alpine mountain peaks in a way closely related compositionally to Willumsen's sketches from the summer in the Alps, and stylistically to those from Jotunheimen. Vallotton's Alpine views (nos. 7–13) are unusual in his oeuvre, which generally, and in contrast to Hodler, for example, seems more French than Germanic, and takes a more intimate and aesthetic perspective on its subject matter. The example of the decorative simplifications of the strongest of these woodcuts, *Le Mont-Rose* (no. 12), *Mont-Blanc* (no. 11), and *La Jungfrau* (no. 13) – their centralized and frontalized compositions framed as if with a distantly trained camera, without reference to foreground or clues as to viewer position – and the broad woodcut character of their forms would help to explain Willumsen's new nonnaturalistic general conclusions and the irregular, sharply angled shapes of the patches of snow scattered across the sides of the mountains in *Jotunheim*, forms that seem to have appeared fully developed in his first sketches. At least two of Vallotton's Alpine prints also show snowclad mountain peaks rising above a blanket of cloud, a motif

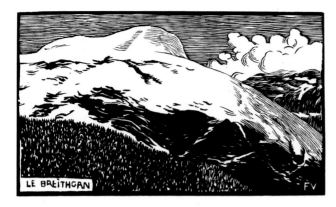

8
Félix Vallotton (1865–1925) Swiss
* *Le Breithorn*, 1892
Woodcut on wove paper. 25 × 36.8 cm
Galerie Paul Vallotton, Lausanne, Switzerland

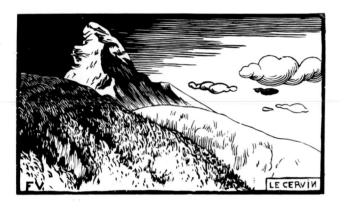

9
Félix Vallotton (1865–1925) Swiss
* *Le Cervin*, 1892
Woodcut on wove paper. 25 × 32 cm
Galerie Paul Vallotton, Lausanne, Switzerland

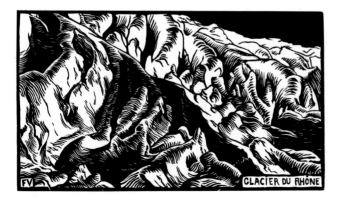

10
Félix Vallotton (1865–1925) Swiss
* *Glacier du Rhône*, 1892
Woodcut on wove paper. 25 × 32.8 cm
Galerie Paul Vallotton, Lausanne, Switzerland

11 (top)
Félix Vallotton (1865–1925) Swiss
* *Mont-Blanc*, 1892
 Woodcut on wove paper. 25 × 32.5 cm
 Galerie Paul Vallotton, Lausanne, Switzerland

12 (bottom)
Félix Vallotton (1865–1925) Swiss
* *Le Mont-Rose*, 1892
 Woodcut on wove paper. 24.5 × 36.8 cm
 Galerie Paul Vallotton, Lausanne, Switzerland

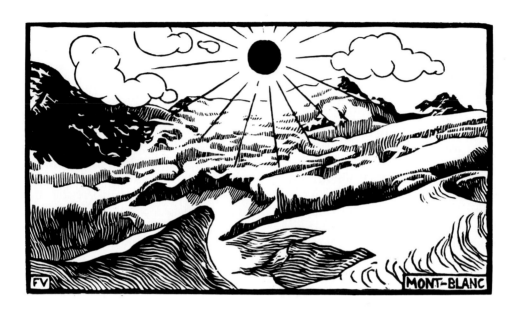

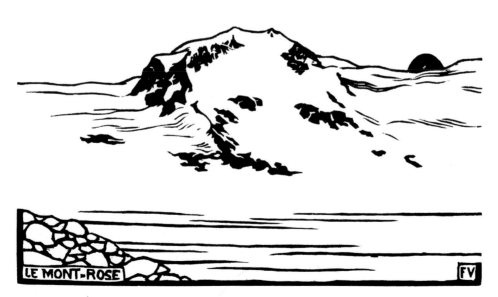

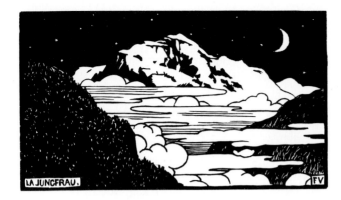

LA JUNGFRAU.

Félix Vallotton (1865–1925) Swiss
* *La Jungfrau*, 1892
Woodcut on wove paper. 25 × 32.7 cm
Art Gallery of Ontario, Toronto

central to Willumsen's allegorical programme. Though the Norwegian mountainscape would have suggested a rather bleak colour scheme, perhaps the simple black-and-white formal juxtapositions of Vallotton's woodcuts suggested the kind of monumentality that could be achieved by emphasizing strong value contrasts. The squarish, almost cubistic white forms in the water in *Jotunheim* are more difficult to explain. Are these reflections ideas crystallized from Willumsen's pantheistic experience of elemental nature?

Vallotton exhibited some of these woodcuts at the Salon des Indépendants in 1893, where he and Willumsen were installed next to one another. There is no evidence that Willumsen saw them until then, and when he describes the exhibition to a friend, the Danish painter Johan Rohde, he sounds impressed but genuinely surprised and puzzled: "Vallotton has several woodcuts ... he has some from Mont Blanc where the snow is black and the black mountains are white. The sun is a black spot, where he wants to go I don't know ... (Otherwise he has a powerful way of presenting things which pleases me.)"[22] However, in the first Salon de la Rose + Croix, which opened on 10 March 1982, Vallotton, despite Péladan's ban on landscapes, exhibited at least two mountainscape woodcuts, such as those shown in the Salon des Indépendants of 1893, their subjects described in the catalogue as "Haute-Alpes," and it would be surprising if Willumsen, otherwise so inquisitive, had not attended that salon.[23]

Northern Symbolism and National Romanticism: Karl Nordström and the Varberg Group

It seems that it will be the wilderness which will preserve our health and our strength.
Karl Nordström[1]

The most important aspect of a painting is not beauty of form, nobility, taste; it is the unfathomable and gripping fabric of memories, of foreboding, and imagination which the artist has spun into his picture.
Richard Bergh[2]

Although Willumsen had at his disposal a full arsenal of Synthetist techniques when he arrived in the Alps in the summer of 1892, he nevertheless felt inadequate to cope with the grandeur of mountain scenery and the profound way that it affected him. It took him another year and an even sterner and remoter northern landscape to realize a commensurately monumental and abstract style. But Willumsen, like Munch, however much their respective developments parallel and intertwine with other northern ones, nevertheless stands somewhat apart as a heroic individual acting out his artistic ambitions on an international stage.

A more telling perspective on the problems, especially the stylistic ones, that northern artists encountered during the early 1890s in pitting their naturalistic training against new motifs and new spiritualizing attitudes is gained by looking at artists more tied to their native countries. The case of Karl Nordström, the leading exponent of the national Romantic movement in Sweden, is especially in-structive here. His transformation from an Impressionist to a Symbolist artist, the general context for that shift, and its subjective and nationalist implications also serve as background for the later discussions of the work of the other major Swedish national Romantic artists, Prince Eugen, Otto Hesselbom, Gustaf Fjaestad, and Helmer Osslund.

Nordström's evocation of wilderness as the panacea for the ills of Swedish art climaxes a series of bitter remarks, which he recorded in a notebook from 1892, about the meanness and pettiness of everyday life in artistic circles in Stockholm, which seemed dominated by demoralizing political intrigues. In disillusionment Nordström decided to leave Stockholm in the summer of that year, taking his family with him, to settle down to work in his native Tjörn, in Bohuslän, on the west coast of Sweden. The region was still primitive and generally inaccessible, little known, except perhaps in summer, to the public in Stockholm. When Nordström's pictures from his west coast years, such as *Storm Clouds*, 1893 (no. 14), and *Varberg Fort*, 1893 (no. 15), were first shown in Stockholm, viewers unfamiliar with such harsh terrain interpreted their severe description of the landscape as Symbolist peculiarities rather than characteristics of the subjects themselves.[3] *Varberg Fort* was executed in Varberg, a city further south on the west coast of Sweden, where in 1893 Nordström joined Nils Kreuger and Richard Bergh, artist friends since student days at the Swedish Academy. Together they would constitute the so-called Varberg group, the

most important of several Swedish artists' colonies formed in the 1890s, and the group that more than any other would come to epitomize Swedish Symbolist or national Romantic painting.

The flight into the wilderness of the Varberg group had motivations rooted in the preceding decade. Like most of their contemporaries they had rushed to Paris during the 1880s, often for lengthy stays, to get away, as Bergh would later put it, "from the land of barbarians. Away from ice and snow. Away from all coarse excesses. Away from ourselves," convinced that Sweden was a "country without motifs."[4] In France they devoted themselves to painting in the open air in the countryside around Paris, forming a small colony, along with other Scandinavians, at Gréz-sur-Loing. If they seemed to be stylistic radicals at home, in France they seldom wandered too far astray from an atmospheric and analytic Naturalism perhaps best exemplified by Bastien-Lepage, though some, especially Nordström, were not immune to the influence of Impressionism. In 1885, they proclaimed their commitment to French artistic models and their opposition to the traditional standards of the Swedish Academy, in an exhibition in Stockholm appropriately titled *From the Banks of the Seine*. Despite the attractions of the artistically stimulating atmosphere of Paris, however, the Paris-trained Swedes were in some ways also exiles, if only from the outmoded and conservative academic teaching system at home, and gradually in the mid-1880s they became swept up in a newly felt patriotism and a longing for native soil. They developed a growing conviction that their Naturalist programme would be better applied to an up-to-date art born out of a deep and heartfelt experience of their own country.[5]

This conviction became especially clear as a consequence of the Universal Exposition in Paris in 1889. Here the Swedes achieved considerable critical success, especially the members of the Artists' Union, which had been organized in 1886 by French-trained artists in opposition to the official system in Stockholm. They nevertheless felt outstripped in their triumph by the Norwegians, precisely because the work of the latter exhibited all the characteristics of an independent national school. Despite their admiration, this was irritating to those Swedish painters

who longed to return north to paint Swedish subjects, especially when they themselves had received acclaim because they were talented propagators of French artistic ideas (for which they had been criticized in Sweden).[6] Consequently, by the end of the 1880s most of the Swedish artists had returned home to create a truly indigenous art. During the 1890s the Swedes, as well as the other Scandinavians, tended to stay at home; the Finnish painter Albert Edelfelt (1854–1905), during a visit to Paris in 1895, observed: "The Scandinavian artists' colony from my time has collapsed in a remarkable way. From around 50 then it has gone down to between 5 and 10 now."[7]

If Swedish sculptors and portrait painters found Stockholm a natural working milieu, the landscape painters were attracted to their own birthplaces and the surrounding regions. In this they quite consciously followed the model of Corot and the Barbizon School, who had proven the viability of intensified regional study.[8] Over the years Swedish artists spread themselves throughout the country, warding off the dangers of isolation in the countryside by joining together into small colonies in order to keep inspiration and artistic development alive.[9] The flight from the city was usually seasonal, and even Nordström, who so earnestly sought refuge in the wilderness, seldom strayed far from cultivated areas, as can be seen in his pictures. Nevertheless he, more than any other Swedish artist of the period, illustrates the appeal that wilderness had during the 1890s, because it seemed shaped by primitive and timeless forces and could restore one's receptivity to one's inner self.

Nordström, one of the oldest artists of the Symbolist generation, first arrived in Paris in 1881 where he sought lessons in the *plein air* painting of the Barbizon painters, in the Naturalism of Bastien-Lepage, and eventually in Impressionism. Working in the company of the other members of the Scandinavian art colony at Gréz-sur-Loing, alongside Christian Krogh and Carl Larsson, he developed an accomplished Impressionist brush technique although his work never incorporated Impressionist colour division. As early as 1886, however, he declared his wish to return home to fulfil his duty, as he saw it, to paint the Swedish landscape.

When in 1886 he exhibited some of his new works based

on Swedish motifs, critics spotted immediately a problem that would become central to Swedish Naturalism during the 1880s, a problem which the critical reception of the Swedish works in the Paris exhibition of 1889 would drive home firmly. The critic Karl Wahlin explained it thus in a review from 1886:

Swedish nature is also painted by the impressionist Karl Nordström though in a way which sometimes seems a little odd to us. When I saw his 'At Harvesttime' it never occured to me that I was in front of a Swedish motif. Concerning the peculiarities of colour which struck us with astonishment in Nordström's earlier work as well as in other things sent home from Paris, we have always had this defence at hand: This is how the landscape is in France. And we have humbly and unquestioningly imagined that it actually looked that way down there. But when the artist now presents himself and paints with those well-known fiery colours and says: this is Bohuslän, then I don't think we can follow him any longer.[10]

In the North the landscape simply did not present itself in the same way. The air was clearer, the contours sharper, and colours much more intense and unmediated. Whatever the nature of Wahlin's specific quarrel with "fiery colours," the standard skills learned in France from Bastien-Lepage, Carolus-Durand, or other popular teachers, such as how to build a painting through a series of subtle value gradations, as well as an imported French palette, were rendered invalid. The problem, typical for Naturalist-trained Symbolist landscapists, became one of learning how to see the northern landscape directly and not through French eyes or the conventions of Naturalist art.

The next several years were a period of considerable uncertainty for Nordström, until in 1893 he finally developed the principles of the style that would not only serve his own work for the next decade but would become representative of Swedish national Romantic painting. In the mean time two influences typical of the period affected him and left lasting traces in his work. The first was Whistler, whose monochromatic atmospheric landscape, often with musical titles, generally reinforced the taste for mood painting as well as for Blue Painting throughout Symbolist Europe. And like many of his contemporaries Nordström engaged in an intense formal study of Japanese art, especially the woodcuts of Hokusai and Hiroshige's views of Mount Fuji. Hartippen, a rocky pinnacle on the island of Tjörn, became Nordström's native Mount Fuji (no. 16).[11]

Nordström's definitive style is given full expression in both *Storm Clouds*, which because of its early spring subject presumably was completed well before he arrived in Varberg, and *Varberg Fort*. Both paintings concentrate on the broader structural features of the landscape. They draw the eye rapidly across a loosely brushed and little differentiated foreground to strongly contoured and frontally oriented elements in the distance: a powerfully built-up range of hills in the first painting and the chunky dense mass of the fort in the second, both of which are dramatically silhouetted, one against an ominously turbulent cloud-filled sky from which a flock of shrieking birds (or so we sense) is fleeing, the other against the bright golden light of a glorious sunset. Both pictures are simply composed as broad panoramas, and colour, especially in *Varberg Fort*, is deep and resonant, applied in loose rhythmic strokes on a rough unprepared canvas, and confined within flat almost abstract forms.

Hartippen, Tjörn, 1897 (no. 16), partakes of the same basic compositional scheme, its dark foreground and truncated trees similarly pushing the eye quickly across the rolling fields of the middle ground to the summit of the mountain, bathed in the red light of the setting sun, and perpetually animated by nature's primal building processes. If Hartippen is Nordström's Mount Fuji, its 1897 portrait also exhibits remarkable similarities, in the profile and general structure of the mountain peak and in its general compositional scheme, to Vallotton's *Le Mont-Rose* (no. 12), equally dependent on Japanese sources. All three pictures, in comparison to Nordström's impressionistic work of the 1880s, dispense with atmosphere and detail to concentrate on the underlying and elemental forms of a severe and formidable landscape, from which human figures are banned. Their focus on distant but monumental heights gives them something of the visionary, and their moods are pervasively melancholy.

Nordström's move in the direction of a simplified and monumental style may have sources in Japanese art, but

14 (opposite)
Karl Nordström (1855–1923) Swedish
* *Storm Clouds*, 1893
Oil on canvas. 72 × 80 cm
Nationalmuseum, Stockholm

15 (below)
Karl Nordström (1855–1923) Swedish
* *Varberg Fort*, 1893
Oil on canvas. 62 × 88.5 cm
Prins Eugens Waldemarsudde, Stockholm

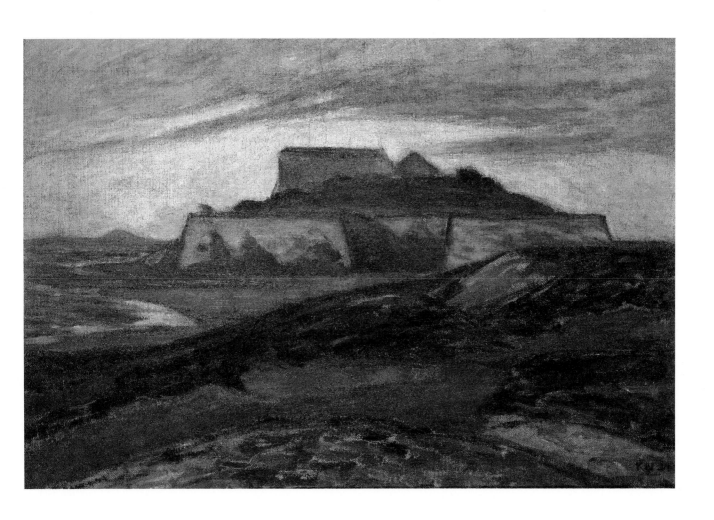

by all accounts it was coming face to face with Gauguin's work in the fall of 1892 that helped bring his years of experimentation to an end. Nordström and his friends had been aware of French Post-Impressionist developments for some time. It is not inconceivable that both Bergh and Kreuger saw the Volpini Exhibition in 1889,[12] though if they did, they were probably still too immersed in Naturalism for the experience to have had any immediately meaningful personal consequences. In 1891 Ivan Agueli, an artist their junior by some fifteen years, sent home from France examples of his latest work, done under the tutelage of Emil Bernard and rife with the influence of both Gauguin and Cézanne, as well as a collection of photographs of the work of Cézanne, Gauguin, and van Gogh.[13] Nordström's first acquaintance with Gauguin's work took place in Copenhagen in the fall of 1892 when, during the exhibition of the Swedish Artists' Union at Den frie Udstilling, he, Kreuger, and Bergh explored the city. Despite its critical fulminations against Willumsen in the immediately preceding years, Copenhagen was

16

Karl Nordström (1855–1923) Swedish

* *Hartippen, Tjörn*, 1897

Oil on canvas. 85.5 × 126 cm

Göteborgs Konstmuseum, Göteborg, Sweden

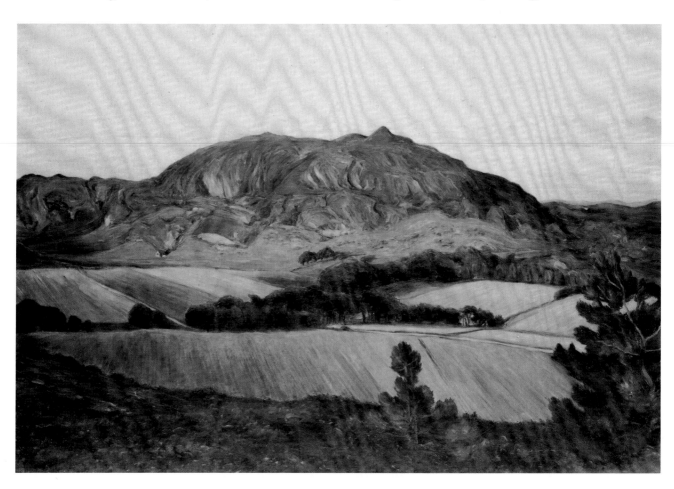

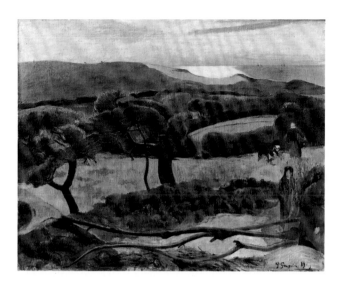

17
Paul Gauguin (1848–1903) French
Breton Landscape, 1889
Oil on canvas. 72 × 91 cm
Nationalmuseum, Stockholm

nevertheless culturally more rich and advanced than Stockholm and had developed a substantial audience for the latest artistic developments.

Who introduced Nordström to the private collections of Gauguin's wife, Mette, and of her brother-in-law Edvard Brandes? Connections with Gauguin and his work were plentiful. It could have been the Danish Impressionist Theodor Philipsen, a friend of Gauguin since the latter's stay in Copenhagen in the mid-1880s, or the Synthetist-inspired Johan Rhode, founder of Den frie Udstilling, and a close friend and faithful defender of Willumsen. More likely it was Richard Bergh himself who, as commissioner for the Artists' Union exhibition, visited Copenhagen in the spring of 1892 and purchased from Mette Gauguin one of her husband's 1889 Breton landscapes (Nationalmuseum, Stockholm). Bergh's Gauguin (no. 17) was the second to enter Sweden in 1892 and accompanied him to Varberg.[14] The other, *Winter*, 1889 (Göteborgs Konstmuseum), acquired by the great Goth-

enburg collector Pontus Fürstenberg, was presumably also readily accessible to the Varberg group.

The close kinship to van Gogh discernible in both the details and general features of *Storm Clouds* (as well as in Kreuger's work at the same time) suggests that Nordström also saw examples of van Gogh's work in Copenhagen in 1892, when there were already several in private collections. Johan Rohde had only recently returned from an extended European trip during which he had devoted much time and energy to searching out van Gogh's work, and he would enthusiastically have shown off a landscape from Saint Rémy which he had purchased from an exhibition in The Hague the same summer. Its foreground, which takes up almost half the picture, is a relatively undifferentiated field of grass, and in the background a powerfully profiled range of hills stands out against a dramatically clouded sky, thus predicting not only the spirit but also the essential elements of Nordström's composition.[15] In 1893 Den frie Udstilling showed fifty paintings by Gauguin and twenty-nine by van Gogh, but, of the Varberg group, only Bergh saw them, although Prince Eugen also visited the exhibition and expressed his particular interest in both Gaugin and van Gogh. It is assumed that van Gogh in particular assisted him in achieving the heightened colour intensities that enter his work during the next summer.[16]

But it was unquestionably Nordström's experience of Gauguin's work in Copenhagen in 1892 that helped point him in his own Symbolist-Synthetist direction. This is the only direct influence that Richard Bergh discusses in his seminal 1896 article on Nordström, written in close consultation with Nordström and built on ideas developed while they worked together in Varberg. Nordström discovered in Gauguin "a fully conscious, severely ornamental ordering of the masses," which from a decorative point of view was especially significant. Because Nordström was on the brink of moving in a Synthetist direction, there were lessons to be learned from Gauguin, who clearly confirmed, in Bergh's words, that "a canvas is not merely a medium through which the artist communicates his mood to the spectator, it is also a decorative object, which, in order to address the eye as it ought, must conform to the laws of harmony common to all

decorative art." Bergh concludes that, though Nordström may already have been convinced of that truth, in Gauguin he found it applied with a severity that he had not experienced before and that became for him "an exhortation, on his own part and in his own way to seek even further along this particular path."[17]

Like Willumsen's, if not precisely in the same way, Nordström's admiration for Gauguin was ambivalent. He was impressed by Gauguin's paintings as useful decorative models on which to base his own Synthetist experiments, but he found them, according to Bergh, "on the whole cold and empty of mood." Gauguin's work seemed limited because it used "ornamental simplicity and clarity for its own sake, for decorative purposes alone." For Nordström this was inadequate, because the real purpose of creating powerful aesthetic harmonies was to make "doubly effective what for him was the principal point of art, namely the mood."[18]

It is, of course, rather curious that Nordström should find Gauguin's work "cold and empty of mood," when we have come to see it as the very epitome of Synthetism, because its simplified forms, bold colours, and flowing rhythmic lines conjure up such strong emotions. But that Bergh and Nordström could discern a difference between their own and Gauguin's decorative principles (and hence those of French art in general) and assert their own northern ones as somehow superior is a measure of the general acceptance of a North-South artistic dichotomy that became a fundamental credo for many northern artists. In relation to it they could thereby define their essential northernness as more profound, more poetic, and, sometimes, more ethically engaged than French values.

A fundamental problem with French art, as the northerners saw it, was its tendency toward pure aestheticism, and its satisfaction with merely superficial beauty, elegant and technically accomplished though it might be. Willumsen would later charge that French art is "artificial because its effect depends more on the means of production than on the subject, whereas there must be art in both." The French, he argued, have no feeling for nature. Their pictures lack poetry, and that is what makes them empty. They miss what lies behind objective appearances because they paint only what they see, not what

they know. Because they cannot dream there is no music in their pictures.[19] This, he maintains, is inevitable because the French "are another race, put together from other materials and otherwise it will never be ... My conviction," he concludes, "is that the Northerner has a greater potential than the Frenchman for developing deep, human and richly poetic art whenever the stream of culture finds its way to the North. It has occasionally been confirmed ... that the Northerner is born with the gift of poetry."[20]

The North-South dichotomy thus expresses itself in several ways. We have already encountered it in relation to *Jotunheim*. It is a motif that will recur often, addressed to questions both of style and of content, and it emerges as a major theme for Bergh in his interpretation of the development of Swedish Symbolist painting and Nordström's national Romantic landscapes. It goes to the heart of the central problem of Symbolist landscape painting: how were artists trained in French Naturalism and Impressionism to come to terms with northern wilderness? And though Berg discusses the problem in terms of Swedish art, it is not confined to it alone, but is rather a restatement of the difficulty Willumsen encountered when first confronted with high Alpine scenery: that neither his eyes nor his hands were attuned to capture so strange and so immense a spectacle. The problem repeats itself in Canada during the first decades of this century and accounts for the importance and special nature of the influence of Scandinavian art on the Group of Seven.

Nordström's work, we have noted, was undergoing a general reconsideration following the severe criticism he received in 1886 for executing Swedish motifs in a French style and palette, and in the intervening years he came under the influence of both Whistler and Japanese art. It was not until 1892, however, when he deserted Stockholm for the west coast of Sweden that the problem was resolved. Nordström was born and spent his youth in this region, and it therefore met the preconditions for a regional patriotism that called the Swedes back from Paris. The value of such arduous repatriation was not always self-evident and became established only in the 1890s. Previously, the west coast had not appealed to him as subject matter. It had generally not attracted Naturalist-

18
Karl Nordström (1855–1923) Swedish
* *Winter Night*, 1907
Oil on canvas. 128 × 173 cm
Prins Eugens Waldemarsudde, Stockholm

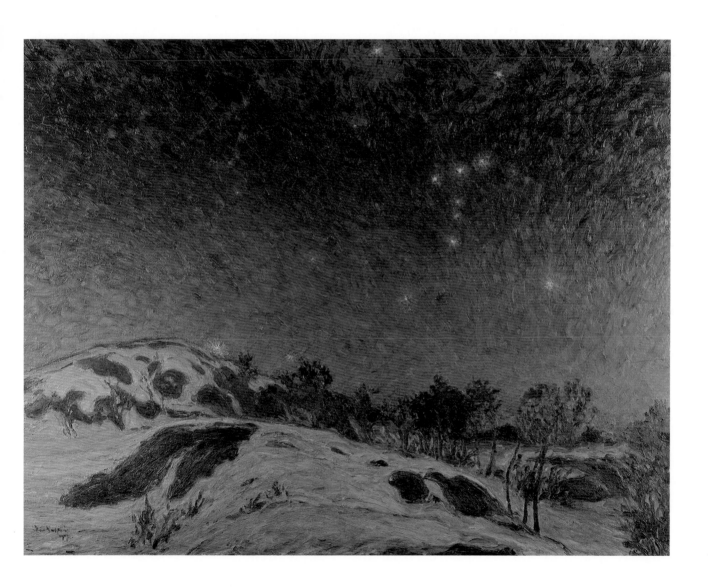

oriented painters during the 1880s and was deemed incapable of objective depiction. As late as 1890 Nordström wrote to his friend the artist Georg Pauli (1855–1935), who also had found the area unrewarding: "It does not surprise me that the landscape of Bohuslän seems strange to you. For me, who was born among the cliffs and have studied them year after year, it has often provided little inspiration to work."[21]

Yet within a year this uninspiring landscape would begin to yield secret glories of its own commensurate with Nordström's transformation from a painter of external reality into a melancholy dreamer. During a visit to his birthplace, Hoga, on Tjörn in the summer of 1891 he was able to describe the area to Bergh in quite a new light: "Here is silence – an absolute silence. Not a single sound. A paradise for nerves grown lax. No sunshine – a soul-refreshing violet tone over mountains and hills and the fields verdure as soft velvet in broad stretches."[22] In the following year Nordström would propose this sunless, silent paradise as the wilderness refuge "which will preserve our health and our strength."[23] The slow process whereby the artist drew closer to his native region was intimately linked with his ability to adapt his art to meet its special challenges. But art did not come easily out of the newly found coexistence with the natural environment; sometimes it needed to be wrested from a recalcitrant nature. Nordström's ability to come to artistic terms with the landscape of Bohuslän and Varberg, so incomparably different from Gréz-sur-Loing, allowed him finally to shake off his French Impressionist viewpoint and establish an independent, mature style that would become the model for Symbolist landscape painting in Sweden for the next decade.

Bergh, primarily a portrait painter, wrote at length about the problems his generation faced in becoming renderers of Swedish subjects, especially landscape. His "Karl Nordström and the Modern Landscape of Mood" was published in 1896, and "Swedish Artistic Character," published in 1899,[24] is largely an elaboration of the theme of the first, given fresh poignancy by the intense feelings of homesickness which Bergh experienced on a recent trip to his beloved Italy. In both articles Bergh elaborates the basic difficulties that his generation had confronted when they returned home from France to discover that their French painting lessons had not prepared them for the particular character of the northern landscape and light. From this follows his argument, most persuasively stated in the 1899 article, for a national art based on the artist's experience of his native land and its people. Bergh's presentation of the problem might be read with the subject of Nordström's *Winter Night* (no. 18) in mind:

Have you wandered outside the city on a cloudy winter afternoon? The air hangs dark grey and heavy over the white snow cover that spreads in front of you with endless uniformity. The air, which in the summer is the brightest element in the landscape, is now gloomy, and it is the fields that glow and spread a niggardly, diffuse light of snowy days over the land. At the horizon the black pine forest draws an uneven serrated contour against the lightless air. It is a dry, dark, and mournful border which frames the white swept countryside and prevents the eye from going further. The trees stand naked and scrubby without any grouping, haphazardly sprung up in the snowy hills; some of them reach their thin, knotty branches toward the sky, some spread them out in all directions, and others let them hang down sorrowfully. Black blocks of stone stick up out of the snow here and there. How nature is torn asunder; what disorder! Where is the architectonic or painterly unity that makes the landscape of the south, with its clear and serene lines, so seductive to artists? Where is the classical line? Not here. Here you have a colourless black and white palette to satisfy your thirst for colour, a formless discord for your sense of form. The whole is a chaotic muddle, embraced by a heavy stifling monotony.

What you have here to represent is not the landscape, it is disheartening. Go home to your room and play the piano.[25]

Bergh's description corresponds to early conceptions of the wilderness before the Romantics infused it with divine presence. Dismal chaos reigns, and the artist's eye becomes confused and lost, receiving no intimations of order from the landscape itself. "The wild and everchanging landscape of the north does not welcome the painter as does the homogenous landscape" of the south, argues Bergh; in France the landscape offers artists motifs "ready-made like ripened fruits," the words echoing Gauguin's

expectations of fruit-laden boughs in Tahiti. There is little common ground between the southern landscape, which over centuries has been shaped by the human hand, and the chaotic visual muddle that is Sweden. As the Swedes themselves had long acknowledged, their native country was "the land without motifs," which was at least one reason why they sent their artists abroad.[26]

Without the mediating silvery mist that makes the French atmosphere so painterly, asks Bergh, how is the northern artist to paint this confusion of mountains and hills, of conifers set alongside deciduous trees, of dark and light green in the hard crisp light? In the north there are only oppositions, no harmony, no unifying tonalities, only dissonant local colours. Bergh's lament coincides with the complaints of the Finnish artist Väinö Blomsted, who, along with Pekka Halonen, had studied with Gauguin in 1894 and returned home to find his native scenery disturbingly unpaintable: "Finland's nature can only confuse a man's head to the degree that he doesn't really know how to grasp it. It is all such a frightful mess wherever one looks that one becomes quite despairing. Begin then to count the twigs on the birches and the spruces and you will go mad soon enough."[27] Prince Eugen recalled that while painting in Norway in 1890 he wanted to paint pine trees because the Parisians had declared them unpaintable.[28]

Bergh's despair is, of course, rhetorical; he was decrying the attitude that Sweden was a barbaric land of ice and snow incapable of producing art. By the time his articles appeared, Bergh and Nordström had come to terms with the recalcitrant scenery and had irrevocably tied their careers to the depiction of Swedish subjects. By then, especially among the members of the Artists' Union, in which Bergh and Nordström were leading figures, the North was seen as able to provide for the whole of an artist's wants. It was considered an act of betrayal to leave home, however seductive the warm and sunny climates and the rich artistic cultures and traditions of the south. To do so was tantamount to running "away from ourselves,"[29] as they themselves had done when they first went to France almost two decades earlier. When Helmer Osslund in 1899 sought financial support to pursue further artistic studies, Bergh advised his patron, the Gotenburg collector Fürstenberg, a devoted supporter of the Artists' Union, that Osslund should not be sent abroad, where he would only "to the detriment of his development come under influences which later would not be easy to get away from."[30]

The relationship of painting to nationalism in Sweden is to a large extent a reflection of that established by the Norwegians during the 1880s. Their success at the Universal Exposition of 1889, which so impressed the Swedes, had been founded on the strong national character of their art. The Norwegian painters had returned home before the Swedes because they had much earlier confronted and mastered Naturalism. For Erik Werenskiold (1855–1938), one of the most nationally oriented of the Norwegian artists, it had been a simple conclusion that "with naturalism a national art *had* by necessity to come ... It is love of nature that brought naturalism into the world, love and good sense. And love of nature must of necessity lead artists back to their own land; because they cannot possibly understand and consequently cannot to the same degree care for foreign lands as their own."[31] Having realized that, it was natural for Norwegian artists to end their exile and return home, and by 1882 most of them had done so. And they had come home to stay, unlike their Romantic forbears, who headquartered in Germany and painted their Norwegian motifs on the basis of studies made during summer visits.

As naturalists the Norwegians practised open-air painting, and like the Barbizon school, from whom they and the Swedes drew their example, they devoted their art to a local and familiar region which they studied long and intensively. If the Barbizons retained romantic and pantheistic attitudes to nature, the Naturalists clearly felt their endeavours more closely related to science. However, their commitment to objective viewing posed special problems to the application of Naturalism in Norway. Naturalism may have been science, but it was also a set of artistic conventions developed mostly in response to a more southern climate and landscape. For the Norwegian Naturalists, as much as for the incipient Swedish Symbolists, northern landscape, where the air was clean and transparent and things stood out sharply, their unbroken local colours unmediated in relation to one an-

other, militated against the Naturalist preference for subtle painterly value transitions and for composing in terms of overall unifying tonalities.

The Norwegians' solution of the 1880s was to select subject matter to which Naturalist conventions were applicable. Their programme required them to strike new paths, particularly in the direction of finding beauty, or at least truth, in the ordinary, the everyday, and even the ugly. But if they focused on the broader and more fertile lowland regions, it was because there they found motifs that were more conducive to the modern demands for painterly treatment and coloristic unity. In contrast to the 1890s, artists in the 1880s particularly avoided wilderness subjects of mountains and fjords, ostensibly because this was the subject matter of their Romantic predecessors and such scenery was now scornfully rejected as tourist country. The mountains were not to be rediscovered, as we have seen, until 1892, and then not by a Norwegian but by the Dane J.F. Willumsen when he arrived in Jotunheimen.

Fritz Thaulow, who was to persuade Monet to come to Norway on a painting expedition in 1895, and who during the 1880s had been a principal contributor to the national programme, could still despair about the sharp unpainterly North in the mid-1890s. His increasingly impressionistic style failed to come to terms with "the red house [which] acted so sharp in colour, so newly painted, and the air [which] was so transparent that one could count the needles on the fir trees." Thaulow eventually found it expedient to return to France in order to remain faithful to his Naturalist-Impressionist style. As Østby has pointed out, it was perhaps easy enough to get the colours true and convincing, but it was much more difficult to get it pleasant, resonant, and harmonious.[32] While Monet was in Christiania in March 1895, he accepted an invitation to visit the Spring Exhibition of Norwegian painters, but he left after going through it without saying a word to the expectant organizing committee waiting at the door. As he revealed later: "What could I possibly have said about all those bright colours?"[33] – undoubtedly referring to those dissonant colours in nature which Bergh describes so eloquently and which had invariably worked themselves into the paintings.

Monet had, however, worked quite successfully with the Norwegian scenery, though in winter and from a snow-covered landscape. It is undoubtedly true, as many writers have suggested, that most of the winter pictures undertaken by northern artists returning from France had less to do with any wish to depict northern barrenness or cold than with a desire to use snow to mitigate the coloristic and formal disharmonies which Bergh describes. In addition, snow with its blue shadows was an ideal subject for Whistlerian tonal painting.[34]

As the 1880s advanced, Norwegian, and later Swedish, artists found decided advantages in confining themselves to dusk and night, when a soft and diffused light melted the hard discordances of local colours and shrouded the formal confusions. The loss of interest in the light of midday was also influenced by a growing concern with feeling and mood. Colour, from being first descriptive, increasingly became the carrier of emotional content. Whistler, whose colour harmonies were well known to northern artistic circles from the mid-1880s, and Puvis de Chavannes were as important in this as they were for other aspects of French Symbolism. Painting in predominantly blue tonalities became ubiquitous by the late 1880s and was to persist through the 1890s. It is apparent in the work of Munch and Sohlberg in Norway, but is pursued to its most dizzying excesses in Sweden, in the work of Nordström, Jansson, and Fjaestad. At first the motif itself, as in the work of the Fleskum painters,[35] retained dominance and was rendered with naturalistic faith to illusion, to atmosphere, and to aerial perspective, imbued, however, with the feeling and mood that colour could contribute. Colour became valued for its musical qualities, perhaps not at first entirely in the Symbolist sense. Østby has astutely analysed this transitional period by describing its use of colour as an accompaniment to the subject matter just as a poem's mood can be intensified by a composer's setting it to music.[36] Only in the early 1890s does Blue Painting become Synthetist.

As early as 1889 Prince Eugen had noticed, when working during the summer in Valdres in Norway, how with the parting of day nature's myriad details faded and forms regained their essential wholeness. As he later noted, "I worked with a great deal of intensity there, and from the

beginning made things which had a northern ring to them, maybe influenced by the Norwegian art exhibited in Paris" (at the Universal Exposition of 1889).[37] In a letter he remarked that "everything becomes simple and grand at dusk. If only one could bring together all the dissimilar impressions and put them down in a single motif, so that the colour would shimmer, have fragrance, and be heard. It is decidedly easier to represent this in poetry," he remarks, as if fresh from reading Baudelaire's *Correspondances*.[38] Undoubtedly twilight had the same effect as Bonnat's admonition: "Clignez des yeux" (screw up your eyes) in order to see the whole over the details, a lesson that he imparted not only to Prince Eugen,[39] but also to many Scandinavians who passed through his school.

Paintings such as Prince Eugen's *Forest Clearing*, 1892 (no. 32), *Summer Night, Tyresö*, 1895 (no. 40), and *Still Water*, 1901 (no. 41), are typical of the most popular landscape subjects of the years 1890–1910. They came to epitomize especially Swedish national Romantic Synthetism; to cite Ragnar Josephson: "In the darkness of the winter evening or in the transparent light of the summer night the discordant Swedish landscape shows itself as a mighty whole. Dusk lets the details fade away revealing the massive structure of the land, the grand natural oneness, pervaded by a lyrical shimmering atmosphere."[40] These subjects also had their patriotic appeal because they typified the northern latitudes (most of the Scandinavian pictures in the exhibition were executed north of the 60th parallel). Hesselbom's *Our Country*, 1902 (no. 42), with its simple massing of a panoramic landscape bathed by the light of a golden sky at twilight, became a kind patriotic symbol for the Swedish nation. It also especially impressed Lawren Harris and J.E.H. MacDonald when they saw it in Buffalo in 1913 because it suggested the terrain of Muskoka or Temiskaming in northern Ontario.[41] And neither Hodler nor Mondrian, as we shall see, was immune to the evocative power of twilight.

The patriotic orientation of Naturalism therefore encouraged a search for typical aspects of nature that also corresponded to growing Symbolist interests. Lingering twilight may have been characteristically northern, but it was also a time conducive to dreaming, and dreaming, by the early 1890s, was the most fruitful route to a new discovery of the northern landscape and to the transformation of it into a vehicle for spiritualizing insights.

To paraphrase a passage from Bergh's article "Swedish Artistic Character," if the landscape does not offer itself up ready-made, as ripened fruit, as in the south, then clearly it is not enough to train one's eyes on it. Sometimes it is better for the painter to shut his eyes and dream about what he has seen and learn how to listen to his feelings, so that they may lead him to uncover the unity in the shifting variety of the northern landscape, in which extremes so often meet. "In France," concludes Bergh, "a landscape painter becomes an artist only with the help of his eye (like Sisley). In the North the landscape painter has also to be a poet."[42]

Two factors are inextricably intertwined in Bergh's artistic programme for Swedish art in the 1890s as practised by the Varberg group. The first is patriotic and assumes that an artist works best in and from the milieu in which he was born and has matured. The second is anti-naturalistic and projects an art based on dream and imagination, even when working with the specific native motif, that transforms nature into a symbol for human emotions, thoughts, and ideas. These two objectives would become united, somewhat uneasily perhaps, as the artist discovered in nature a mirror for his own soul which simultaneously uncovered the soul of the Swedish people who shared with the artist the conditions that had formed his character.

The gamut of positions from internationalism to nationalism that prevailed among artists in Scandinavia at the turn of the century are not conveniently summarized because contradictory points of view are held by members of the same generation working in the same idioms. Developments in Norway by the Naturalist generation are strongly characterized by patriotism and commitments to home turf, but Christian Krogh, a teacher of Munch and one of the most influential figures of his period, persists, as does the impressionistic Fritz Thaulow, in characterizing himself as an internationalist. The successive phases of internationalism and nationalism do not coincide from country to country. For Norwegians patriotism was an important motivation in the 1880s; in Sweden and Finland it climaxed in the 1890s. In all three countries these per-

iods brought moments of exceptional artistic achievement, usually on all fronts, and not equalled in subsequent developments. (The Danes were a little more blasé, and could afford to be so. They had behind them a whole century of solid indigenous tradition that had begun with Eckersberg and Købke, and they could proceed with a confidence that was envied by the other Scandinavians.[43])

The essential clue may lie in Krogh's paradox: "All nationalist art is bad, all good art is national."[44] Certainly all the members of the national Romantic generation would have scorned even a taint of jingoistic nationalism in their art. They were radical and almost all were opponents of the régimes in power, artistic as well as political. As a consequence, the Swedish artists around Bergh and Nordström, as well as Prince Eugen (even though he was a member of the royal family), generally supported the Norwegian cause during the Union crisis at the turn of the century, when the Swedish government was on the verge of invading Norway in order to keep it from declaring independence. They interpreted the dissolution of the political union of Norway and Sweden as an inevitable consequence of Norway's advanced development, particularly in art, and it seemed natural that they should support its demand for independence.[45]

The nationalism to which many of the artists so fervently subscribed had no chauvinistic content but grew instead out of the emotional need to root their art in the people and the places of their birth. It was more regional than national, something one felt in one's bones, as even August Strindberg, cosmopolitan as he was in the 1880s, would attest. Of one of the characters in a short story he was writing in 1885 he observes that foreign countries may well give him new impulses, but not "a milieu which suited his organic and physical existence."[46] If Swedish artists thrived in Paris, especially during the 1880s, and were proud of the official recognition they received in the salons and the response from French critics, they were also exiles. Many were in Paris, not simply because they wanted to study abroad, but to broaden their minds. Artistically and paedagogically they had no place at home within systems that were oppressively outmoded, conservative, and authoritarian. In France, they tended to be well received if they had learned their French lessons, and if their work reflected the virtuosity and finesse that, according to current critical standards, had given French art supremacy.

In 1887 Bergh wrote with some exasperation to his friend Pauli: "We must become Swedes, we have now been Frenchmen long enough. We must take off our French gloves and creep into our 'peau de Suede'."[47] Over the next decade Bergh would propose that an artist could be true to himself (and a nation's art true to itself) only if it arose out of the land that had nurtured him and shaped his character. Only by respecting this principle, through the study of the forms and colours of its countryside and its people, could a country develop an independent art, because "when a country's art in its essential characteristics does not resemble its natural environment, then it is a given sign that foreign influences rule among its artists."[48]

Bergh had taken the core of his ideas from Herbert Spencer and Hippolyte Taine, whom he had read from an early age, especially Taine's notion that a work of art is an essentially relative and contingent phenomenon, the character of which is determined by race, milieu, and moment. Bergh transformed this basically materialist and deterministic understanding of art through attitudes tinged with mysticism: the child and the young man as he wanders through his native tract absorbs an unending stream of impressions and influences. If there emerges a man of feeling, his reception of his surroundings will by no means be passive. He will perceive the life of nature as if it were that of another person. He will sense its pain during the period of dying, when it is ravaged by winter, and will be gripped by its joy during resurrection, when spring the liberator comes. Nature offers him all the nuances of growth and death. It forces on him its hope, its belief in life, its clarity, its joy, but also its clouds, its melancholy, its chill, and its lack of feeling. "Just as the vibration of string may cause another, similarly tuned, to vibrate in unison, so the soul of the youth is retuned in harmony with nature's changing moods," Bergh writes, echoing Aubert's paraphrase of Carus, in "The Northern Feeling for Nature and Johan Christian Dahl." He thus, unwittingly perhaps, creates a bridge between the 1890s and the early years of German romanticism.[49] Bergh concludes:

In such a way the landscape, that tract in which we live, affects our lives, not just in the superficial sense of enforcing on us certain fixed living conditions, but also by the purely suggestive influence it has on our soul. That drama which daily is in front of our eyes put its mark on our inner being. Every sensation, every emotion leaves behind – says Taine – an indelible mark inside us and all these little marks together bring about without our knowing it the big stamp on our being which we call: character.[50]

It is this mystical union with nature, where we read her moods, not her superficial aspects, that interests the man of feeling and the Symbolist landscape painter. "These sober trivialities and factual traits do not matter alongside those fantastically formed and richly shimmering silhouettes of light and shadow, which the light or the play of the clouds draws across the landscape, alongside the grand eternal strife between the dark and the light, or alongside the drama of the wild and high-born powers of nature. Alongside the *weather* in nature."[51]

But the moods of nature do not exist outside the mind of the artist, outside the conceptions he has formed of it, as he has recreated it after his own needs, his own joys and sorrows, his own longings.[52] Landscape is above all mood, the artist's own mood; thus he "gives nature a soul, a speaking tongue, whose language his art interprets."[53] "Every landscape is a state of mind," concludes Bergh, a simple definition with which few of his northern contemporaries would have quarrelled.[54]

Bergh read widely, and the ideas that he expressed in his polemical articles on behalf of national Romantic art depend on sources other than Taine and Spencer, to whom he specifically refers. He undoubtedly had read closely Aubert's books on J.C. Dahl, the second devoted to a discussion of the northern feeling for nature.[55] Here he would have become familiar with the nature mysticism and pantheism of early nineteenth-century Germany, particularly through the work of Runge, as well as Friedrich, whom Aubert was instrumental in rediscovering during the 1890s. Aubert cites liberally from both artists, as well as from Carus's comments on landscape and nature, which should have struck chords in Bergh's own heart.

If Bergh needed contemporary support for his revival of Romantic and spiritual ideas about landscape, and their application to contemporary problems, we can also imagine that he referred to Lange's demand for "an art of memory" to replace the Naturalist devotion to superficial momentary effects. Certainly Lange could have guided Bergh in reconciling Symbolism's individualistic requirement of isolation, quiet recollection, and personal dreaming with the obligation to address the patriotic aspirations of a whole nation. For Bergh it was more or less given that if an artist were a man of feeling, no matter how private a person he might be, the spirit of the times would always find access to his consciousness, where it would dwell as a "tool of his waking dreams." As a consequence, "when the landscape painter depicts the spirit of nature, then it is not only his own that he thereby embodies, but it is also that of his own time."[56] Therefore, in the words of Lange, we "will learn to know one another through art":

Perhaps one maintains that the purely personal recollection is merely something for oneself, and that one cannot make it valid for others. But do not be afraid. One ventures something forth, anxiously, fearing not to be understood, because it is something so entirely, intimately, privately, and personally experienced ... that one dare not presume that others can have access to it – and then one discovers to one's surprise that it is precisely this that others understand best, the truly universal ... Even if a society is ever so fragmented it reknits its mesh of unity through reciprocal personal communication.[57]

Finland:
Akseli Gallen-Kallela and
Pekka Halonen

... then I long even more: *back to the time before the break between heathendom and Christianity*. In the depths of the wilderness I will own a castle with battlements and towers of grey stones, pine and oak.

Akseli Gallen-Kallela[1]

There appear to have been no direct contacts between Finnish artists and Gauguin until Pekka Halonen and his friend Väinö Blomsted (1871–1947) met him by chance in a Paris restaurant in late 1893 and became his students in early 1894.[2] Nevertheless Finnish art during the 1890s was motivated by primitivistic impulses that paralleled the interest of French artists in Brittany and Gauguin's ideas when he exchanged Europe for Tahiti in 1891. The similarities in motivation between Gauguin's journey to the south and the search of Finnish artists for redemption and renewal, focused on the region of Karelia, were so striking that when Yrjö Hirn in 1939 used the term *Karelianism* to describe the idealization by the Finns of their northern wilderness, he also characterized Karelia as a domestic vision of Gauguin's Tahiti.[3]

Karelianism, which reached its highest pitch during the 1890s, based itself on the Finnish folk epic the *Kalevala*, which was published in 1835 by Finnish folklorist and philologist Elias Lönnrot (1802–1884), who had assembled it out of a collection of folk poetry that he had gathered among the Finnish tribes living in remote regions of northeastern Finland and western Russia. The individual poems of the *Kalevala*, which had been for-

gotten in the major inhabited areas of western Finland, had been preserved in the remote areas by a sung oral tradition that prevailed well through the nineteenth century. Though the poems, as Lönnrot collected them, had no particular unity among themselves, he imposed on them an epic form suggested not only by Homeric and other ancient models but also by modern ones such as *Ossian*. The poem became a grand telling of the prehistory of the Finnish people, beginning with the myth of the creation of the world and ending with the arrival of Christianity. It established a pantheon of mythical Finnish heroes such as Väinämöinen, Ilmarinen, and Lemminkäinen, as well as Kullervo, whose exploits would constitute the central events of Finland's most significant art, music, and literature at the end of the century – best known internationally in the work of Jan Sibelius and Akseli Gallen-Kallela. In addition, the poem described in rich detail old Finnish customs and traditions that even at the end of the century were still preserved and waiting to be discovered at the end of long and difficult journeys into Karelia.

The *Kalevala* was an important focus of Finnish national feeling throughout the century. It provided evidence of a long Finnish tradition that antedated Christian times and that could rally nationalist aspirations against both the Swedes, from whom Finland was separated in 1809, and the Russians, of whose empire Finland then became a Grand Principality. A political slogan from the early nineteenth century proclaimed: "We are no longer

Swedes, and don't want to be Russians – so let us be Finns."[4] The *Kalevala* also established both inside and outside the country the notion of Finland as a northern Arcadia, where life was lived harmoniously and poetry and music overcame the hardships of poverty and the cold.[5]

For visual artists interest in the *Kalevala* intensified in the 1880s when Naturalist curiosity could be patriotically aroused because the wilderness offered ready-made subjects from a much earlier historic time. For Naturalism, if old Kalevala customs lived on in Karelia, it was simply a matter of recording them.[6] This was Gallen-Kallela's approach in his first major Kalevala project, the first version of *The Aino-Myth*, which he completed in Paris in 1888. He was already an accomplished Naturalist who had studied every winter in Paris since 1884. Like so many other Scandinavians, he was especially influenced by the *plein air* style of Bastien-Lepage, and closely associated with the Scandinavian colony in Paris, especially Zorn and Edelfelt. When the Finnish government commis-

sioned a second version of the subject, Gallen-Kallela felt the need for greater authenticity than had been possible working on foreign soil and with French models, and in the summer of 1890 he undertook his first trip into Karelia.

The six-week stay was planned for Lapinsalmi, deep in the eastern part of Finland, in order for Gallen-Kallela to carry out, undisturbed, studies for his Kalevala work. During a visit by the Swedish painter Louis Sparre, however, the two artists ventured across the border into Russian Karelia some distance further east. Sparre's wife, Eva, whose recollections and eye-witness accounts convey the flavour of early primitivistic fascination with Karelia, was later to write:

19

Akseli Gallen-Kallela (1865–1931) Finnish
The Aino-Myth, 1891
Oil on canvas. 153 × 307 cm (triptych)
Art Museum of the Ateneum, Helsinki

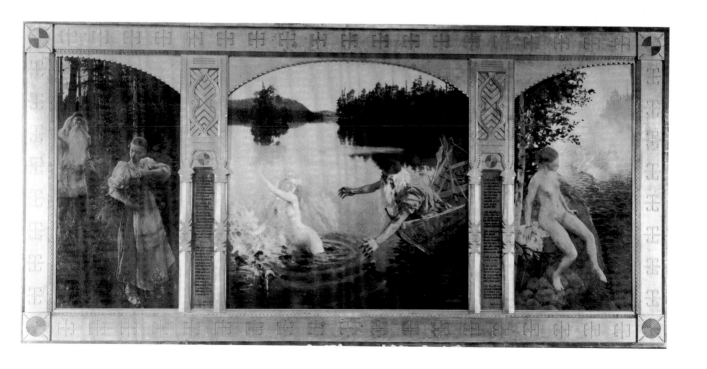

Their interest and curiosity were awakened by descriptions of towns, customs, and usages in this strange out-of-the-way countryside, where the people, although Orthodox, speak Finnish, and without delay Gallén and Sparre decided on an expedition into this unknown wonderland. What they saw there becomes for them a major surprise, and with the return to Lapinsalmi they had firmly decided to return armed with their painting things. On this later trip, which lasted a week, Mrs Gallén was taken along.[7]

Three years later Sparre took his own wife to Russian Karelia, and her expectations were thoroughly aroused by the accounts she had heard of this

... Wonderland in the east, where the rules and customs of life still to a large extent dated to the Middle Ages. From time before memory, the people in this Russian borderland had the fortune to preserve their Finnish language. The official religion was Greek Orthodox, but the Karelians, who only a few times a year were visited by a priest, in the mean time continued to live according to time-honoured habits, without worrying about imposed forms ... As far as I knew, Mrs Gallén was the only Western woman before me to have been to these areas of Russian Karelia.[8]

These initial journeys set the precedent for what would soon become a rush of Finnish-minded artists into the eastern wilderness, where one could still have firsthand experience of a way of life that one could image pointed back almost to the most elemental beginnings of existence.

Gallen-Kallela's 1890 trip was quite short, but it left impressions that were deep and long-lasting. His observations about the surviving habits, costumes, and tools and other objects of use had immediate results in his work on the second version of *The Aino-Myth* (no. 19), in which the details were ethnologically correct and the landscape had an authentic feeling of sunrise in the Finnish wilderness. The rendering of the wilderness and of the northern light also conveyed a mood of Romantic longing for mythic times, but otherwise the painting was executed in an uncompromising Naturalist style that, somewhat comparably to Norway in the 1880s, had also become associated with the nationalist aspirations of Gallen's cir-

cle. Generally the painting was received enthusiastically in Finland and understood to have fulfilled the expectations of the national renaissance that it had become Gallen-Kallela's task to initiate. There were also dissenting voices: Theodolf Rein, in an 1891 article, maintained that the new style that would suggest the dreamlike and unreal nature of the Kalevala legends must be authentic in detail yet not naturalistic or realistic, or it would risk lapsing into ethnographic costume drama.[9]

In mid-March 1892 Gallen-Kallela returned to Paris with the intention of showing *The Aino-Myth* in the Salon du Champ-de-Mars. He had every expectation of a positive reception on the basis of his preceding participation in the Paris salons, including the Salon du Champ-de-Mars in 1891, when he had been named a member of the Société nationale des Beaux-Arts.[10] Since his last winter in Paris in 1889 the artistic climate had, however, changed considerably. In the context of what was to be seen in 1892, including Neo-Impressionist, Synthetist, and the Symbolist works of the Salon de la Rose + Croix, the innovative nature of Gallen-Kallela's national Romantic picture seemed much less certain, and even fellow Finns realized its shortcomings in the new context. While some found joy in the painting's "northern freshness,"[11] it could not be contested, even by Gallen-Kallela himself, that its sunlit illusionistic Naturalism was retrogressive alongside the new demand for a more dreamy kind of poeticizing.

As Salme Sarajas-Korte has suggested, perhaps Gallen-Kallela felt that he had fulfilled the new Symbolist needs for spiritual content in turning to national Romantic subjects and had not given thought to the need for stylistic changes, assuming that naturalistic technique was a sufficient tool, and that what mattered was the development of the right ideas.[12] Moreover, he must inevitably have retained considerable loyalty to Naturalism, which at least in its technical aspects had helped Finnish art to mature.[13] His reaction to the new Symbolist activities, especially to

20

Akseli Gallen-Kallela (1865–1931) Finnish
* *Lake in the Wilderness*, 1892
Oil on canvas. 72 × 51 cm
Gösta Serlachius Fine Arts Foundation, Mänttä, Finland

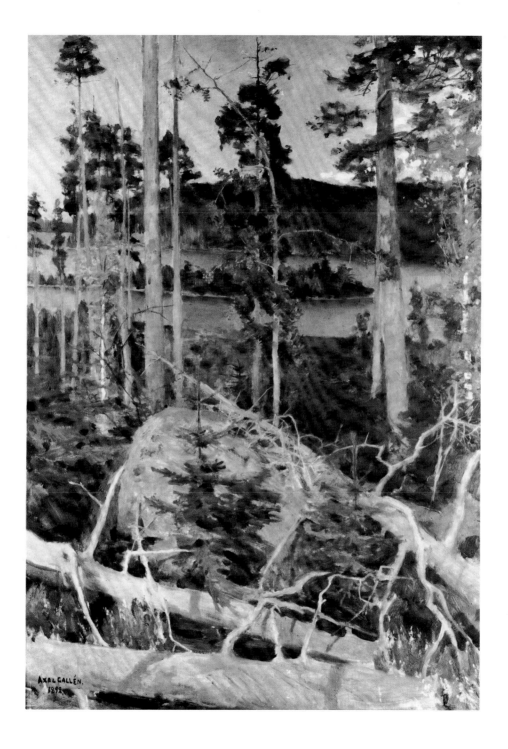

what he saw at the Salon de la Rose + Croix, was thoroughly antagonistic. He could discern only "death-rattles" in the work itself, a reaction that in turn he translated into a violent reaction to Paris and to "the old culture of the French and its blossoms (the fruit will never ripen, it rots while still green)."[14] He would subsequently shun French art altogether and absent himself from Paris until the Universal Exposition of 1900. In that year the Finns for the first time exhibited independently of Russia (in a pavilion partially decorated by Gallen-Kallela and Halonen), using the occasion as a political and patriotic demonstration against a newly initiated Russianization programme.[15] Otherwise, not unlike the Swedish Artists' Union, Gallen-Kallela discouraged his students from venturing to France, warning them, as he did the young Hugo Simberg as he was about to set out on his first study tour abroad in 1895, about the moral ruin of Paris.[16]

To regain his own balance after the disruptive experiences of Paris in 1892, Gallen-Kallela took himself into the wilderness of northeastern Finland (to Kuusamo near the eastern border). According to Sarajas-Korte: "The trip this time was a flight-like search for cure and protection from a dangerous disease."[17] The depth of feeling that Gallen-Kallela developed for the wilderness that summer, later recalled in panegyric fasion in the autobiographical *Boken om Gallen-Kallela* (1932), was a mystical fulfilment of the experiences from the preceding year in the Karelia: "Up there in the north, beyond the Arctic Circle, I got to see those sights that I had longed for right from my childhood. There I met forms of life that really suited my nature. There one could still find a roadless wasteland, there the horizon was still framed by an unspoiled wilderness that lived its own life. There the transparency of the sky and the intoxicating mystery of the forest captivated my soul with newborn magical powers."[18] The wilderness farther south could not offer the same peace and sense of freedom because roads inevitably led to somewhere, no matter how distant, and however far one was from a town, there was always another one just over the horizon. So special was the feeling of freedom in northern Finland that its memory would in later years overshadow Gallen-Kallela's response to almost every other landscape, except, as he acknowledges, Estonia and

certain equatorial parts of Africa. "In the great cultured countries like Germany, France, England, and Italy, I have never been able to depict a landscape ... not once have I even wanted to, and this is because of my homesickness."[19] Gallen-Kallela's flight into the wilderness reiterates Gauguin's. In such a place one could clear one's mind of all the confused impulses from the preceding Paris winter and fantasize about the world of the *Kalevala*, about life as it ought to be.

The wilderness did not effect any immediate change in Gallen-Kallela's Naturalist style, which he continued to apply to the national Romantic ends already defined in *The Aino-Myth*. In liberal artistic circles in Helsinki realism was identified with progressive thought and therefore with the great future of Finland. Gallen-Kallela was given the task in painting, as Sibelius in music, of depicting his people's past in monumental form,[20] something he would eventually achieve in his severely stylized Kalevala paintings, which finally emerge in 1895. In the mean time, however, his Paris Symbolist experiences were not without effect. In several landscapes, especially *Waterfall at Mäntykoski* (no. 21) and *Great Black Woodpecker* (no. 22), as they underwent several changes over the next year or two, we can trace a developing crisis with naturalistic representation and an increasing urge to find new pictorial forms for expressing deeper pantheistic feelings about nature. If these pictures hover somewhere between Naturalism and Symbolism, then, as Hirn maintains, "one understands that Gallén must have said to himself that something was wanting in his purely factual rendering of nature, and that he could not, until this something was found, in a satisfactory way deal with subjects from the world of the *Kalevala*.[21] He was still too much a Naturalist to allow himself to paint imaginary landscapes. But, keeping in mind Rein's criticism of *The Aino-Myth*, that the sense of the everyday must be done away with, Gallen-Kallela turned his attention to a wilderness land-

21

Akseli Gallen-Kallela (1865–1931) Finnish

* *Waterfall at Mäntykoski*, 1892–4

Oil on canvas. 270 × 156 cm

Jorma Gallen-Kallela Family Collection, Helsinki

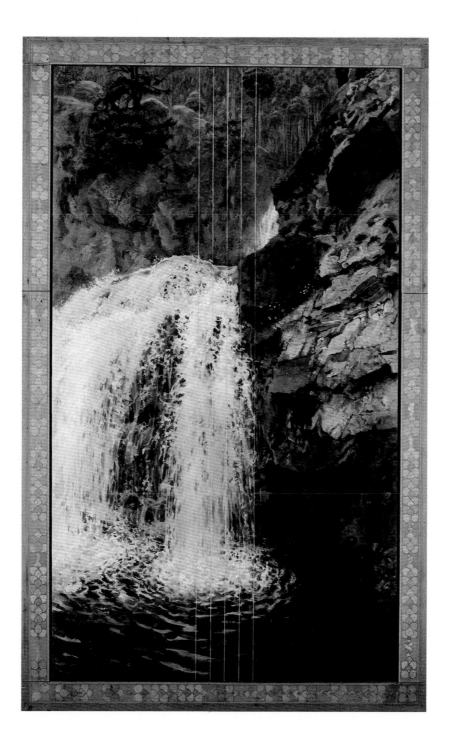

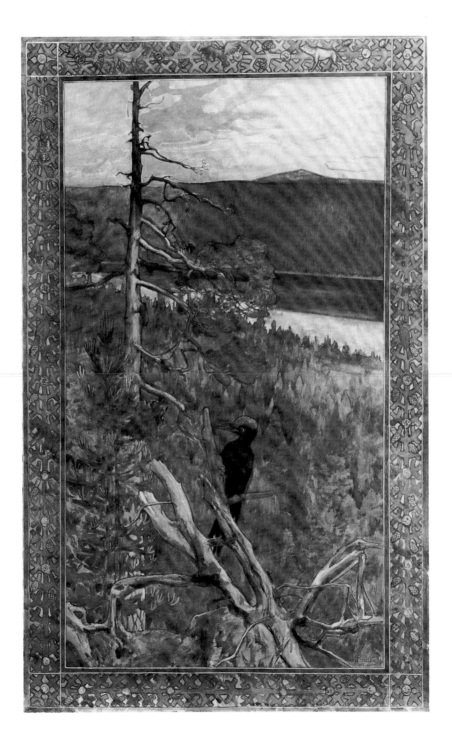

scape which, although quite real, awoke in the spectator the sensation of "something remote, alien and beyond reach."[22]

Waterfall at Mäntykoski was begun in 1892, the transitional year for the development of northern Symbolist landscape painting. It is monumental in size but executed in the same detailed Naturalist style that Gallen-Kallela had developed under the influence of Bastien-Lepage, with the remarkable exception, of course, of the five parallel golden lines, representing the strings of a harp, drawn vertically from top to bottom down the centre of the picture surface. This curious juxtaposition of realistic description and a quite unrealistic symbolic element signals Gallen-Kallela's departure in the direction of Symbolism, but clearly not along the Synthetist path of Nordström and Willumsen. The harp strings are an ambivalent device: because they have no scale relationship, and certainly not a realist one, to the rest of the painting, they seem to be an experiment with a kind of pure abstract Symbolism more at home in the next century. Yet they serve as a quite traditional symbol to equate the sound of rushing water with harmonious music.

The painting was originally conceived as figurative allegory presenting a pantheistic celebration of the music of nature as sounded by the spirit of the falls. Its models were correspondingly more traditional – Böcklin's *Die Meeresbrandung*[23] or Ernst Josephson's (1851–1906) *Water Sprite*, 1884 (Prince Eugen's Waldemarsudde, Stockholm), the latter depicting a naked watersprite sitting at the foot of a waterfall playing a golden violin. Josephson's painting, one of the first works in Scandinavia to break with Naturalist ideals, became a subject of considerable controversy in early 1893 when Stockholm's Nationalmuseum rejected Prince Eugen's proposed gift of it, a matter well reported in the Finnish press.[24] In its original form *Waterfall at Mäntykoski* included two such allegorical figures, a water nymph, the spirit of the falls, playing

nature's harp, and a listener who sits immersed in dreams at the edge of the water. In time, however, Gallen-Kallela seems to have become dissatisfied with this form of outmoded allegory and removed the two figures (the overpainted listener is still discernible at the lower right). To convey the idea of the music in the roar of the falls he resorted instead to the five golden strings, which stand independent of the image and outside its space.

Gallen-Kallela's decision to exclude figures from his waterfall landscape seems less personal in light of Hodler's decision to remove a lone figure from what is surely also his first Symbolist landscape, *Autumn Evening*, 1892 (no. 79). As first exhibited, it included a small human figure facing in to the space of the painting and, in the manner of C.D. Friedrich, acting as a kind of surrogate through whom the viewer experiences the sunset at the end of the avenue of chestnut trees. Thus, independently but simultaneously, both artists asserted a belief that landscape could by itself convey the kind of higher meaning that in earlier Romanticism and Symbolism had required the presence of some human element. Certainly after 1892 Hodler excluded human figures from his landscapes. Gallen-Kallela did not, for his programme of Kalevala pictures required the depiction of heroic human dramas within a primitive wilderness (*Kullervo's Curse*, no. 24). Even so, in the Kalevala motifs there is a tendency for the human action to occur along a foreground plane that quite dominates the background landscape. The easy integration of figure and landscape that we are accustomed to in Romantic and Realist painting and in Gallen-Kallela's own work up to 1892 has no place in future Symbolist landscape painting.

Waterfall at Mäntykoski is unusual also in the way it combines monumentality with intimacy. Water rushing across rapids or down steep cliffs was a popular subject in Romantic painting, but typically its deafening roar embodied the most sublime forces of nature and it flowed through wild landscapes, the space of which was deep and cosmically inclusive. Gallen-Kallela's water falls with another kind of rhythm, steady and even. Its sound is constant and all pervasive in the narrow space of the painting which, pushed almost claustrophobically close, is like a private natural room. Its soothing and enveloping

22
Akseli Gallen-Kallela (1865–1931) Finnish
* *Great Black Woodpecker*, 1893
Gouache on paper. 144 × 89 cm
K.O. Donner, Helsinki

presence becomes a hushed stillness that demands the profoundest meditative concentration. The landscape rises virtually to the top of the canvas, to be closed off by a dense forest of tree trunks, leaving no escape route for the eye but imprisoning us with the roar of the waterfall until it turns into beautiful and soothing music. Thus, despite the grand size of the painting, its space is designed for solitary reverie.

The consistently shallow, almost flattened space of the painting has caused critics to remark on its tapestry-like quality, a characteristic that goes a long ways toward ameliorating the apparent stylistic disparity between the Realism of the landscape and the abstract Symbolism of the golden strings. The strict Parallelism of those strings, as if in echo of the trunks of the forest above, golden too in the light of the sun, seems to impose on the landscape a strict formal order that has some of the timeless implication of the more programatic Parallelism of Hodler's *Autumn Landscape*. The harp strings consequently succeed in being more than symbols for the music of nature, rather extracting it and making it audible. *Waterfall at Mäntykoski* implies an awareness of Symbolism's belief in the theory of correspondences, as well as the often drawn analogies between art and music. It stands as Gallen-Kallela's most radical and venturesome, though perhaps not his most successful picture for several years. The painting achieved its final form in 1894 and was first exhibited that year.[25]

Great Black Woodpecker, 1893 (original title *Wilderness*), is a motif from the same region as *Waterfall at Mäntykoski*. It exists in two versions. One is an oil painting, essentially Naturalist in style, which Gallen-Kallela began in 1882 and later destroyed or damaged, and then, with his wife's encouragement, salvaged, completed, and dated 1894; it is much damaged and considerably overpainted.[26] The other, a gouache, is dated 1893, but was apparently viewable in the studio at the end of 1892.[27] This version is the most interesting. It is slightly more closely cropped and has a more ornamental character because of stronger contour lines throughout. The ornamental quality is not as pronounced as in Willumsen's *Spanish Chestnuts* (no. 3) from 1891, though both works integrate the frame and picture. Gallen-Kallela's frame closely resembles the dec-

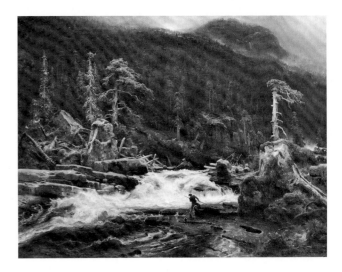

23
August Cappelen (1827–1852) Norwegian
Waterfall in Telemark, 1852
Oil on canvas. 70 × 102 cm
Nasjonalgalleriet, Oslo

orated one of *Waterfall at Mäntykoski*, and there is a close correlation between the rectilinear alignment of the golden strings and the edges in the latter work and the use of the upright and vertical tree trunks in establishing the formal structure of *Great Black Woodpecker*.

For Gallen-Kallela the woodpecker perched on the upturned tree roots at the front of the picture was a significant symbol for the wilderness. It "has always been my friend. Every time I hear its fresh and shrill voice, I get the feeling of finding myself so far from human habitation that I no longer have any contact with it ... The woodpecker's red hood constitutes the cry of life of the individual in the silence of the wilderness."[28] As in *Waterfall at Mäntykoski* there is a tension between the meaning of the painting as expressed through a private symbol prominently placed in the painting and its more formal Symbolist expression. But here also the composition has been tailored to make more direct and rather special the relationship between the viewer and the wild and lonely

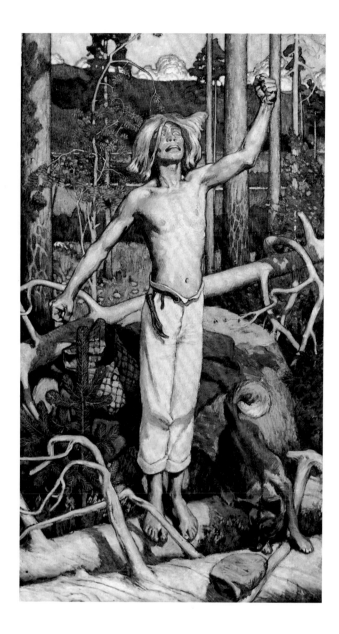

24

Akseli Gallen-Kallela (1865–1931) Finnish

* *Kullervo's Curse*, 1899

Oil on canvas. 186 × 105 cm

Art Museum of the Ateneum, Collection Antell, Helsinki

wasteland to which the painter is paying pantheistic tribute.

All in all, with the paintings celebrating unspoiled wilderness landscapes begun around 1892 Gallen-Kallela joined contemporary Scandinavians such as Nordström and Willumsen in several discoveries. They all embraced a variety of landscape subjects to which the previous Naturalist decade was blind or indifferent; they infused those subjects with symbolic meaning; and they found ways of recasting these landscapes in compositional schemes that disrupted the paintings' continuity with the immediate physical world and shifted them out of the physical time and space of the viewer, thereby transforming them into worlds primarily accessible to the eye and to the imagination.

The wilderness paintings of Gallen-Kallela, including *Lake in the Wilderness*, 1892 (no. 20) might well serve as the models from which all other compositional types developed during the Symbolist landscape period. They are structured almost identically, in three parallel layers: a close-up foreground tangle of deadwood and underbrush; a thin middle-ground established by single trees or a row of trees arranged across our view, truncated at the top and joining with the frame, so as to form a sort of screen; and, through the screen, at some distance, a magnificent broad and expansive landscape, in *Woodpecker* seen in the light of an early mid-summer morning.

Gallen-Kallela's reminiscences about what he wanted to achieve in *Woodpecker* help to explain how such compositions developed. He sought to convey a heightened impression of the silence, solitude, and vastness of the wilderness before which he could feel the thrill of complete dissociation from civilization. The vantage point of the viewer was a place, Gallen-Kallela recalls, to which he would climb because he knew that there he had finally turned his back on any signs of human presence and in front of him "the mood of the wilderness ruled absolutely."[29] The place was the furthest he climbed to, and from there he would resort to his binoculars to explore the distant forests, lakes, and mountains. Perhaps his account of finding the motif is a parallel to the meaning of the painting: he leads us to the threshold of the wilderness, which is as far as we can, and perhaps should, go lest we defile the sanctity of the wilderness. What lies

beyond, comparable to Willumsen's distant mountain peaks, is experience accessible only to vision and longing.

In earlier Romantic painting of even the most sublime scenery (no. 23) the spectator was provided with a point of entry – a foreground ledge or a pathway – and at least one tiny surrogate human figure to ease his passage. The transition from foreground to middle ground to the most distant background was continuous, and, if the way was arduous, it was in theory physically negotiable. In both of the Gallen-Kallela pictures the foreground refuses to provide us with even a semblance of a footing. There is foreground, but it is precariously steep and looks slippery. A scramble up it would be both difficult and undignified, and it would lead only to a sharp falling away just beyond. In effect the tree screen divides the picture into two distinct and spatially disconnected parts: a compacted, large-scale, physically tangible microcosmic foreground, pushed here claustrophobically close to our faces; and a distant panoramic mascrocosm for imaginative exploration. Most of the northern landscapes of the period will either repeat this juxtaposition of disparate scalar realms or simply scan the distant one or burrow into the near one.

Gallen-Kallela himself reverted to this layered type of composition several times. He seems to have first employed it in 1889 in an earlier version of *Lake in the Wilderness*, and, as Onni Okkonen has suggested, his 1892 revival of it proves that he saw something worthier in it.[30] It reappears most grandly in *Kullervo's Curse* in 1899 (no. 24) – a final painted version of a composition first developed in a drawing from 1891 – from which an etching was produced in 1896. Stylistically *Kullervo's Curse* is a reversion to Gallen-Kallela's more realistic style of the early 1890s. It is quite dissimilar to the highly stylized and archaized Kalevala paintings from the intervening years, yet, if we compare the landscape of *Kullervo's Curse* to *Lake in the Wilderness*, which it closely follows, the later painting is executed with a more intense colour scheme laid out in flat patterns of searing juxtapositions, as if to give visible sound to Kullervo's rage. Moreover, the form-dissolving painterliness of the earlier picture has been replaced by a solid sculptural rendering of forms, applied not only to the foreground tree trunks in an echo of the heroic determinedness of the young hero's slender body,

but also to the solid masses of clouds hanging above the ridge of the hills in the distance.[31]

Certainly Pekka Halonen sought a comparably heroic image of the Finnish forests in his closely related *Wilderness* (no. 26), also from 1899, when he and Gallen-Kallela were in regular contact and he would have been able to watch *Kullervo's Curse* in progress in Gallen-Kallela's studio. The heroic landscape period of Halonen's work was fairly short, not more than five years around the turn of the century. Halonen and other Finnish artists, writers, and musicians, including Jan Sibelius, participated in the establishment in about 1897 of a kind of artists' colony in a small village, Tuusulassa, in the Finnish forests, with the objective of finding peace to work in an environment cut off from urban life. All were committed to the national Romantic movement and constructed studios in old Karelian building styles. They were following in the footsteps of Gallen-Kallela, who in 1895 had built his wilderness studio, Kalela, in Ruovesi, seeking the consoling loneliness of the wilderness after a period of intense immersion in fanciful Symbolist metaphysical speculation.

Thus for many Finnish artists the restorative powers of the wilderness forest and its mediating capacity to point to the very sources of life, sometimes made more poignant when filtered through Kalevala lore, constituted a common faith throughout the 1890s. In notes he kept during 1895 Gallen-Kallela speaks of the intuitive experience of nature as a pathway to mystical knowledge: "The eternal life" is sensed everywhere in the actions of nature, which he explored in order to "come into a more intimate touch with the elemental." His own thoughts "will-lessly" rise and fall, losing themselves in eternity, with the rhythm of waves on the surface of the lakes across which he paddles his canoe. On the basis of old Finnish myths and popular superstitions he imagines the wilderness peopled with wood and water spirits. He speaks often about wonderful things that can be read in every tree and bush, about the beautiful "unknown" which can be found in nature and about which we can learn only with the help of presentiment.[32] The following is perhaps his definitive statement on the transcendental, mystical, and recuperative powers of nature:

25
Akseli Gallen-Kallela (1865–1931) Finnish
* *Broken Pine*, 1906–8
Oil on canvas. 124 × 137 cm
Private collection

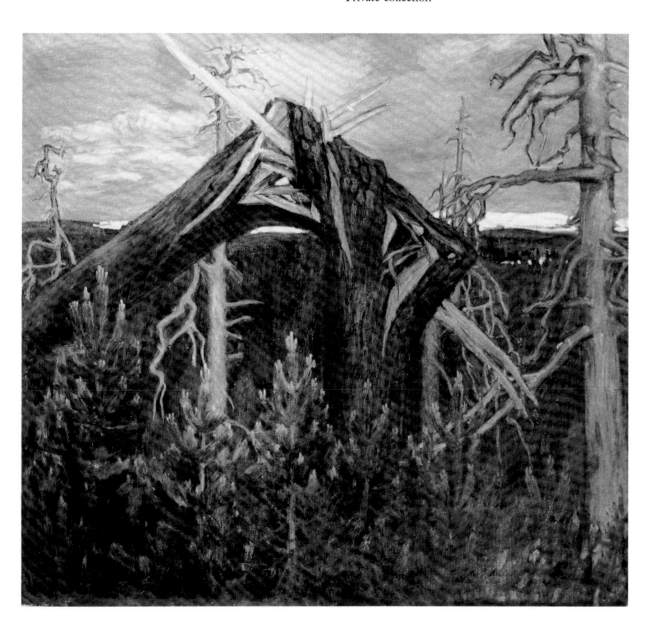

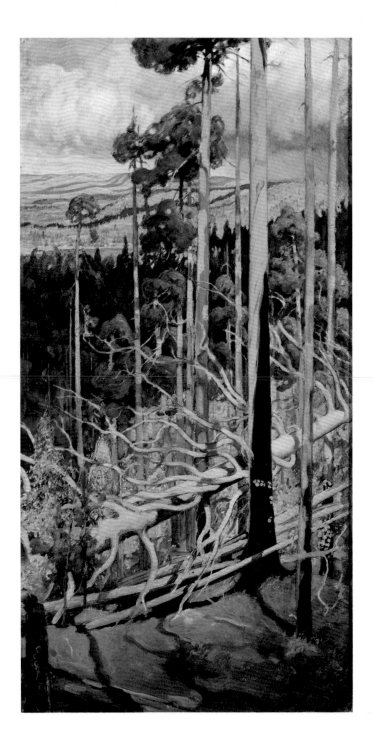

The man who, even in these times, in certain harmonious moments can find himself standing in powerful unity with all of nature has assuredly gotten more life than others. During such solemn times of cohabitation with nature he can know how her soul at the same time dives deep and flies high into the all. It is the man who lives alone in the wilderness with unspoiled nature and within the circle of its life who comes nearest to that wonderful condition. The first consequence of the renewed understanding of life that results is that he begins to love the earth in another way than before. The earth begins, in his imagination and thought, to play the role of a living, impressively grand, overpowering, and eternal motherly being.[33]

Halonen had visited Karelia as early as 1892 and had, like many Finnish artists, become obsessed with Karelianism. During that year and the next he became increasingly preoccupied with spiritual questions, reading Theosophy, Tolstoy, and oriental religions, dabbling in spiritism, and undergoing a religious crisis. As a student of Gauguin he could hardly have avoided coming under the spell of Symbolist thinking, but in the end he became neither a Theosophist nor a Symbolist. His painting remains a kind of modified Realism, though the Synthetism of Gauguin and lessons from related French artists, including Puvis de Chavannes, emerge. Though he was as deeply patriotic as Gallen-Kallela, Halonen never treated the *Kalevala*. He seems, however, to have been just as obsessed with national romantic ambitions and to have had an equally profound love of nature. Thus his motivations for building a wilderness *atelier* paralleled Gallen-Kallela's and was probably deeply influenced by him. In the wilderness, which was undisturbed by traces of man and difficult of access, Halonen also discovered the paradise that he had longed for from afar in the city.

It was with such an attitude that he painted *Wilderness* during the summer of 1899. The painting is entirely without human or animal life, unlike Gallen-Kallela's *Great*

26

Pekka Halonen (1865–1933) Finnish
* *Wilderness*, 1899
Oil on canvas. 110 × 55.5 cm
Turku Art Museum, Turku, Finland

Black Woodpecker. Originally it was conceived otherwise, as a picture of folk life with men cutting down trees much in the manner of the painting *Pioneers* (Ateneum, Helsinki), from the next year. In the end, however, he let the landscape act for itself, throwing the emphasis on the high vertical format and underscoring the height of the trees by dramatically truncating them at the top and contrasting their heroic growth to their fallen *confrères* in the foreground. The composition is strongly related to the group of Gallen-Kallela landscapes discussed previously. The meaning of the painting is usually discussed in terms of national feelings, of the Finnish forest standing strong in face of the threat of increasing Russianization caused by Czar Nicholas II's February Manifesto in 1899, which brought Finland under the domination of Russian imperial legislation. In a letter to fellow artist Emil Wikstrom, Halonen wrote: "The Finnish people are tough as Juniper; we can't be beaten by so little ... the land and the nation will live."[34]

In marked contrast to the determined national optimism of Halonen in 1899 is Gallen-Kallela's personally pessimistic *Broken Pine* (no. 25), 1906–8, painted during a period of dejection and artistic paralysis. It depicts a fertile forest of young trees out of which rise several dead and dried out trees, surrounding a mighty broken pine, its top fallen out of sight. In *Boken om Gallen-Kallela* he describes the special meaning that these still-standing trees, bereft of leaves and life, had for him: "There in the distance on a high slope it stands dry and grey, a blue-grey dried pine. In its hollow core it carries a hawk's nest with young fledglings ... see there one of the last survivors of a Finland, a homeland, that once was wholly mine."[35] In the middle of the forest stands the gigantic pine that once must have reached far above the frame and from the top of which one would have been able to scan the most distant horizon. Its trunk has broken and its crown has fallen to the ground. Its wood is not dry, but soft and alive, brutally mangled and twisted, with long sharp splinters protruding from it like shafts of swords plunged into its heart. In contrast, a younger generation of trees, the tips of their branches brown with new growth, threatens to overgrow, submerge, and forget the beaten coniferous giant crudely felled by malevolent forces before its time.[36]

58 Gallen-Kallela's dejection was given gripping expression in another large canvas, *The Lament of the Boat* (private collection, Helsinki). In it the artist, through the image of an old warrior leaning on the hulk of his decayed boat, expresses his feelings of wanderlust and his powerlessness to act on them.[37]

Gallen-Kallela's last great display of artistic power was the decoration for the Juselius Mausoleum im Pori, executed between 1901 and 1903. It was a commission that he undertook with some enthusiasm. In 1897 he had travelled to Italy to study fresco painting in order to be able to undertake major monumental decorative projects, an ambition shared by most northern artists at the end of the century, including Munch, Willumsen, and Prince Eugen. Gallen-Kallela's first work in an architectural set-

27
Pekka Halonen (1865–1933) Finnish
* *Washing on Ice*, 1900 (commissioned for the Finnish Pavilion, Universal Exposition, Paris, 1900)
Oil on canvas. 125 × 180 cm
Art Museum of the Ateneum, Collection Antell, Helsinki

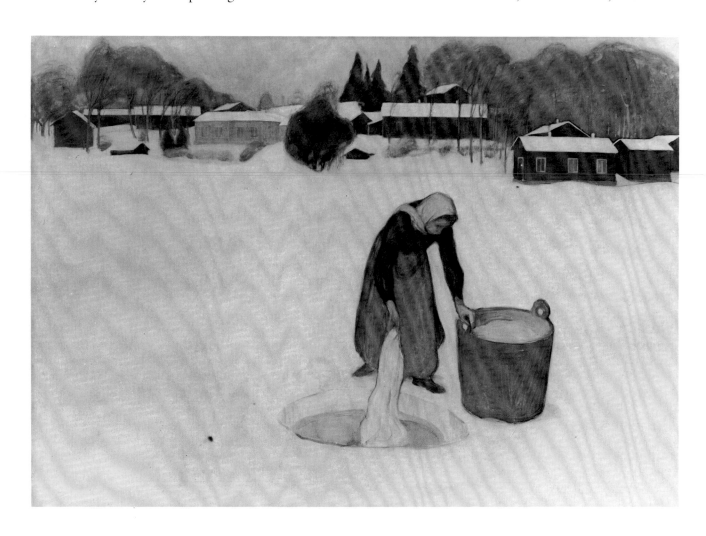

ting was the decoration devoted to subjects from the *Kalevala*, for the Finnish Pavilion in Paris in 1900. Several Finnish artists contributed decorative paintings to the Paris pavilion, including Halonen, who sent such grandly scaled works as *Washing on Ice* (no. 27) and *The Lynx Hunter* (no. 28). In these he has given full expression to the Synthetist lessons that he had learned under Gauguin's tutelage in Paris in 1894 or from Puvis de Chavannes. Though the settings are landscapes, the pictures are dominated by monumentalized foreground figures silhouetted against the flat planes of snow or the distant forest. Forms are broadly simplified and contained within strong contours, sometimes with art-nouveau curvilinear play, and colours are muted by a matte fresco-like surface.

Halonen's celebration of life on the edge of the wil-

28
Pekka Halonen (1865–1933) Finnish
* *The Lynx Hunter*, 1900 (commissioned for the Finnish Pavilion, Universal Exposition, Paris, 1900)
Oil on canvas. 125 × 180 cm
Art Museum of the Ateneum, Collection Antell, Helsinki

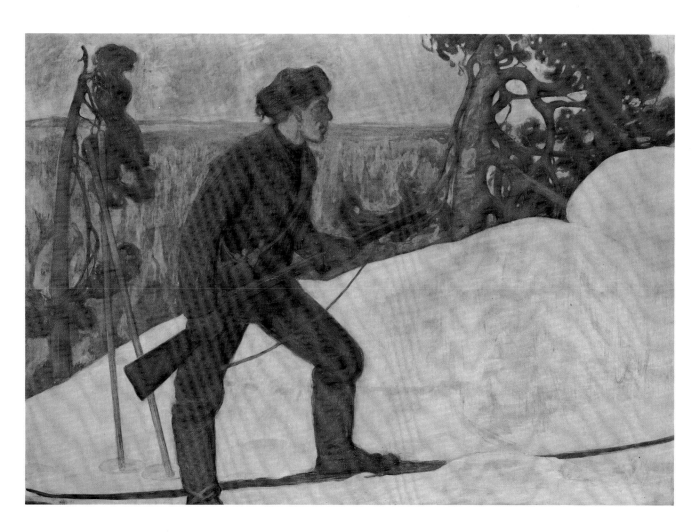

derness reflects the optimistic vigour which around the turn of the century began to sweep away the melancholy of the preceding decade. We can observe it in the neo-Realism that increasingly replaced decorative and mood-inducing stylizations in the work of northern landscapists and in the return to sunlight and daytime pleasure in the direct experience of nature. It happens to Willumsen, Munch, Prince Eugen, Jansson, and Osslund, and also to Gallen-Kallela in winter paintings, such as the *The Lynx's Den*, 1906 (no. 31), that rediscover nature with a directness and freshness less concerned with deeper interpretations. Gallen-Kallela's decorations for the Juselius Mausoleum seem, in contrast, to belong in their brooding mood entirely to the preceding decade.

The mausoleum was built by a Pori industrialist in memory of his eleven-year-old daughter. The architect, Josef Stenbäck, engaged Gallen-Kallela to execute the interior decorations and suggested that they deal with the motif of "death's triumph over the body"; the artist was immediately attracted to the project. Not only did it offer an opportunity to work at an architectural scale, but it also brought back memories of the death of his own young daughter in 1895. As he wrote to Stenbäck: "For a long time I have had similar ideas, though not in so limited a context. My proposal is to show the still passage of our people along the crooked path of life down into the arms of the kingdom of death. Since the death of my daughter some years ago this thought has become much clearer."[38] In *On the Way to Touenela*, a scene reminiscent

29
Akseli Gallen-Kallela (1865–1931) Finnish
* *Autumn*, 1902 (a study for the frescos in the Juselius Mausoleum Chapel at Pori, 1903)
Tempera on canvas. 77 × 143 cm
Sigrid Juselius Foundation, Helsinki

of Dante, the departing stand in quiet resignation on the shoreline of a black river, waiting for the ferryman to carry them to the land of the dead.

A key theme of the other compositions is the portrayal of the seasons and their activities. From the beginning their cycle is pervaded with premonitions of death, which conquers all as inevitably as the seasons run their course. *Autumn* (no. 29) does not celebrate the glorious colour of turning leaves in nature's final efflorescence, but testifies to the destructive force of the cold winds of the coming winter. Its sweeping shoreline recalls Munch's Aasgaardstrand, but it is already snow-blown, and crushed ice floes crowd its edge. In the foreground a paltry windblown willow tree and five forlorn and staggering black crosses push out beyond the edges of the painting and screen our view across a dark sea to a long straight extension of land, the edge of which finally merges with the horizon under a purple sky. It is a bleak, chilling, and forbidding scene, in contrast to which the snow cover of

Winter (no. 30) seems serene and protective. The close-up view of the rounded rhythms of snow-laden branches is close to Fjaestad, though the Swedish artist's lighter touch deprives his work of the meditative perplexity Gallen-Kallela feels in the face of this strangely imprisoning fragment of forest trunks and branches. The extent to which *Winter* is dominated by *Jugendstil* stylizations may be observed by contrasting it with *The Lynx's Den* (no. 31), in which equally heavy rhythms depend much more on the observation of natural phenomena. With the first decade of the new century, however, Gallen-Kallela's creative period had run its course.

30
Akseli Gallen-Kallela (1865–1931) Finnish
* *Winter*, 1902 (a study for the frescos in the Juselius Mausoleum Chapel at Pori, 1903)
Tempera on canvas. 76 × 144 cm
Art Museum of the Ateneum, Collection Antell, Helsinki

Akseli Gallen-Kallela (1865–1931) Finnish

* *The Lynx's Den*, 1906

Oil on canvas. 40 × 30.5 cm

Gösta Serlachius Fine Arts Foundation, Mänttä, Finland

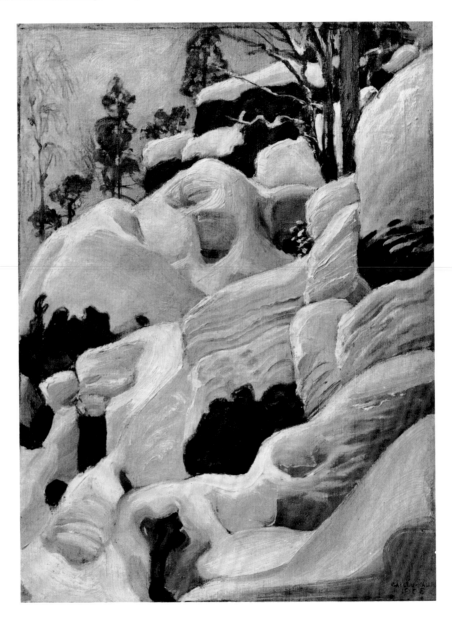

Sweden:
Prince Eugen, Otto Hesselbom, Gustaf Fjaestad, Eugène Jannson, and Helmer Osslund

... everything becomes simple and grand at dusk. If only one could bring together all the dissimilar impressions and put them down in a single motif, so that the colour would shimmer, have fragrance, and be heard.
Prince Eugen[1]

In reference to the work of the early 1890s by Munch, Willumsen, Nordström, and Gallen-Kallela we have observed the transition within Scandinavian art from a commitment to close naturalistic observation of nature to a growing interest in emotional, psychological, spiritual, and idealistic states of mind. Throughout Scandinavia landscape was proving a genre able to embody and convey these kinds of experiences behind appearances. Artists also preferred motifs drawn from more remote and wild regions of their native countries for both personal and patriotic reasons. Wilderness was what was most identifiably unique to northern countries, but it was also a place of refuge from the turmoils of a spiritually confused world, and the very nature of its unspoiled remoteness suggested that there would be revealed messages of the mysterious but elemental and primitive sources of experience. Artists had to reformulate their styles and learn to synthetize and reconstruct pictorial space in order to transform their paintings from representations of nature to symbols of an inner life. It remains to fill out the broader picture of these developments in Europe over the following two decades.

Along with Nordström, Prince Eugen made the most important contribution to Swedish national Romantic landscape painting in the 1890s. His royal position prevented him from joining the Artists' Union in its opposition to the academy: the academy was after all royal. But his liberal attitudes in politics and art meant that his sympathies lay with the Artists' Union, and he regularly exhibited there as a guest. Prince Eugen had followed the usual path of his fellow Scandinavians, studying in Paris under such artists as Léon Bonnat, Henri Gervex, and A. Roll, along with a short stint with Puvis de Chavannes which left important marks on his career. Throughout the 1890s critics also detected, if in a less defined way, the influence of Böcklin, who for the young Symbolist generation was something of a hero because of his willingness during the Naturalist period freely to reorganize nature for idealist and poetic purposes.[2]

Eugen was strongly impressed, as we have seen, by the Norwegian presentation in the Universal Exposition of 1889, both for its stylistic strengths and because, as he wrote home, "one can really recognize their national character in their art."[3] The succeeding two summers, 1889 and 1890, he spent in Norway in the region of Valdres, working from the example of Werenskiold, Skredsvik, Munthe, and the other leading Naturalists. At the same time, probably under the influence of Norwegian mood painters, he began also to pay attention to the qualities of twilight, especially its effect of washing out details and massing the landscape into greater wholes. During this period he also developed and introduced into the art of

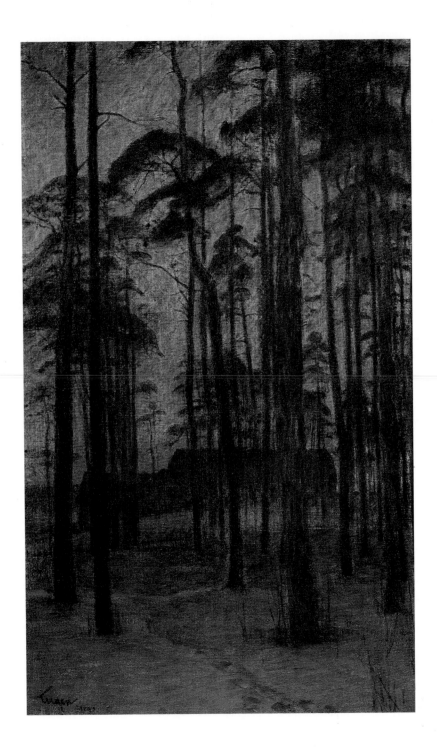

32 (opposite)
Prince Eugen (1865–1947) Swedish
* *Forest Clearing*, 1892
Oil on canvas. 76 × 45.5 cm
Prins Eugens Waldemarsudde, Stockholm

33 (below, left)
Prince Eugen (1865–1947) Swedish
The Forest, 1892
Oil on canvas. 150 × 100.5 cm
Göteborgs Konstmuseum, Göteborg, Sweden

34 (below, right)
Gustave Doré (1833–1883) French
Alpine Scene
Oil on canvas. 194.3 × 180.3 cm
Art Institute of Chicago

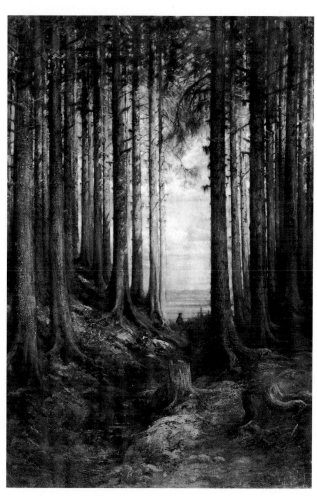

the 1890s a long panoramic compositional format which embraced wide expanses of glistening lakes and tree-coverered islands seen at dusk or in the light of the mid-summer night. This format attained a kind of national epitome in Hesselbom's *Our Country*, 1902 (no. 42).

Forest Clearing, 1892 (no. 32), identifies Eugen as a more lyrical artist than Nordström. At a glance the painting may seem close to naturalistic mood painting, but to contemporaries it looked new. Its melancholic depiction of a deserted forest edge and its cold air glowing with sunset looked homegrown; and it appealed to the emotions in a way that sunlit impressionistic winter scenes had not. It was also new to organize a subject in such a way as to thwart easy and unconscious access to pictorial space. We are drawn inward by the orange light of the sky and a path of tracks in the snow; but we are held back by the dark silhouettes of the buildings and by the trees, the haphazard growth of which does not open up a clear passage. The trees form a kind of maze, not very complex, which frustrates expectations and creates feelings of unease and apprehension. The tall parallel forms of the trunks of the pines cut off by the upper frame form a barrier not only within the natural setting but also, and comparable to Gallen-Kallela's contemporary pictorial solutions, as part of the formal structure of the painting.[4] The particular moment of evening just after the sun has sunk below the horizon and when the sky takes on its deepest reds and oranges appealed to Eugen because of its evocative qualities. That it did to several other artists at the same time is indicated by Nordström's *Varberg Fort* (no. 15), Sohlberg's debut picture, *Night Glow* (no. 66), and, with terrifying intensity, Munch's *The Scream* (Nasjonalgalleriet, Oslo), all from 1893.

Prince Eugen's *Forest Clearing* hints at, and *The Forest* (no. 33), 1892, clearly illustrates, the special nature of a Symbolist forest. Its frightening, almost impenetrable denseness, which the viewer is put in the very middle of, implies other meanings than the openness of Romantic or realist forest subjects such as Gustave Doré's *Alpine Scene* (no. 34), despite their shared subject matter: Doré has used standard Romantic devices to ameliorate the terrors of the forest by opening up the foreground and driving a broad path down the middle of the picture. He has organized his forest as a kind of natural Gothic cathedral under a vault of branches in which a tiny figure guides our passage from the foreground narthex, down the central nave, toward full illumination in the light of day in a vast apse beyond.[5] The Symbolists, even in landscape painting, were more likely to want to dwell on rather than dispell the mysteries of nature and usually eschewed such rationalizing conventions. It is consequently curious to hear Richard Bergh describe Eugen's *The Forest* in traditional terms: "thousands of majestic pillars in a boundless church – in nature's own great temple. Over there, the glow of the evening sun – many miles away – resembles a faintly shining choir window with gilt glass, toward which all the pillars, tall and majestic, lead."[6] The sense of endlessness and distance is correctly observed, but the architectural metaphor distracts from the mysterious disorder of the forest, imbued with all the terrors of a fairy tale, where one's eye is seduced inwards more and more deeply until, in Gauffin's description, "one cannot see the forest for the trees, [and is] without resistance pulled toward the unknown of the burning glow of the sunset furthest in, mysterious as a sparkling eye of a troll in the depth of the primeval forest."[7] Later wooded scenes, such as Mondrian's *Woods*, 1898–1900 (no. 95), and Gustav Klimt's *Birch Forest*, 1901 (no. 35), achieve a more decoratively flat surface, but share with Eugen what Goldwater has described as "a breathless presence [which] seems to inhabit the intervals between the forms, an evocative silence that gives a 'secret emotive meaning to appearances'."[8]

When Eugen turned to the sunlight of midday, it was curiously not to lighten his mood. It was as if he surmised that anyone can brood at twilight, but that real personal anxiety persists through the light of day. *The Old Castle*, 1893 (no. 36), in which towering storm clouds threaten an old ruined building set in an otherwise broad and brilliantly sunlit landscape, was painted during a period

35
Gustav Klimt (1862–1918) Austrian
Birch Forest, 1901
Oil on canvas. 100 × 100 cm
Gemäldegalerie Neue Meister, Dresden

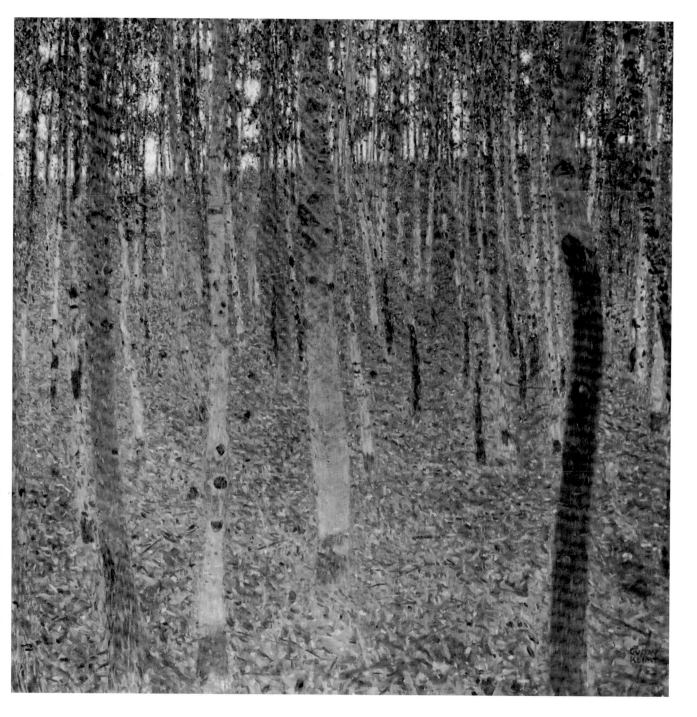

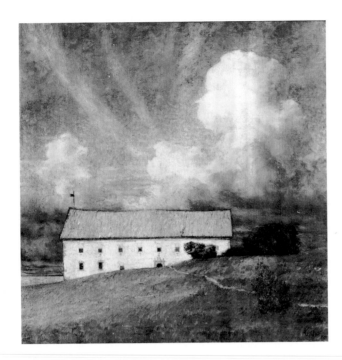

36
Prince Eugen (1865–1947) Swedish
The Old Castle, 1893
Oil on canvas. 101 × 97 cm
Prins Eugens Waldemarsudde, Stockholm

subject matter, but in the paint itself, applied in nervous, loosely structured parallel strokes that follow the contours of the hill, animate the trees, and infuse with tension and passion what otherwise could be construed as a tranquil scene. As Eugen wrote to his mother after having discovered the motif for *The Old Castle*, there "must always be a certain correspondence between nature and what one oneself knows and wants."[11] Such sentiments corresponded to Bergh's in the theories concerning national Romantic landscape painting which he was formulating in relation to Nordström.

Later in life, but in terms applicable to the 1890s, Eugen elaborated on the relationship between the artist and his subject matter:

It is often an impression of nature, simplified and summarized in the memory, that inspires a work of art. The artist's more indefinite longing suddenly meets an accord in nature ... a work of art is born. But far from seldom it is the artist's idea ... that is primary. Then the artist seeks corresponding occurences in nature ... Yes, nature is quite recomposed according to the artistic intention ... Paradoxically it has also been said that art reshapes nature; in any case it alters the human being's capacity to see and apprehend nature.[12]

As an illustration of how radically emotional states of mind could influence the perception of nature, Eugen recalled his response to the original site of the subject matter of *The Cloud*: "The whole corresponded to my intentions, or so I thought. Then I worked out my motif on the spot in front of nature, but when I came back there the following year, I could not recognize the motif any longer, nor could anybody else."[13] Because of their relatively pastoral settings and classical tranquillity, these two sunlit pictures by Eugen finds their closest parallels in the work of turn-of-the-century Danish artists, such as Vilhelm Hammershøi (*Sunshine and Shower, Lake*

of personal crisis when he was overcome by feelings of doubt and isolation. Sandblad has called it his "Scream,"[9] echoing Eugen's words to a friend while planning the painting: "I will paint a canvas with only great disharmony, so that it will cut into every other person who sees it. It will have the effect of a scream."[10] Such bitterness of tone is perhaps a little difficult to discern today in a picture that is otherwise dominated by a classical clarity and order and is a product of considerable distillation and reorganization of observed reality. It is closely allied to *The Cloud*, 1895 (no. 37), which also has about it a kind of idyllic monumentality and an intimation of sunny arcadian visions reminiscent of both Böcklin and Thoma. *The Cloud* is a picture full of movement, not only in the

37 (opposite)
Prince Eugen (1865–1947) Swedish
* *The Cloud*, 1895
Oil on canvas. 112 × 103 cm
Göteborgs Konstmuseum, Göteborg, Sweden

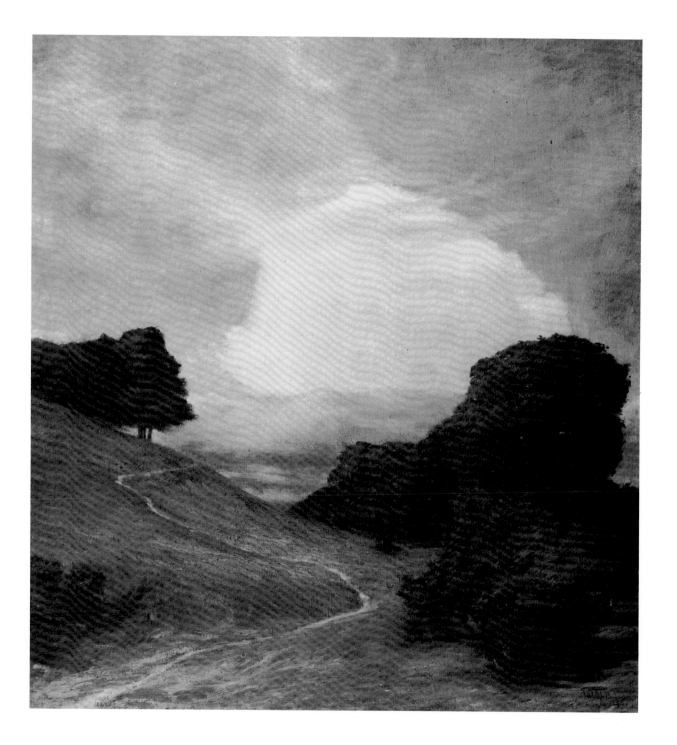

38 (top)
Vilhelm Hammershøi (1864–1916) Danish
* *Sunshine and Shower, Lake Gentofte*, 1902
Oil on canvas. 83 × 78 cm
Private collection

39 (bottom)
Ejnar Nielsen (1872–1956) Danish
* *Landscape from Gjern, Jylland*, 1897
Oil on canvas. 110 × 220 cm
Vejen Kunstmuseum, Vejen, Denmark

40 (opposite)
Prince Eugen (1865–1947) Swedish
* *Summer Night, Tyresö*, 1895
Oil on canvas. 78 × 144 cm
Nationalmuseum, Stockholm

Gentofte, 1902, no. 38) and Ejnar Nielsen (*Landscape from Gjern, Jylland*, 1897, no. 39), who, unless they went abroad, had little wild or desolate scenery to refer to and had to discover grandeur in the rolling farmlands of Jutland or parklike woods of Zeeland.

In other paintings Eugen worked in a spirit closer to Nordström's northern severity. In *Summer Night, Tyresö*, 1895 (no. 40), he resumes the twilight-shrouded broad-format landscape that he originated in Norway in 1891. The viewer is set afloat indeterminately in space in a manner reminiscent of *Jotunheim*, but little else is similar to Willumsen's hard-edged vision. Eugen has erased all individual detail, and landscape forms float elusively in the greenish shimmer of night light characteristic of the northern summer. He evokes a silence that rises almost audibly out of the shadows to resonate in colour that, as he wrote, "shall be so deep ... that it will have the effect of organ tones, and ... must sound like a folk ballad, monotone, plaintive, but beautiful."[14]

His last Symbolist landscape painting, *Still Water*, 1901 (no. 41), is also his most monumental. Set at sunset, its stark and symmetrical composition establishes a powerful contrast of moods between its upper and lower portions. The sky, which occupies three-quarters of the picture surface, is filled with tumultuous clouds in restless flight. Below, a small, perfectly circular lake lies in the middle of a silent and serene landscape, its unruffled black surface casting off only a few reflections of orange sunlight. Its reticence about revealing anything from its mysterious depths suggests that it might be a Symbolist interpretation of Thoreau's description, in *Walden*, of a lake as the "earth's eye; looking into which the beholder measures the depth of his own experience."[15] However, Eugen's lake has about it something of the demonic ambiguity of

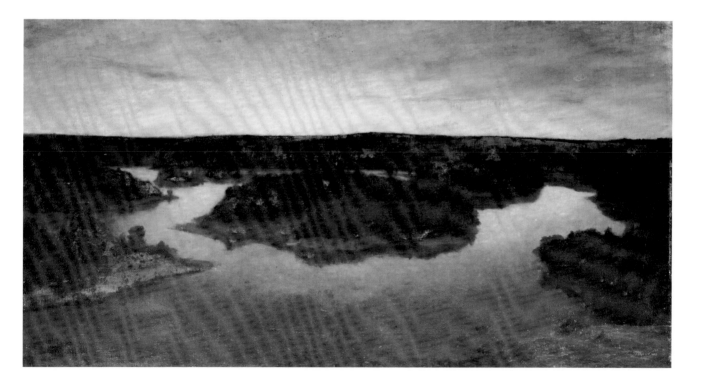

72 41

Prince Eugen (1865–1947) Swedish
* *Still Water*, 1901
Oil on canvas. 142 × 178 cm
Nationalmuseum, Stockholm

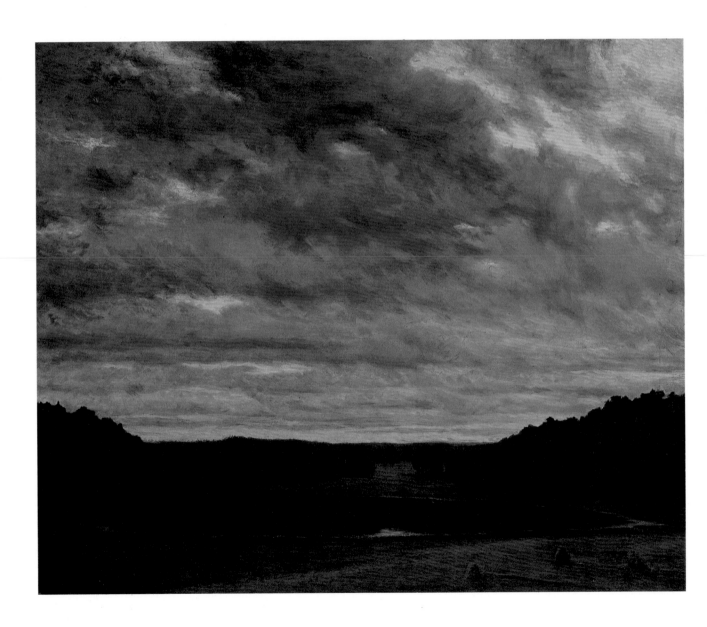

Otto Hesselbom (1848–1913) Swedish
* *Our Country, Motif from Dalsland*, 1902
Oil on canvas. 126 × 248 cm
Nationalmuseum, Stockholm

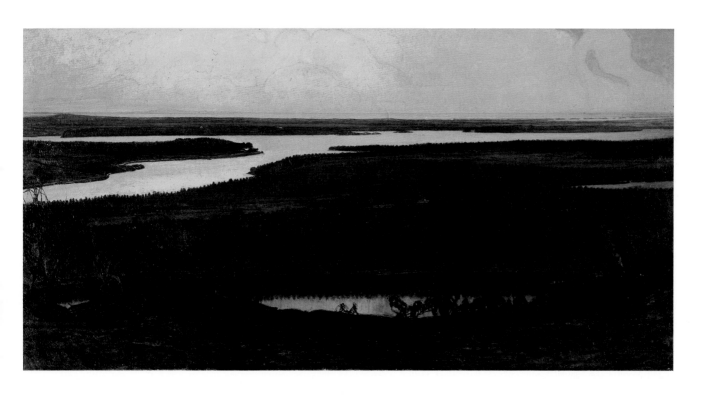

the look of Professor Teufelsdröckh's eyes in Carlyle's *Sartor Resartus*, which had "the gravity as of some silent, high-encircled mountain pool, perhaps the crater of an extinct volcano; into whose black depths you fear to gaze: those eyes, those lights that sparkle in it, may indeed be the reflexes of the heavenly Stars, but perhaps also glances from the region of Nether Fire!"[16]

Still Water is perhaps the period's most eloquent and solemn hymn to the northern twilight. In its eerie and profound stillness (the little boat on the shoreline seems to intensify the feeling of loneliness) it constitutes a powerful lowland symbol for those mysterious and unattainable truths of existence that Willumsen, Sohlberg, and Hodler usually consigned to the tops of mountain peaks. This is what distinguishes the painting from more sentimental examples of national Romantic sunsets and sets its ambitions alongside those of the profoundest international Symbolist landscapes – Hodler's Lake Geneva paintings (no. 84 and 85) or Mondrian's sea after sunset pictures (no. 100) – which similarly assemble the landscape into all-encompassing patterns with a geometric regularity that seems to reveal an order of eternity beneath the shifting appearances of nature.

After 1900 Prince Eugen's work reverts to a kind of lyrical and impressionistic Naturalism, which, in tune with general northern tendencies, discards the melancholy moods and compositional stylizations that dominated the preceding decade. Throughout the 1890s he had wanted to draw symbolic and expressive meaning out of the landscape without distorting the appearance of nature by undue decorative mannerism. He wrote: "I have always striven for and believed in getting a decorative effect in a landscape without any stylization and manner," a goal for which he found support in Danish Golden painting, especially Köbke.[17] This conviction sometimes aligns his work with contemporary Danish landscape painting and distinguishes *Still Water* from Otto Hesselbom's *Our Country, Motif from Dalsland*, 1902 (no. 42), which perhaps more than any painting of the turn of the century typecast the twilight as a symbol of the north, and more specifically as a rallying point for Swedish patriotic feeling. Hesselbom borrowed his panoramic perspective from Eugen, and shares with him deep feelings for the resonant silence that can spread over the landscape at dusk and in the midsummer dark. But Hesselbom organizes his pictures in more self-conscious decorative patterns, characterized not only by a simplified handling of form and colour, but also by an ornamental line, adapted from Japanese art and *Jugendstil*, that is applied not only to the general patterning of water and land but also to the rendering of details. The colour scheme of Hesselbom's paintings is reduced to a few powerfully dominating tonalities, the yellow of the sky and of the water reflections and the dark green of the land masses, which often have something gloomy and distressed about them. "But it is in the clouds," to refer to the typical words of a nearly contemporary analysis of *Our Country*, "whose light structures he knows how to handle with startling veracity, that he establishes the explanatory contrast to the dark, heavy masses of the earth. For them he has saved all the spiritualizing light-power of his palette. From the fantastic gyrations of vapours, he builds – not a castle in the air, life has taught him its perishability – but a temple of unattainable light to long for. Thus Otto Hesselbom preaches to us, paintbrush in hand."[18]

A closely related landscape in format, subject, and mood, *Ahvenanmaa (Åland)* (no. 43), from the island in the Baltic sea, was executed by the Finnish landscape painter Victor Westerholm between 1899 and 1909, when annually he transported the painting in progress back and forth from the subject itself in Åland to his studio in Turku.[19] Although Westerholm was essentially a Düsseldorf- and Paris-trained Realist painter, for a short time around the turn of the century he was smitten by Symbolist tendencies and organized his landscapes in a more summary and decorative way; of these works *Åland* is the most monumental example.

As its regional painter Hesselbom became strongly associated with the province of Dalsland, in the way that Nordström was associated with his native Bohuslän, and Eugen with the region around Stockholm. Hesselbom also saw nature from a strongly Christian point of view that mingled with his patriotism to make the study of the landscape of Dalsland comparable to worship before a benevolent creator. The title of *Our Country* suggests that there was in his concentration on Dalsland a greater

ambition than regionalist depiction, and eventually he and his audience would learn to read his provincial subjects as national symbols. From his debut in Berlin in 1896 to his death in 1913 Hesselbom was regularly invited to participate in important international exhibitions, where his broad panoramic views were accepted as real revelations. *Our Country* struck a very sympathetic chord with Harris and MacDonald when they saw it in Buffalo in 1913, not only for its techniques and stylistic devises, but also because it reminded them of their own northern Ontario landscape in Muskoka or Temiskaming.[20]

43
Victor Westerholm (1860–1919) Finnish
* *Ahvenanmaa (Åland)*, 1909
Oil on canvas. 200 × 263 cm
Turku Art Museum, Turku, Finland

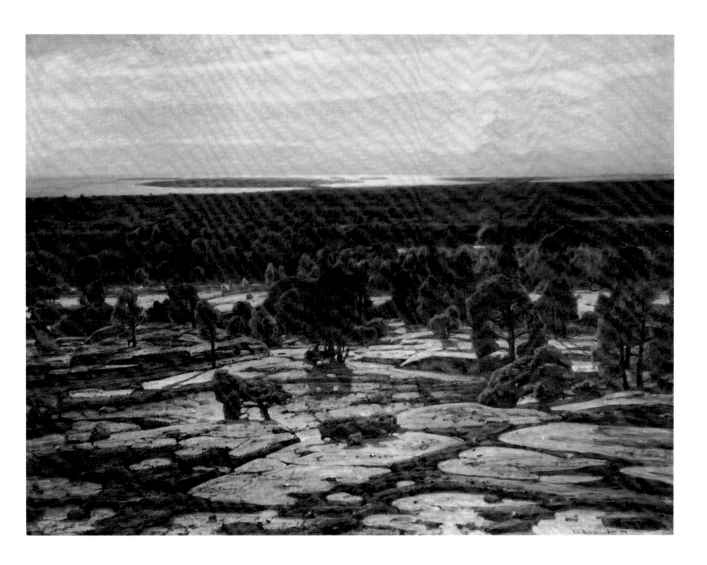

44
Gustaf Fjaestad (1868–1948) Swedish
* *Winter Moonlight*, 1895
Oil on canvas. 100 × 134 cm
Nationalmuseum, Stockholm

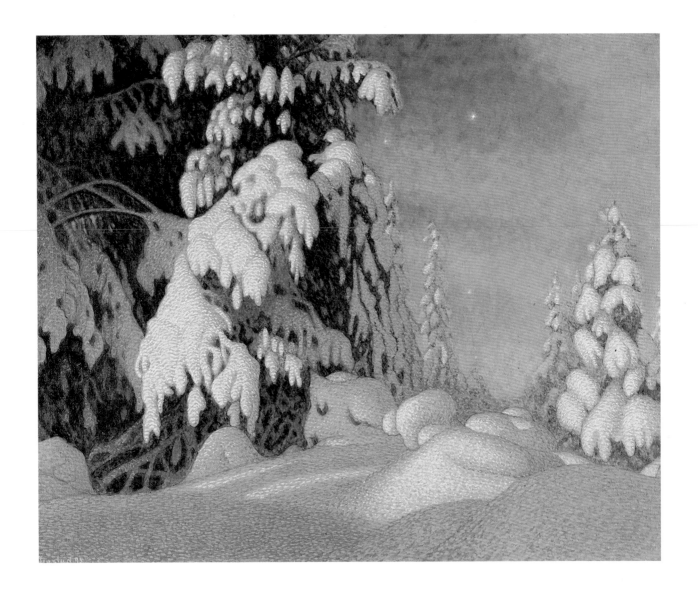

45
Gustaf Fjaestad (1868–1948) Swedish
* *Snow*, 1900
Oil on canvas. 99 × 141 cm
Göteborgs Konstmuseum, Göteborg, Sweden

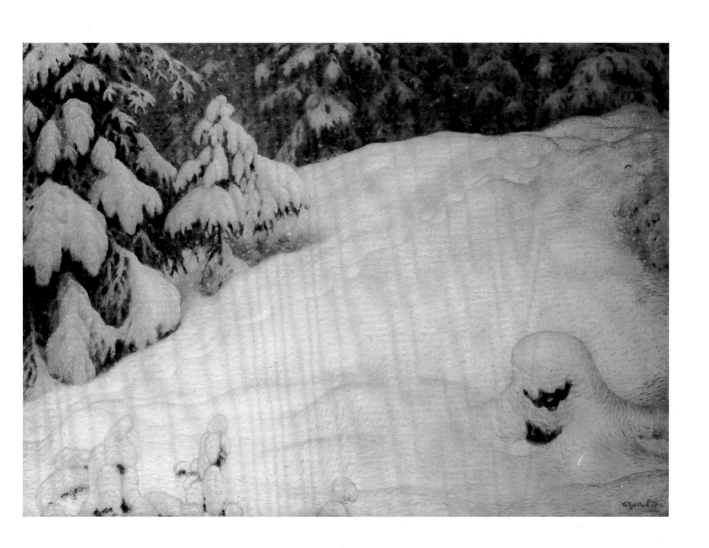

Jansson and Nordström interpret nature in subjective mood pictures ... For Fjaestad nature is rather a source of ornamental motifs – at least he is more successful when he treats it that way.
Osvald Sirén[21]

In Buffalo the two Canadians were even more impressed by Gustaf Fjaestad and very quickly, almost as if in competition, emulated the subjects he dedicated himself to, especially snow-laden trees and running water. Fjaestad struck special chords in them because he confirmed a sense of communality among northern artists. MacDonald described his works as "true souvenirs of that mystic north round which we all revolve," and they provided a kind of revelation that would teach them to "know our own snows and rivers better." His paintings clearly illustrated how one could be an astute observer of natural phenomena and yet reveal nature's most permanent underlying structures. As MacDonald observed, Fjaestad's work was "more definitely stylized than that of most of the painters" in the Buffalo exhibition and proved him "a remarkable gatherer and presenter of nature's design."[22]

Fjaestad's artistic personality was formed in the early 1890s in the context of the national Romantic programme of the Artists' Union, especially under the tutelage of the naturalistic animal painter Bruno Liljefors (1860–1939), as well as Carl Larsson (1853–1919), whose domestic interiors and large mural commissions were characterized by an energetic flowing line inspired by art nouveau. Fjaestad assisted both artists in the execution of major decorative commissions in the early 1890s. From Liljefors he learned to be a diligent observer, to look for his motifs in unspoiled nature, and to develop an interest in outdoor life. He became an accomplished athlete in summer and winter sports, indicative of the growing interest in outdoor recreation and the parallel development of artistic interest in wilder nature; the cult of the North linked cultural rebirth and a healthy and vigorous life of physical hardship, a belief central to the wilderness expeditions of North Americans such as the Group of Seven.

From Larsson, as well as directly from art nouveau and Japanese art, Fjaestad learned how to impose broad decorative unity on his nature studies, and his swelling, rhythmic forms had immediate appeal to Canadians, many of whom had been trained in commercial art-nouveau design. *Winter Moonlight*, 1895 (no. 44), which won Fjaestad his first critical attention, typifies his preference for nearly monochromatic colour schemes and a pointillist technique that has nothing to do with Neo-Impressionist colour division but is used in an entirely decorative way.[23] Most of his paintings were winter scenes of snow-laden trees in moonlight or late afternoon sun, glistening frosted branches, and pristine snow-covered forest interiors, sometimes as in *Snow*, 1900 (no. 45), disturbed by the tracks of a human passer-by or running brooks. His decorative treatment often closely resembles Gallen-Kallela's after the turn of the century.

Even his large-scale, downward-looking view in *Running Water*, 1906 (no. 47), has relationships to Gallen-Kallela. Like the latter's *Waterfall at Mäntykoski*, *Running Water* forces the viewer into rapt contemplation, seduced by the sound, here an almost silent ripple, of moving water. To achieve a comparable intimacy, as well as a powerful decorative unity, Fjaestad has tipped up his river surface until it is almost parallel to the plane of his canvas, a device he could have learned directly from Liljefors and that otherwise was applied to water surfaces only by Monet at the time. The colour scheme typically, but unlike the treatment of similar subjects by Osslund, Hodler, or the Group of Seven, is restricted to whites, greys, and earth browns and shows Fjaestad's feeling for the nuances of neutral colour tonalities.

Fjaestad was able to apply the same motifs almost unchanged to both paintings and tapestries (*Running Water*, 1906, nos. 46 and 47); the design is already abstracted into a flat pattern and the Pointillist technique is directly reproducible in the structure of the weave. About the translation of his harmoniously muted colours from painting to tapestry Fjaestad explained: "The material is common Swedish wool on fish-net warp. After I completed the cartoon, I realized the impossibility of making the dyer appreciate the small necessary differences in the values and colours of the water. I therefore asked him to die wool that had not yet been spun with the lightest

blue and the darkest brown, and then we mixed the intermediate shades from these two just the way you mix colours on a palette."[24] Fjaestad shared with Willumsen and Gallen-Kallela an active interest in the decorative arts, and his tapestries were often as prominent as his paintings in international exhibitions.

46
Gustaf Fjaestad (1868–1948) Swedish
* *Running Water*, 1906
Woollen tapestry. 203 × 312 cm
Göteborgs Konstmuseum, Göteborg, Sweden

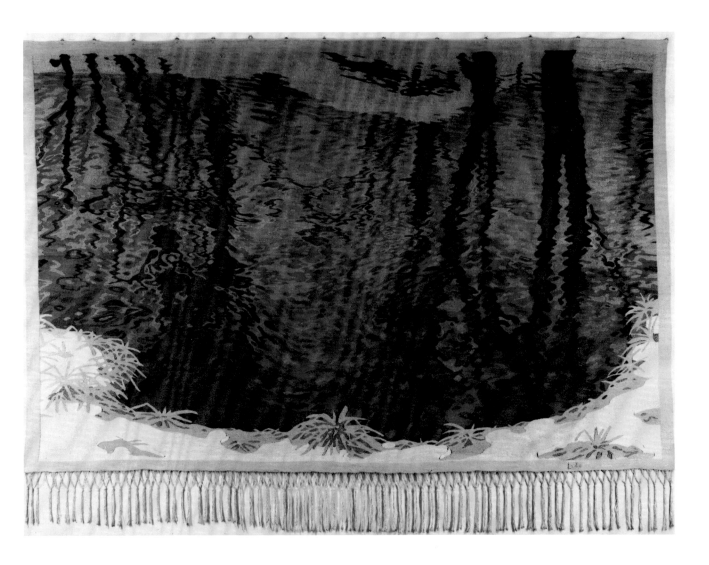

80 47
Gustaf Fjaestad (1868–1948) Swedish
* *Running Water*, 1906
Oil on canvas. 120 × 148 cm
Thielska Galleriet, Stockholm

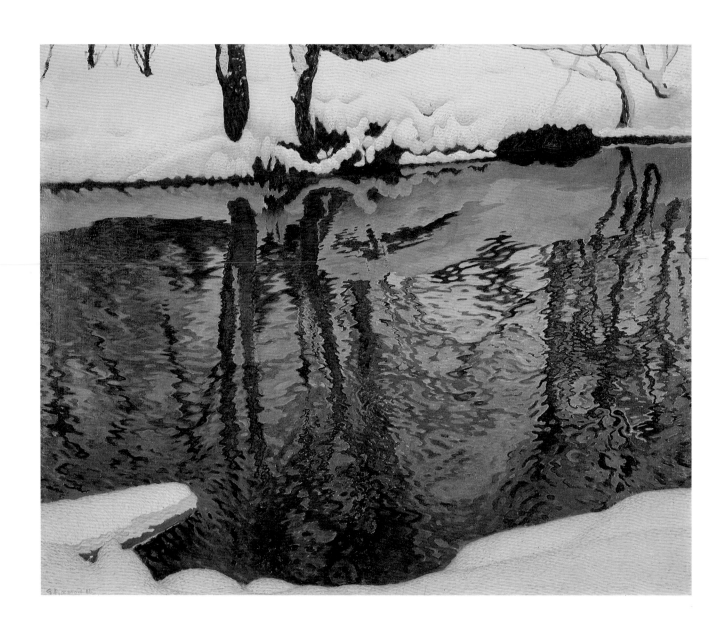

Eugène Jansson (1862–1915) Swedish
* *Nocturne*, 1901
Oil on canvas. 149 × 201 cm
Thielska Galleriet, Stockholm

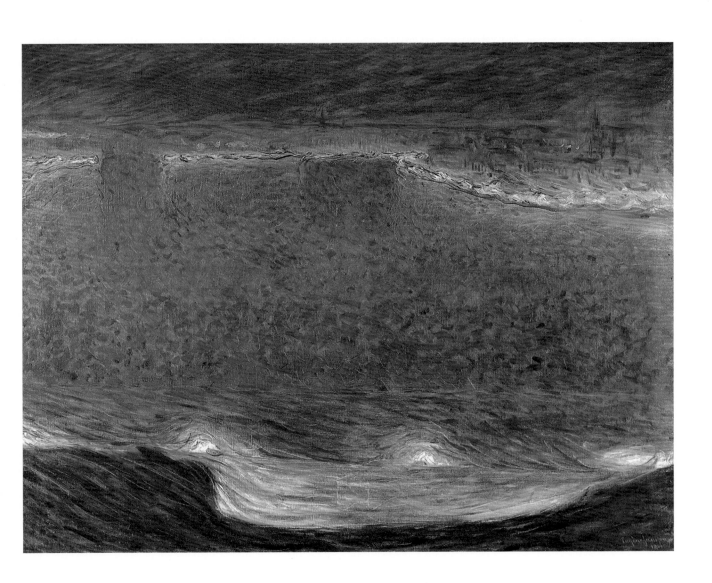

His canvases are his experiences, the most important and pro-
found – if we understand this, then his life, on the surface so
wanting and monotonous, seems unusually exciting, passionate,
almost dramatic.

Tor Hedberg[25]

Wilderness offered the freedom and solitude in which to
wrest oneself free from the opinions and prejudices of
urban society. The journey outward from the city could
be a journey inward into oneself. For several artists at
the end of the century, however, the city itself could
constitute a kind of wilderness as empty and desolate and
enigmatic as any mountain top or untrod forest.[26] For no
one was this more true than Eugène Jansson, who trans-
formed the city of Stockholm, which for a large period
of his life is almost his only subject, into a visionary
dreamland as emotionally and spiritually evocative as the
most glowing sunset at a distant horizon or as despairing
as a Munchian nightmare.

Jansson's city, usually painted late in the night, is typ-
ically composed of reflection-filled stretches of water, bor-
dered above and below by undulating shorelines,
accentuated by sweeping rows of street lights, and ruled
over by broad night skies. Not a single window is lit,
and the scene is as empty of human beings as the most
distant wilderness landscape. Often, as in Willumsen's
Jotunheim or Eugen's and Hesselbom's lake and island
panoramas, these city views are seen from a high and
hovering viewpoint: Jansson painted from an apartment
window on the island of Söder looking across Riddarfjär-
den and Old Stockholm to the northern parts of the city.
In *Nocturne*, 1901 (no. 48), the view is angled sharply
downwards onto the surface of the water in a way rem-
iniscent of Fjaestad's *Running Water* despite the differ-
ences of scale. The compositions of the two pictures, the
contours of foreground, the shape of the intervening water,
and the line of the far shore are so close to one another
that they could be superimposed, *Nocturne* emerging as
a macrocosmic version of *Running Water*. In colour Jans-
son reduces his palette as radically as Hesselbom, pre-
dominantly to blues and yellows. He is the period's most

consistent Blue Painter, but he applies his brush strokes
in a variety of personal calligraphic ways which in the
individual areas of the landscape, land, sea, and sky, set
up their respective, but only subtly differentiated, fields
of energy. In his broad designs Jansson depends on art-
nouveau rhythms as much as Hesselbom and Fjaestad,
but with an expressive urgency reminiscent of and un-
questionably dependent on Munch.

In the mid-1880s Jansson sought contact with the Swedes
returning from Paris and became a member of the Artists'
Union, but unlike them he did not have the benefit of
study abroad and did not travel outside Sweden until
1900. His particular style, the energy of his brush strokes
and drawing, and his cosmic interpretation of the night
sky with a palette of blue and yellow invite comparisons
with Van Gogh's Arles period. He seems, however, to
have developed primarily under the influence of the Var-
berg group, especially Nordström. Munch's exhibition in
Stockholm in 1894 appears also to have been an essential
influence, leading Jansson to endow his work with a new
rhythmic synthesis. The predominantly blue palette and
the musical titles stem from Whistler, though Jansson's
biographer, Nils Wollin, has suggested that the intensity
of the blue of the night air is also explained by the fact
that Jansson painted the city in darkness, studying it from
the window of a lighted room.[27]

The sense of loneliness that pervades these night-time
paintings is even more chillingly conveyed when Jansson
descends into the streets themselves to look down their
deep deserted perspectives, where, as in *Hornsgatan at
Night*, 1902 (no. 49), the emptiness seems as vast and
eternal as the sky. The ghostly apartment buildings have
dark windows; the lines of light from the streetlamps
seem to recede infinitely into the darkness. And yet there
is a kind of exuberance in these pictures, carried by the
vigour of the sweeping brush strokes laid on a white
ground that shines through and gives a sense of pervasive
luminosity. Each light from the lamps, built up in heavy
impasto strokes, unfolds like a blossoming flower, its
white and yellow centre surrounded by a halo of pure
blue, seeming to burst upon the darkness with an expan-
sive energy one associates with the early Futurist painting
of Balla or Russolo.

49
Eugène Jansson (1862–1915) Swedish
* *Hornsgatan at Night*, 1902
Oil on canvas. 152 × 182 cm
Nationalmuseum, Stockholm

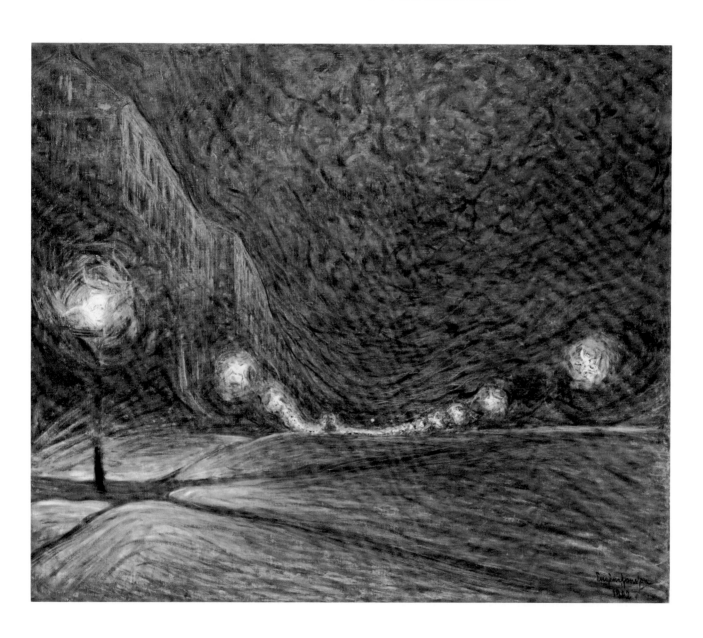

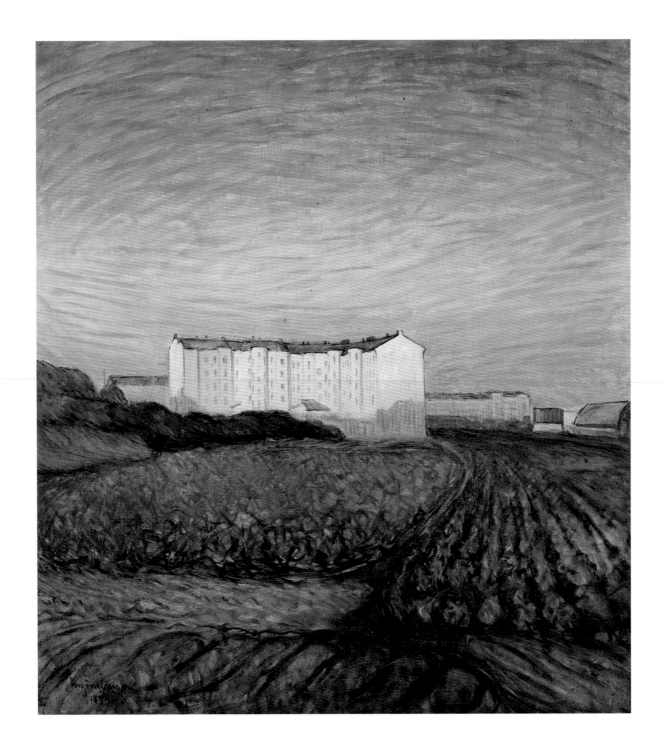

Jansson shared the radical social ideas common to the members of the Artists' Union, no doubt influenced by his own unrelentingly difficult economic circumstances. He was the only member of the group to attempt to give pictorial form to socially engaged ideology. His *Demonstration Day*, 1896–1901 (Folkets Hus, Stockholm), which depicts an endless procession of flag-waving demonstrators winding across a vast landscape, may, moreover, be the only socially committed painting to emerge from Sweden at the turn of the century. His concern with proletarian problems has also been detected in a number of paintings of workers' tenements, such as *The Outskirts of the City*, 1899 (no. 50). Yet, although the buildings are desolate and out of place on the edge of the landscape, waiting for the city to catch up to them, and although it requires little effort to imagine the poverty within them,[28] in the warm pinkish light of the setting sun they rise rather heroically out of the cool green and relatively empty foreground, to be silhouetted against an energized blue sky. Jansson has borrowed a typical compositional scheme from Nordström, found in both *Varberg Fort* and *Hartippen, Tjörn*, and shares their mood of quiet melancholy. On the whole there is little reason to interpret the townscapes of the period differently from pure landscapes, though perhaps a cityscape cannot escape the implication of extrapersonal meaning. Certainly the ambiguity between personal and social intention is characteristic of the urban scenes painted by the Symbolist artists of the period, for example, Sohlberg's *Night*, 1904 (no. 72); Hammershøi's *The Buildings of the East Asiatic Company*, 1902 (no. 76); Harris's *Elevator Court, Halifax*, 1921 (no. 126); and O'Keeffe's *East River from the Shelton*, 1927–8 (no. 150).

50

Eugène Jansson (1862–1915) Swedish
* *The Outskirts of the City*, 1899
Oil on canvas. 152 × 136 cm
Nationalmuseum, Stockholm

The new generation of painters ... have a fresher more brutal view of nature than the painters of the 1890s, less mood, less synthetism, less symbolism.[29]

Helmer Osslund belongs to the second generation of Swedish national Romantic painters, not because of age (he was born in the 1860s), but because his painting career started late. His work did not attain maturity until the first decade of the twentieth century. As a consequence, it is characterized less by, though not devoid of, *fin-de-siècle* melancholy and introspection and takes a fresh look at nature using an intensity of colour that dispels much of the moodiness of the 1890s.

Only in 1887, when he was in his early twenties, did Osslund discover his talent for decorative art. He obtained a position with a Stockholm porcelain factory where, under the influence of oriental art, he produced several independent works. A trip to London exposed him to Turner and Constable, whose work encouraged his growing interest in landscape painting. In 1893 he resigned his job and left for Paris, thus becoming one of the very few northern landscape painters to study there during the 1890s. He began his training at the Académie Colarossi, where he seems to have sought the companionship of the American students (he had himself spent eleven months in the United States in 1886–7) and read a good deal of English literature and American philosophy, especially Ralph Waldo Emerson.[30] In 1894 he studied for a short time with Willumsen, an episode that was not especially productive but did bring Osslund full time into Willumsen's studio and home, at a time when *Jotunheim* must have been very conspicuously present.

During this period Osslund had his eyes open to most modern developments though he was not always sympathetic to them. His special admiration was reserved for Renoir and Puvis de Chavannes. Neo-Impressionism and van Gogh he found too sharp and raw in their colours. Most important was the short period he spent as a pupil of Gauguin, presumably at more or less the same time as Halonen. Gauguin's influence still predominates in *Autumn Day, Fränsta*, 1898–9 (no. 51), the first painting in

which Osslund succeeded in capturing something of the essential character of the landscape of Norrland where, along with Lapland, he would concentrate his efforts for most of the rest of his life. Only with his return to Norrland, where he was born, after some ten years of international wandering, did his art begin to get a sense of direction. Also during 1899, feeling in need of further

51
Helmer Osslund (1866–1938) Swedish
* *Autumn Day, Fränsta*, 1898–9
Oil on canvas. 63 × 82 cm
Private collection

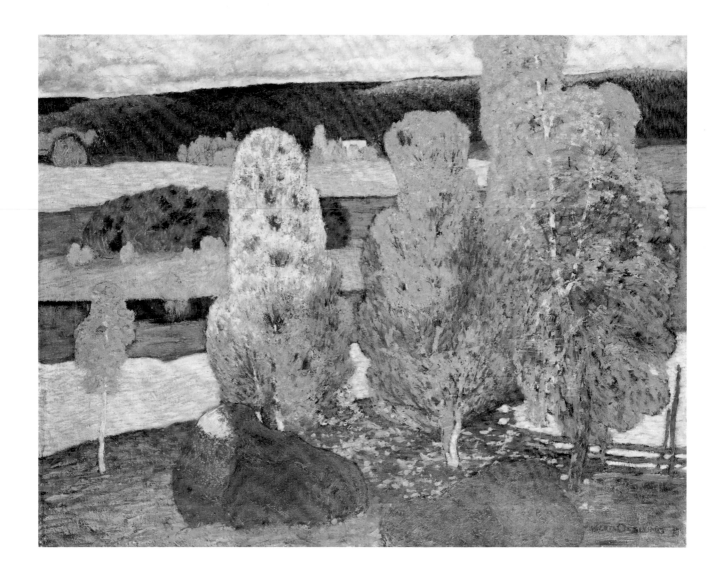

supervised study, he attended the Artists' Union school, where he particularly thrived under the tutelage of Richard Bergh.

Autumn Day, Fränsta is very directly dependent on Gauguin, especially in its decorative arrangement of broad areas of colour contained with almost Cloisonist severity within strongly contoured planes. Colour is applied in a uniform stippled manner, but the autumn yellows and oranges, the blue of the water, and the pink fringe on the hills stand out with a freshness that is quite new. Osslund would always prefer the Swedish landscape when it erupted in the burning colours of autumn.

On his first trip to Lapland in 1905 Osslund saw a new kind of wilderness with a scale too unusual for him to come to terms with immediately, and it took a second visit, in the fall of 1906, before he could adapt his style to cope with its special qualities. In this period his work changes quite radically from a predominantly decorative style to a much more directly expressive manner. There exist a few drawings and paintings from this period in which a kind of energetic line and handling suggest a fresh reconsideration of van Gogh.[31] Such experience results in a spontaneity of paint handling that also bespeaks a new personal and emotional investment in Osslund's landscape motifs. His rougher brush technique is applied to bolder summaries of landscape details and to a more

52

Helmer Osslund (1866–1938) Swedish
* *Before the Storm, A Motif from Lapporten*, ca 1907
Oil on canvas. 56 × 98 cm
Private collection

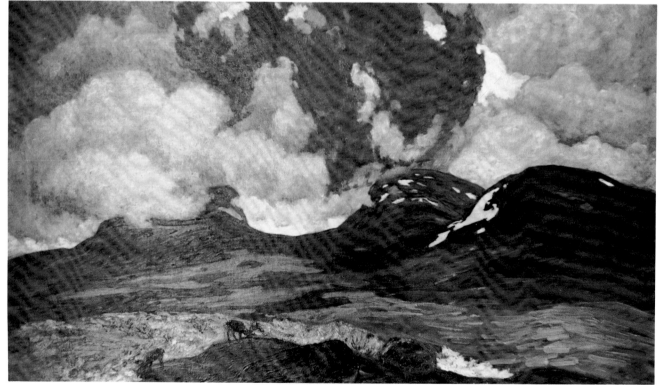

ardent colour scale.[32] His work also reconfirms his alignment with the tradition of national Romanticism, especially with Nordström. This is particularly apparent in the dramatic weather effects of the swirling clouds in *Before the Storm, A Motif from Lapporten*, around 1907 (no. 52), which restates in a much more grandly scaled landscape and with a heightened colour scheme Nordström's *Storm Clouds* from over a decade earlier. Osslund's *Autumn Day at Torne Träsk*, 1909 (no. 53), resumes the panoramic perspective in an even broader format than Prince Eugen's or Hesselbom's. The extreme length of the painting may perhaps be explained by its being a commission from which two tapestries were completed in 1912. The work was reproduced in *Studio* in March 1913, in an article purportedly well known to Tom Thomson and the Group of Seven.[33] *Laplander's Store* (no. 55), from the same period, vies more directly, however, with the vigour and boldness of the small wood-panel sketches that the members of the Group of Seven executed on their expeditions into the northern woods of Canada.

During these years Osslund established his style for the remaining thirty years of his life. Like the Symbolist landscape painters of the 1890s, his work was rooted in a close and intimate study of nature: "A work of art," he remarked, "must first of all be based on the study of nature and not be a pure creation of the imagination." But nature must be transformed according to Snythetist principles: "I always strive for a unified effect regarding form, and a resonant effect of contrast in relation to colour."[34] His preferred medium became oil on paper, which served the unencumbered way he liked to work in front of the subject, unburdened by heavy painting equipment on the sometimes long treks in pursuit of subjects, and also satisfied the practical man's scorn for sophisticated artistic trappings: "I have noticed that the more the easel, sun shade and strange chairs preside, the worse the result is."[35] His son described Osslund's usual method of working: "We had some cartons with lids with us, ca 35 × 45 cm in size. They were made of strong cardboard and had earlier been used to pack starched white shirts. In both the top and the bottom of the carboard box grease-proof paper was fastened with pins ... The sheet of grease-proof paper in the bottom of the box became the support for the painting, the lid with its paper the palette ... Back home at the end of the day the painted paper was put on the wall to dry."[36] As long as the grease-proof paper was available only in one size, 33 × 44 cm, larger pictures were made by joining together several single sheets, as in *Autumn Evening, Nordingrå*, 1910 (no. 54), and *Waterfall, Porjus*, 1915 (no. 56).

53
Helmer Osslund (1866–1938) Swedish
Autumn Day at Torne Träsk, 1909
Oil on canvas. 103 × 351 cm
Nordiska Museet, Stockholm

54
Helmer Osslund (1866–1938) Swedish
* *Autumn Evening, Nordingrå,* 1910
Oil on paper. 66 × 97 cm
Nationalmuseum, Stockholm

55
Helmer Osslund (1866–1938) Swedish
* *Laplanders' Store*, ca 1907
Oil on canvas. 33 × 43.5 cm
Göteborgs Konstmuseum, Göteborg, Sweden

Both paintings again reveal Osslund as the last major adherent of the national Romantic tradition. The twilight mood of *Autumn Evening,* with its pale light reflected in the water, dark-green forest-covered hills, and red en-flamed clouds, restate, with a more varied and rich colour scheme and a more painterly touch, the theme of Hesselbom's *Our Country. Waterfall, Porjus,* with greater gusto and more lively painterly handling, recalls Fjaestad's flowing streams, as well as the innumerable brooks, rivers, and waterfalls which, beginning with Gallen-Kallela's *Waterfall at Mäntykoski,* were produced throughout the Symbolist landscape period. Osslund's painterly directness, his bold colours, and his robust response to nature, however, make him the European closest in spirit to the Group of Seven. Yet the Canadians probably did not see his work at first hand, though *Autumn Evening* won a gold medal at the San Francisco World's Fair in 1915, and both it and *Waterfall, Porjus* toured the United States in a group exhibition of Swedish painting in 1916.[37]

56

Helmer Osslund (1866–1938) Swedish
* *Waterfall, Porjus,* 1915
Oil on paper. 55 × 127 cm
Nationalmuseum, Stockholm

Norway:
Edvard Munch, Harald Sohlberg, and Nikolai Astrup

EDVARD MUNCH

Walking here [at Aasgaardstrand] is like walking among my pictures. I get such a strong urge to paint when I am walking in Aasgaardstrand.
Edvard Munch[1]

Symbolist landscape painting in Norway does not have the coherence of a movement the way it does in Sweden. It is primarily the product of three dogged individualists, Edvard Munch, Harald Sohlberg, and Nikolai Astrup. They were all bred in the milieu of Norwegian Naturalism, but with distinct stylistic results. They made their respective painting debuts almost ten years apart: Munch in the 1880s, Sohlberg in the 1890s, and Astrup in the first years of the twentieth century. Unlike either the Finns or the Swedes, the Norwegians did not work from strong patriotic imperatives, a task that had already been taken up by their Naturalist predecessors in the 1880s. Only Astrup became a dedicated regionalist on Swedish patterns.

It was not until the end of the 1890s that pure landscape painting became a major preoccupation for Munch, but as we have already observed, throughout "The Frieze of Life," to which he devoted his major energies during the 1890s, his psychologically and erotically toned subjects usually have landscape settings, the meaning of which in turn depends on compositional schemes that are common to Symbolist landscape painting. What is so striking about Munch, who has usually been examined somewhat apart from his immediate context, is that he nevertheless shares unwaveringly the artistic points of view of his Nordic contemporaries.

The similarities are particularly noticeable in his treatment of tree and forest subjects, which are especially common around 1900, as in the monumental winter landscapes from Ljan, 1901 (no. 58); the companion summer scene, *Train Smoke*, 1900 (no. 59); and the proto-Expressionist *Forest*, 1903 (no. 60). The forests at the edge of the shore at Aasgaardstrand had, of course, played far from passive roles in several pictures from "The Frieze of Life": in *Ashes*, 1894 (Nasjonalgalleriet, Oslo), mood-inducing and symbolic in its brooding and impenetrable darkness; and in *Summer Night's Dream (The Voice)*, 1893 (no. 57), more actively structural as well as symbolic. In the latter the forest edge appears as a thin screen separating the near physical space of the young girl from the mysterious blue twilight world beyond, which seems to embody her confused minglings of fear and desire. The irregularly staggered distances of the trees between the two realms, in a way reminiscent of Eugen's contemporary, if more naturalistic, forest pictures, suggest also the emotional tangle that impedes the union of desire and fulfilment.

The *Voice*, as opposed to *Melancholy* (no. 2), with its rapid spatial recession, is composed according to Gallen-Kallela's system in *Great Black Woodpecker* (no. 22) in its use of parallel layers of space, a here and a beyond separated by a screen of trees, the rise of which is truncated both at the tops and bottoms with an unprecedently powerful effect, both decoratively and emotionally. We

might detect references here to the frieze-like use of clearly spaced trees by Puvis de Chavannes, whose art, more atmospheric and mood-inducing than narrative, was undoubtedly a model for Munch in *The Voice*. Munch's composition of vertical tree trunks is also reminiscent of the Japanist truncations in Van Gogh's *Les Alyscamps*, 1888 (private collection), or of Puvis de Chavannes as translated by Gauguin, Bernard (especially his *Madeline in the Bois d'Amour*, 1888, Collection Clément Altaribba, Paris), and the Nabis. These are strikingly related, but a measure

57
Edvard Munch (1863–1944) Norwegian
Summer Night's Dream (The Voice), 1893
Oil on canvas. 96 × 118.5 cm
Munch-museet, Oslo

of Munch's radicalness is his capacity to transform essentially pastoral models into taut psychological statements, by drastically undercutting the traditional spatial continuities, as well as, of course, by calling to attention every element of nature, aligning and frontalizing them and thereby reducing them or heightening them into abstract symbols of the tense erotic mood of the summer night. Munch's reduction of his composition to precise verticals counterpointed with a horizontal shoreline also predicts Sohlberg's unpeopled rendering of Aasgaardstrand in *Fisherman's Cottage*, 1906 (no. 74), and Mondrian's *Woods near Oele*, 1908 (no. 98), both of which look into the twilight or the sunset through a close-up frontalized barrier of tall trees.

A measure of the anti-naturalistic extremities of Munch's spatial construction is that the figures are not free to move, certainly not in and out of the depth of the pictures. They are held in frontal or dorsal poses within a formal structure that has stripped natural elements of descriptive details so as to give bald expression to its symbolic message. As Rosenblum points out, Munch's means "tend to immobilize the image as a universal, primitive, emblem that would pinpoint for all time the mysterious core of man and his place in nature."[2] If the task is to concretize primal subjective experience, then it is also appropriate that these pictures should be set on the Norwegian fjords, at the edge of the wilderness forests, and at the foot of mountains – all locations that other northern artists were exploring in search of comparable elemental and spiritual experience.

Munch's major pure landscapes from around the turn of the century, such as *Train Smoke*, 1900 (no. 59), and its winter counterpart, *White Night*, 1901 (no. 58), have a clear place alongside other contemporary northern landscape painting, despite his bolder and more expressive handling. As is commonly observed, these two paintings are rendered with flowing art-nouveau linear rhythms and

have a new monumentalized scale, as do several of the figurative pictures from the period, such as *Girls on the Pier*, 1900 (Nasjonalgalleriet, Oslo). Otherwise, the two paintings perpetuate Munch's stylistic tendencies of the 1890s, with the contrast between near and far, the disorienting truncation of the trees along the bottom edge, the Expressionist forcing of colour, and the technical freedom, as exemplified by the colour run in the sky that forebodes rain. The foreground emotional turmoil suggested by the agitation of the close-up pines and the jagged tops of the spruces somewhat further in depth is resolved in the calm surface of the fjord and by the far horizon, ignited by the setting sun or dominated by the blue light of a winter's night.

Both paintings have resemblances to Willumsen's *Spanish Chestnuts*, 1891 (no. 3), which Munch saw in Christiania in 1892: in the ornamental treatment of the trees, in the patterning in the water that ameliorates the transition from a contorted foreground to the horizontal calm of the distant blue horizon, as well as in the technique of smudging the paint surfaces to indicate rain. Sohlberg's *Summer Night*, 1899 (no. 68), layers the landscape in a comparable way, contrasting a precisely detailed profusion of domestic details on the balcony in the foreground and a dense close-up forest with a peacefully abstracted distant view of serene blue islands, still green water, and glowing, almost mystical, white light at the horizon.

Alongside the *fin-de-siècle* mixture of melancholy and vague emotional yearning of these paintings, *Forest*, 1903 (no. 60), is an unexpected contrast. All vestiges of art-nouveau design have vanished as have any lingering intimations of mood painting. It is the same forest that stretches impenetrably across the background of *Ashes* from ten years before, but now brought closer to the picture surface, its edge defined by three centred and evenly spaced tree trunks, cut off, as we have come to expect, by the top edge of the frame. Behind them grows a dense profusion of trees and bushes, impenetrable less because of any physical denseness in the forest than because of the concentrated surface energy of the paint itself. It is applied in bold and free brush strokes hardly bound by descriptive imperatives and in pure bright colours that are often self-referential, so that the painting

58
Edvard Munch (1863–1944) Norwegian
* *White Night*, 1901
Oil on canvas. 115.5 × 110.5 cm
Nasjonalgalleriet, Oslo

59 (below)
Edvard Munch (1863–1944) Norwegian
* *Train Smoke*, 1900
Oil on canvas. 84 × 109 cm
Munch-museet, Oslo

60 (opposite)
Edvard Munch (1863–1944) Norwegian
* *Forest*, 1903
Oil on canvas. 82.5 × 81.5 cm
Munch-museet, Oslo

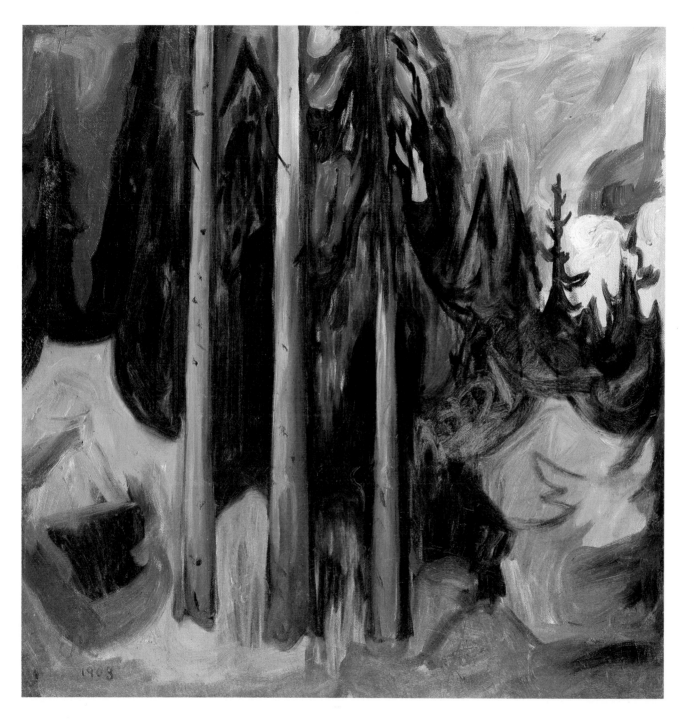

looks several years into the future, to the intense Expressionist colour schemes of the artists of Die Brücke.

 Forest was exhibited by Munch in 1911 and 1912 as part of a group of forest pictures executed between 1899 and 1903 on the general subject of "fairytale woods."[3] Stylistically, with the conspicuous exception of *Forest*, the pictures in the group share the art-nouveau curvilinearity of

61
Edvard Munch (1863–1944) Norwegian
* *The Sun II*, ca 1912
Oil on canvas. 163 × 205.5 cm
Munch-museet, Oslo

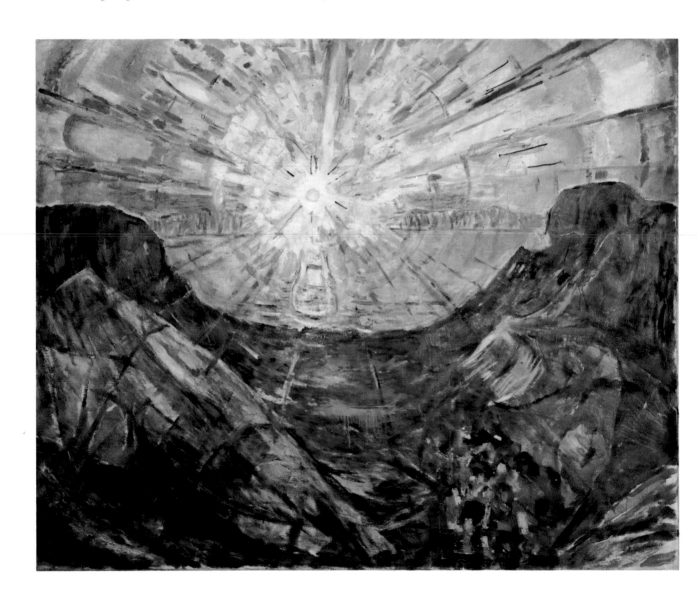

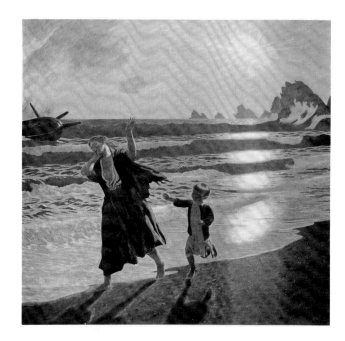

62
Jens Ferdinand Willumsen (1863–1958) Danish
After the Storm I, 1905
Tempera on canvas. 155.5 × 150 cm
Nasjonalgalleriet, Oslo

Train Smoke and *White Night*. Though the methaphor of the Gothic cathedral is generally not appropriate to describe how the 1890s saw the interior spaces of forests, Munch was continually fascinated by it and refers to it in several literary notations.[4] Both on the cover of the catalogue of the 1911 exhibition, in which his "fairytale woods" paintings were first gathered together, and in a group of sketches listed generally in the catalogue under the title "The Sun Shines through the Forest," the motif of the natural cathedral has been united with the image of the sun that would subsequently constitute the dominant subject of the decorations of the Aula (assembly hall) of the University of Oslo which occupied Munch from 1909 until 1916. The forest of the 1911 catalogue illustrations and related sketches is depicted as opening

out to form a nave, sometimes vaulted with branches, at the end of which, like a rose window in an apse, shines a radiant sun. As Eggum points out: "The bringing together of the two pictorial ideas, the sun and the forest temple, illustrates the sacred point of departure for the apparently naturalistic Sun" of the assembly hall of Oslo University.[5]

In the Aula decorations the monumental rendering of the sun is stripped of Christian connotation, and its golden radiating light, worshipped by nude male and female figures, in separate panels on both sides, becomes the embodiment of the most primordial birth-giving and life-supporting forces of the universe. The colour scheme of a preliminary study, *The Sun II*, around 1912 (no. 61), perpetuates the freshness and vigour of *Forest* and conveys a vision from the first day of creation. This is also perhaps the first time in the north, at least during the Symbolist decades, that the sun is depicted in full ascendant glory at the beginning of a new day, rather than in the fading splendour of its setting.

The university murals also represent a considerable departure from Munch's work of the 1890s in their shift of attention from the emotional life of human beings to the realm of general ideas. Perhaps these decorations constitute Munch's parallel, if on a vaster scale, to Willumsen's *Jotunheim*; they are more intellectually programmed, but their figurative allegories centre finally on a monumental landscape image, the white hot orb of the all-powerful rising sun, as against the ice-cold peaks of the highest, unattainable mountains. Willumsen himself painted the sun in *After the Storm I*, 1905 (no. 62), and in a second version from 1916, *Fear of Nature (After the Storm II)* (no. 63), but as a malevolent rather than a benevolent force.

After the Storm I was conceived on the coast at Le Pouldu in Brittany. In it, too, the sun hangs low in the morning sky and sears the landscape with its intensity, setting afire the clothing of the lone woman fleeing from its glare, oblivious to the child who chases along behind. In the background the breakers beat on a wreck, and on the horizon sharp cliffs rise out of the sea. We are transported to some primeval time when man lived helpless against destructive nature.[6] The painting was generally admired for its success in conveying anguish and dishar-

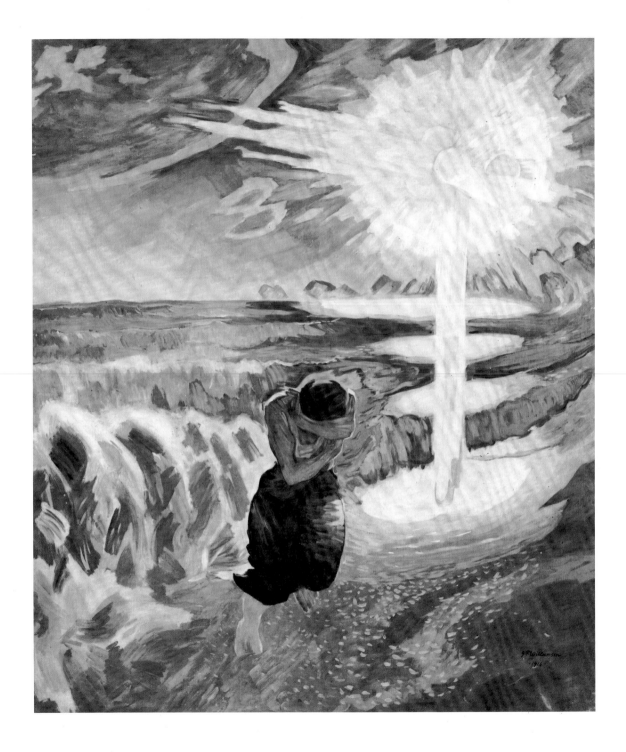

mony directly through colour, though Jens Thiis objected to "the dangerously theatrical narrative" and looked askance at the wreck, which he called a "piece of theatrical property." Willumsen must have agreed with these criticisms; when he repainted the subject in 1916, he omitted the narrative elements and relied on a heated colour scheme and a brutal brush technique to carry his meaning.[7]

Munch's *Forest* and *The Sun* and Willumsen's second version of *After the Storm* belong within the realm of modern Expressionism, though they retain their links with Symbolism, perhaps a comment on the connections between Symbolism and Expressionism. It has also been remarked that *The Sun*, with its fragmented and abstracted structure of light, represents a new kind of Symbolism, much closer to Delaunay and Kandinsky.[8] Yet it is deeply rooted in the study of nature and thus reconfirms the deep Naturalist roots of northern Symbolist landscape painting.

If Munch's painting during the first decade of the twentieth century can simultaneously point both forward and backward, to Symbolism and to Expressionism, its general tendency is away from private despair in favour of detached observation. This is simply illustrated by comparing *Winter Landscape, Elgersburg*, 1906 (no. 64), from the period before Munch's nervous breakdown and his admission to Dr Jacobsen's care in Copenhagen in 1908, to *Winter, Kragerø*, 1915 (no. 65). Both are unpeopled snow scenes composed with high horizon lines and deep spaces, and both have loosely painted and descriptively unspecific foregrounds which the eye must traverse in order to find resolution in more distant places. The earlier painting, from Thüringer near Weimar, is pervaded by heavy melancholic rhythms that hark back to the undulating art-nouveau linearity of the Ljan pictures from 1901. The season is late winter, and the snow on the fields is thawing and uncovering the plow furrows, which are exposed like sorrowful wounds. This is more than meteorology, standing as an external correlative for inner weather. The 1915 painting is set in midwinter, when the land is in the grip of cold, but not in order to depict it as forbidding and unapproachable. On the contrary, nature stands majestic, proud, and forceful, as if the fresh clear air has finally swept away the pessimistic obsessions of previous decades. The landscape is seen without stylizing interventions, in a straightforward, faithful, and positive way.

63
Jens Ferdinand Willumsen (1863–1958) Danish
* *Fear of Nature (After the Storm II)*, 1916
Tempera on canvas. 194 × 169 cm
J.F. Willumsens Museum, Frederikssund, Denmark

Edvard Munch (1863–1944) Norwegian
* *Winter Landscape, Elgersburg*, 1906
Oil on canvas. 84 × 109 cm
Munch-museet, Oslo

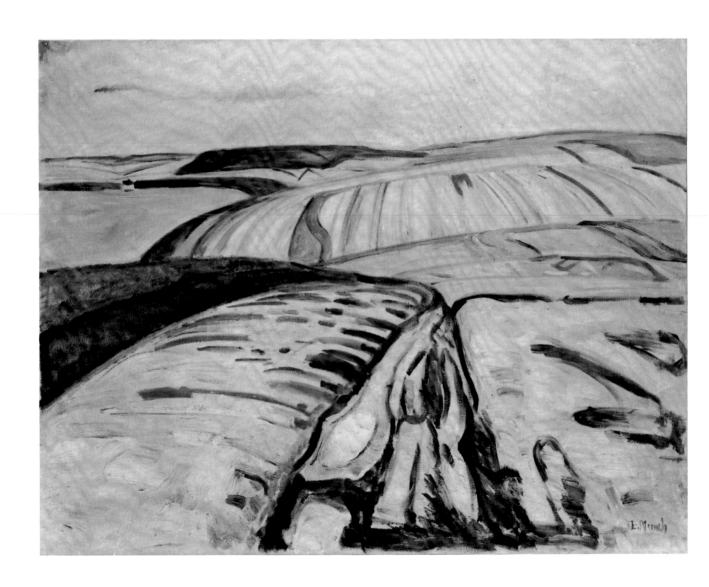

Edvard Munch (1863–1944) Norwegian
* *Winter, Kragerø*, 1915
Oil on canvas. 103 × 128 cm
Nasjonalgalleriet, Oslo

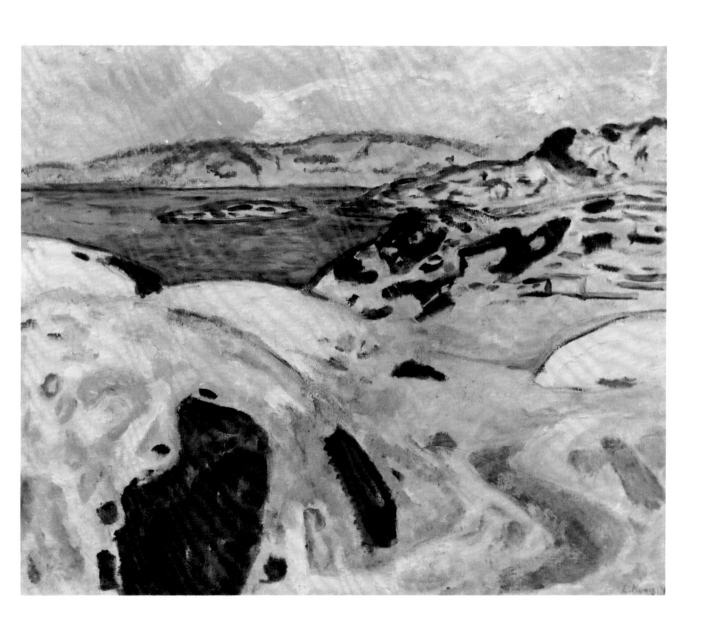

I have the distinct feeling that I am standing on a heavy and solid globe from which I can look into the unending realm of space.
Harald Sohlberg[9]

The year before Harald Sohlberg's death in 1935, there appeared Leif Østby's *Fra naturalisme til nyromantik*, a seminal study of the transitions in Norwegian art between 1888 and 1895.[10] In the book Sohlberg plays a relatively small role, because his public debut did not come until 1894; however, Østby's study caused him to reflect on his own career. In a letter addressed to Østby in praise of the work he dated his turning point to the painting of *Night Glow* (no. 66), completed in the summer of 1893, and discussed its importance in deciding the future programme of his work. The initial impetus came from the subject matter itself, as he recalls: "The sun had set in flames behind the Frogner hills. And against its fiery mass of blood red colour a small young tree traced itself with its delicate leaves almost black against the sky." This, as he remarks, was his "first understanding of the wonderful beauty of detail ... There is no doubt that the subject I mentioned here with its dark details against a brilliant sunset impressed itself so strongly and unforgettably on my mind ... This sense of details amid grandeur like the rich and overwhelming ornamentation of a church interior showed itself also in a couple of other works from the same year and place. *That* was the beginning of my later career."[11]

In 1894 Sohlberg made his debut to much acclaim with *Night Glow* in the official Oslo exhibition, which also included Prince Eugen's *Forest Clearing* (no. 32), with which *Night Glow* has many affinities. Sohlberg, however, always stood somewhat apart from Eugen, and from other contemporary Scandinavian landscape painters, because of his obsession with combining bold compositions with a profusion of meticulous observations. As Østby has suggested, he wanted to look at nature simultaneously through a microscope and a telescope. Sohlberg detested the hastiness of Impressionism and noted that his own first impression was always of the larger forms of nature,

"but certainly within my overall conception I make it my goal to include as much of the beautiful, often extraordinary details that landscape offers me – to omit such details would, it seems to me, often make the landscape poorer, and cut in half the meaning of my work."[12] In this he has closer connections to Hodler's work of the early 1890s, such as *Autumn Evening*, 1892 (no. 79). This was a work that Sohlberg could not have seen, but he shares Hodler's ability to correlate a simplified decorative disposition of form with strong colour and a jewel-like precision. These virtues led Andreas Aubert, in his review of the 1894 exhibition, to detect in *Night Glow* a "pure and original feeling reminiscent of early and youthful art, of the Lippis and the time of Sandro Botticelli."[13]

In his letter to Østby Sohlberg denied the influence of foreign art in 1893 – certainly Italian art, as well as oriental art – which Østby had stressed as the source for the severe linear stylization of Sohlberg's work over the next years. Sohlberg's early work followed in the footsteps of Norwegian Naturalism, though in 1891 he experimented briefly with Pointillism. From December 1891 to May 1892 he was in Denmark studying under Kristian Zartmann. The incipient Synthetism of *Night Glow* suggests, however, that he must have had his eyes open to more modern developments than his teacher could offer him and that he had taken notice of more radical French-influenced Danish painting. Sohlberg seems not to have left any clues as to the formative influences on his art, but 1892 was an eventful year in Copenhagen, when French Synthetism made a major assault on Danish sensibilities in the second exhibition of Den frie Udstilling in March. The exhibition included twelve works by Willumsen (among them *Spanish Chestnuts*, no. 3), exploring various current radical styles but dominated by Gauguin's influence. One can detect Willumsen's influence on Sohlberg, at least in some work of 1894.[14] Other Danes, including Johan Rohde and Mogens Ballin, also would have been enthusiastic pro-

66
Harald Sohlberg (1869–1935) Norwegian
* *Night Glow*, 1893
Oil on canvas. 79.5 × 62 cm
Nasjonalgalleriet, Oslo

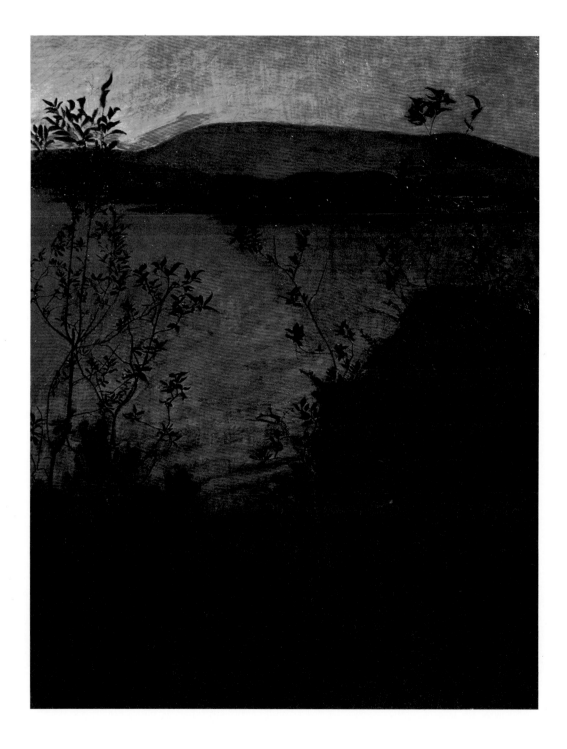

moters of French Symbolist painting.

Sohlberg went to Paris for the first time in 1895–6 on the first instalment of a two-year travelling scholarship, but, after spending the summer in Norway, he decided not to return. Instead, in late 1896 he set out for Weimar, travelling via Hamburg and Berlin in order to visit the museums, presumably for the better opportunities the Academy in Weimar offered to study from the live model.[15] When he returned home in September 1897, he regarded his education as more or less finished and did not travel for another ten years.[16]

His experiences in France and Germany seem not to have altered his basic conception of landscape: the paintings that follow over the next decade do not essentially deviate from the idiom he defined in *Night Glow*. *Ripe Fields* (no. 67), which was first exhibited in 1898,[17] also establishes its immediate foreground with a delicate tracery of finely leaved trees and branches. These intervene between the viewer and a sweeping, almost monochromatic, green landscape, arranged in a series of horizontal bands, and rise to a high horizon line, at the middle of which a small hill has climactically been spotlighted by

67
Harald Sohlberg (1869–1935) Norwegian
Ripe Fields, before 1898
Oil on canvas. 73 × 116 cm
Private collection

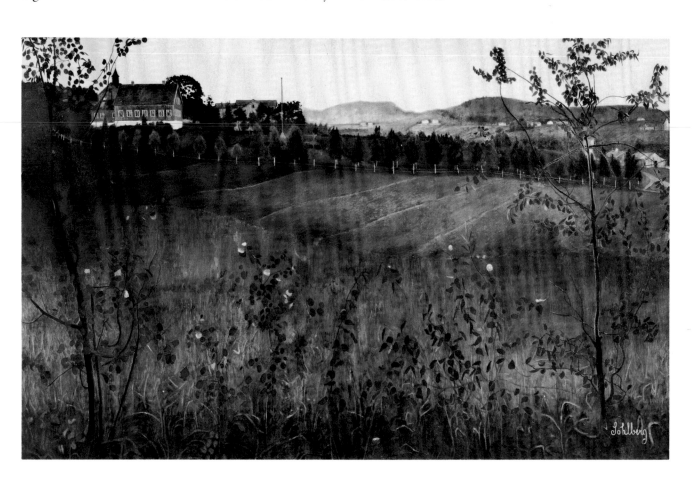

the orange light of the setting sun. Sohlberg's last important painting of the 1890s, *Summer Night*, 1899 (no. 68), similarly works on the tension between a meticulously studied, profusely detailed, and carefully defined foreground and a far distance serenely simplified and as if silently suspended in the timeless magical light of the

68
Harald Sohlberg (1869–1935) Norwegian
Summer Night, 1899
Oil on canvas. 114 × 135.5 cm
Nasjonalgalleriet, Oslo

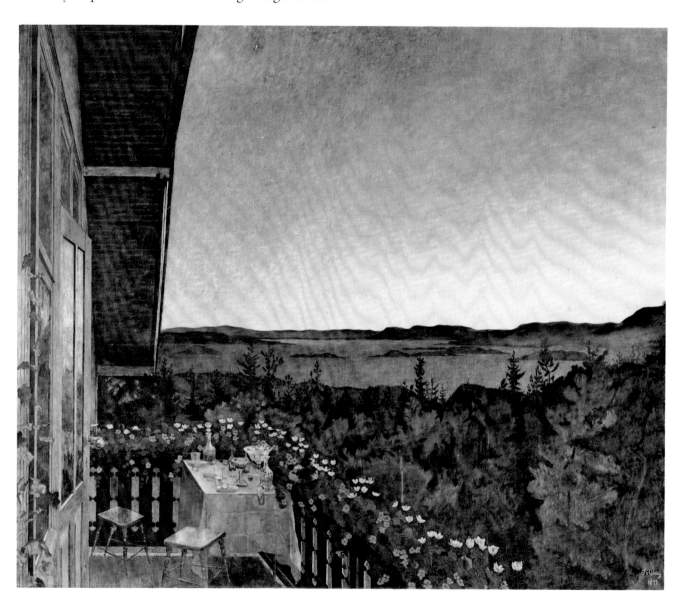

69
Harald Sohlberg (1869–1935) Norwegian
* *Winter Night in Rondane*, 1901
Oil on canvas. 68 × 91 cm
Hilmar Rekstens Samlinger, Bergen, Norway

summer night. The foreground details, a table laid for two, the remains of a pleasant meal, a lady's hat and gloves left behind, give a special poignancy to the absence of human figures. This absence is crucial to Sohlberg's pictures, and to almost all the northern Symbolist landscapes, a matter to which we shall return.

During 1900 Sohlberg began his most ambitious project, his work on the subject of the mountains of Rondane seen under moonlight in the winter night, the definitive

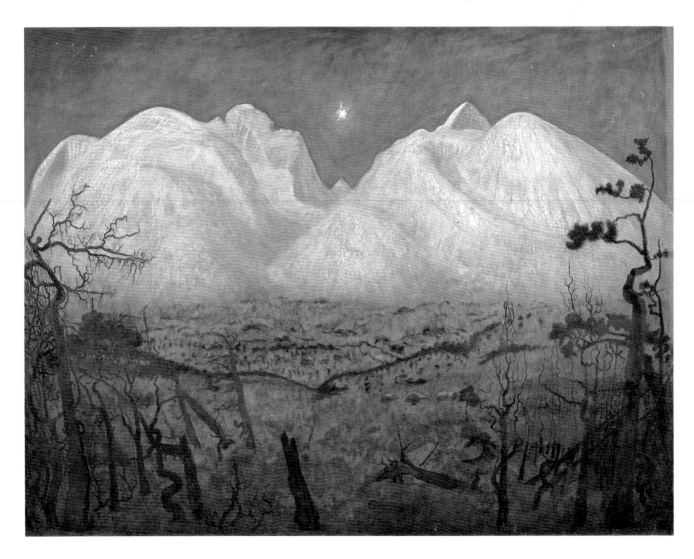

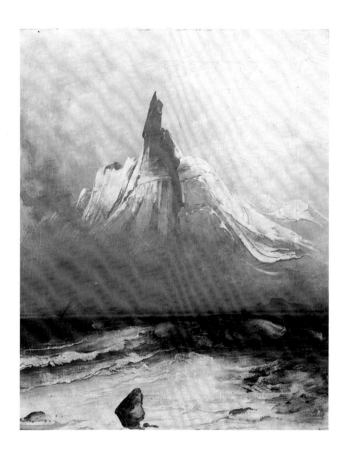

70
Peder Balke (1804–1887) Norwegian
Mount Stedtind in Mist, 1864
Oil on canvas. 71 × 58 cm
Nasjonalgalleriet, Oslo

version of which, *Winter Night in the Mountains* (Nas-
jonalgalleriet, Oslo), he was not to complete until 1914.
The most concentrated on-site study, in 1900 and 1901,
produced a series of sketches, large and small, and in all
imaginable techniques. The most important is the paint-
ing in the Hilmar Reksten Collection in Bergen, *Winter
Night in Rondane*, 1901 (no. 69), which was also included
in the 1913 exhibition that so impressed J.E.H. Mac-
Donald and Lawren Harris. Forced to leave Rondane in

1902 because of his wife's health, Sohlberg did not resume
work on the final version of the subject until 1911, when
he returned to the mountains, continued outdoor studies
when the moonlight was right, and otherwise worked on
the painting in his studio until he felt challenged to com-
plete it, in time for the Norwegian Jubilee Exhibition in
1914.

Mountain subject matter had aroused no interest in
Norway since the late Romantic but curiously prophetic
work of Dahl's most important pupil, Peder Balke (1804–
1887) (no. 70). It is also unlikely that Sohlberg could have
seen Willumsen's *Jotunheim* before he began his own
Rondane pictures: when *Jotunheim* was exhibited in Oslo
in 1896, Sohlberg was in Paris, though he had probably
heard discussion of this extraordinary work.[18] There are
remarkable parallels between the ways in which Willum-
sen and Sohlberg came to terms with their lofty motifs,
and they both tended subsequently to mythicize the con-
ception and production of the paintings in order to make
the story as heroic as the intended artistic and visionary
message.

The "Winter Night" project was conceived on a ski
trip in which Sohlberg participated around Easter 1899.
In early 1900 he returned and for most of the next two
years worked on site. The work was hard and undertaken
with incredible concentration. It is "so difficult and ex-
hausting," he reported to a friend in November 1900,
"that I often after only a half hour's work have to put
the paint brush away; it is as if everything reels around
me."[19] In winter, when clear weather under a full moon
is rare, he could seldom see the landscape in the right
mood. In the cold mountain night he required both a
lantern and a bonfire to see to work by and to keep his
materials from freezing.[20]

In 1914, when the final version of *Winter Night* was
being considered for purchase by Nasjonalgalleriet in Oslo,
Sohlberg wrote to the acquisition committee, explaining
some of the steps by which the painting had come about
and describing the transformation of his conception from
a naturalistic to a symbolistic one.[21] When he first saw his
mountain motif, he noted, it was indescribably surprising,
"stately and beautiful," but as subject matter it interested
him only for the coloristic problems it might pose. The

first picture he projected was therefore "relatively mild and elegiac" in mood, in contrast to the "solemn and dramatic" character of the final version. Even the foreground as originally envisaged "resembled a peaceful, somewhat overgrown, but quite ordinary garden of apple trees." But as his work became more intensive, as he studied his motif in "summer and winter, by night and day, in good weather and bad," it began to take on other qualities. His experience grew to include, he wrote, as if echoing Willumsen's adventures in Jotunheimen in 1892, "the powerful and quite incredible forces that could be released in among the mountains or that could suddenly pour out from them, breaking and shattering ... in violent and frightening, but fantasy-arousing moods." Under such conditions his perception of the mountains changed and he eventually underwent a revelation, which overturned his original reading of his subject:

One moonlit, winter night, when it was deathly still and I once again stood all alone on the same deserted, eternal stretches in front of the same mountains, and in exactly the same lighting as when I first saw them. Now they were more than a stately and beautiful coloristic effect; now it was as if I stood at the threshold of another fantastic and incomprehensible world.

Then I understood that the picture that I had already begun was quite wrong-headed, because in no way did it tell it as it now was, what I now unshakeably felt before the mountains, now, when not only the painter but also the human being in me, in the deepest and most humble sense, was a participant.

As he concludes, the subject had to be reworked. A "slavishly representational" approach was now inadequate to convey what he had in mind, and the problem became one of clarifying new intentions and eliminating or bringing into harmony anything that disturbed them.

If one accepts Arne Stenseng's chronological ordering of the extant preliminary sketches and paintings from 1900–1, there seems to have been no abrupt change in Sohlberg's point of view, but rather a gradual realization of the monumental, decorative, and symbolic potential of the subject matter. The first sketches are quite naturalistic, with little formal unity and no systematic groupings or placings. On occasion skiers move through the

foreground. Increasingly the stars, which were generally scattered across the sky, form into readable constellations and take central positions. Concomitantly the mountains are reorganized into symmetrical masses and the viewpoint rises. Finally the knarled and twisted black trees in the foreground are pulled to the side like a stage curtain that has been opened to reveal the dazzling white and blue moonlight vision of the powerfully contoured mountains. They too have drawn apart, drawing our attention to a smaller, lower peak that points upwards to a single central star set just at the height of the right-hand peak on which the snow, caught in a cut in the cliffside, has formed a little cross. This is the awesome revelation Sohlberg has in mind, and not the first sight of his subject matter, which he purports to be describing in a letter to a Chicago patron, Byron L. Smith, in 1915:

When I first met with this motif ... I was almost overcome by a rush of emotion greater than I had ever experienced before. The longer I stood gazing at the scene the more I seemed to feel what a solitary and pitiful atom I was in an endless universe. I grew uneasy. I could hear my heart beginning to beat loudly. It was as if I had suddenly awakened in a new, unimagined, and inexplicable world.

The deep, long moor where I stood was bathed in a half light and mysterious shadow. I saw deformed, gnarled, and overturned trees, mute expressions of unconceivably strong forces of Nature, of the might and rage of storms.

Now all lay calm and still, the quietness of death. I could hear my own quick breathing.

Before me in the far distance rose a range of mountains, beautiful and majestic in the moonlight, like petrified giants. The scene was the grandest and most full of fantastic quiet that I have ever witnessed.

Above the white contours of a northern winter stretched the endless vault of heaven, twinkling with myriads of stars. It was like a service in some vast cathedral.[22]

71 (opposite)
Harald Sohlberg (1869–1935) Norwegian
* *Street in Røros*, 1903
Oil on canvas. 60.5 × 90.5 cm
Nasjonalgalleriet, Oslo

In discussing *Winter Night in Rondane* Sohlberg always pointed out his emphasis on its decorative effect. Unlike the works from before 1900, he has opted here for a symmetrical composition. However, he continued to rely on the contrast between a detailed foreground and a simplified distance as a fundamental expressive device, a technique that he shares with Munch in the years around 1900:

In relation to the mountains' calm and grand simple lines, the foreground must be broken up into many nervous short lines ... Because it is precisely the opposition between the calm and grandeur and power of the mountains and ... the broken-up nature of the foreground, and its small forms and lines, that determines the character and purpose of the picture. In this, precisely in this, lies the whole secret of the picture.[23]

Of the religious or philosophical meaning of this mysterious blue, lonely, and timeless hieratic image Sohlberg said little. That such overtones were central to his experience of nature cannot be doubted, and perhaps they were Christian in a fairly traditional way. We have already noted his methaphorical use of the image of a church in describing his impression of the motif of *Night Glow*, and, correspondingly, of a cathedral in reference to *Winter Night in the Mountains*. The tiny cross on the right-hand mountain peak in the latter painting he always explained as a natural shape formed by the snow, and it would be

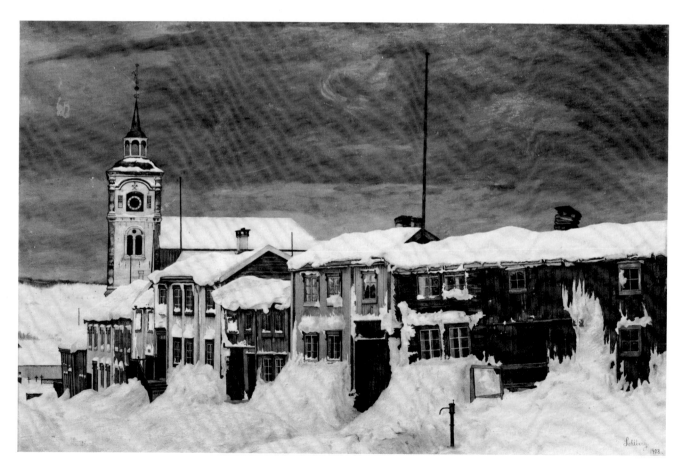

72
Harald Sohlberg (1869–1935) Norwegian
* *Night*, 1904
Oil on canvas. 113 × 134 cm
Trøndelag Kunstgalleri, Trondheim, Norway

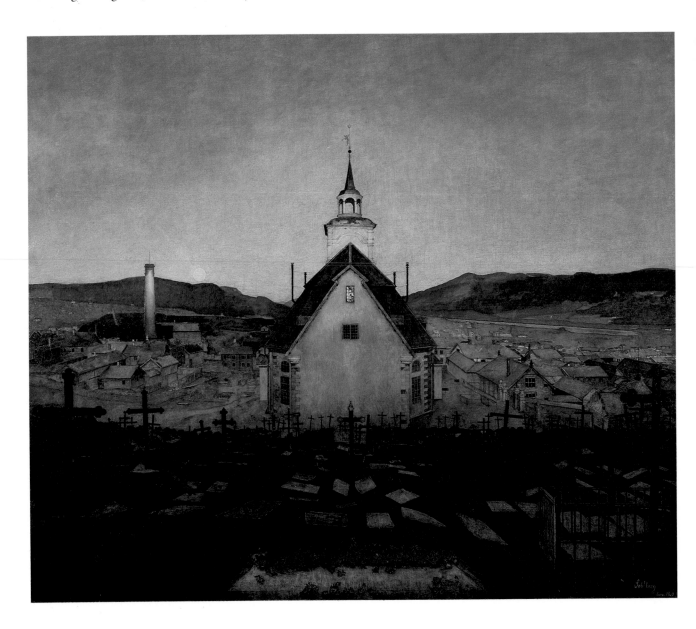

characteristic of his work to include such a detail. Nevertheless the central star and the cross make their appearance only in the later versions of the motif, when he is refining its decorative organization. It is also reported that while Sohlberg was working on the colour lithograph of the same subject in 1917 he dwelt long on the symbols of the cross and the star.[24] He noted in discussing his drawing of the mountains that there must not be anything "brutally concrete" about it; "everything must stand guard like a dream."[25]

From 1902 to 1906 Sohlberg and his wife lived in the small, rough mining town of Røros, high on the mountain plains of central Norway. The first works executed here are street scenes of the town's brightly coloured but weather-beaten wooden houses, depicted with meticulous detail. In *Street in Røros*, 1903 (no. 71), the town is seen after a heavy snowfall and under a leaden sky; in contrast to the whites and greys, the strident reds, yellows, and purples of the house fronts stand out with almost disharmonious intensity. It was perhaps these paintings that Sohlberg described, in now familiar terms, as having the distinctive colours of the northern landscape, which are "pure, clear, and strong" and have "the sound of a brass band, in comparison to the greyer, the softer, more muted colours ... of the landscapes of southern countries."[26]

The late Baroque church that rose above the town, surrounded by a desolate and forsaken graveyard, became the subject matter of *Night*, 1904 (no. 72), perhaps Sohlberg's masterpiece. He found the motif almost immediately after arriving in Røros and was moved by the presence of death that lay over it, its crosses having fallen helter-skelter. "I remember that on one of them it said: 'You are not forgotten.' But the cross had fallen to pieces. Yes, this was humanity." In the middle of this stood the church itself "as a frontier between the abodes of the living and the dead."[27] As in *Winter Night in the Mountains*, the colour is predominantly blue, though the bright yellow light of the setting sun is reflected in the upper window of the church, and a pale white moon hovers on the horizon. Though essentially faithful to the original motif, Sohlberg has taken several significant liberties with it. He has aligned all the gravestones to the long axis of the church, though in reality they lay perpendicular to it, and removed the sacristy on one side, in order to achieve maximum frontality and symmetry. The freshly dug rose-covered grave in the foreground, turned parallel to the picture's surface, is, however, the artist's own invention, to provide a contrast, as he said, "to how everything was ruined and forgotten.';

Almost everything in *Night*, as well as in *Flower Meadow in the North*, 1905 (no. 73), another work from the end of the Røros period, is organized quite strictly according to a grid pattern viewed in receding one-point perspective. The eye is thus quickly enticed into the space of the picture, toward a distant vanishing point, yet it is continually frustrated in its goal by a succession of barriers lying frontally across the picture surface: the new grave, the many crosses, house fronts and gables, the distant hills, and the church itself. It is anxiety-producing that the church has been so placed that it blocks out the vanishing point for which so much else strives and that it hides its own face. It turns its back to us, occupying the centre of the painting with its flat rear wall, blank in comparison to the myriad details that surround it, its lower window black and blind, the upper one casting back at us the reflection of light already behind us.

Despite its pastoral setting in the magical moonlight of a northern summer night and its mood of reverential silence, *Flower Meadow in the North* is equally ambivalent. Compositionally it works much the same way as *Night*, but in a much simpler way, the recession of the meticulously detailed field of white ox-eye daisies seeming to sweep the eye, as if along the road of Hodler's *Autumn Evening*, into depth and toward the white moon which hangs just above the horizon in the very centre of the painting. The view of the moon is itself unimpeded, but the field of flowers, strangely geometric in an organic world, stops abruptly, and the green band of landscape that lies between them has the power to separate by an eternity the earthly and the heavenly realms of white. The blanket of ox-eye daisies becomes a sumptuous prayer rug on which, if we dare defile it, we can conduct the rituals of a pantheistic moon worship.

Fisherman's Cottage, 1906 (no. 74), was painted at the entrance to Oslo Fjord, not far from Aasgaardstrand. We

114

73 (below)
Harald Sohlberg (1869–1935) Norwegian
* *Flower Meadow in the North*, 1905
Oil on canvas. 96 × 111 cm
Nasjonalgalleriet, Oslo

74 (opposite)
Harald Sohlberg (1869–1935) Norwegian
* *Fisherman's Cottage*, 1906
Oil on canvas. 109 × 94 cm
Edward Byron Smith, Chicago

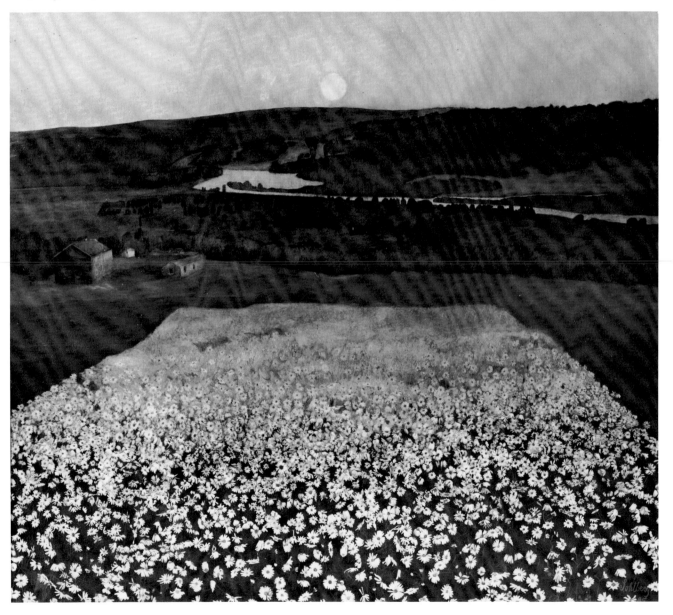

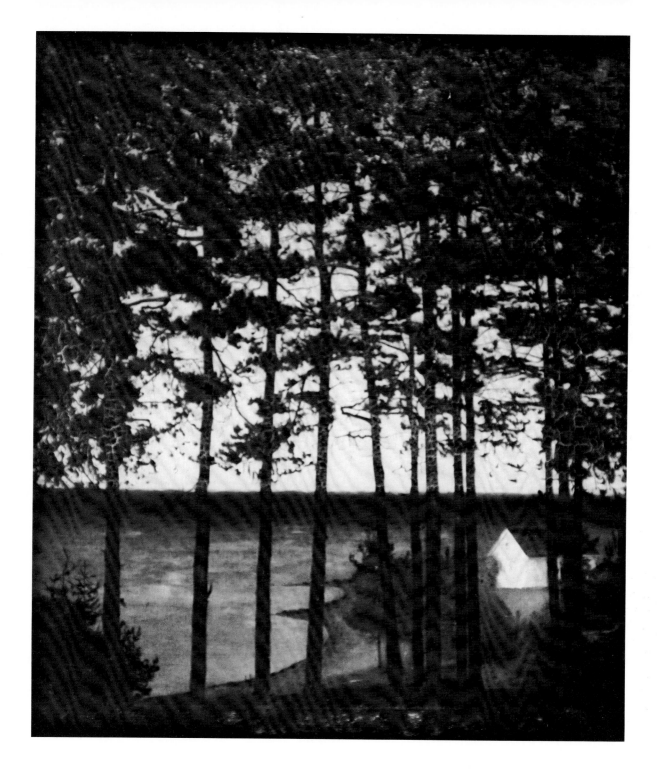

can imagine Sohlberg walking along a beach not dissimilar to Munch's in *Melancholy, The Yellow Boat* (no. 2), with its white house in the distance, then stepping off into the forest on the right in the footsteps of the girl of *The Voice* (no. 57), turning about, and discovering from its murkiness, from behind its coalblack tree trunks, his motif of the translucent blue light of the night sky rising from the distant dark shore on the other side of a dense lead-grey sea. This fits with Sohlberg's account of the painting of the picture to Byron S. Smith in 1915:

As you know we have light summer nights here. It was on one of these glorious, calm summer nights that I was wandering aimlessly around, enjoying the delights of witnessing the wonderful, dreamy northern night, when suddenly I found a great motif in the peacefully slumbering, little fisherman's home, a tiny modest human abode in a setting of natural beauty and mystery.

It was perhaps a commonplace, very ordinary and poor motif in itself, and could be seen by the hundred along our endless coast; but in the stillness of the night, – when as it were one could almost hear nature breathing, – and in the highly receptive mood that happened to possess me at the time, all moved me profoundly, told me much, and awakened intense interest.

This is really all there is to tell. I painted what I had seen, cut out disturbing elements, emphasised what I desired to bring into prominence, and in short tried to put on canvas what I have felt.[28]

In 1906 Sohlberg's subject matter, as well as his handling of it, was familiar in terms of his own work and yet characteristic in a general sense of a well-established tradition of Symbolist mood painting. The paintings' unique contribution lay in the concentrated and breathless intensity of Sohlberg's vision. It "has a solemnity greater and deeper than anything else I know," wrote as experienced a commentator as Christian Krogh in a review from 1908; all its elements combine "to produce an organ tone full of universal melancholy."[29] When planning his participation in the Panama-Pacific International Exhibition in San Francisco in 1915, Sohlberg began to think of *Winter Night in the Mountains* and *Fisherman's Cottage* as companion pieces: "I believe they will go well together

75
Caspar David Friedrich (1774–1810) German
Monastery Graveyard, 1819
Formerly in Nationalgalerie, Berlin

as regards colour, and they will moreover deepen each other. Thus although these paintings offer the greatest contrast to each other, they are both a story of the Northern Night, one a summer night's dream, and the other a winter fairy story."[30]

Often in northern Symbolist landscape painters we can detect both theoretical and visual reflections of early German Romantic art. Sohlberg especially invites us to question whether he could have known and been influenced by the work of Caspar David Friedrich. Sohlberg, like Friedrich, searches for religious revelation in secular subjects. Both use nature as a personal confessional and transform its random appearances into symmetrically ordered symbols of transcendent longings. Both build their meaning out of the structure of their pictorial space, which for the exploring eye of the viewer becomes a metaphor for

76
Vilhelm Hammershøi (1864–1916) Danish
* *The Buildings of the East Asiatic Company*, 1902
Oil on canvas. 158 × 166 cm
Private collection

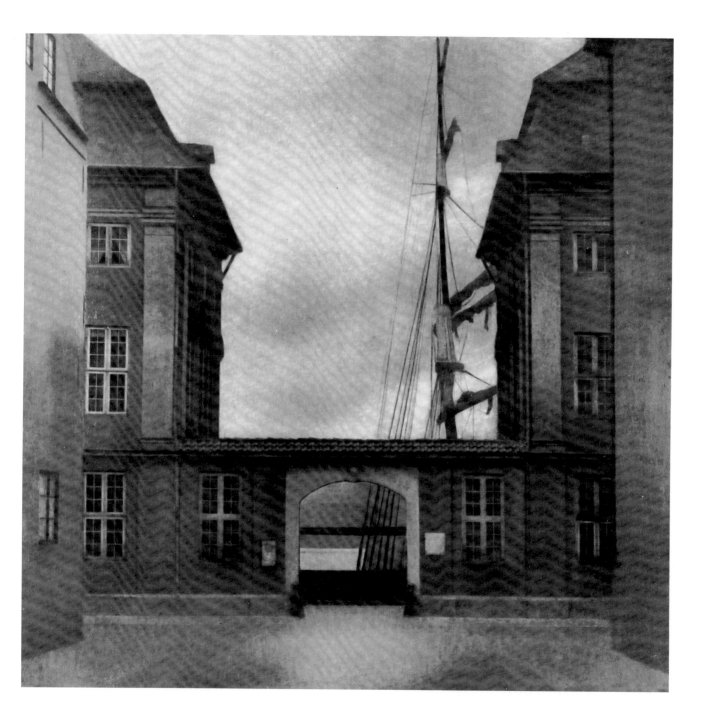

the discontinuities and alienations of modern experience. But in this Sohlberg is only a creature of his time, and the affinities he has with Friedrich he shares with Munch, Hodler, and Mondrian, who also have elicited comparisons to Friedrich. Yet Sohlberg's relationship to Friedrich seems closer. There are not only the meticulous attention to detail, the smooth, precise painting technique, and the desire to see up close as well as in terms of abstracted wholes, but also a remarkable similarity in specific subject matter and composition types. One can imagine *Night* and *Winter Night in the Mountains* as inspired by and built upon Friedrich's *Abbey in the Oakwood*, 1810 (Staatliche Schlösser und Gärte, Schloss Charlottenburg, Berlin), or *Monastery Graveyard*, 1819 (no. 75), drawing from them not only their centalized symmetrical compositions, but such iconographical elements as the church, the crosses, and the gravestones, the framing device of twisted, weather-beaten, leafless trees, the winter setting, and luminous skies.

Though the rediscovery of Friedrich coincided with the development of Symbolism, he was still virtually forgotten in the 1890s, and had been so since the 1830s. As Magne Malmanger has pointed out, it is highly improbable that Friedrich's work would have been visible enough for him to have had any influence on artists around the turn of the century.[31] Norway, however, provided an exception because there Andreas Aubert, while writing his two major studies of J.C. Dahl, published in 1893 and 1894, also did pioneering work on the rediscovery of Friedrich. The relevant sections from the 1894 study were published in German translation in the periodical *Kunstchronik* in 1895–6.[32] In 1891 Aubert had been instrumental in acquiring a small Friedrich painting for the Nasjonalgalleriet in Oslo.

If Sohlberg had not met Aubert before, he certainly got to know him in Paris in 1895–6, when both frequented the same circle of Norwegian artists and writers. They exchanged letters on personal matters as late as 1906.[33] Perhaps Aubert discussed Friedrich with Sohlberg, was partially responsible for Sohlberg's choosing to study in Germany instead of France for the second year of his scholarship, and told him where he could see works by Friedrich during his stops in Hamburg and Berlin, as well as in Weimar, his destination. There is no hint that Aubert later saw any similarities to the German artist in Sohlberg's work: in 1907 he described *Night* as "Halfways like an old Flemish primitive, halfway in a modern synthesis."[34]

In this context we may also observe the close affinities to Sohlberg's *Night*, as well as to Friedrich, in Vilhelm Hammershøi's *The Buildings of the East Asiatic Company*, 1902 (no. 76). The composition is strictly frontal, centralized, and symmetrical; the technique is meticulous; details are closely observed; and the view through the portal leads out to a desolate and empty sea. The fragmentary glimpse of a ship's mast and rigging in the right half of a precisely constructed architectural opening, so close to the structure of Friedrich's *Woman at the Window*, 1822 (Nationalgalerie, Berlin), or to an 1806 related wash drawing (Kunsthistorisches Museum, Neue Galerie, Vienna),[35] especially suggests that Hammershøi's painting may be a coldly pessimistic rethinking of such earlier German works that deal with views out of windows from inside domestic interiors. The problem of Friedrich's precedents arises again when one ponders over the sources of Hodler's *Autumn Evening*.

I have tried to express some of that feeling for nature which comes over you when you make your way through the landscape of Jølster; that smell and mouldy dampness of old heathendom and primitive religion, that earth rich in sagas; these often raw colours have more importance for my art than as mere subjects for my pictures. And this in my opinion is what motifs should be to all painters, that they, in other words, should be closer bound to the earth; then they will also be less dependent on bad influences from foreign art. I am perhaps one of the most place- and earthbound painters in the whole country, and have staked my honour on being uninfluenced from all directions. – Nikolai Astrup[36]

Unlike Munch or Sohlberg, Nikolai Astrup (1880–1928) made it a virtue, and a self-conscious programme, to be a regional painter. He worked most of his life in relative isolation in the remote community of Jølster, on the west coast of Norway, where he was raised, and where his father was the local pastor. He was the youngest of the original contributors to the first phase of northern Symbolist landscape painting, and his best work was produced between 1900 and 1910. His roots, however, are firmly in Norwegian Naturalism, so that, even if his values belong to Symbolism, his paintings almost smell of the soil and have a kind of earthbound solidity that we know from Swedish national Romanticism, especially from Nordström, a similarity that has not gone unnoticed by Swedish critics.[37]

Astrup's formal training period was remarkably short – three years. In Oslo from 1899 to 1901 he was a student of Harriet Backer, a Naturalist trained in Munich and Paris; and from 1901 to 1910 he worked under Christian Krogh at the Académie Colarossi in Paris. Both Backer and Krogh quickly recognized Astrup's talent and artistic maturity. By his own account he was fully committed to Neo-Impressionism while he was in Paris and avidly studied Monet, Gauguin, and the artists who exhibited in the Salon des Indépendants: "I participated in the maelstrom until I got to see the young – the youngest of all the directions: Rousseau and Denis – then my eyes were suddenly opened."[38]

The importance of Denis and Rousseau corresponds to Astrup's lifelong interest in artists who were devoted to the naïve and the primitive and to the mystery in nature, such as Gauguin and Böcklin, after whom Astrup named his son. Later in life he credited Rousseau especially with turning him away from Neo-Impression, which he described as cheap and tinsely, and back to Naturalism, but with something of the instinct of a natural and primitive man.[39] Norwegian commentators have also suggested that it was very much on the model of Gauguin that Astrup chose to return permanently to Jølster in 1903, in effect turning his back on modern life in favour of "a countryside where life was lived in the old Norwegian way, in close sympathy with the earth and in battle against the powers of nature, a place where superstition still had a hold on the mind, where old customs ruled."[40]

Astrup found himself in the peculiarly ambivalent position of a native who was also an outsider. The attempt of the son from the parsonage to live the hard life of a peasant on a small farm was as little understood by the local population as his wanting to make pictures. He took little interest in contemporary problems, but dwelt with stories that he had heard as a child, old customs, and myths. But his position as an outsider also gave him a privileged, if instinctive, perspective on the unique and isolated community's special form of life and its relationship to a powerful natural setting, as it was reflected in primitive superstitions and old ways of life and thought. A typical pronouncement illustrates the profundity of his primitivistic outlook and the depth of his mystical relationship to the land: "It seems to me almost a religious act to dig in the deepest earth and bring up unused soil which has lain there since the earliest of time and waited to be cultivated."[41] Astrup called himself a "naturalistic naïvist."

Astrup's paintings, such as *Kollen*, 1906 (no. 77), and *Dusk in Spring*, around 1909 (no. 78), may be structured like Sohlberg's, symmetrical and frontalized, with foreground detail contrasted to background monumentality, but otherwise they have little in common. Astrup does not (and here he differs from Nordström) cast his longings onto a distant unattainable horizon; rather his landscapes are held together by an organic unity and a vitalistic

77 (below)
Nikolai Astrup (1880–1928) Norwegian
* *Kollen*, 1906
Oil on canvas. 101 × 120 cm
Rasmus Meyers Samlinger, Bergen, Norway

78 (opposite)
Nikolai Astrup (1880–1928) Norwegian
* *Dusk in Spring*, ca 1909
Oil on canvas. 98.2 × 106.2 cm
Rasmus Meyers Samlinger, Bergen, Norway

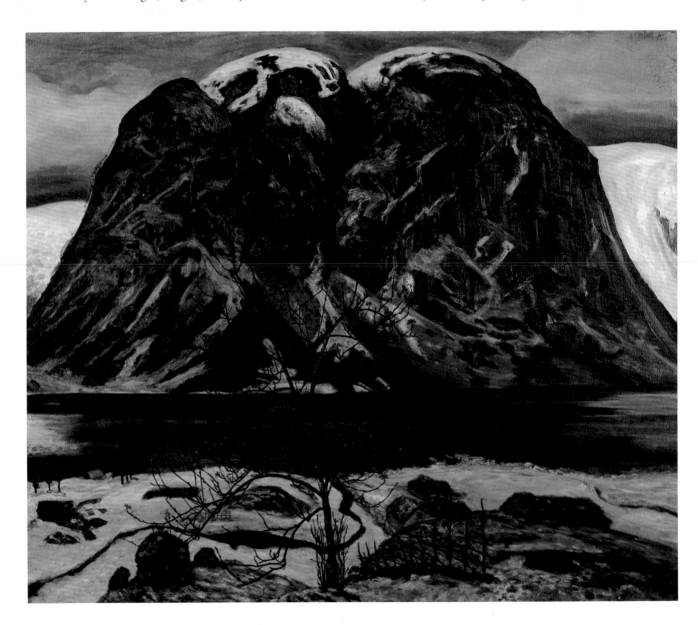

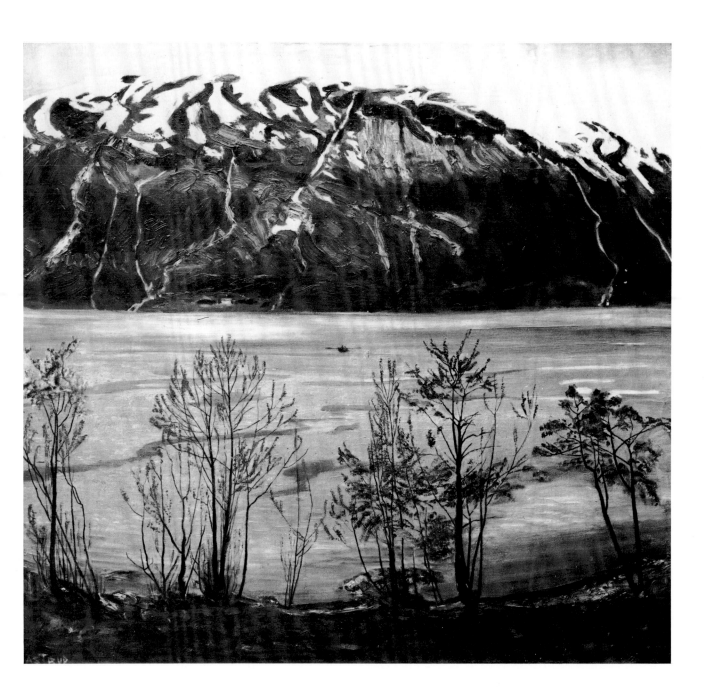

life that rules the grass at one's feet and the rocky crests of the mountain tops. By saturating his pictures with weather so that we shiver at the damp or the cold, he thrusts us into intimate relations with nature, fuses us with its rhythms of growth and decay. Like the people he depicts, we respond instinctively to its beneficence or malevolence, not from some metaphysical projection but in pantheistic worship which we feel in our bones.

Kollen, which has also been called *Grey November Morning*, is Astrup's most monumental and solemn dirge to a cold and threatening nature. Though its details – the leafless tree hung with frozen clusters of rowanberries, the snow-covered farm, the black creek bed, the icy greenish water of the fjord, the grey-brown snow-capped mountain, the distant snow fields – have all been studied with the greatest Naturalist fidelity, Astrup has taken significant compositional liberties. The most important has been to pull together the sides of the mountain[42] to give it height, mass, and frontality so that it rises to the top of the frame and is pushed forward through the transparent atmosphere by the white stretches of snow behind. The mountain looms over and encloses the miniature foreground scene with an intimacy, albeit foreboding and oppressive, that we have seen evoked more often and more idyllically with smaller chunks of nature, as in Gallen-Kallela's *Waterfall at Mäntykoski* (no. 21). Astrup's broad painterliness further underscores the weight and physical presence of nature, and the predominantly grey, black, and brown palette, juxtaposed to the white snow, evokes its chilling moodiness. The writer Hans E. Kinck, describing the painting in an article that appeared in 1911, found in it "only pressing hardened solemnity" and thought that Astrup had "painted death itself, the nightmare of the great nothing. And this surrender facing life's end is so unconditional that one stands sick at heart in front of it."[43]

Outside Scandinavia:
Ferdinand Hodler and
Piet Mondrian

Hodler straddles two epochs, one of which is oriented toward naturalist observation, and the other toward the creative imagination. The ambivalent appearance that clothes his work reveals in fact only the Janus-headed character of his time.
Wilhelm Hausenstein[1]

But to use more general terms, the natural appearance *veils* the expression of relations. When one wants to express definite relations plastically, one must show them with greater precision than they have in nature. In the landscape before us, the relations of position are not apparent to the superficial eye.
Piet Mondrian[2]

From the discussion so far it seems that the interest in extracting spiritual meaning from the uninhabited landscape was primarily an affair for Scandinavian artists. Although within Scandinavia Munch stands out as the major artist of the 1890s, he is not alone, but shares in the concerns of a host of worthy fellow Symbolist landscape painters. In contrast, both Ferdinand Hodler in Switzerland and Piet Mondrian in the Netherlands stand relatively alone, with few lesser luminaries providing a context for their work. Both also, much more so than Munch, developed in an atmosphere of artistic isolation, Mondrian until almost 1907 clinging to the Dutch landscape tradition of the Hague school and the Amsterdam "impressionists." Both made major contributions to Symbolist landscape painting, but for Hodler it was the culmination of his work, whereas for Mondrian it was a transitional phase, albeit a crucial one, on the way to the discovery of Cubism and the development of Neo-Plasticism. The insights into the underlying structure of nature that Mondrian achieved in his Symbolist period, about 1907–10, helped to focus his spiritual search in such a way that, assisted by the intellectual rationale that Theosophy could provide, he could subvert the purely aesthetic concerns of Cubism and transform the style into a transcendant language. There are notable affinities between Mondrian's stylistic reductions during those years and those Hodler began to effect in the early 1890s on the basis of his theory of Parallelism.

FERDINAND HODLER

The period 1890–1910 was a time of general artistic blossoming in Switzerland. In addition to Hodler, several artists who subsequently achieved international reputations come to mind: Felix Vallotton, Cuno Amiet, Giovanni Giacometti, and Giovanni Segantini. But though Hodler worked most of his life in Geneva, it was in German Switzerland that his art was primarily received and discussed.[3] During his 1904 retrospective at the Vienna Session, Franz Servaes, while allowing that Hodler's "primordial instincts are essentially Germanic, forming a compound of bluntness, obstinacy, and rigidity," also perceived a compensating Latin sense "of clear and noble forms that allows him to free himself from the mists and

79

Ferdinand Hodler (1853–1918) Swiss

* *Autumn Evening*, 1892

Oil on canvas. 100 × 130 cm

Musée d'art et d'histoire, Neuchâtel, Switzerland

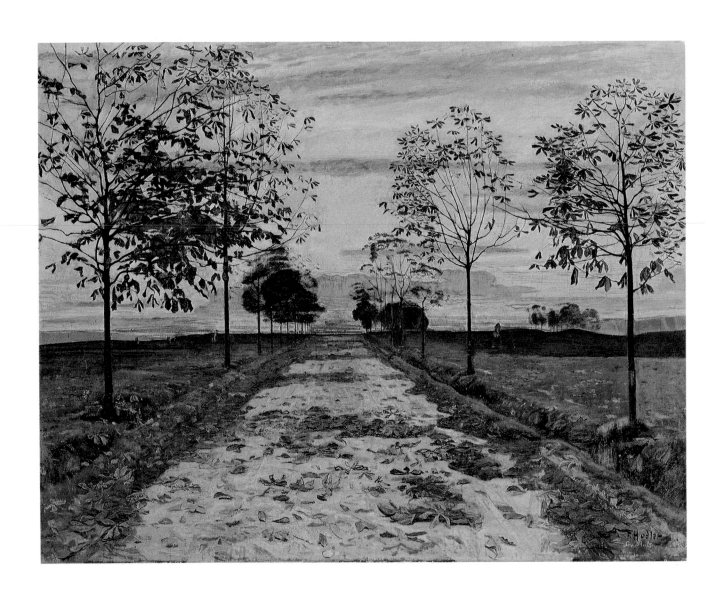

the torpors inherent in the Nordic spirit, and not lose sight of reality, even in his mystical visions."[4] But Hodler's success in Germany and Austria was not repeated in France. France on the whole was not receptive to northern artists during the 1890s. Hodler received praise from Puvis de Chavannes for his *Night* at the Salon du Champ-de-Mars in 1891, was subsequently made a member of the Société nationale des artistes français, and was also invited to participate in the first Salon de la Rose + Croix in 1892, yet interest in his work declined, his art rejected as Germanic.[5] Between 1900 and 1913, while his reputation was at its height in Germany and Austria, he did not show in France at all, and when he did return in 1913, the general attitude was perhaps summarized by the critic Louis Vaucelles, who declared that Hodler "owes nothing to French culture," unlike Steilen, Grasset, or Vallotton, who "have become ours, by their choice. They ... paint like the French," even if "in some of them one objects that they remain frigid in spirit and temperament, let us say Alpine, or, better, protestant."[6] As Vallotton commented: "The French prefer refinement and things less loud."[7]

Throughout his career Hodler divided his time between figure painting and the landscape, with the latter taking on increasing importance toward the end of his life. He maintained that his figure compositions constituted his major achievement and that he practised landscape more by way of relaxation.[8] But even during his lifetime the critical opinion was voiced that "it could be that the history of art will consecrate the superiority of Hodler the landscapist, over the master of monumental painting."[9] And as Goldwater has suggested, it was only in the landscapes that Hodler, as well as Klimt (no. 35), was able to achieve the unity between outward appearance and hidden meaning that was the aim of Symbolism.[10]

It is probably not arbitrary to posit as Hodler's first Symbolist landscape painting *Autumn Evening*, 1892 (no. 79), though a few explanations are required. Pure landscapes are part of his repertoire from the beginning of his career in the early 1870s, reflecting through the teachings of Barthélemy Menn in Geneva the influence of the Barbizon painters and Corot and Manet. These works constitute a kind of closely observed Naturalism that,

unlike Impressionism, respected the individual formal integrity of all the elements of the landscape. Landscapes with figures for anecdotal interest recur, if decreasingly, until the end of the 1880s. More significant is the appearance of a special type of figure composition, exemplified by *Dialogue with Nature*, 1884 (Kunst Museum, Bern), in which a heroic nude male figure dominates a Puvis de Chavannes type of classicized landscape, with a horizon line raised almost to the top of the picture plane, transforming the landscape into a kind of backdrop for the devotional gesturing of figures in rapt absorption with the mystical messages of nature.[11] *Dialogue with Nature* and its successors, such as *Communion with the Infinite*, 1892, seek to revive, as Hirsh suggests, the Romantic belief in the spiritual replenishment and uplifting experience to be derived from oneness with the grandeur of nature. But Hodler increasingly emphasized the figurative components of such pictures, and nature itself receded, as in the monumental figurative Symbolist paintings inaugurated in 1890 with *Night* (Kunstmuseum, Bern) to become eventually an abstracted sign of nature rather than something directly observed. In contrast, even after 1892 the pure landscapes, like those of Scandinavian Symbolism, continue to be deeply rooted in close observation as if the aim were to do nature's portrait, studying its physiognomy for what it may reveal of the more profound and timeless truths that lie beneath.

Autumn Evening, 1892, is not such a portrait and is probably only loosely based on any specific motif. It is, however, a radical departure from any preceding Hodler landscape, including *The Road to Evordes* (Stiftung Oskar Reinhart, Winterthur), from around 1890, which is sometimes considered a forerunner of *Autumn Evening*[12] because of its centralized tree-lined road running from the bottom corners straight into the middle depth of the picture, where, however, its course is cut off by a range of hills. The work describes a closely observed corner of nature, atmospheric and rich with the feeling of the variety and changeability of reality. *Autumn Evening*, in contrast, though it may depict a transitory season, has made the moment linger, fixing it in a relective silence and imbuing it with the power of eternal truth.

What was natural in *The Road to Evordes* has become

126

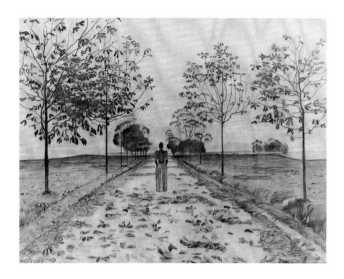

80
Ferdinand Hodler (1853–1918) Swiss
Sketch for 'Autumn Evening', 1893
Hard pencil and water-soluble coloured crayon on paper.
26.3 × 33.7 cm
Musée d'art et d'histoire, Geneva

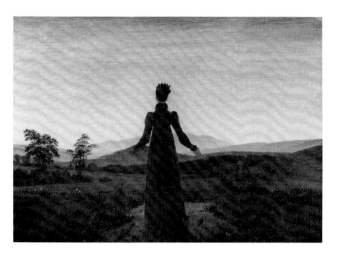

81
Caspar David Friedrich (1774–1810) German
Woman before the Setting Sun, ca 1818
Oil on canvas. 22 × 30 cm
Museum Folkwang, Essen, West Germany

supernatural in *Autumn Evening*, and is rigorously subjected to pictorial order. In the earlier landscape, despite the rapid recession of the central road, the eye would nevertheless be enticed to rove leisurely along its edges and stray into the fields to smell the flowers and to feel the coolness of the shadows. In the Symbolist painting, however, everything conspires to concentrate both our gaze and our thought. The symmetry along the vertical axis down the centre of the receding road is almost perfect, the trees are only slightly staggered so as to underscore the speed of its recession, and little distracts us to the sides. Moreover, recession is sharply foreshortened and the road reaches the horizon long before its parallel edges have met at infinity, as if collapsing the distance to our destination. This sensation is underscored by an air drained of atmosphere, which causes the light of the distant setting sun to have as much intensity, substance, and immediate reality as the crisply detailed autumn leaves

underneath our feet in the foreground. By the focus, clarity, and rigour of his design, and by the subversion of realist spatial continuity both in the system of perspective and in the elimination of atmosphere, Hodler has overturned his Naturalist background as radically as did Munch during the same year in *Melancholy, The Yellow Boat* (no. 2). At the same time Hodler has recognized the mood-bearing capacities of the sunset and twilight to infuse his work with the air of melancholy appropriate to the Symbolist concern with death and dying implied by his images of the fading day and the falling leaves.

We know from a related drawing that the painting originally included a female figure standing on the path a short distance along the road, with her back to us and facing toward the sunset (no. 80). As Hirsh has pointed out, this makes *Autumn Evening* remarkably reminiscent of Friedrich's *Woman before the Setting Sun*, around 1818 (no. 81), in which a similar figure, with arms outstretched, receives nature as an embodiment of the divine presence.[13] Hodler's figure, as depicted in the drawing with hands

held against her hips, seems much less certain about what awaits her at the end of the road. *Autumn Evening* was painted for the 1893 Concours Calame, an annual painting competition in Geneva, which that year required "a landscape with figures or animals representing the setting sun in autumn."[14] Hodler, however, seems not to have been satisfied with his use of the early Romantic device of the female figure as mediator between the viewer and the experience of nature. He soon painted her out,[15] transforming the viewer, as had Gallen-Kallela in *Waterfall at Mäntykoski*, painted at more or less the same time, from an observer to a participant in the mysterious revelation of nature's divinity.

The simple symmetry and regularity of the painting are usually attributed to Hodler's application of Parallelism, first articulated in a lecture entitled "The Mission of the Artist," delivered in Friburg in 1897.[16] In pictorial composition Parallelism is a principle of order and beauty based on the observation of the unity and harmony that underlie all nature and can be discovered everywhere: in the repeated vertical lines of the tree trunks of a forest, in a field of dandelions, in a wide expanse of ground covered with rocks from a mountain slide, in autumn leaves scattered on the ground, in the innumerable mountain tops in the Alps, in the extension of the sea and the sky, and in the symmetry of the human body. As a compositional device Parallelism implied the repetition of similar natural elements and the relationships that existed among them, such as the evenly spaced chestnut trees which line each side of the road of *Autumn Evening*. A particularly persuasive example of this kind of natural repetition is Hodler's image of a forest, which, though it recalls Bergh's description of the interior of Prince Eugen's *The Forest*, does not revive the Romantic metaphor of the "natural cathedral." It consequently has a special appropriateness to the recurring Symbolist treatments of the forest subject matter from Munch to Mondrian to Emily Carr. "If I go for a walk in a forest of very high fir trees, I can see ahead of me, to the right and to the left, the innumerable columns formed by the tree trunks. I am surrounded by the same vertical line repeated an infinite number of times. Whether those trunks stand out clear against a darker background or whether they are silhouetted against a deep blue sky, the main note, causing that impression of unity, is the parallelism of the tree trunks."[17]

Hodler was purportedly often dogmatic in his espousal of the theory of Parallelism, "like a professor of the Academy," according to a contemporary recollection by Koloman Moser: "I am always astonished that he produces such strong works despite his theory (thanks to it, he thinks)."[18] But in another context, and in reply to the suggestion that not all his pictures were marked by the theory of uniformity, Hodler explained: "I do not feel myself tied to the theory of Parallelism, but I have profited from it in any case. This theory of Unity reveals in me the feeling of the grandeur of nature, the power of the visible, of permanence, of the existence of the universal, whether this nature be a flower or the sky, or our constitution, our common sensibility, etc."[19]

Hodler's first application of Parallelism is usually assumed to be *Beech Forest* (no. 82), which, though dated 1890 by Hodler, has been convincingly redated by Brüschweiler to 1885, when it was executed in accordance with that year's subject requirements for the Concours Calame: "a wood interior, undergrowth, effect of morning sunlight, with a group of woodcutters comprising four figures."[20] (Three of the figures were subsequently painted out.) The painting would seem to fulfil the experience of Parallelism as conveyed by the description of the fir forest in the 1897 lecture, though the trees are not firs and not very straight, except for one or two at the extreme left and right that act as framing devices. Otherwise the trees are fairly evenly distributed across the picture surface, with the edge of the forest presenting a sort of frontal mass and only a small opening in the centre foreground recalling more traditional compositions. The painting was not selected by the competition jury, not only because "all the details were treated with equal importance and a uniform clarity," presumably a Parallelist decision, but because it "does not give that impression of unity indispensable to a work of art." Hodler had discovered a principle of unity that ran counter to traditional pictorial conceptions.[21]

Though Brüschweiler has dated *Beech Forest* to 1885, and though the painting has significant Parallelist elements

which align it with those first Symbolist Scandinavian forest pictures from 1892–3, to cite it as the beginning of Hodler's Symbolist period is problematic. The painting hovers between Naturalism and the urge toward some other meaning, in the way, for instance, that the subject fully fills the picture plane and presents a kind of confused denseness so different from the much more rational ordering of Romantic or Realist forests. Nevertheless, in

82
Ferdinand Hodler (1853–1918) Swiss
Beech Forest, 1885
Oil on canvas. 102 × 131 cm
Kunstmuseum, Solothurn (Dubi-Müller-Stiftung),
Switzerland

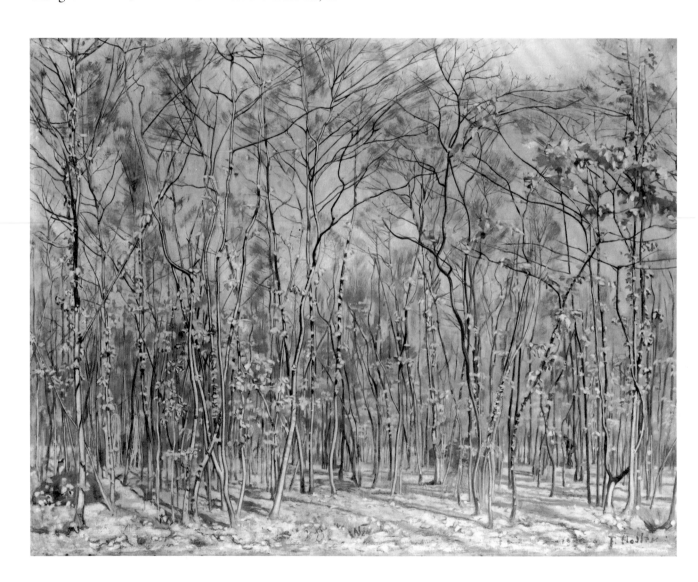

the intervening years, until *Autumn Evening* in 1892, there are few deviations from an otherwise thoroughly Naturalist approach to landscape painting. Though there can be only speculation as to why and when Hodler misdated *Beech Forest* to 1890,[22] there must nevertheless be some connection to that dating and to Hodler's own declaration that it was with *Night* in 1890 that he made his "first entirely conscious use of Parallelism."[23] Unless the dating was simply an error, was it more motivated by considerations of artistic development than by strict concern with chronological correctness? Was it only in 1890 that Hodler fully understood the foresightedness of his picture from five years before and perhaps realized its implications for his now conscious formulation of a theory of underlying natural as well as pictorial order?

The problem of Hodler's over-painting three of the four woodcutters is also interesting in light of his subsequent over-painting of the single figure in *Autumn Evening*. Whatever the motivation, and it is difficult to draw too firm a conclusion because of the relationship of both pictures to the Concours Calame, the decision seems finally to have effected a clear distinction between monumental figure painting and landscape. The former was played against an anonymous and abstracted nature; the latter concentrated on landscape portraiture, however stylistically condensed and spiritually heightened. Thus, though *Autumn Evening* was a kind of hybrid, an abstracted landscape designed as a setting for human action, it was also the most conspicuously Symbolist painting to date in which landscape dominated to the point where it seemed capable of being self-sufficient. Perhaps because Hodler had here for the first time consciously applied parallelism to a landscape, it finally confirmed that landscape, as much as figure painting, could independently speak of higher things.

In accordance with the general practice of Symbolist landscape painting, Hodler had also, in an essay on "The Physiognomy of Landscape,"[24] warned against the use of figures in landscape paintings, because their "presumed mobility" would distract from the "motionless character of the subject." The manuscript of the essay, now lost, has been variously dated pre-1885 and post-1892. The earlier date was transmitted by C.A. Loosli, who copied the text from personal papers lent to him by Hodler. The later date is suggested by Brüschweiler because Hodler proscribes the inclusion of figures in landscape painting, a practice that he himself would not follow rigorously until the elimination of the female figure in *Autumn Evening*, that is, after 1892.[25] One is more inclined to date the text to the early 1890s, because of the very specific exaltation of "the emotional elements" and "the purely personal ... impressions" of the landscape. The success of a landscape, according to the essay, depends on how well it awakens "memories and feeling" in the spectator. To be able to do so the artist must carefully consider his means, that is, the entire picture must be capable of being embraced in one glance; therefore the essential structure and the composition must be so striking that the impact of the "main accent," the essential emotion, is clear and immediate. The painter must also choose light and colours that "render the most intense emotion." The text consequently seems to have less to do with landscape paintings executed before *Autumn Evening*, which are primarily devoted to objective naturalistic observation, *Beech Forest* of 1885 notwithstanding, than the kind of consciously constructed, simplified, and synthesized compositions that come after. As well, Hodler's prescriptions for landscape painting, which call for organizing the subject matter in order to arouse the emotions or awake memory, correspond almost word for word with burgeoning Symbolist landscape theorizing throughout the rest of the north at this time.

Closely related to *Autumn Evening*, and similarly reminiscent of Friedrich (for example, his *Cross in the Forest*, Staatsgalerie, Stuttgart), is a small picture, *The Path of the Chosen Souls*, 1893 (no. 83). It is composed, like *Autumn Evening*, with a pathway leading down the centre of the painting, grassy and covered with marguerites, bordered on either side by blossoming lilac bushes. At the end of the path stands a tall frail cross. Though in 1893 the Bible was still regular reading for Hodler, and though he maintained that "basically, I have painted nothing other than religious works,"[26] it is unusual in his oeuvre, otherwise nonsectarian and universalist, to find such an overt Christian symbol. It is usually assumed[27] that the painting represents Hodler's momentary response to the promotion

of the Catholic occult by the Salon de la Rose + Croix, in which he participated in 1892 and 1893.[28] In any case, the painting stands as an interesting curiosity alongside other similar and equally rare instances of Christian iconography in Sohlberg and Gallen-Kallela.

Generally speaking, Hodler's subsequent landscapes di-

83
Ferdinand Hodler (1853–1918) Swiss
The Path of the Chosen Souls, 1893
Oil on canvas. 47 × 57 cm
Private collection, Switzerland

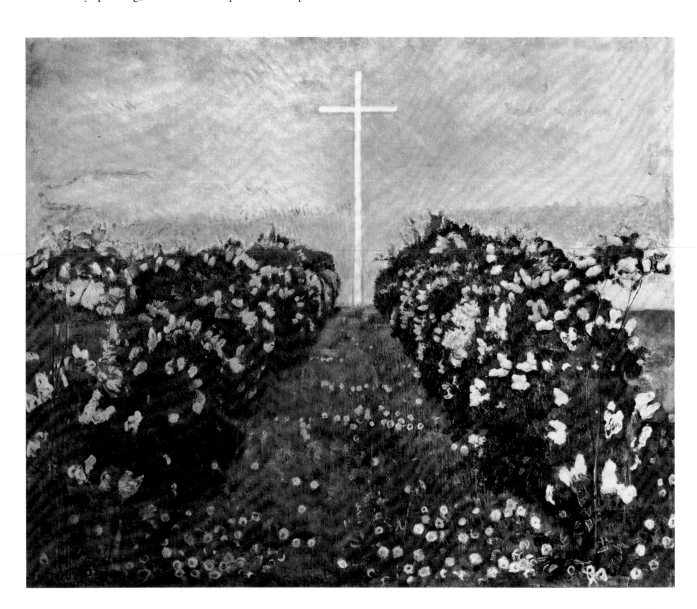

vide into three subject categories: panoramic views of Lake Geneva; mountains, usually mountain tops; and mountain brooks. The Lake Geneva pictures, similar to *Autumn Evening*, are usually organized along a central axis, horizontal rather than vertical. From their high vantage point, looking across the great expanse of the lake, they organize the landscape according to simple geometric forms, usually a flattened oval. *Lake Geneva from Chexbres*, 1894–5 (no. 84), is the first masterpiece of this kind. It retains from *Autumn Evening* the transparent atmosphere through which we can see with consistent linear crispness to the mountains on the far side, and which, in the lingering moments of twilight, seems to hold a timeless silence. The elements of the landscape are

84

Ferdinand Hodler (1853–1918) Swiss
Lake Geneva from Chexbres, 1894–5
Oil on canvas. 100 × 130 cm
Kunsthaus, Zürich (Gottfried Keller-Stiftung)

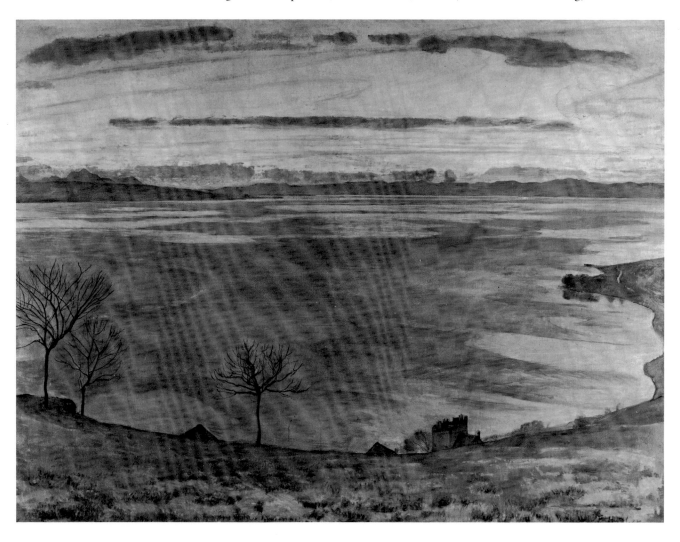

132 85
Ferdinand Hodler (1853–1918) Swiss
* *Sunset on Lake Geneva*, 1915
Oil on canvas. 61 × 90 cm
Kunsthaus, Zürich

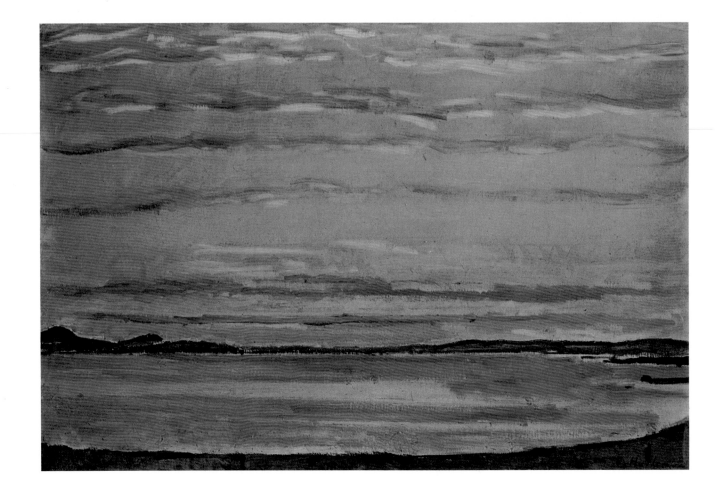

Ferdinand Hodler (1853–1918) Swiss
* *Lake Thun*, 1909
Oil on canvas. 67.3 × 92 cm
Musée d'art et d'histoire, Geneva

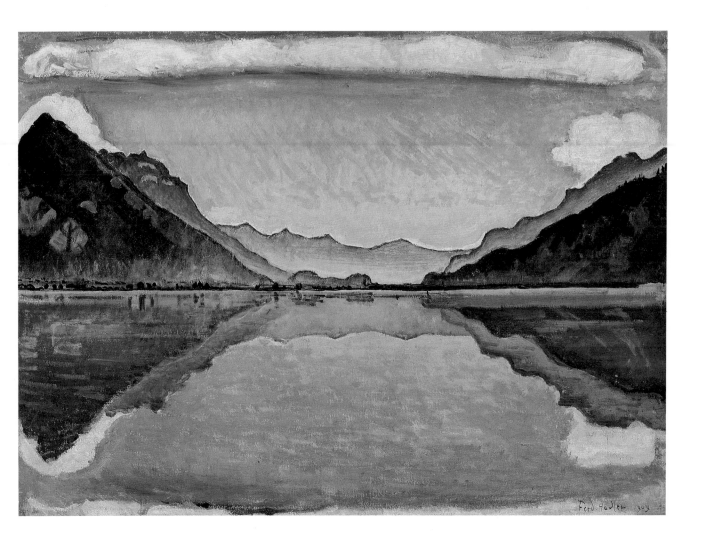

considerably simplified. The swinging foreground line of the lake's edge is echoed not only in the sweep of the mountains on the opposite shore but also in the arc of the purple clouds at the top of the painting, thus assembling the landscape into two great ovals, one deep, the other on the surface, which underscore the unity within nature according to the principle of Parallelism.

Toward the end of his life Hodler would stretch out those ovals until their sides almost become parallel lines. In the much more loosely painted *Sunset on Lake Geneva*, 1915 (no. 85), the solid elements of nature – the shoreline and the range of mountains in the distance – have been reduced to uninterrupted horizontal linear bands of colour of little more substance than the light reflection on the surface of the lake or the cloud stratifications. More than ever, the light of sunset induces a kind of submissive, sorrowful serenity, commensurate with the resignation to death with which these late canvases are associated. Hodler may never have been explicit about this, but he did speak of the death of mountains, which "become lower and more rounded by the centuries until they become flat as the surface of water."[29] The reduction of the composition to calm, recumbent parallel lines reflects Hodler's earlier and contemporary depictions of the deathbed scenes of his mistresses, Augustine Dupin in 1909, and Valentine Godé-Darel in 1915, in which the bodies are stretched out flat, like the worn-down mountain summits. The prostrate bodies at the base of the paintings are reiterated at the top by three parallel lines painted on the surface of the background wall. According to Hodler, these stood for the soul of the deceased,[30] and we may imagine the late landscapes too as spiritual manifestations, paintings of the soul.

These sunset panoramas, of course, have their Scandinavian counterparts, such as Eugen's *Still Water* (no. 41), and Hesselbom's *Our Country* (no. 42). Mondrian's "sea at sunset" pictures from 1909, in a similar way, from a position in front of large expanses of water, reduce the landscape to essential form and hover, despite their basis in close observation, on the edge of abstraction. There should be no implication that Hodler, had he lived longer, would have followed Mondrian into pure abstraction, but these paintings are perhaps his supreme achievement in

that direction. As Schmalenbach has observed about the monumental figure compositions: "The expressionism does not lie in the picture, rather it is advanced in the model. The model performs an expressive pantomime which the picture in undistorted form presents." Consequently, as he maintains, these have remained Realist depictions of Expressionist distortions.[31] In the landscapes, in contrast, Hodler has seamlessly fused subject matter, style, and expressive meaning and thus achieved the Symbolist ideal.

Hodler's most formally rigorous exploration of natural and pictorial order occurs in a number of head-on views of mountains and their reflections seen across a lake from the edge of an immediate shore, such as *Lake Silverplana*, 1907 (Kunsthaus, Zürich), and *Lake Thun*, 1909 (no. 86). In these paintings the accidental and the irregular in nature have been severely contained within a near-geometric order of double-axis symmetry. Were it not for the softening effect of the ripples on the surface of the lake, on an otherwise almost mirror-perfect reflection, these images could be inverted with only minimal diminution of their compositional power. An early version of *Lake Thun* (*Lake Thun Seen from Därligen*, 1905, Musée d'art et d'histoire, Geneva) is dominated by a linearity reminiscent of art nouveau; nevertheless these monumental and hieratic images, especially in their observation of light and colour, remain faithful to the feeling and the texture of the original natural motif.

In contrast to these all-inclusive views, which look from foreground into almost infinite distance, and laterally scan broad horizons, in 1908 Hodler for the first time turned his gaze onto mountain tops and thus added an important new category to his repertoire of subjects. Mountains as architectonic structures, and mountain peaks as sites of superhuman powers, had interested Willumsen since 1892 and Sohlberg from 1900. Mountain painting also had strong traditions in Switzerland, where during the nineteenth century it had come to represent the very embodiment of national art, especially in the hands of Alexandre Calame and François Diday, whose dramatic and pathos-filled Alpine scenes, rendered with painstaking detail, are a Swiss counterpart to the Romantic Norwegian painting of J.C. Dahl and Thomas Fearnley. Toward the end of the century Giovanni Segantini, especially, built a major

reputation as a pantheistically inspired painter of the heights of the Engadine, giving mythical dimensions to its snow-covered ridges. But ultimately he compromised his Symbolism by filling the foregrounds of his naturalistic and Divisionist canvases with Millet-influenced allegorical scenes of peasant labourers. Cuno Amiet, Giovanni and Augusto Giacometti, and Felix Vallotton turned to mountain subject matter only rarely, and then usually as

87
Albert Trachsel (1863–1929) Swiss
Sunrise, ca 1909
Oil on canvas. 72.5 × 91 cm
Kunstmuseum, Solothurn (Dubi-Müller-Stiftung), Switzerland

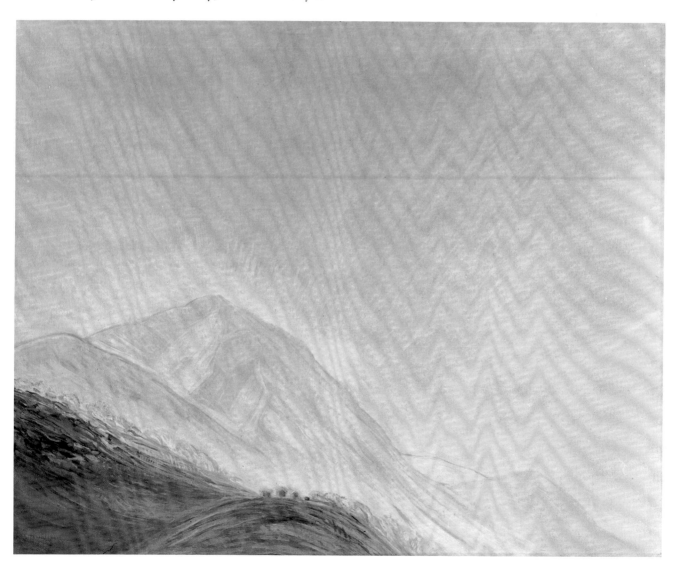

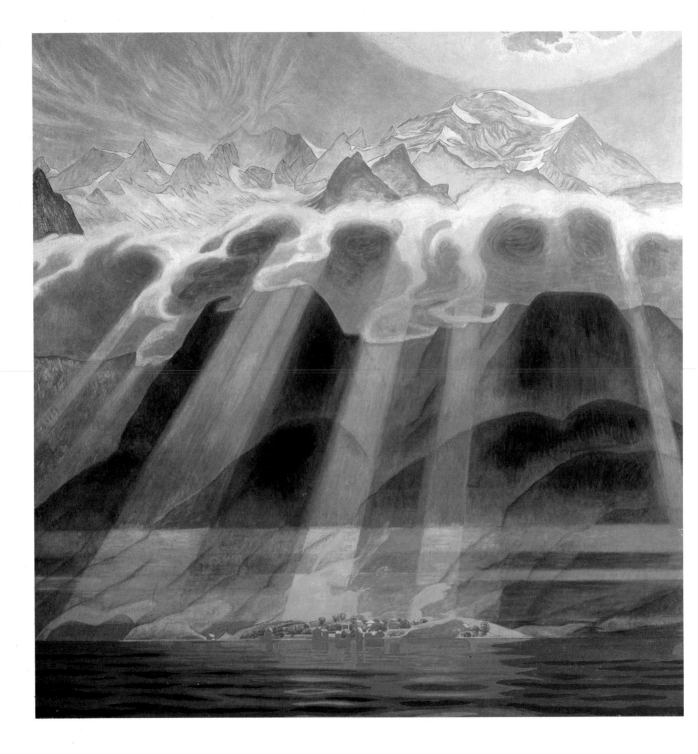

88 (opposite)
Jens Ferdinand Willumsen (1863–1958) Danish
* *Mountains under the Southern Sun*, 1902
Oil on canvas. 209 × 208 cm
Thielska Galleriet, Stockholm

89 (below)
Ferdinand Hodler (1853–1918) Swiss
* *Eiger, Mönch and Jungfrau above a Sea of Mist*, 1908
Oil on canvas. 67.5 × 91.5 cm
Musée Jenisch, Vevey, Switzerland

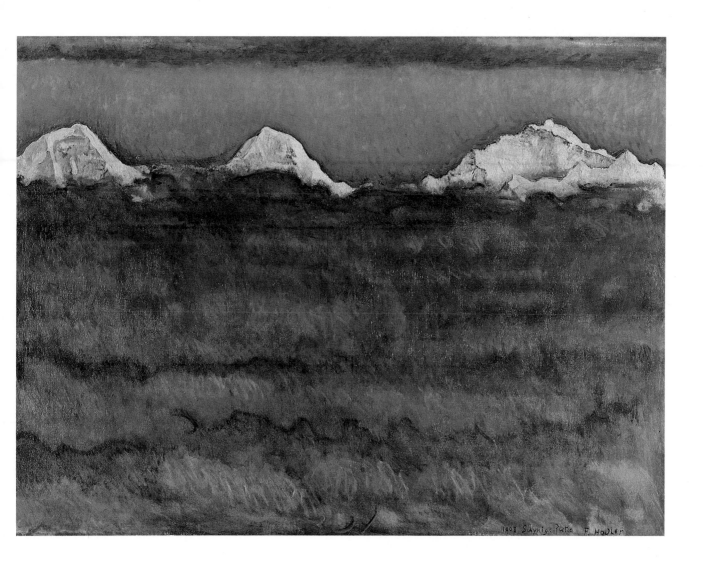

seen from a domesticated perspective. Vallotton's seven Alpine woodcuts from 1892 (nos. 7–13) are both early and rare for their avoidance of anecdotal features and for their lofty air-borne point of view. Albert Trachsel, after 1900, trained his eyes upwards in a comparable way in a series of visionary and strangely coloured "dream landscapes" (no. 87), but it was finally Hodler who, with incomparable devotion, most profoundly grasped the monumentality and the mystery of soaring mountain summits.

In the literature of Romanticism mountains often appear as vantage points. To Wackenroder the "top of a high mountain" was symbolic of the cultural and intellectual privileges of man at the end of the eighteenth century, enjoying an unprecedented overview in terms of both history and geography. His was a lofty viewpoint from which the world, all its places, ages, and people, lay open for his eyes to wander over, striving "always to find in all their varied feelings and the products of this feeling, the human spirit."[32] For Carus it was from the top of the mountains that our glance at "the great ... enormous circle of natural phenomena" would reveal the "quiet and eternal laws" whose "secret power ... would divert us from ourselves." As he counsels us: "Look over the long range of hills, observe the flow of the rivers and all the splendour that opens before you, and what feeling touches you? It is one of quiet devotion within you; you lose yourself in boundless space; your whole being undergoes a quiet refining and cleansing; your ego vanishes; you are nothing; God is all."[33] The image here implied of a lonesome pantheistic contemplator of the vast and superhuman expanse of nature is perhaps embodied in Friedrich's *Wanderer over the Sea of Fog*, around 1818 (Kunsthalle, Hamburg) with its single monumental figure, viewed from the back, and standing atop a high craggy cliff gazing across an immense and awesome natural setting.

Friedrich's painting, however, is perhaps not entirely satisfactory, because there is something incongruous about the juxtaposition of the timeless landscape and the male protagonist, dressed in a rather too realistically rendered fashionable coat and leaning on a cane. Friedrich has, perhaps unwittingly, predicted here the threat to spiritual experience that would be imposed by an increasingly materialist nineteenth century, something that Carlyle drolly reminds us of in *Sartor Resartus*, published in 1836 on the basis a close study of German Romantic writers, and dedicated to the unveiling of the fundamentally spiritual character of reality.

In *Sartor Resartus* we follow the wanderings of Carlyle's wayfaring hero Professor Teufelsdröckh, during a flight "into the wilds of Nature" in search of emotional healing. We discover ourselves on several occasions gazing over our shoulder from mountain tops the views from which rival in transcendent splendour the finest imaginings of the author's German predecessors:

But sunwards, lo you! how it towers sheer up, a world of Mountains, the diadem and centre of a mountain region! a hundred and hundred savage peaks, in the last light of Day; all glowing, of gold and amethyst, like giant spirits of the wilderness; there in their silence, in their solitude, even as on the night when Noah's Deluge first dried! Beautiful, nay solemn, was the sudden aspect to our Wanderer. He gazed over those stupendous masses of wonder, almost with longing desire; never till this hour had he known Nature, that she was One, that she was his Mother, and divine. And as the ruddy glow was fading into clearness in the sky, and the Sun now departed, a murmur of Eternity and Immensity, of Death and of Life, stole through his soul; and he felt as if Death and Life were one, as if the earth were not dead, as if the Spirit of the Earth had its throne in that splendour, and his own spirit were therewith holding communion.[34]

Alas the professor's rapturous spell is soon broken by a sound of carriage wheels, a gay barouche-and-four, and a wedding party in which the bride is none other than his own lost love who has deserted him for a richer man. Later, at North Cape, when our hero stands in solitary contemplation of the "Silence as of death" of the Arctic sea, lit by the low-hanging midnight sun, "and before him the silent Immensity, and the Palace of the Eternal," it is a Russian smuggler who interrupts him and has to be scared off with a "Birmingham Horse-pistol."[35]

When, in *A View into the Infinite*, 1902–3 (present location unknown), Hodler resurrected the pictorial type of Friedrich's *Wanderer over the Sea of Fog*, it was with significant alterations. Hodler's figure is a nude youth

stripped of particularizing accoutrements, standing on the highest of the peaks visible above a sea of mist, who faces us in the guise of a young god, or rather, as appropriate to the age, like a Nietzschean superman, in an image suggestive of Gallen-Kallela's 1900 drawing of the philosopher himself standing "on the top of the Alps," though here with his hands stretched upward.[36] Hodler's end-of-the-century formulation is thus more in line with Balzac's concept, in his Swedenborgian novel *Saraphita* (1834–5), of mountain tops as places of superhuman abode.[37] Balzac envisages the mountain peaks of Norway as clothed in year-long snows and thus guarded "from profaning foot of traveller," "virgin still," and attainable only in mystical experience or through the intervention of superhuman beings such as the hermaphroditic Seraphita/Seraphitus, who eventually achieves apotheosis through transformation into pure spirit. The novel establishes a dichotomy between "the solemn permanence of those frozen summits" and the landscape below, subject to the weather and the seasons, which spreads out in images of eternal struggle. "There, beneath us," observes the hero/heroine, "I hear the supplications and the wailings of that harp of sorrows which vibrates in the hands of captive souls. Here [above] I listen to the choir of harmonies. There, below, is hope, the glorious inception of faith; but here is faith – it reigns, hope realized!" Here "we may breathe the thoughts of God." Throughout Romantic thought, nature was a "garment for" or a "footstool" and "stepping-stone" to knowledge of the divine, but in *Saraphita* nature also divides itself symbolically into material and spiritual realms, the latter the unattainable majestic mountain summits, to be possessed only by hope and longing, more usually hidden by clouds, which, we also learn, "signify the veil of the Most High."

Is it possible that Willumsen had read *Seraphita*, as, according to Bodelsen, he did Carlyle's *Sartor Resartus*, while formulating the programme of *Jotunheim*? His division of nature into the everchanging world below the clouds and the realm of ideal permanence above is, in any case, remarkably similar. He repeated this symbolic scheme in *Mountains under the Southern Sun*, 1902 (no. 88), in which the sun in all its glory bathes the frozen crystalline blue summits of the mountain tops, while a heavy layer of clouds shrouds the landscape below. Through a few openings, however, pass gleaming rays of divine sunlight, powerful enough to set aflame the tiny town down below on the lakeshore.

In the first mountainscapes of 1908 Hodler focused his sights on the realms above the clouds, as he had in 1902–3 in *View of Infinity*. Now, however, they are pure landscapes, with the ambivalent appearance of being inaccessibly remote at the same time as they seem monumentally close. In the previous year Hodler had in a notebook commented on the "grand unity" of the mountain, which reigned with the clouds, "remote from everybody like death."[38] Earlier, in 1897, he had given another clue to the range of meanings he attributed to mountain tops in a poster, entitled *Art*, for the Zürich Kunstlerhaus; in it he depicts art as a beautiful young female personification seated atop an Alpine peak. She was no doubt meant as an idealized embodiment of the ambitions for art that he expressed in his Friburg lecture, "The Mission of the Artist," delivered in the same year: that it was the artist's responsibility to "express the eternal element of nature, beauty, to express this essential beauty ... [in] a work which is commensurate with his experience, his heart and his mind."[39] Willumsen, in what may be a later interpolation inspired by Novalis, recalled in his memoirs his first experience of the Alpine peaks in 1892. He had stared enraptured at the mountains and met in them "the eternal and the everlasting," which in turn reflected and gave form to his strongest feelings and gave him the power to strive "for heights, where the mysterious blue flower of art buds and unfolds in the sun"[40]

Although in the tradition of Willumsen and Sohlberg, Hodler's *Eiger, Mönch and Jungfrau above a Sea of Mist*, 1908 (no. 89), is also significantly different. Hodler has been more radical in severing his three white and yellow mountain peaks from their gravitational anchor. As if seen through a telephoto lens, these pinnacles seem far away in real distance, but experientially very near, their location made ambiguous by the absence of aerial perspective as they rise behind a hazy blue mist, the colour of which is continuous with the sky above. A degree of Parallelism remains in the close resemblance of the three peaks and in the horizontal banding throughout the mist and in the

sky, but it is quite relaxed; the loose handling of the paint in the blue areas, set against the much tighter drawing in the mountains, underscores the mysterious nature of this silent and serene ethereal vision.

Hodler's post-1908 perspective on mountains seems closely related to Vallotton's Alpine woodcuts from 1892,

90 (below)
Ferdinand Hodler (1853–1918) Swiss
* *Breithorn*, 1911
Oil on canvas. 67 × 89.5 cm
Kunstmuseum Lucerne, Lucerne, Switzerland.
On permanent loan from the Bernhard Elgin-Stiftung

91 (opposite)
Ferdinand Hodler (1853–1918) Swiss
* *Mönch*, 1911
Oil on canvas. 88 × 66 cm
Jacqueline and Max Kohler, Switzerland

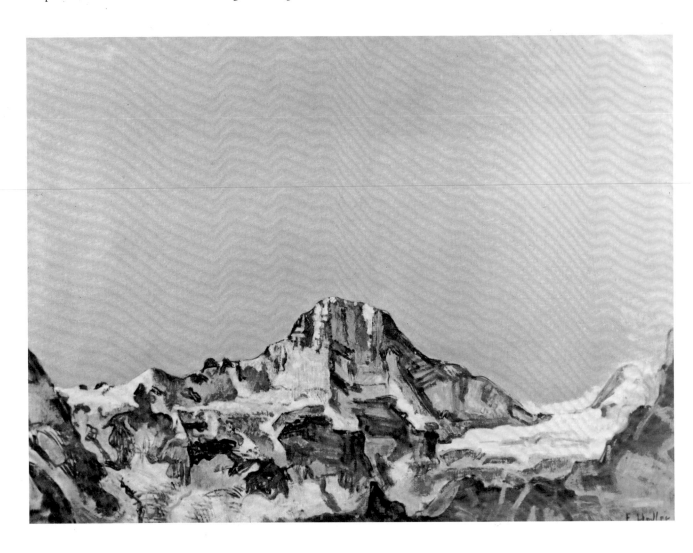

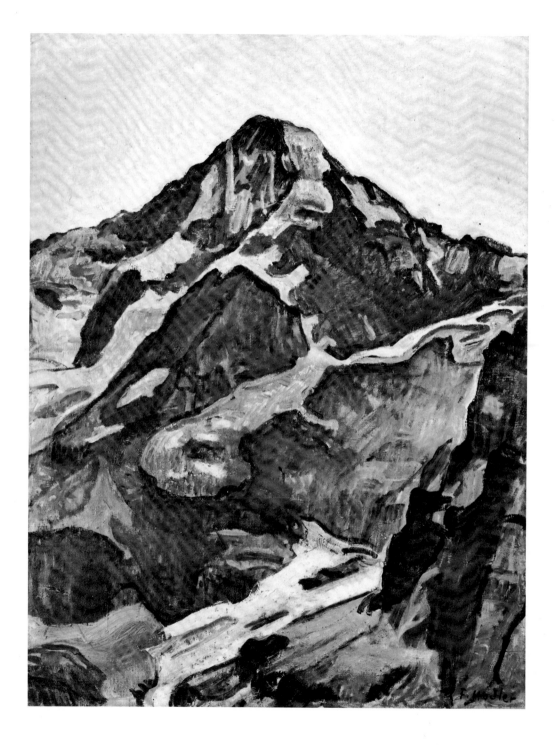

particularly in their framing. Vallotton makes somewhat more use of *repoussoir* devices, but the views are similarly telescopic, and the pinnacles, reduced to essential masses, rise above layers of cloud (nos. 12 and 13). This is especially apparent in the heavily sculpted mountain views such as *Breithorn*, 1911 (no. 90), and *Mönch* (no. 91). Such pictures are usually quite rigidly centralized and pressed monumentally close to the front of the painting with an aggressiveness common to Hodler's contemporary self-portraits, which were hewn with a similar ruggedness.

And in the purest sense these are mountain portraits, dedicated to representing not only individual physiognomies but also something of the essence of mountainness, its pyramidal concentration and stability and its

92
Ferdinand Hodler (1853–1918) Swiss
* *Les Dents du Midi*, 1916
Oil on canvas. 64 × 88 cm
Musée d'art et d'histoire, Neuchâtel, Switzerland

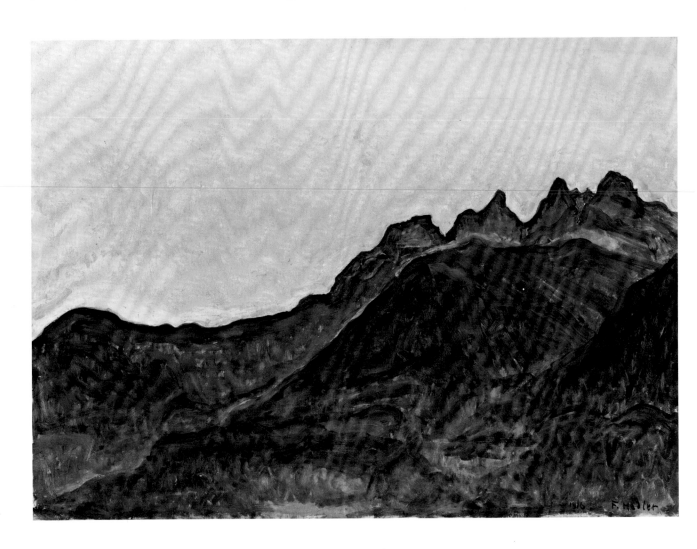

magisterial height in which is consecrated our highest aspirations. Occasionally, halo-like patterns of clouds will add to the sanctity of these clear daylight visions.

Though Hodler, by various compositional devices, concedes to decorative pictorial demands, this group of

Ferdinand Hodler (1853–1918) Swiss
* *Mountain Stream at Champéry*, 1916
Oil on canvas. 82 × 98 cm
Germann Auktionshaus, Zürich

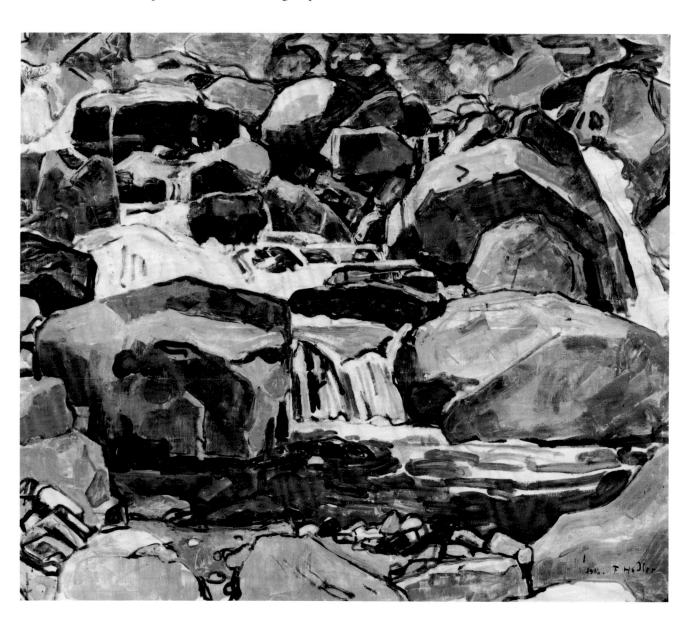

paintings sets itself apart from his preceding landscapes by the vigour of the execution, which completely avoids art-nouveau linearity. Strokes of the brush or the palette knife are laid down with structural weight and physical particularity that underscore the material presence of the subject matter. This characteristic quality of Hodler's technique, whereby paint strokes can be said to play both a formal and a descriptive role, has often been considered reminiscent of Cézanne, a comparison which is probably fundamentally wrong. Hodler's technique, unlike Cézanne's, ultimately bears on the material character and quality of things in nature, and only incidentally on independent pictorial structure, confirming his accord with the commitments of northern artists to the earth and soil. Like them, Hodler more commonly acknowledges Modernism's demand for decorative unity by a Synthetist arrangement of flattened shapes or linear patterns. This tendency may, for example, be observed in later pictures, such as *Les Dents du Midi*, 1916 (no. 92), in which the mountain shapes have been reduced to linearly reinforced dark blue and green silhouettes, contrasted to the plane of a golden sky. This is not to say that the mountains have lost any of their physical presence, or the sky its luminous depth, but there is no detailed description now, and the paint is laid down in long, broad, almost abstract brush strokes, not without parallels in Munch.

Mountain Stream at Champéry, 1916 (no. 93), though different in subject, relates to an example of Parallelism that Hodler described in his 1897 lecture: "Picture yourself in the middle of a wide expanse of ground covered with rocks fallen from a mountain side: you will have the same feeling [of repetition]."[41] And indeed this extreme downward close-up view of the tumbling water of a stream bed has all the monumentality of the massive mountain tops of 1910–11, and, like Van Gogh's iris plants which can loom as large as a tree, it has inherited from a longer northern Romantic tradition what Rosenblum has described as "that strange, anti-Renaissance sense of a scale unrelated to human hierarchies."[42]

Hodler had painted flowing streams since the 1880s and showed increasing interest in the rocky river beds which allowed him to discover the unity in the variety of the shapes, sizes, and colours of the stones which more and more came to occupy the major portion of his compositions. The late Champéry versions from 1916 are exceptional for Hodler in their concentration on a microcosm of nature. Despite the initial appearance of chaos, these paintings are quite severely ordered and frontalized and strike a subtle balance between natural appearance and decorative unity. Again, the painterly vigour and diversity of paint application are striking. But the restricted viewpoint has also given the subject matter material consistency, and hence has allowed an equally uniform technical handling across the whole surface of the painting, contributing, in Hodler's late style, to the kind of Parellelist fusion of image, style, and meaning that he was simultaneously achieving in the macrocosmic late views across Lake Geneva.

Mondrian was born two decades later than Hodler and Nordström, and one decade later than Munch, Willumsen, and Gallen-Kallela. When, around 1907–8, he broke free from the Dutch Naturalist tradition, he entered an art world very different from the one that had challenged the older northern Symbolists around 1890. Post-Impressionism, Symbolism, and Synthetism were bearing fruits that neither Gauguin, Seurat, Cézanne, and Van Gogh on the one hand nor Munch and Hodler on the other would necessarily have understood, except perhaps in a theoretical way. It was one thing to realize that pictorial meaning could be enriched by an imaginative manipulation of line, form, and colour; it was another to take a further step and attribute to the formal vocabulary of art its own expressive power, independent of subject matter. It took a younger generation to discover and put into practice what in retrospect appear to have been the inevitable consequences of the work of the Symbolist generation. Mondrian's own development, from his rejection of Naturalist values beginning in 1907–8 to his discovery of Cubism in 1911, constitutes a review of Symbolist art, particularly Symbolist landscape painting, as a necessary foundation, theoretical and practical, for his subsequent journey of discovery into pure abstraction.

During those few years around 1910 Mondrian rapidly absorbed from his contact with the Dutch "luminists," such as Jan Sluyters and Jan Toorop, the more advanced stylistic techniques and the brighter palette of both Neo-Impressionism and Fauvism. Yet even when his stylistic sources were French, Mondrian seemed little interested in the immediate sensual and aesthetic pleasures of form and colour, as was Matisse, for instance. Instead he strove for monumental intensity and formal clarity, confirming his interest in more profound and solemn values that could be revealed by exposing the permanent structures of nature. His choice of motifs and his anti-Naturalist monumental treatment of them have caused him to be compared to both Hodler and Munch: these comparisons could be extended to other northern Symbolist landscape painters, though there is no evidence that Mondrian had contact with the work of any of these artists. In addition,

as Rosenblum has noticed, "three of his most consistent iconographical motifs – a bleak and uninhabited landscape, a frontally viewed church facade, an infinite vista of the sea – are precisely those which most inspired Friedrich."[43]

Until 1907–8 Mondrian worked consistently under the strong influence of the naturalistic Dutch landscape tradition as practised by the Hague school and Amsterdam "Impressionists" such as George Breitner. As Robert Welsh suggests, Mondrian's stylistic development during this period "might just as easily be explained as reflecting a national resistance to, as a lack of opportunity to experience foreign developments first hand."[44] The Hague school was considered the national school *par excellence*; it represented a still vital tradition of native Dutch painting which through its long course had influenced most major international movements and was consequently considered equal to any other, and there seemed little reason to deviate from it.[45] A curious exception to most of Mondrian's early activity is a small group of works from the late 1890s represented by *Church at Winterswijk*, 1898–1900 (private collection) (no. 94) and *Woods*, 1898–1900 (no. 95). These may depend entirely on Mondrian's borrowings from Dutch Symbolist and art-nouveau sources, from Toorop and Floris Vester;[46] or their self-conscious concern with compositional principles may, as Herbert Henkels suggests, "be traced back to his highly intensive drawing training, since the principles and practice of composition and perspective took pride of place in the particular text books that he would have used."[47] However, they also strike significant similarities with contemporary northern landscape painting precisely because their compositions undermine that illusion of easy entry into the space of the picture that was so dear to Hague-school painting.

Church at Winterswijk, a gouache from 1898–1900, clearly belongs to the visionary realm of Symbolist landscape and compares in many particulars to Sohlberg's *Night* (no. 72) and *Ripe Fields* (no. 67), both of which are almost contemporary. The preparatory sketches and an etching that precede Mondrian's gouache are all quite naturalistic studies viewed from the backyard of Mondrian's parents' home. The gouache, which is a composite of the indi-

vidual sketches, has, on the contrary, imposed near-symmetric order on their relatively casual point of view. Like Sohlberg, Mondrian has marked off his foreground plane with a thin screen of trees and bushes, the network of branches and a contorted leafless hedge forming an open pattern of Gothic interlace through which we must peer across a band of flat green field to see the pale blue, almost visionary silhouette of the centrally positioned church, with its pinnacled cross that marks the very centre of the sky. While Mondrian's forms are as rooted in observed reality as Sohlberg's, he has subjected his drawing to subtle stylization, the twisting of the branches determined as much by a desire for linear patterning as by actual appearances. In the rendering of the field, the village houses, and the church, detail has been played down and essential geometric shape stressed, in a way that is different from the simplifications in the related etching, where the regular crosshatching stands as a sign for the rich texture of observed reality. Thus, like Sohlberg, Mondrian works with several anti-naturalistic formal tensions, contrasting detailed linear precision and abstracted form, and distorting traditional spatial continuity. More is at stake in *Church at Winterswijk* than his other Hague-school preoccupations can account for. The flattened pattern of intertwined branches, of course, becomes a common motif, culminating in the expressionistic tree paintings of 1908 and the subsequent Cubist ones, though by then the different spatial layers, so significantly distinguished here, will have become fully integrated. A look forward should, however, be balanced by a backward glance and a reminder that Sohlberg and Mondrian, unbeknownst to one another, at this moment share similar affinities to Friedrich, though their shared emphatic delimitation of the foreground plane is a device more common to the end than the beginning of the nineteenth century.

Woods, 1898–1900, stands apart from the work inspired predominantly by the Hague school in a somewhat similar way and finds a comfortable place alongside the many contemporary forest pictures with their parallel vertical tree trunks. The simple colour reductions and the flattening linearity of the drawing are reminiscent of the Nabis, Serusier, and Denis, but the forest itself, with its irregularly dispersed trees through which shines a heavy,

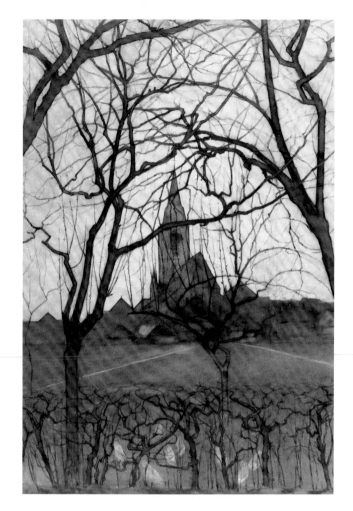

94
Piet Mondrian (1872–1944) Dutch
Church at Winterswijk, 1898–1900
Gouache. 75 × 50 cm
Private collection

almost palpable light, links it more with contemporary northern works. The quite abrupt lifting up of the ground and the viewpoint focused on the lower trunks force an intimacy with the subject matter with which we are familiar from Fjaestad, Gallen-Kallela, and later Hodler.

There is also a pronounced frontality to the composition, in surprising contrast to Mondrian's own later forest interiors, such as his 1906 drawing *Forest near Oele* (Gemeente museum, The Hague) which is traditionally picturesque. The earlier watercolour is in fact much more modern in feeling than the 1906 drawing and is the real predecessor for the painting *Woods near Oele*, 1908 (no. 98), from Mondrian's post-Naturalist period. Perhaps not

95
Piet Mondrian (1872–1944) Dutch
* *Woods*, 1898–1900
Watercolour / gouache. 45.3 × 56.7 cm
Gemeentemuseum, The Hague

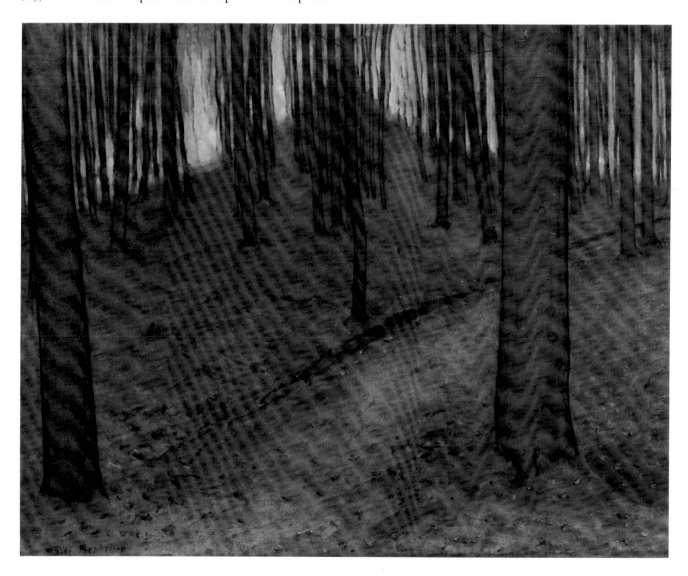

much more should be made of these excursions into Symbolist landscape other than to acknowledge them as forward-looking anomalies within Mondrian's general development, somewhat like Hodler's 1885 *Beech Forest*, the implication of which he will only later understand.

Although in the intervening years Mondrian's work was devoted to the careful study of natural appearances, he eschewed the kinds of compositions favoured by painters of the Hague school, which quite unconsciously drew the viewer into the space of the painting. Even in his Naturalist work Mondrian liked to draw attention to the construction of his pictures, often using planar designs and motifs with water reflection, which allowed him to establish symmetry across a horizontal axis. Such structural decisions constitute the steps with which, seen in retrospect, Mondrian would proceed with unwavering logic toward abstraction. Mondrian's activity between 1905 and 1908 has also been called the "period of the night

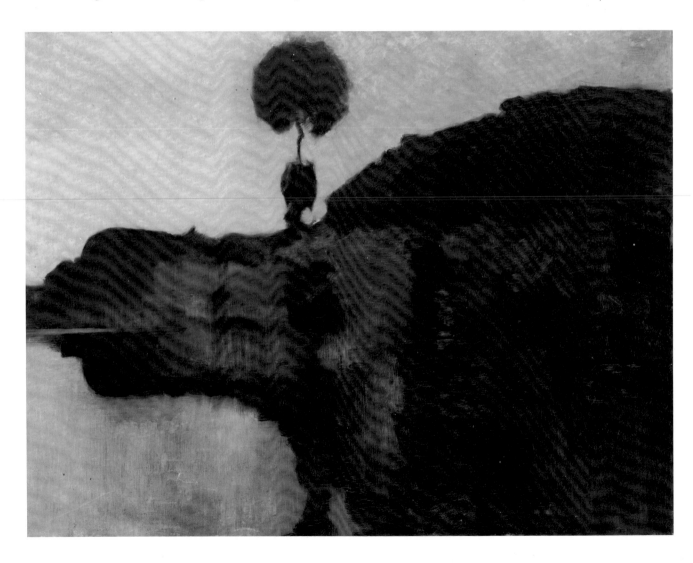

96
Piet Mondrian (1872–1944) Dutch
* *Evening on the Gein*, 1907–8
Oil on canvas. 65 × 86 cm
Gemeentemuseum, The Hague

97
Piet Mondrian (1872–1944) Dutch
* *Trees on the Gein, with Rising Moon*, 1908
Oil on canvas. 79 × 92.5 cm
Gemeentemuseum, The Hague

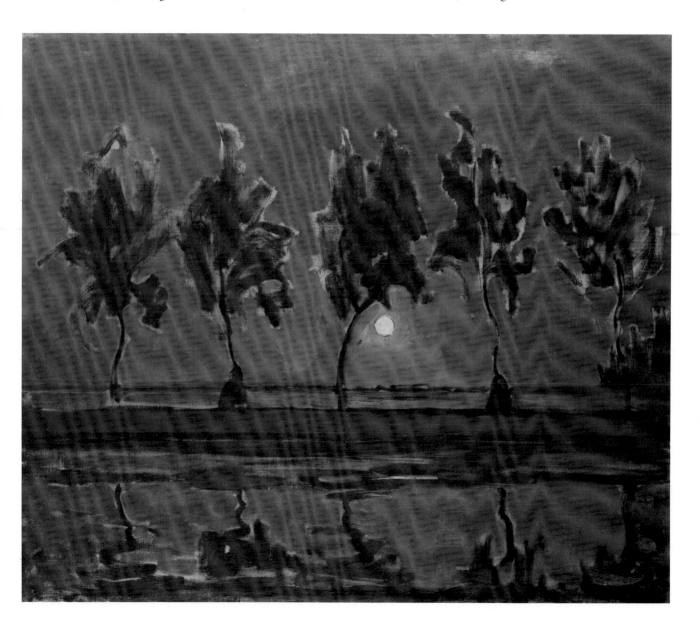

landscapes," because of the predominance of evening settings, devoid of human presence and filled by stillness and loneliness.[48] In their evocative atmosphere these paintings are closely related to Scandinavian mood painting from the late 1880s; they seem to have helped Mondrian achieve the transition from Naturalism to Symbolism in much the same way. We note, for instance, in *Evening on the Gein*, 1907–8 (no. 96), how twilight has wiped out details and organized the landscape into a simplified, almost undifferentiated shape, broken only by a single tree. In his essay in dialogue form from 1919–20, "Natural Reality and Abstract Reality," which constituted a defence of pure abstraction, Mondrian argued his case with a retrospective reference to the first discovery of pure relations in the landscape itself. In effect he was also giving a rationalized summary of his own painting experience in the final years of his nature-based work and of his discovery of both underlying formal order and spiritual meaning. As he notes, it is "particularly now that night has come, and the details are effaced; all has become flat."[49] In another scene in the essay we learn that "while natural roundness, in a word, corporeality, gives us a purely materialist vision of objects, ... the flat aspect of things makes them appear much more inward."[50]

In *Evening on the Gein* the symmetry of the reflections in the water across a horizontal axis contributes to the flattened severity of the composition, a scheme Mondrian would apply more rigorously in *Trees on the Gein, with Rising Moon*, 1908 (no. 97), a work closely related in format to Monet's paintings of poplars from the 1880s. Mondrian's composition of basic horizontals and verticals predicts the universal structure of Neo-Plasticism. But the contorted forms of the trees silhouetted against a dull red sky impart a mood of intense anguish, which is reminiscent of Munch in the 1890s and also marks the painting as a red counterpart to Scandinavian Blue Painting.

Trees on the Gein, with Rising Moon also recalls the setting for Scene II of "Natural Reality and Plastic Reality," which Mondrian describes as follows: "Capricious forms; on the clear sky with moon, the trees stand out in black relief." One of the participants in the dialogue reads into these capricious natural forms "all sorts of heads, living forms." The five animated trees arranged frieze-like across the front of the picture recall Hodler's preference for an odd number of figures in his monumental compositions, not only because the general impression is enhanced by repetition, but "because an odd number heightens the order of the picture and creates a natural centre within which I am able to concentrate the expression of all five figures."[51] In Mondrian's painting the middle tree leans over protectively, pulling in under its arching trunk the moon which has filled the atmosphere with red lunar light. In his 1919–20 essay Mondrian argued that both a red moon and capricious forms are tragic.[52] Neo-Plasticism would later overcome the tragic of lunar red by balancing it with its opposite blue so as to force attention onto eternal relationships rather than transient particulars, such as emotions and moods; but in 1908 that was not yet Mondrian's programme.

Mondrian's definitive break with Hague-school painting, however, probably occurs in *Woods near Oele*, 1908 (no. 98), which in several ways sums up central themes of northern Symbolist landscape painting. It is in the tradition of Blue Painting, it is a sunset subject, and it is a forest subject in the manner of Hodler's *Beech Forest*, Munch's *Summer Night's Dream (The Voice)* (no. 57), and Sohlberg's *Fisherman's Cottage* (no. 74). Like its predecessors, Mondrian's painting is dominated by a frontal plane of tall straight tree trunks that define the edge of the forest, and through them we peer toward the light of the setting sun. Mondrian has retained some capricious forms, however: the two leaning trees on the right (taken directly from nature as we can tell from the 1906 drawing of the subject) ease the transition to the round form of the sun, with its bright swirling Dionysiac force that seems to animate the attendant trees and counterpoint the otherwise solemn, puritanical rectitude of the rest of the forest. The critic Israel Querido described the symbolic content of *Woods near Oele* and its use of bright colours in exultant terms as "a veritable victory of the cosmic forces of light over those of fear and darkness."[53] Mondrian seemed quite receptive to Querido's emphasis on the symbolic content of the painting and also his interpretation that it represented an important shift in his stylistic development, a shift no doubt he related to the increasing interest in spiritual matters which led Mon-

drian to join the Dutch branch of the Theosophical Society in May 1909. Theosophical teaching would prove crucial in assisting him to construct a significant intellectual rationale for the evolution toward abstraction which was already developing a purely artistic momentum within the work itself.

Woods near Oele is constructed of long fluid strokes of the brush laid down side by side with equal material substance whether describing objects or the spaces between them. With obvious exceptions the strokes follow

98
Piet Mondrian (1872–1944) Dutch
Woods near Oele, 1908
Oil on canvas. 128 × 158 cm
Gemeentemuseum, The Hague

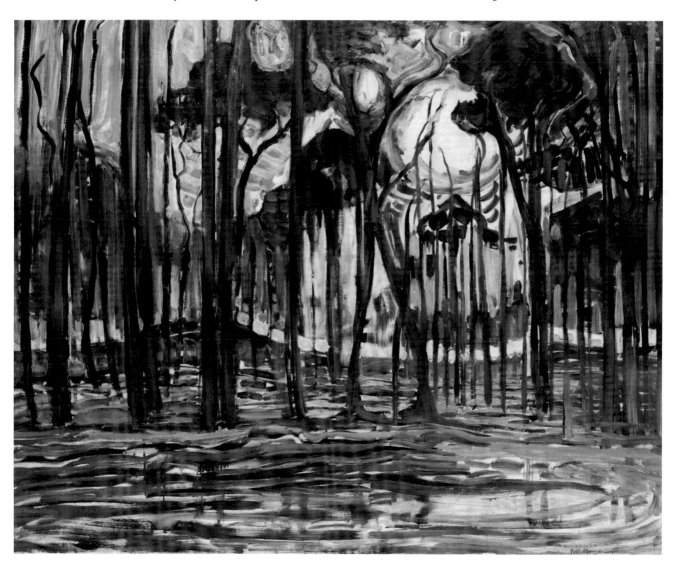

either the verticality of the forest, the horizontality of the ground, or the circular radiance of the sun, but with expressive force as well as descriptive purpose. Though in the foreground they hover ambiguously between being abstract and being referential, singly they tend to identify whole forms; thus they embody on a grand scale the movement and energy of nature and thereby help account for the monumentality of the painting as a whole. In the subject matter and in the way in which he has infused all the long fluid brush strokes – tautly vertical, languidly

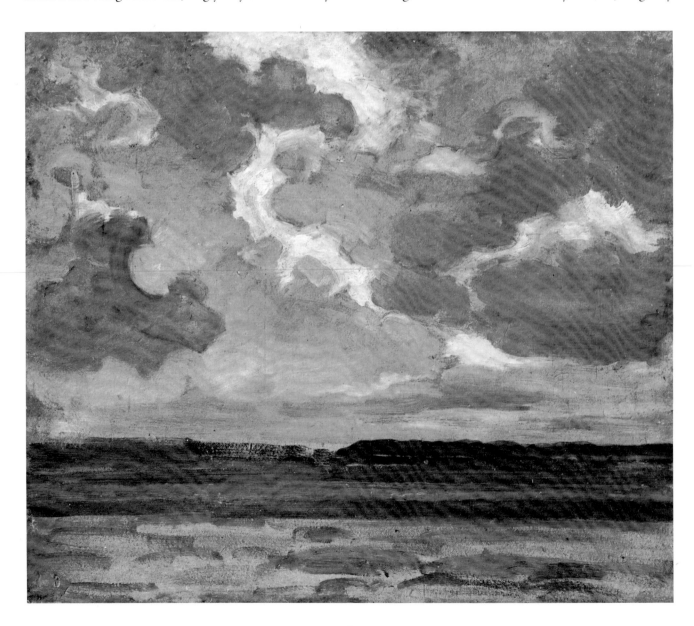

99 (opposite)
Piet Mondrian (1872–1944) Dutch
* *Evening Sky*, 1907–8
Oil on paper laid on canvas. 64 × 74 cm
J.P. Smid, Art Gallery Monet, Amsterdam

100 (below)
Piet Mondrian (1872–1944) Dutch
* *Sea after Sunset*, 1909
Oil on canvas. 41 × 76 cm
Gemeentemuseum, The Hague

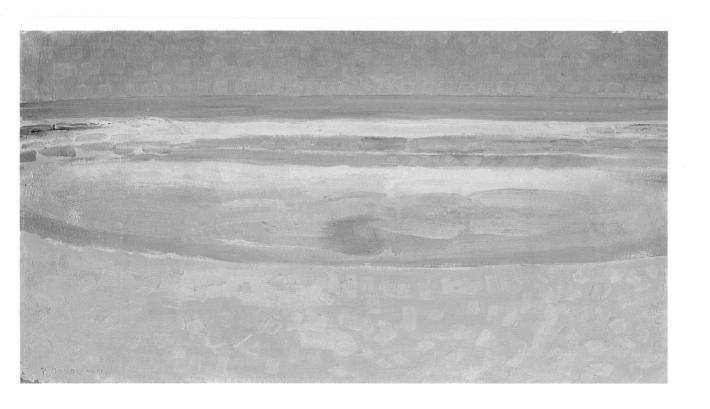

horizontal, or radiantly circular and diagonal – with sharply focused expressive and emotional content, Mondrian establishes close affinities with Munch, even though he may never have had first-hand contact with the work of the Norwegian artist.

A comparable monumentalized transformation of a traditional piece of Dutch subject matter may be seen in *Evening Sky*, 1907–8 (no. 99), a simple luminous oil sketch of a bleak and uneventful flat landscape set off against a broad cloud-filled sky. Whatever the affinities with earlier Scandinavian Symbolist subjects, the flat, loosely executed brushwork in the foreground, as much as the subject matter, establishes the grandeur of the conception and thus anticipates the more radical use of a similar technique in *Woods near Oele*.

Evening Sky also sets the scene for *Sea after Sunset*, 1909 (no. 100), an even more radical departure, in which the infinitude of nature becomes re-experienced, not merely as descriptive fact, but as an idea that requires yet another step in liberating painterly means from representational obligations. This realization was made possible by Mondrian's experience of the endless breadth of the sea on the island of Walcheren, to which he began yearly trips in 1908. For the first time he turned his back on man-made landscapes and confronted a natural setting comparable to the wilderness world of high mountains and deep virgin forests of other northern artists. In Rosenblum's words, he found himself "on the very brink of the most elemental mysteries of nature ... [left] alone to meditate on the infinite oneness of sea, sky and sand." The "haunting solemnity"⁵⁴ of the ocean pictures that result are entirely commensurate with the sensibility of Prince Eugen's *Still Water* (no. 41), Munch's views over the Norwegian fjords with the sun or moon hovering on the edge of the horizon, and Hodler's panoramic views of Lake Geneva. As in Hodler's late *Sunset on Lake Geneva* (no. 85), in *Sea after Sunset* the foreground shoreline also curves, lifting at the lateral edges of the canvas, as if somewhere outside peripheral vision it will swing around to join the horizon line and form a mystical circle of completeness.

But if such comparisons to Hodler and the Scandinavians still remind us of the general ambiance in which

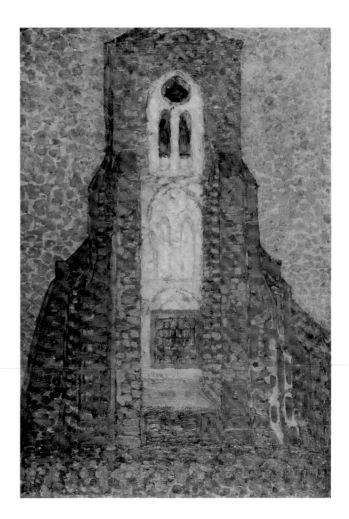

101
Piet Mondrian (1872–1944) Dutch
* *Church at Zoutelande*, 1909–10
Oil on canvas. 90.7 × 62.2 cm
Canadian Centre for Architecture, Montreal

these Symbolist landscapes were produced, they also begin to lose their relevance, because in his last pre-Cubist landscape-based paintings – the ocean views, the church facades, the sand dunes, and so on – Mondrian has begun to cross a threshold into a realm of aesthetic thought that

was inaccessible to his older northern contemporaries. Thus, while one can perceive *Sea after Sunset* in depth, the eye moving from close-up naturalistic particulars to tranquil resolution in the peaceful infinity of the horizon line, there is another reading that is perhaps stronger. The pointillist paint application across sand and sky, the comparable painterly treatment of the sea, and the simple compositional order give to the painting a surface unity of a more purely abstract kind, which stands as a formal sign for the unity of nature. Heretofore the balance in Symbolist landscape painting was usually tipped in favour of the character of the motif; in Mondrian the idea begins

to assume its own abstract independence. In *Sunset on Lake Geneva*, Hodler powerfully evokes the light, the atmosphere, and the things of nature and thereby reiterates their relative location in space. In Mondrian colour – the

155

102
Piet Mondrian (1872–1944) Dutch
* *Dune VI*, 1909–10
Oil on canvas. 134 × 195 cm
Gemeentemuseum, The Hague. On extended loan to
Solomon R. Guggenheim Museum, New York

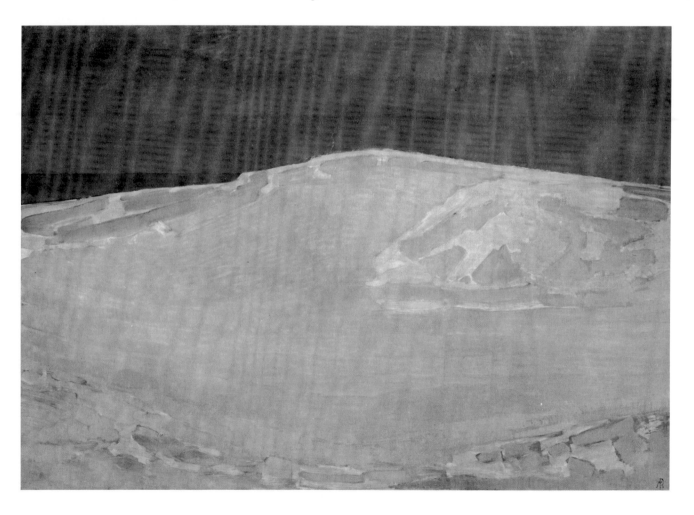

156 103
 Piet Mondrian (1872–1944) Dutch
 * *Dune IV*, 1909–10
 Oil on canvas. 33 × 46 cm
 Gemeentemuseum, The Hague

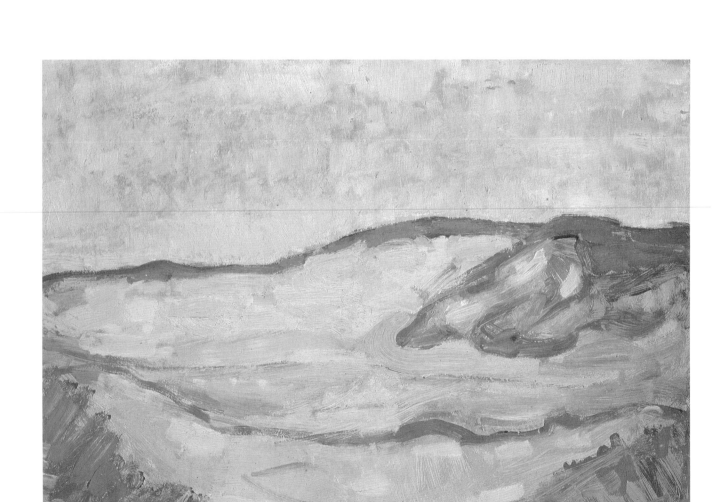

yellow of the sand and the blue of the sky – has become abstracted from its natural derivatives and assumed an independent formal life.

Nevertheless Mondrian follows the example of his Symbolist landscape contemporaries when he shifts his perspective from panoramic scannings to extreme close-up viewpoints. If the subject matter of a centralized church in his *Church at Zoutelande*, 1909–10 (no. 101), recalls Sohlberg's *Night* (no. 72), then Mondrian has approached so near his motif that it entirely blocks off our view of its surroundings and dominates as an uncannily powerful personalized presence. Mondrian has retained some interest in naturalistic phenomena, distinguishing between the shaded left and the sunlit right sides of the church front and varying the density of his pointillist paint application relative to building facade and sky. But the overall consistency of the paint surface establishes its own independent unity. And if the geometric clarity and hieratic frontality of the church facade reveal "a spiritual skeleton of transcendent order [which] lies beneath the transient, material surface of things,"[55] then this is achieved all the more powerfully because of the unanticipated immediacy and coincidence between the motif as represented and the purely pictorial form into which it has been fitted.

The sand-dune pictures from 1909–10 are another version of extreme close-up monumentalizing in which the viewer loses touch with the normal scale of things. Even in so small a painting as *Dune IV* (no. 103) the sand mountain looms large and could vie for power with Hodler's peaks did it not have so rounded a profile. *Dune VI* (no. 102), despite its more advanced style, by its sheer size belongs in the ranks of monumental mountain painting as established by Willumsen, Sohlberg, and Hodler. Perhaps coincidentally there is a curious similarity between the shapes of the yellow patterns of the sunlight both at the crest and at the base of the sand dune, sometimes semi-biomorphic and sometimes near-geometric, as if Mondrian has subjected natural observation to a process of stylization comparable to Willumsen's treatment of the snow patches and water reflections in *Jotunheim*. The sun patches, like the halos of clouds in Hodler's mountain portraits from around 1911–12, form a great oval that seems to lift the dune out of its seaside context and imbue it with a completeness and self-identity that speak of timeless and universal meaning.

In their extreme economy of means Mondrian's sand dune and shoreline paintings come as close as possible to abstraction within the confines of the transcendent Naturalist tradition which, as Rosenblum maintains, stretches back to the elemental economy of Friedrich's *Monk by the Seashore*, 1809 (Staatliche Schlosser und Gärten, Schloss Charlottenburg, Berlin). In his revelation of structures that are the permanent attributes of the natural world, Mondrian is more absolutist than Hodler and the Scandinavians, who searched nature for counterparts for their emotional and psychological states of mind. As we have seen, they all sought a common point of departure in subject matter drawn from remote and unspoiled natural settings, and in the appearances and moods of sunsets and twilight, and all set out with a yearning to give expression to an invisible world of experience which Naturalism and Impressionism, in their fresh discovery of how the world appeared, had momentarily set aside. Mondrian would subsequently wish to look for order behind both the weather of landscape and the weather of personal emotions, both of which for him constituted the tragic of the particular; he, therefore, set out on a yet longer road in pursuit of an art that would uncompromisingly deal with pure objective relations.

Canada:
The Group of Seven, Tom Thomson, and Emily Carr

It is not so important that all small nations make immediate and astonishing contributions to the great culture ... It is, on the contrary, of major importance that they develop independently and logically from their own roots, working with subjects which especially suit them – in order little by little, and in an original way, to grow part of the larger organism, and address its variety from an original and vital perspective.
Richard Bergh[1]

One of the reasons that landscape painting is the typical expression of new movements in new lands is in the fact that the artist is, intuitively, the medium through which this knowledge (so essential to growth) of environment must flow into consciousness ... Today ... wilderness is understood as a source of power.
Arthur Lismer[2]

In the mythology of Canadian art the Group of Seven is acknowledged to have formed the first genuine school of Canadian art and to have been the first to paint the Canadian north. However many earlier artists devoted themselves to the Canadian landscape, the Group of Seven not only identified its wild and rugged character as uniquely Canadian, but also recast it in a stylistic form that would determine, for this century at least, how Canadians perceived their landscape. Out of trees, rocks, and lakes the members of the Group also established the basic symbols of national identity, however romantic and unrelated to the realities of contemporary life these may have been. In this they did for Canada what Nordström and the national Romantic movement had done for Sweden two decades earlier, with sunsets and midsummer twilight.

The Group of Seven was formally organized only in 1920. Its original members included Lawren Harris, A.Y. Jackson, J.E.H. MacDonald, Arthur Lismer, Frederick H. Varley, Frank Johnson, and Franklin Carmichael. Their period of joint activity, however, began during the prewar years, between 1911 and 1913, when the various future members, and Tom Thomson, began to assemble and work together in Toronto. Tom Thomson, who made decisive contributions to the Group and long remained a figure of inspiration, drowned mysteriously in 1917. The Group disbanded in 1931, reforming as the Canadian Group of Painters, in order to establish a broader national base.

In *A Canadian Art Movement* (1926), the first comprehensive history of the development of the Group of Seven, F.B. Housser remarks somewhat strangely: "The story of the rise of the Scandinavian native school of painting sounds like an echo of the story of our own."[3] We may assume that the chronological inversion of his simile, whereby a later source produces an earlier echo, was not entirely innocent, but something of a deliberate obfuscation designed to acknowledge certain similarities between Scandinavian painting and the Group of Seven without having to concede any essential dependence of the Canadians on their Scandinavian predecessors, which might cast into doubt the formers' originality. It was, of course, a prevailing myth concerning the Group that its work came about because its members divested them-

selves of "foreign-begotten techniques" and turned freely and receptively to the native landscape itself for direction. Housser said as much in an article in *Yearbook of the Arts 1928–29*: "The essential difference between the Canadian movement and art movements in other lands was that its inspiration was one of the *country* ... [and] drew its life from certain elements belonging especially to Canada, primarily to the North, with all its peculiar influence of sky, water and land." The Canadians had created a peculiarly native expression because "there were spiritual moods and physical effects in Canadian landscape for which no aesthetic equivalent existed in the art of Europe, because European painters had never been called upon to find such equivalents." It is true, he admits in this later context, that Scandinavians have similarly drawn their inspiration from the North, but, even so, scarcely any Scandinavian works had been seen by the Canadians.[4]

Housser was not incorrect in maintaining that the artists who would unite to form the Group of Seven in 1920, as well as Tom Thomson, had seen very little Scandinavian art. Only Lawren Harris and J.E.H. MacDonald had, and on only one occasion when they saw the exhibition of contemporary Scandinavian art that visited the Albright Art Gallery in Buffalo in January 1913. For both Canadian artists, however, the experience of that exhibition was seminal and long-lasting and celebrated in reminiscences long after the fact. That their confrères, who knew about Scandinavian art only at second hand, should be less enthusiastic is understandable; the presumption of a European source interfered with the most fundamental conception of the new painting, namely that it grew out of an unprecedented, original, and immediate response to the uniqueness of the Canadian landscape.

But even A.Y. Jackson, who consistently maintained that the Group had learned everything from the land itself, in 1919 could speak of a similarity of approach to that of the Scandinavians. He indicated that the Group "frankly abandoned any attempt after literal painting and treated our subjects with the freedom of the decorative designer, just as the Swedes had done, living in a land where the topography and climate are similar to our own."[5] Later in life he acknowledged that the Buffalo show was much discussed when he arrived in Toronto in May 1913

to meet MacDonald, Lismer, and Varley, as well as Harris, with whom he began to share a studio in 1914.[6] But as Robert Stacey has described it, it is with "an almost grudging, offhand tone" that, at age eighty-two, Jackson accounts for the genesis of the Group: "What had started all this [i.e., the interest in Canadian subject-matter] was that MacDonald and Harris had become excited about a show of Scandinavian paintings they had seen. Now, the north of that country is much like Canada, and these fellows from over there were painting their north country the way that MacDonald and Harris thought we should paint ours. I guess if there was a starting point for the Group of Seven, that would be it."[7]

Both MacDonald's and Harris's accounts of the meaning and significance of the 1913 trip to Buffalo have been widely reproduced. They are examined here in conjunction with precisely the kind of Scandinavian painting that had impressed them. MacDonald's account was presented in a lecture devoted to a general survey of modern Scandinavian art, delivered at the Art Gallery of Toronto (now the Art Gallery of Ontario) on 17 April 1931.[8] But it grew directly out of his experiences from eighteen years earlier when he had seen the Buffalo exhibition. In his recollections he wanted to recreate the exhibition for his audience and give them a sense of the "affinity of inspiration" that the Canadians had discovered to exist between Scandinavian and Canadian artists. He and Harris were already prepared to respond sympathetically to contemporary Scandinavian art: they "were full of associated ideas," based not on any direct experience of Scandinavia, but on "feelings" about their own country, "of height and breadth and depth and colour and sunshine and solemnity and new wonder," for which there were correspondences in the Scandinavian pictures. The natural aspects of both parts of the world were similar, and also the "general attitude" of the Scandinavian artists paralleled their own. The resemblances were so strong that, "except in minor points, the pictures might all have been Canadian." But paintings such as these had not yet been produced at home, and thus, as MacDonald and Harris concluded, "we felt, 'This is what we want to do with Canada.' "

What pleased the Canadians were the virtues that had become international commonplaces for Symbolist land-

scape painters in the North. Scandinavian art had about it "a sort of rustic simplicity ... It seemed an art of the soil and woods and waters and rocks and sky ... with its foundations broadly planted in the good red earth." MacDonald's own work, as he moved tentatively toward a Canadian expression, had been described in similar terms by the painter and critic C.W. Jefferys in 1911: "native – as native as the rocks, or the snow, or pine trees or lumber drives that are so largely his themes."[9]

The Scandinavian work in the exhibition was "not at all Parisian or fashionable." On the contrary, it was "indigenous ... an art of the north, rising out of different conditions from that of Greece or Rome" (MacDonald uses the example of the Neo-Classical sculpture of Thorvaldsen as a foil to the general rule that Scandinavian art is indigenous). "It is the difference between olives and vineyards and heather uplands and the cliffs of fjords, the Isles of Greece and the rocks and birch groves of the Baltic."

MacDonald's praise of Scandinavian art for not being fashionable must be read in the context of his 1931 antipathy to more recent manifestation of modern art and "the frosty condescensions of super critics on *volumes* or *dimensions*, and other art paraphernalia." Scandinavian art, presumably like that of the Group of Seven, could be "understood and enjoyed without metaphysics." It was, and this is the essential point, the work of "a lot of men not trying to *express themselves* so much as trying to express something that took hold of *themselves*. The painters began with *nature* rather than with *art*." Therefore "its notes have been Night, Winter, Spring, Wild Life, The Home, Our Own People, and in general it has run the elemental rhythms of sky, waves, land and trees." In the same way as the Scandinavians, concludes MacDonald, he and his associates "have our feet on Canadian earth and live in the Canadian sun," and correspondingly their art should begin at home and join Scandinavian work in being "true souvenirs of that mystic north round which we all revolve."

Harris's summation of the significance of the Buffalo visit took a more succinct form in a lecture on the genesis of and the ideas surrounding the Group of Seven, delivered at the Vancouver Art Gallery in 1954:

MacDonald and I had discussed the possibility of an art expression which would embody the varied moods, character and spirit of this country. We heard there was an exhibition of modern Scandinavian paintings at the Albright Gallery in Buffalo – and took the train to Buffalo to see it. This turned out to be one of the most exciting and rewarding experiences either of us had. Here was a large number of paintings which corroborated our ideas. Here were paintings of northern lands created in the spirit of those lands and through the hearts and minds of those who knew and loved them. Here was an art bold, vigorous and uncompromising, embodying direct first hand experience of the great North. As a result of that experience our enthusiasm increased, and our conviction was reinforced.

From that time on we knew we were at the beginning of an all-engrossing adventure. That adventure, as it turned out, was to include the exploration of the whole country for its creative and expressive possibilities in painting.[10]

Though put down on paper many years after the fact, both accounts coincide on all essential points. The Scandinavian pictures spoke to what MacDonald called their own "associated ideas" and arose out of a sense of an "affinity of inspiration" between the two groups of northern artists. They helped focus nascent ideas about painting the Canadian landscape and gave moral support to the validity of the enterprise by providing convincing and impressive models of how it could be done. The Scandinavians seemed to reinforce the belief that a native art in the North could arise only out of a close affinity with and love for the essential characteristics of one's country. For both the Scandinavians and the Canadians these characteristics constituted the natural elemental forces to be discovered only in the northern wilderness, which, as MacDonald also understood, was a landscape distinct from the cultivated south and therefore requiring different means to represent it.

Two issues are critical to the examination of the relationships between the Scandinavian and Canadian artists. The first is the nature of the "affinities of inspiration" between the two groups of artists, which are much more striking than Housser, Harris and MacDonald may have suspected. The second is the specific role that the works

included in the exhibition had in the development of Tom Thomson and the Group of Seven. The importance of the exhibition cannot be discounted. The beginnings of a new movement or direction in art can seldom be pinned down to one source or a single occurence, but it is possible that the Buffalo trip was crucial in crystallizing and focusing the many preliminary and preparatory steps, however uncertain, that went before. Native Canadian landscape painting seems to have found its indigenous style and direction immediately following the 1913 exhibition, so that the work of the Group looks discernibly different after the exhibition, as if a mantle of traditional, more southern European stylistic domination has finally been cast off. This is true, despite objections that there were many "northern-minded" Canadian artists before 1913. After all, Nordström became "Swedish-minded" long before he ceased to paint the Swedish landscape in a French Impressionistic manner.

In deciding to visit the exhibition Harris and MacDonald seem to have had some premonition that Scandinavian art had something substantial to say to them. Both speak of the Scandinavian exhibition as having confirmed thoughts they had already discussed, rather than inspiring them with ideas new in themselves. Several Canadian commentators had indeed earlier expressed interest in Scandinavian art. C.W. Jefferys (who had recognized the "native inspiration" in MacDonald's exhibition in 1911) had in 1899, after his return to Canada from seven years in the United States, begun to promote ceaselessly the depiction of Canadian historical and scene subjects.[11] He attributed his becoming "northern-minded" to his first observation of Canadian and Scandinavian affinities at the Columbian Exhibition in Chicago in 1893: "Here we saw the work of artists dealing with themes and problems of the landscape of countries similar in topography, climate and atmosphere to our own: snow, pine trees, rocks, inland lakes, autumn colour, clear air, sharply defined forms." These were all subjects that might have been found in Canada: "Our eyes were opened. We realized that on all our painting, admirable as much of it was, lay the blight of misty Holland, mellow England, the veiled sunlight of France, countries where most of our painters were born or had been trained."[12] Robert Stacey, who

has attempted to trace pre-1913 Canadian-Scandinavian contacts, cites the observations of another Canadian critic, W.A. Sherwood, who drew attention to "the brilliant sunlight and atmospheric clearness of the Norwegian painters" in Chicago and urged the development in Canada of "a new school of National painters" dedicated to the accurate depiction of the characteristic features of their country.[13] Another commentator, J.A. Radford, used the same occasion to call for an art that was "purely Canadian with the very scent of the soil," but simultaneously decried the absence of "historical, allegorical, figure, cattle, humorous, dramatic or pathetic subjects" by Canadian artists. His comments remind us that these earlier conceptions of Canadian native art probably had little in common with what MacDonald, Harris, Jackson, Thomson, and the others were to produce twenty years later. The 1893 observers may well have been struck by the similarity of subject matter and light characteristics in northern Europe and Canada, but the artists they saw and referred to, Zorn, Liljefors, Larsson, and Thaulow, would have been working in Naturalist or Impressionist styles.

Nevertheless, the notion that Scandinavian art had valuable lessons to teach Canadians seems to have persisted. James Mavor, a professor of political economy at the University of Toronto, may have conveyed his enthusiastic experience of Scandinavian art to the future members of the Group of Seven in encounters at the Arts and Letters Club in Toronto. He recalled in his autobiography, published in 1923, having seen paintings in the Ateneum in Helsinki in 1899 (perhaps by Gallen-Kallela or Halonen?) which were remarkable "because of the extraordinary fidelity with which they reproduce in paint the peculiar character of the northern atmosphere." In a description that brings to mind Gallen-Kallela's *Kullervo's Curse* (no. 24) Mavor advises on the special features of the North to which artists ought to give attention: "the clearness of it and the sharpness of the land and even of the cloud contours which result from this clearness ... When this is done with due skill in drawing and in colour the effect is vastly different from the rendering of any landscape in more southerly latitudes." The main point of his argument, a conclusion borne out in the new cen-

tury by Harris and MacDonald, is this: "An intelligent painter of atmosphere, if he paints in northern regions, will inevitably paint in a manner at least approximating to the manner of the Scandinavians."[14]

Until 1913, however, despite the many calls for a truly native Canadian art, results were tentative. Thus in the much cited review in 1910 in the London *Morning Post* of an exhibition sent to England by the Royal Canadian Academy (RCA) the writer, however much he may praise the contributions of a number of Canadians, especially Jefferys and A.Y. Jackson, nevertheless detects a considerable dichotomy between the grandeur of the vast Canadian landscape and its depiction. "At the moment," he writes, "observation of physical fact is strong, but the more immutable essence of each scene is crushed out by a foreign-begotten technique." He is not, however, really surprised that Canadians are on the whole unable to give original expression to native motifs, because their artist have had to seek "the means of expression in the ateliers of a foreign land, far from the inspiration of native history, types, and environment." Because most of the artists in the exhibition are foreign-trained, the writer can only conclude that, "when the teaching in the art schools of Canada will have reached the level of those of France and England, art in Canada may rise above" imported formulas and "move in consonance with the spirit" of the land.[15]

Thus the crux of MacDonald's achievement in his 1911 exhibition in the Arts and Letters Club, and the grounds for Jeffrey's enthusiasm, were not that MacDonald had dealt with Canadian themes, ("in themselves ... Canadian themes do not make art, Canadian or other, but neither do Canadian themes expressed through European formulas or through European temperaments"), but rather that "so deep and compelling" was the "native inspiration" that it had "to a very great extent found through him a method of expression in paint as native and original as itself."[16] That it was not a matter merely of what was depicted, but of how, was reiterated by Lawren Harris in his review of the RCA exhibition in the same year; he noticed work that was more original, vigorous, and fresh, "a true Canadian note, not so much in the choice of subject as in the spirit of the thing done."[17]

The pre-history of the Group of Seven, therefore, like that of Nordström and the Varberg group, focuses on the problem of how to paint native subjects with foreign techniques. Similarly, the distinctive qualities that defined the new painting of Tom Thomson and the Group of Seven would develop only once they applied themselves to wilderness subject matter that defied representation within prevailing stylistic conventions, whether of the Barbizon school, the Hague school, or impressionistic Naturalism. Some had confronted the problem: Maurice Cullen, for example, clearly realized the need to adapt Impressionism in order to accommodate the clearly defined forms and the vivid colours that stood out in the crisp atmosphere of a northern winter day, and he did so with results that could well have invited the same censure that Monet directed toward the Norwegian Naturalist landscapists in Oslo in 1895.[18] In general, however, available techniques and prevailing taste tended to favour subjects from the cultivated and Europeanized corners of the landscape. A.Y. Jackson's *Edge of the Maple Wood*, 1910 (no. 104), vividly impressed Lismer, MacDonald, Harris, and Thomson when it was shown in Toronto in 1911, because of its "native flavour" (MacDonald) and because it was the "freshest, brightest, most vital Canadian note in the exhibition!" (Harris).[19] But the impact must have had more to do with the vigour of its impressionistic technique, which was new in Toronto, applied to Canadian subject matter, than with any inherent native characteristics within Jackson's pastoral scene itself, which otherwise has a considerable French flavour to it. J.W. Beatty's *The Evening Cloud of the Northland*, 1910 (National Gallery of Canada, Ottawa), may have drawn attention to the grandeur of the northland, but the artist unwittingly vitiated its power by his use of a familiar muted and subtly valued palette. Paintings such as Beatty's, however, were instrumental in extending the range of Canadian subject matter further into the North so that, as Dennis Reid has pointed out in reference to Harris and MacDonald, in 1912 they "had their subject. What they still lacked was a meaningful approach, a compatible technique."[20]

As originally conceived, the Group's objective was to paint the northern landscape on its own terms – in Har-

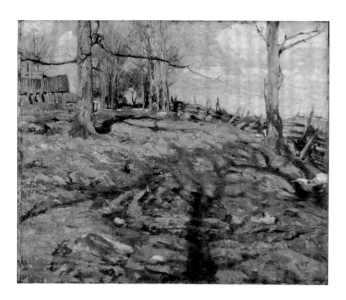

104

A.Y. Jackson (1882–1974) Canadian
Edge of the Maple Wood, 1910
Oil on canvas. 54.6 × 65.4 cm
National Gallery of Canada, Ottawa

ris's words, "to permit the country to dictate the way it should be painted."[21] The landscape was to be seen with fresh and original eyes and not through the filter of imported styles and conventions developed for other places and needs. Painting the landscape became intimately tied up with exploring it, often with the sense of being the first pioneers to set foot on new ground. Thus Mac-Donald in Algoma in September 1918 looking at the majestic site of the Montreal River and Montreal Lake for the first time: "We felt we could understand something of the feeling of the early explorers. The whole scene seemed so primeval and unspoiled."[22]

The excursions of the members of the Group of Seven, which over the years increasingly penetrated further and further into the North and eventually across the country, were undertaken with the sense of excitement of discovery that we recall from the account of the first ventures of Gallen-Kallela and the Finnish national Romantics into

Karelia: great physical hardships could be endured if they brought one closer to the spirit of the country. But, just as for the Swedes of the Varberg group, the landscape did not initially offer up its treasures willingly. First, there was the problem of the quality of the northern light, which, from as early as Jefferys's observations of Scandinavian art in Chicago in 1893, had been isolated as a specific phenomenon of northern climates and one not compatible with French-, Dutch-, or English-trained eyes. Second, there was the character of the northern wilderness landscape itself, which resisted discovery because it would not differentiate itself according to established compositional schemes.

The response of A.Y. Jackson to his native landscape is a case in point. In a polemical article in the *Montreal Herald* on 27 May 1912 decrying the predominance of Barbizon and Dutch pictures in the spring exhibition of the Art Association, Jackson berated the Canadian collector who, "living in a brilliant atmosphere, surrounded by colour, from the dazzle of white winter snow to golden autumn, finds relief in low-toned pictures, extracts his joy out of gloomy Israels, or something lost in gloomy varnish." In a similar vein, in his memoirs, *A Painter's Country* (1958),[23] he recalled his experience, in the spring of 1910, when he had returned from two years of painting in Europe: "After the soft atmosphere of France, the clear crisp air and sharp shadows of my native country in the spring were exciting." Jackson's correspondence from the spring of 1910, when he painted *Edge of the Maple Wood*, suggest, however, that the transition from French subjects to Canadian ones was not so easy. "Yesterday," he writes in late March, "it was so clear you could see the houses on Beloiel thirty miles away, while Mount Royal was quite sharply defined. Nice air to breathe, but not to sketch."[24] In contrast, a letter from October speaks more enthusiastically about the landscape around Montreal. It now seems "more painterly all the time," a point of view perhaps related to the different quality of the fall atmosphere and its harmonious colours, because, as he writes, "We have been having some hazy sunny days, while the trees are changing colour, orange, reds and browns."[25]

If in 1910 hazy sunny days lend themselves more readily

to sketching than cold crisp ones, so do familiar landscape types. There is more than an echo of Nordström's reaction to the harsh and bleak landscape of the Swedish west coast, before he came to terms with it in a Synthetist way during 1892 and 1893, in Jackson's response to the region of Georgian Bay which he first visited in 1910. A letter to his mother, written in July, is not enthusiastic about the possibility of painting the area: "I have done very little sketching, the country does not lend itself to it, and the weather has been very monotonous ... It is a great country to have a holiday in ... but it's nothing but little islands covered with scrub and pine trees, and not quite paintable ... Sketching simply won't go."[26] In late September things are much better back in the pastoral countryside around Montreal where, as we learn in another letter, he has "spent a few days in the country since I got back [from Georgian Bay], at one of my happy hunting grounds, just a sketch of undulating open country, patches of wood and meadowland."[27]

Jackson spent the period from September 1911 to February 1913 in Europe again, and in the fall of 1913 returned to Georgian Bay: "After painting in Europe where everything was mellowed by time and human associations, I found it a problem to paint a country in outward appearance pretty much as it had been when Champlain passed through its thousands of rocky islands three hundred years before."[28] The canvases and sketches from that fall he described as "direct transcriptions from nature." In *Terre Sauvage* (no. 105), painted in Lawren Harris's studio in Toronto on the basis of some of those sketches, Jackson finally threw off his European stylistic baggage and produced a picture that confronted head on the heretofore unpaintable problems of the northern wilderness. In what it rejects from Impressionism and what it establishes as essentials of the new stylistic vocabulary – a panoramic and monumentalized vision: a bold simplification of form and strength of contour; intensified colour concentrated and juxtaposed within simple forms in a manner that approaches being Cloisonist; near symmetry; a frontal orientation of basic elements (the foreground rock, the jagged tree silhouettes, in the middle distance, the royal blue sky and the heavy clouds, parallel to the picture plane); and a tendency to rush the eye over a relatively undifferentiated foreground toward the distance – *Terre Sauvage* stands at the beginning of the new Canadian movement with the same authority with which, twenty years earlier, Nordström's *Storm Clouds* and *Varberg Fort* had heralded the start of Swedish national Romanticism. Jackson called the painting "the first large canvas of the new movement" and recounts how MacDonald called it Mount Ararat because "it looked like the first land that appeared after the Flood subsided."[29]

Because the accounts of the formative years of the Group's style come from later stages of their careers, when ideological positions were fully entrenched, it is difficult to ascertain just what Jackson thought he had achieved with his Synthetist stylizations in *Terre Sauvage*. He wrote to Albert Laberge in the spring of the next year, 1914, that he was in the north country, "striving to translate ragged and uncombed nature into terms of art"; his problem seems to have been one of getting nature down the way it looks, as opposed to filtering it through the conventions of European Realist art: "It is not Corot country or Jacob Maris' land, to them it would have seemed hopeless."[30] The old Realist styles would show the northern landscape unrealistically. In the face of the wilderness, European realism is unmasked as convention and a hindrance to the problem of recording nature faithfully. Certainly there is rarely in the statements by members of the Group any acknowledgement that they were consciously stylizing nature. Their response, they seemed to claim, was intuitive, and the look of their paintings developed in accordance with "what a scene or a subject itself dictated," to quote Harris from as late as 1954.[31]

Even in the decade after the First World War, when the various members of the Group began to develop more formal ideological positions, they seldom spoke about specific aesthetic problems and tended to fall back on the formula that the style of their paintings was dictated by nature. Despite the references they allowed to the Scandinavians, for example, it was as if they were, nevertheless, naïvely oblivious of their dependence on advanced turn-of-the-century European movements and on the frank adaptations, especially by Tom Thomson, of art-nouveau designs. Any discussion of the history of the Group of Seven inevitably centres on the contradiction between fact

A.Y. Jackson (1882–1974) Canadian
* *Terre Sauvage*, 1913
Oil on canvas. 128.8 × 154.4 cm
National Gallery of Canada, Ottawa

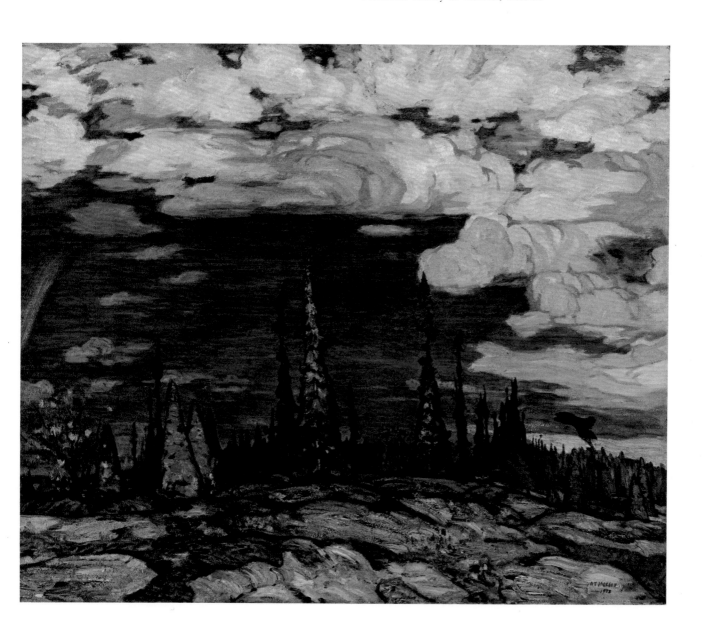

and fiction, between its members' claim to a kind of primitivistic originality and the reality that they were working in an artistic and philosophical framework with a demonstrable European pedigree.

On the meaning and purpose of the Group's work, some of its members, particularly Lismer and Harris, were somewhat more eloquent, especially during the 1920s. If the initial task had been to come face to face with nature, it was finally not nature's body that was the object of investigation. As Housser has pointed out, to comprehend it was the role of science, while "art tries to apprehend the spirit."[32] In a 1925 article on "Canadian Art" published in the *Canadian Theosophist*, Lismer corroborated the official position that the work of the Group of Seven was dedicated to the land and sharply distinguished it from art concerned with that rarefied realm of aesthetics "where the soul is anaesthetized into a peaceful submission." An art of the land, in contrast, he argued, leads to the "open air of purpose, where the free wind blows amid the trees and open space," beneath "stars displaying creative purpose." Such an art, arising out of free communion with nature, will also learn to look into the spirit of nature and observe there "a reflection of God's purpose." Art thereby comes into close kinship with religion and philosophy and will stand as a "consciousness of harmony in the universe, the perception of the divine order running through all existence." The work of an artist sensitive to the rhythms of existence will therefore project, "not an imitative outward appearance of the common aspects of life, but an inner, more noble life than yet we all know."[33]

In theoretical accounts of the relationship between the artist and nature, therefore, the Group of Seven exhibits remarkable trans-Atlantic affinities and shows itself a latter-day adherent of turn-of-the-century northern Symbolist thought. The Canadians' ideas had more immediate North American roots and sprang from enthusiastic readings of the American Transcendentalists, Emerson, Thoreau, and Whitman. Their ideas, spiritual and nationalist, were reinforced by their engagement in various mystical movements including Christian Science and Theosophy and their interest in Irish nationalist writers. As well, of course, there are important correspondences with the aesthetic ideas of Richard Bergh formulated some three decades before in defence of the Swedish national Romantic movement in painting.

In so many words the various members of the Group of Seven conceived of their art as national Romantic, not only because it was the result of their charge finally to yoke Canadian art irrevocably to Canadian subject matter, but also because it found its motivation in a mystical bonding with the land, the character of which provided the basis for common experience and, by analogy, national unity. The spiritual identification with nature then became inextricably identified with the demands of patriotism, a feeling expressed by A.Y. Jackson as early as 1914: "The Canadian who does not love keen bracing air, sunlight making shadows that vie with the sky, the wooden hills and frozen lakes. Well he must be a poor patriot."[34] The nationalist ideas of the Group were most persuasively argued by Lismer and Harris, but they were probably held by all. Witness MacDonald's statement in 1920, in terms that echo Bergh's reading of Taine: "Every country has its peculiarity of physical features, its characteristic scenery, its distinguishing climate and atmospheric effects; and out of these and other well-recognized traits of the land and their outgrowth in the life of the people has grown each country's art."[35]

In his 1925 article Lismer argued the position at somewhat greater length. Canada is not a traditional pastoral land, but rugged, vast, and untamed, perhaps untameable. Everything about it is extreme and elemental, a setting of "truly epic grandeur – no timid play for subtleties, but bold massive design." If this is the character of the country, then it also forms the character of the people: "its virility and emphatic form is reflected in the appearance, speech, action and thought of our people. It is the setting for our development, firing the imagination, establishing our boundaries. It is home land, stirring the soul to aspiration and creation."

In the 1890s Bergh had written in almost visionary ecstasy about the responsibility of the Swedish national Romantic artist, who, armed with his knowledge of his native land, was charged with revealing to his people the secret passages of their innermost being and through these lead them out onto the vast and unbroken landscape of shared character and common strengths.[36] Almost as if in

emulation, Lismer admonishes the Canadian artist: "Know also thy country, know its character, what its form, its typical contours, its wealth of beauty in river and mountain, the effects of its seasons, its rocky barren places, its fertile valleys. Become home conscious." The natural world "exists to the artist as to the religious devotee as a means of ecstasy." Its beauty will "be an ever-recurring source of sustenance to the spiritual and aesthetic life" of the inhabitants of this country, and consequently it is the responsibility of the artist to make us "nationally conscious with our environment, setting the stage for true nationality."[37]

These thoughts of Lismer, which appeared in 1925, would be elaborated in the next year, again in the *Canadian Theosophist*, by Lawren Harris in an article entitled "Revelation of Art in Canada." Harris, who was to become one of the foremost cultural nationalists of his time, had long been associated with the Theosophical movement, as were Housser and his wife, and Lismer. Harris too spoke of the informing spirit of nature and national expression in the most transcendent and mystical terms, giving to the North itself a special place in his ideology. Indeed the new painting had in it "a call from the clear, replenishing, virgin north that must resound in the greater freer depths of the soul or there can be no response." In his thought the American Transcendalist's antipathy to the urban life, which was not without influence on the Canadians, is restated in relation to the south. He uses terms which parallel the north-south juxtaposition that we have seen in the development of Scandinavian Symbolism and recall Theosophy's cultivation of the North as the site of the new renaissance. Harris contrasts Canada to the United States:

We in Canada are in different circumstances ... Our population is sparse, the psychic atmosphere is comparatively clean, whereas the States fill up and the masses crowd a heavy psychic blanket over nearly all the land. We are on the fringe of the great North and its living whiteness, its loneliness and replenishment, its resignation and release, its call and answer – its cleansing rhythms. It seems that the top of the continent is a source of spiritual flow that will ever shed clarity into the growing race of America, and we Canadians being closest to this source seem destined to produce an art somewhat different from our Southern fellows – an art more spacious, of a greater living quiet, perhaps of a more certain conviction of eternal values.[38]

Ultimately Harris and the Group of Seven argued themselves into an artistic isolationism that far surpassed that of the Artists' Union in Sweden, which in the 1890s had declared it useless to study abroad because foreign influences would only corrupt the purity of vision that the land and its character could inspire. But isolation was difficult to maintain for long in Europe. In Canada, as Jack Bush (1909–1977), who grew up and became an artist in Toronto in the 1920s and 1930s, recalled, if perhaps with some exaggeration, the dominance of the Group of Seven during that period kept younger artists ignorant of what was going on in the rest of the world until the 1940s. "They had been to Europe, to London, to France. They knew all about the Impressionists and so on and about the good American painters, Marsden Hartley and several others. They never told us where their influence had come from. Suddenly they were indigenous to Canadian soil through self-toil and all that nonsense."[39]

Lismer, for example, argued that it was irrelevant to judge Canadian art in terms of that of other countries or to compare it to modern art, because the relevance of Canadian art could be measured only in terms of how it made us "aesthetically aware of our environment." This regionalist stance led the members of the Group to overlook the artistic roots of their own style, to accept it uncritically as something almost organically growing out of the land, and never to acknowledge that it too in the end was a set of conventions developed in response to a specific new challenge. Their argument ran: as long as the land itself could continue to challenge, there was no need to think about art or what was going on elsewhere. Thus Harris's response to the problem of abstract art in a letter to Emily Carr in June 1930: "We should saturate ourselves in our own place, the trees, skies, earth and rock, and let our art grow out of these. If it becomes abstract, wholly or in part or not at all is not the paramount thing. It is the life that goes into the thing that counts." Though abstract art may have great possibilities, he argues, nature is crucial for Canadian art: to uncover

its deepest intimations and life and incorporate that into art. Abstraction may now seem natural to European artists. However, thinks Harris, "though they sever themselves from earth they are not yet, any of them in heaven." Profundity, maintains Harris, "is the interplay in unity of the resonance of mother earth and the spirit of eternity, which though it sounds incongruous means nature and the abstract fused in one work."[40]

One may perhaps discover here the theoretical roots of Harris's curious and naïve approach to abstract art, which he began to practise later in the 1930s. He would increasingly abstract individual elements of nature until presumably they would attain pure universal form. However, he did not submit space to a similar critical rethinking, or finally consider it in relation to the purely formal properties of painting in a Modernist sense. As a consequence, his so-called abstract paintings are often compromised by an uneasy coexistence of abstract forms, which have something of the force of independent symbols, and representational space. It is as if form and meaning have been severed again, as they were in academic Symbolism at the end of the nineteenth century. In the long run Harris's most successful work will no doubt be judged to be the paintings which, like northern Symbolist landscape painting from the turn of the century, attempted to integrate form and meaning through a careful balance of natural observation and Synthetist form.

How then do we evaluate the significance of the Buffalo exhibition in terms of stylistic influence on the development of the work of Tom Thomson and the Group of Seven? Looked at in broad terms, as we have seen, the Scandinavians of the 1890s and the Canadians of the 1910s launched their art from very similar motivations. Both groups sought to reveal beneath the surface of nature something more profound and enduring, which would not only reflect subjective responses but also be the basis for shared experience and eventually the common denominator for defining a national spirit. It often seems the Canadian movement reiterates many of the theoretical positions formulated earlier in Scandinavia, especially by the Swedish national Romantic movement, with Bergh as its spokesman. But because they could have known very little about their northern European predecessors,

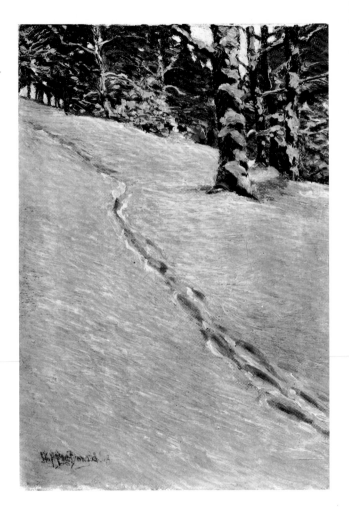

106
J.E.H. MacDonald (1873–1932) Canadian
Morning after Snow, High Park, 1912
Oil on canvas. 71.8 × 91.4 cm
Art Gallery of Ontario, Toronto. Gift of Mrs W.D. Ross, 1952

it is problematic to speak about direct influences. However, one is tempted to analyse the situation in terms of sequential synchrony, the Canadian development being a delayed response to a comparable landscape determined

by similar forces. If we are witnessing a case of history repeating itself, what does this mean in terms of stylistic relationships between the paintings of the Group of Seven and other northern Symbolist landscapes? Can we attribute specific influences from the Buffalo exhibition, or did it serve more as a kind of catalyst, speeding up, perhaps, what would have happened in any case?

The answer lies to a large extent in speculation, because by 1912–13 there were so many ways of disseminating the advanced artistic styles that had developed in France and elsewhere in the late nineteenth century, even if they were sometimes received with only fragmentary understanding. In Montreal Maurice Cullen and James Wilson Morrice were working in Impressionist and Post-Impressionist styles respectively, and the lessons they offered for spontaneous paint handling and decorative surface treatments were reinforced by A.Y. Jackson in his *Edge of the Maple Wood*, which created so much excitement in 1911. Most members of the Group of Seven were professionally trained in commercial design and were thoroughly familiar with art-nouveau graphic styles. There were also the art magazines, especially *Studio*, which continually reproduced Symbolist and Synthetist painting, including work by Scandinavian artists, and which could have provided formal (though not colour) models for the post-1913 painting. Certainly if there were influences from Buffalo, the greatest impact was on formal design and composition rather than on colour or paint handling, in which the Canadians were bolder than their predecessors. If *Terre Sauvage* is the first large canvas of the movement, then it must be kept in mind that it was executed by an artist who had not seen the Buffalo exhibition, nor been in Toronto to hear the immediate reports about it in January 1913.

Stylistic affinities with Scandinavian art can be seen in the work of the artists who went to Buffalo in 1913 and in the work of those who did not. As we know from MacDonald's annotated copy of the exhibition catalogue,[41] he and Harris were particularly struck by the work of Sohlberg and Fjaestad. MacDonald's predilection for Fjaestad no doubt originated in his own work of 1912 (no. 106), which, even if it did not break out of naturalistic bounds, touched on elements of mood painting and Blue Painting which were fundamental to Fjaestad's own beginnings. In his winter scenes, which included such details as tracks left in the snow by lonesome passers-by, and in his isolated close-ups of stream beds from the northern wilderness, MacDonald had broached Fjaestad's most common subject matter, as it was represented in the exhibition or as it could be known from *Studio* and other illustrated sources. But though in his 1931 lecture MacDonald credited "Fjaestad's revelations" with teaching Canadians how to get to know their natural environment better, the Swedish artist seems to have had relatively little influence on MacDonald himself. With the exception of *Snow-Bound*, 1915 (no. 108), which appears to be a direct homage to Fjaestad, MacDonald rarely painted snow scenes after 1912. And, with the exception of his interest in the intimate viewpoint in his many paintings of running-water subjects, he never adopted Fjaestad's *Jugendstil* stylizations, his muted palette, or his air of serene silence. On the contrary, such representative works of MacDonald's as *A Rapid in the North*, 1913 (no. 107), or *Leaves in the Brook*, 1919 (no. 119), for which specific Fjaestad sources have been suggested,[42] are pervaded with another spirit. Inherent in their spontaneous paint handling and their sonorous colour schemes is the exuberance of fresh and stylistically unmediated experience, which makes both paintings sound as well as look different.

Harris was much more demonstrably influenced by Fjaestad's winter scenes, and for four years, 1914–18, he seems to have responded to their challenge. On one occasion, in *Snow*, around 1917 (no. 109), he followed the lead of MacDonald's *Snow-Bound*, 1915 (no. 108), and looked downwards onto snow-laden boughs and the forest floor. More commonly, as in *Snow II*, around 1916 (no. 110), like Fjaestad's *Winter Moonlight*, 1895 (no. 44), he looks head on at his subject matter deep in space. Fjaestad's rounded rhythmic forms and his ability (in which he surpassed everyone else in the exhibition, according to MacDonald) to impose a decorative unity on natural observation were crucial to Harris. Certainly the stylistic direction he takes in his snow scenes is from Naturalism to increased abstraction, and Fjaestad's example no doubt assisted him in imposing a more forceful decorative order

on his own work, which in the 1920s would sacrifice detail in favour of monumental simplifications. In his snow paintings Harris follows Fjaestad's example of cropping foreground elements so as to emphasize the composition as a two-dimensional design, a technique that also accounts for the close formal resemblance between *Snow* and Gallen-Kallela's more *Jugendstil*-flavoured *Winter* (no. 30). Harris also adapts Fjaestad's enlarged pointillist technique, laying down his paint in a patchwork of short regular strokes, which, when they do not follow the contour of a form, are applied in a tapestry-like pattern of parallel horizontal bands. In his 1931 lecture MacDonald recalled "finely harmonized pinks and purples and blues and cream yellows" in Fjaestad's snows,[43] but Harris's colour, even if it emulates Fjaestad's tonalities, becomes

107
J.E.H. MacDonald (1873–1932) Canadian
* *A Rapid in the North*, 1913
Oil on canvas. 51.4 × 72.1 cm
Art Gallery of Hamilton, Hamilton, Ontario. Gift of the MacDonald Family, 1974

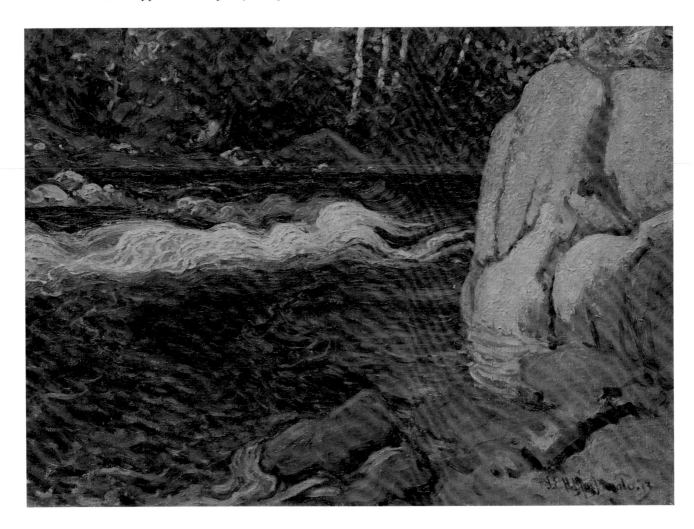

increasingly bright and exaggerated, and, like Mac-Donald's, dispels any lingering *fin-de-siècle* moodiness. Unfortunately, Harris in several of his snow pictures of this period has a propensity to follow Fjaestad into occasional excesses of prettiness.

Harris did not establish his closest spiritual affinities with Sohlberg until the 1920s. In the snowscapes, especially those of 1914–15, Sohlberg's formal influence, however, is often as strong as Fjaestad's. It is difficult to dissociate the composition of *Winter Sunrise*, around 1915 (no. 111) – with its regularly spaced trees, the branches of which intertwine, becoming a solid mass at the upper edge of the frame – from a comparable decorative scheme

in Sohlberg's *Fisherman's Cottage* (no. 74), a painting that Harris saw in the Buffalo exhibition. In his urban scenes Harris had, of course, defined his foreground plane with rows of trees as early as 1910, but there they were given, already arranged in the motif and lined up in front of an equally frontalized row of house facades, so that there is little of the tension between near and far that is a source

108
J.E.H. MacDonald (1873–1932) Canadian
* *Snow-Bound*, 1915
Oil on canvas. 51.1 × 76.5 cm
National Gallery of Canada, Ottawa

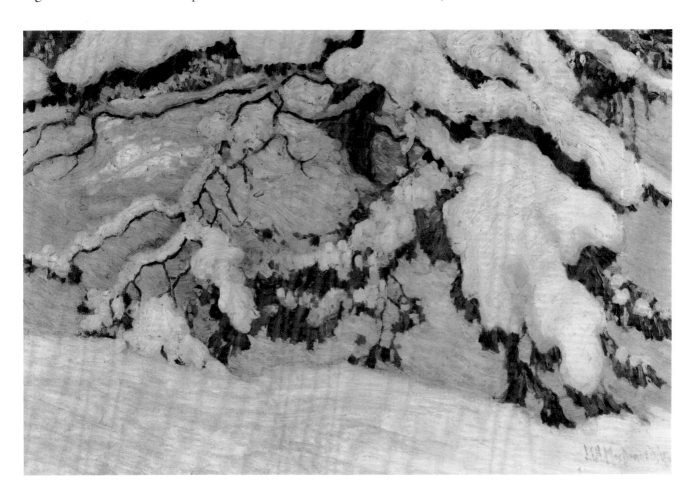

109 (below)
Lawren S. Harris (1885–1970) Canadian
* *Snow*, ca 1917
Oil on canvas. 69.7 × 109 cm
McMichael Canadian Collection, Kleinburg, Ontario.
Gift of Mr and Mrs Keith MacIver

110 (opposite)
Lawren S. Harris (1885–1970) Canadian
* *Snow II*, ca 1916
Oil on canvas. 120.3 × 127.3 cm
National Gallery of Canada, Ottawa

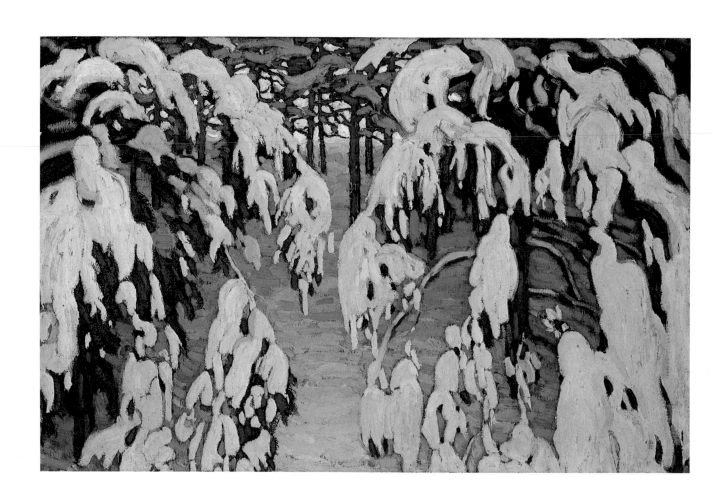

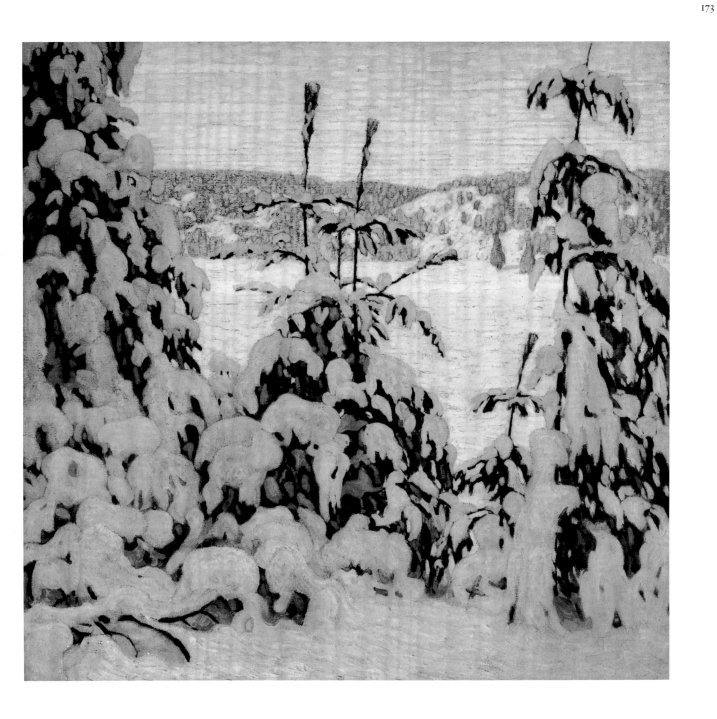

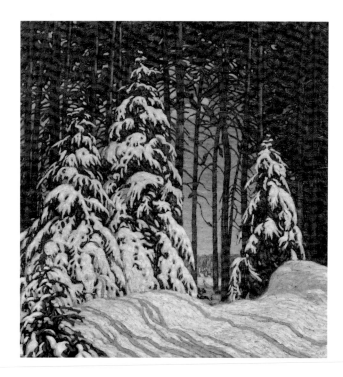

111
Lawren S. Harris (1885–1970) Canadian
Winter Sunrise, ca 1915
Oil on canvas. 127 × 120.7 cm
Norman Mackenzie Art Gallery, Regina, Saskatchewan

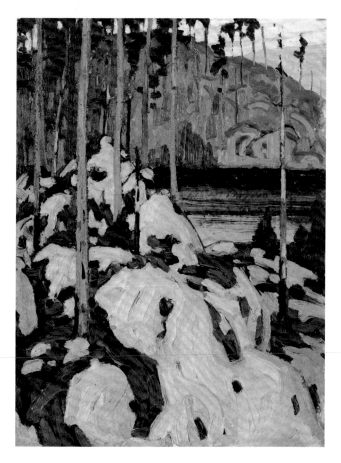

112
Lawren S. Harris (1885–1970) Canadian
* *Aura Lee Lake, Algonquin Park*, 1916
Oil on board. 26.7 × 35.6 cm
Private collection

of considerable mystery in the wilderness paintings. A small panel from 1916, *Aura Lee Lake, Algonquin Park* (no. 112), is reminiscent of Gallen-Kallela's 1892–3 forest paintings (nos. 20 and 22), and, like them, organizes space into several distinct layers, from monumental foreground rocks and trees to the hill and sky in the distance. The rocks themselves, rendered with broad, fluid strokes of plump paint, fill the foreground with some of the claustrophobia-inducing pressure of Gallen-Kallela's eroded snow banks in *The Lynx's Den* (no. 31).

 Beaver Swamp, Algoma, 1920 (no. 113), is closer in spirit to Sohlberg's *Fisherman's Cottage*, dependent as it is on the eerie silhouettes of stands of foreground trees against the spectral light of a sunset sky. This, as Jeremy Adamson maintains, is Harris's most moving landscape;[++] it is pervaded by solitary, melancholic brooding that harks back to an earlier decade. This work and, especially, *Above Lake Superior*, around 1922 (no. 114), are Harris's quintessential Sohlberg compositions, whether or not either was consciously conceived as such. R.H. Hubbard has proposed

Lawren S. Harris (1885–1970) Canadian
* *Beaver Swamp, Algoma*, 1920

Oil on canvas. 120.7 × 141 cm
Art Gallery of Ontario, Toronto. Gift of Ruth Massey
Tovell in memory of Harold Murchison Tovell, 1953

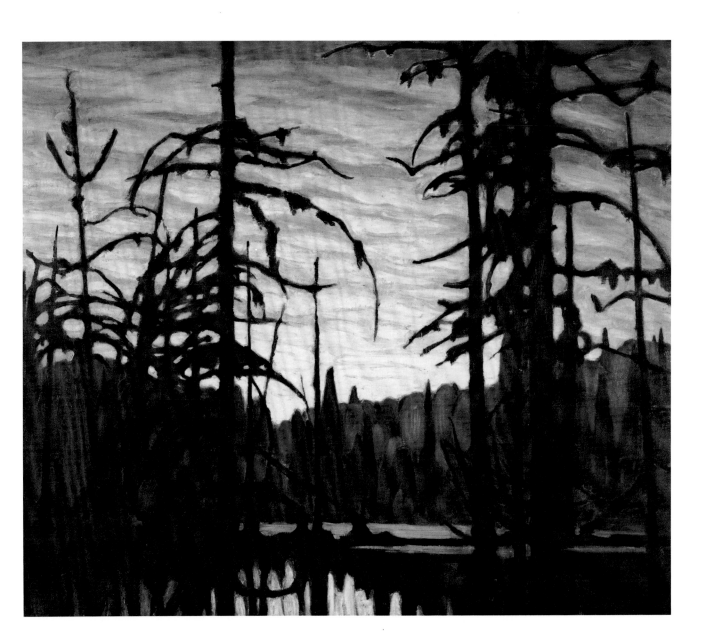

114 (below)
Lawren S. Harris (1885–1970) Canadian
* *Above Lake Superior*, ca 1922
Oil on canvas. 121.9 × 152.4 cm
Art Gallery of Ontario, Toronto. Gift from the Reuben
and Kate Leonard Canadian Fund, 1929

115 (opposite)
Tom Thomson (1877–1917) Canadian
* *Northern River*, 1915
Oil on canvas. 115.1 × 102 cm
National Gallery of Canada, Ottawa

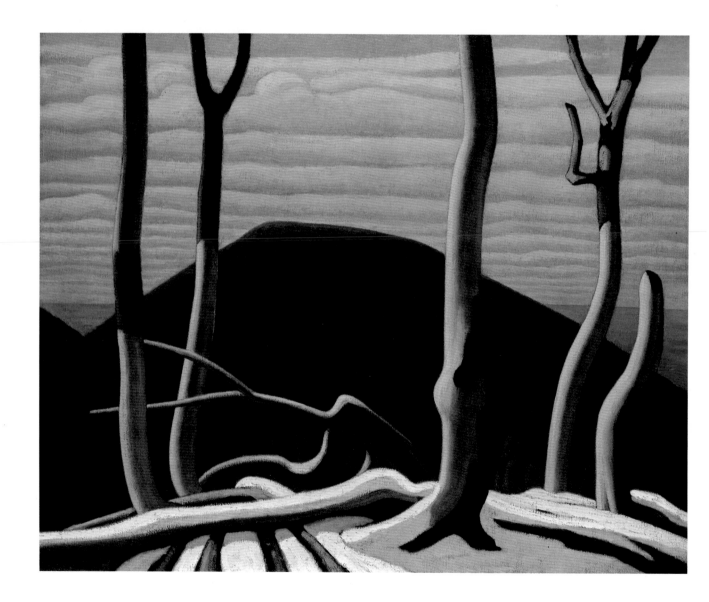

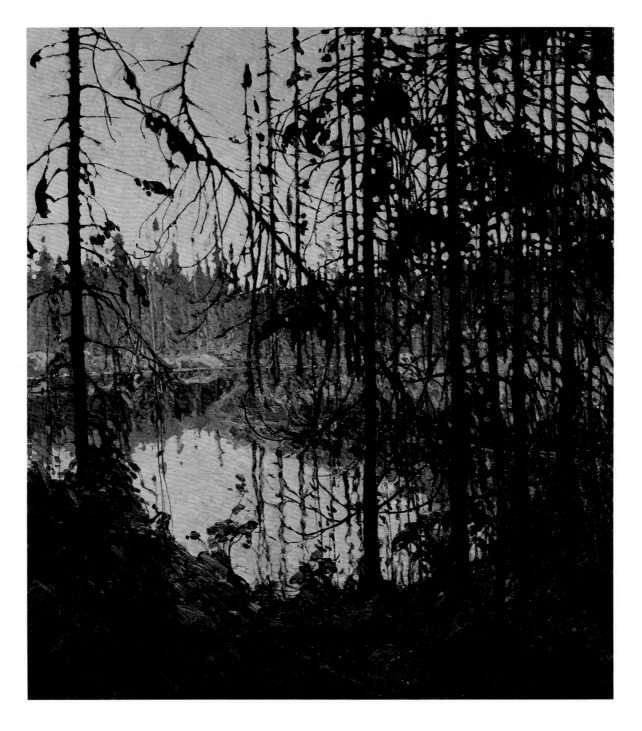

Winter Night in Rondane (no. 69) as the compositional source for Harris's *Bylot Island*, 1930 (National Gallery of Canada, Ottawa),[45] presumably on the basis of a similarity in the outline and simplified modelling of the mountain ranges of both works. In a similar way one can imagine memories of the Rondane painting lingering in Harris's mind while he was increasingly stripping his own style of surface sensuality and reducing forms to visionary transcendental ones, often, as in *Lake and Mountains*, 1927–8 (no. 128), dominating his colour schemes with sharp crystalline blues. Harris's style by then was taking directions commensurate with Macdonald's vivid and correct recollection of Sohlberg's painting in 1931, some twenty years after the fact, which stressed its monochromatic "dazzling blue," its "icy sharp" light and colour, and its surface "smoothly finished as though enclosed in ice," conceived "with cold passion."[46] By the later 1920s, however, Harris's work had long since developed its own inner logic, and his choices of form and colour were equally attributable to Theosophical and other mystical doctrines in which he was deeply immersed, so that it would be arbitrary to attempt to locate sources for details that were by then integral to his style.

Above Lake Superior, in contrast, refers to *Winter Night in Rondane* less in matters of detail (though these are not irrelevant) than in terms of overall conception and employs all the intricacies of Sohlberg's pictorial, even theatrical, composition in order to endow his own subject matter with visionary import. Most importantly, Harris has adopted Sohlberg's basic structural scheme, which contrasts foreground detail ("subdued restlessness and disorder")[47] with distant abstracted and monumentalized forms ("grand stable forms [rendered with] simplified ponderous lines"), because, recalling Sohlberg: "it is precisely the opposition between the calm and grandeur and power of the mountains and ... the broken-up nature of the foreground and its small forms and lines that determine the character and the purpose of the picture." In both paintings the foreground planes are strewn with twisted pieces of deadwood, amongst which rise a few solitary tree trunks, "in a kind of frozen animation,"[48] as a physical barrier; far beyond these, lofty architectural forms rise austerely and peacefully as symbols of transcendent experience. While Sohlberg transports us from confused darkness, where forms are reduced to flat silhouettes, to the glistening volumetric clarity of the mountain peaks, marked with a cross and surmounted by a single sparkling star, Harris sets out from a world of sunlight and solid shapes and carries us toward the formal flatness of his mountain which looms in unknowable darkness. Both paintings work within considerably reduced colour schemes and avoid sensual surface textures, as if the artists have distanced themselves personally and emotionally from their subject matter in favour of a kind of cerebral spirituality.

More difficult to account for is the development of those artists, especially Jackson and Thomson, who had not seen the Scandinavian exhibition and yet immediately gave a new agressive turn to their work. This shift quickly aligned them with the spirit of the northern Symbolist landscape tradition and produced a number of landmark pictures that set the style for the Group of Seven. Thus Jackson at the end of the year completed *Terre Sauvage* (no. 105), which, more boldly than anything by Mac-Donald or Harris heretofore, proposed itself as the severe, frontalized, and symmetrical model, garishly immodest in colour, for seeing the North in its primitive grandeur. Next year in *The Red Maple* (National Gallery of Canada, Ottawa), Jackson, in contrast, celebrates nature's intimacies, in warm and glowing fall colours, in a composition perhaps dependent on, but far surpassing in ambition, MacDonald's 1913 paintings of flowing streams. Also more convincing than the latter, Jackson's composition, with its clear parallel bands of foreground bank, river, and opposite shore, stands out as an independent and self-confident tribute to Fjaestad's flowing water compositions, reproductions of which were readily available.[49] Jackson, however, has added to the interest of his composition by letting the little red maple tree, after which the painting is titled, spread its branches from bottom to top and across the foremost foreground of the picture, piquantly establishing that tension between here and there that persists as a powerful structural device in northern painting for establishing the psychological and physical discontinuities that are central to Symbolist experience and for which wilderness experience was itself a symbol.

These frontalized screens, either continuous or pulled aside like a stage curtain, which we know especially from Gallen-Kallela and Sohlberg, were a standard compositional device for Jackson in the years before the First World War and for Thomson until his death in 1917 and they were also, as we have seen, important for Harris during the 1920s. Thomson's breakthrough painting, *A Northern Lake*, 1912–13 (no. 116), is quite self-consciously of this sort, establishing its foreground in now familiar ways, by rudely painted boulders and a tangle of deadwood and undergrowth; a pair of flanking tree trunks on either side frames a view of stormy meteorological as well as psychological weather. In his *Northern River*, 1915 (no. 115), the device, though it has parallels in Sohlberg's *Fisherman's Cottage* and in Harris's contemporary snowscapes

116
Tom Thomson (1877–1917) Canadian
* *A Northern Lake*, 1912–13
Oil on canvas. 69.9 × 101.6 cm
Art Gallery of Ontario, Toronto. Gift of the Government of the Province of Ontario, 1972

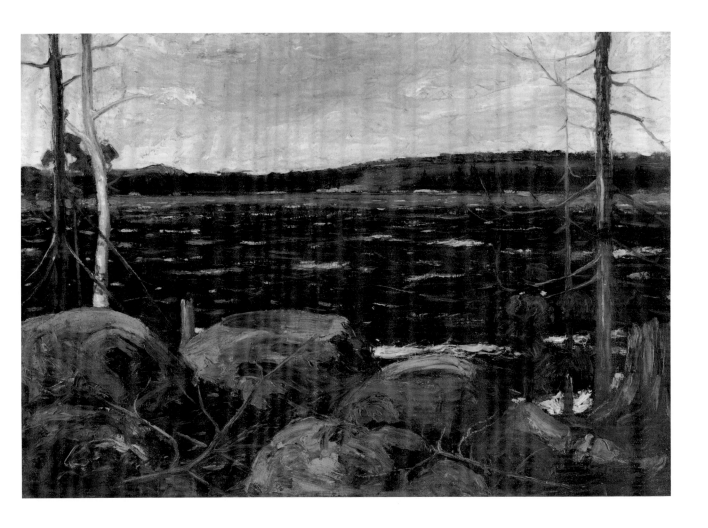

180 117
Tom Thomson (1877–1917) Canadian
The Jack Pine, 1916–17

Oil on canvas. 127.9 × 139.8 cm
National Gallery of Canada, Ottawa

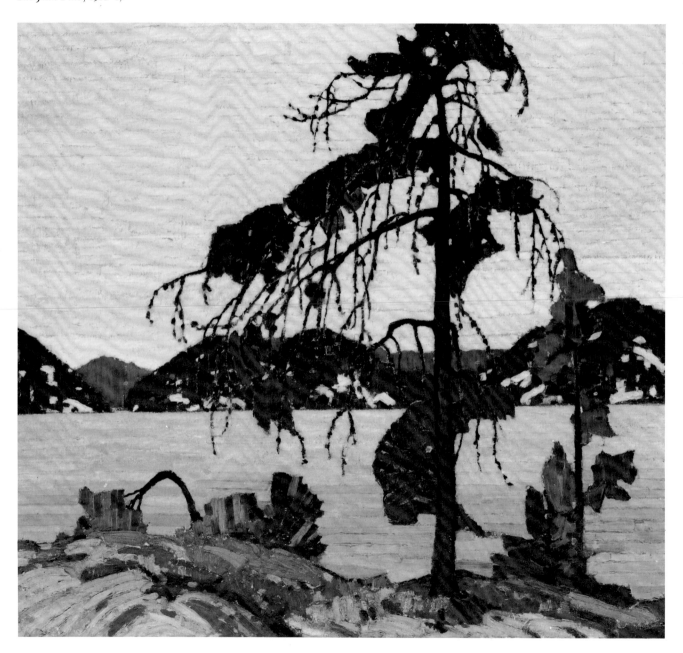

(no. III), is also conspicuously dependent on art-nouveau design, especially marked by the elegant S-curve of the centrally placed tree which swings out to define the foreground plane of the open left side of the composition. Whatever the sources, conscious or not, that Thomson has assimilated and drawn from in planning the work, the whole effect of the intricate frontalized linear design – the *contre-jour* lighting effects, the rather subdued colour

118
Thomas Fearnley (1802–1842) Norwegian
Old Birch Tree by Sognefjord, 1839
Oil on canvas. 54 × 65 cm
Nasjonalgalleriet, Oslo

J.E.H. MacDonald (1873–1932) Canadian
* *Leaves in the Brook*, 1919
Oil on canvas. 52.7 × 65 cm
McMichael Canadian Collection, Kleinburg, Ontario.
Gift of Dr Arnold C. Mason

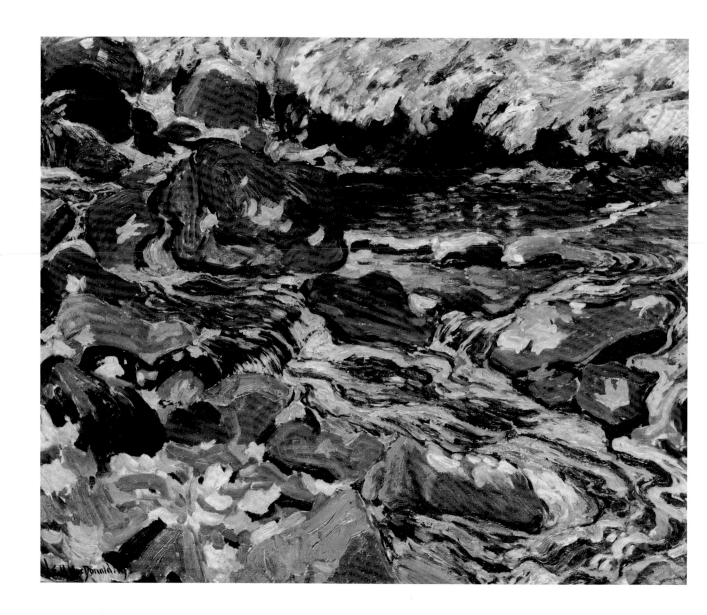

J.E.H. MacDonald (1873–1932) Canadian
* *Falls, Montreal River*, 1920
Oil on canvas. 121.9 × 153 cm
Art Gallery of Ontario, Toronto

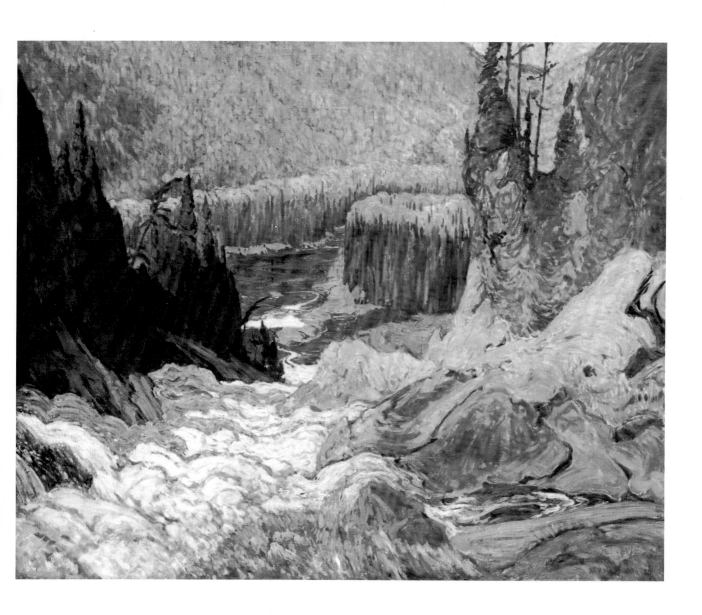

scheme of contrasting oranges and blues, the application of paint to achieve a controlled tapesty-like effect, and the general sense of refinement and discretion – gives the picture a curious retrospective look, its melancholy feeling more in tune with Scandinavian twilight mood painting, such as Sohlberg's *Night Glow* (no. 66), than with the virile drama of Jackson's pre-war paintings.[50]

It is commonly held that the sketches rather than the larger canvases developed from them are the most valuable work produced by Thomson and the Group of Seven, because they are truer records of the artists' first responses to the northern wilderness. The large works in comparison are often rhetorical and stiff, as David Silcox argues, and betray the Group's "nineteenth-century academism in no uncertain terms."[51] But in the sketches, too, despite their freshness of observation and their spontaneous appearance, the landscape is usually viewed from the same perspectives, and with a similar understanding of space, that characterize the larger works. The composition of the large canvas is already given in the sketch; no fundamental changes are required, and the process of "working up" seems instead to be a matter of reinforcing the aesthetic conventions that already underlay the initial choice of subject matter. To complain, therefore, that the final version of *The West Wind*, 1917 (Art Gallery of Ontario, Toronto), has lost the freshness of its sketch is to devalue Thomson's Symbolist need to distil observed experience and to make nature speak more eloquently of and to human feelings. The importance of an overall decorative scheme in achieving the iconic power of both *The West Wind* and *The Jack Pine*, 1916–17 (no. 117), may be measured in relation to comparable pictures. In Varley's *Stormy Weather, Georgian Bay*, 1920, and Lismer's *A September Gale, Georgian Bay*, 1921 (both National Gallery of Canada, Ottawa), the symbolic poignancy of the single-tree image has been diminished proportionately as the trees themselves have been integrated into a continuous landscape. But, like *Northern River*, the works from 1917, along with Harris's later *Beaver Swamp, Algoma*, look back to the turn of the century, especially when they invite us to creep into the shadows or linger in melancholy thoughts. The wistful twilight mood of *The Jack Pine* harks back to the sunset pictures of Sohlberg, Hesselbom, Prince

Eugen, and Hodler. Thomson's symbolic isolation of lonely, heroic, sometimes weather-beaten trees has, with a few conspicuous exceptions, such as Hodler's *The Fir Tree at Chamby*, 1905 (private collection, Kilchberg), and Gallen-Kallela's *Broken Pine*, 1906–8 (no. 25), been a less common pictorial subject since the early-nineteenth-century Romantic painting of Friedrich, Dahl, and Thomas Fearnley, among others. Fearnley's *Old Birch Tree by Sognefjord*, 1839 (no. 118), silhouetted in the hushed evening silence against distant mountains and surmounted by a golden sunset sky also reflected in the water below, is another telling predecessor of Thomson's *The Jack Pine* and an interesting foil against which to measure Thomson's twentieth-century adaptation of an old theme.[52]

After having been dispersed by the First World War, the members of the Group of Seven worked most closely together again, during their annual trips to Algoma between 1918 and 1921. This was when MacDonald produced some of his finest paintings, and when, perhaps for the last time, it is possible to speak of their work in general terms. Certainly if we compare their paintings from this period, they display a common outlook on nature and a common artistic purpose: MacDonald's *Leaves in the Brook*, 1919 (no. 119), *Falls, Montreal River*, 1920 (no. 120), and *Gleam on the Hills*, 1921 (no. 122); Harris's *Waterfall, Algoma*, 1918 (no. 121), and *Beaver Swamp, Algoma*, 1920 (no. 113); Jackson's *October Morning, Algoma*, 1920 (no. 124); and Carmichael's *Autumn Hillside*, 1920 (no. 123). Most of these paintings celebrate nature on a grand scale in the full rich harmonies of autumn colours. They are composed in bold decorative patterns, and the brush strokes weave intricate, forceful tapestry patterns across the picture surface. We may draw attention to a number of echoes from earlier Scandinavian work and observe, for example, the comparable shallow perpendicular space within which we are enclosed in both Harris's waterfall picture and Gallen-Kallela's *Waterfall at Mäntykoski* (no. 21). We can note the compositional similarities between Osslund's *Autumn Day, Fränsta* (no. 51) and Carmichael's *Autumn Hillside*, between Osslund's *Autumn Evening, Nordingrå* (no. 54), and Jackson's *October Morning, Algoma*, as well as between Osslund's stream and waterfall paintings and those of MacDonald. We can note in a more

general sense that the members of the Group like the European Symbolist landscape painters, continue to swing between extreme close-up views of nature (see also Lismer's *Old Pine, McGregor Bay*, 1929, no. 125) and broad panoramas, but seldom integrate the two polarities into a continuous space, as least not when working with the

121
Lawren S. Harris (1885–1970) Canadian
* *Waterfall, Algoma*, 1918
Oil on canvas. 120.2 × 139.6 cm
Art Gallery of Hamilton, Hamilton, Ontario.
Gift of the Women's Committee, 1957

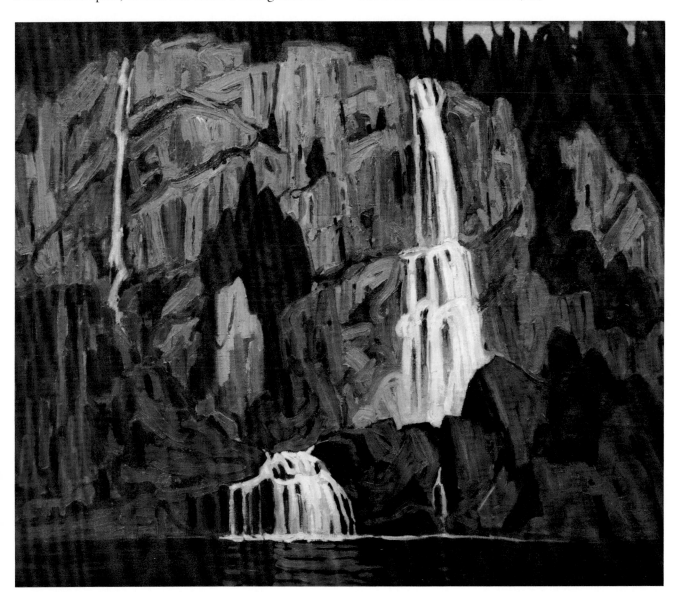

186 122
J.E.H. MacDonald (1873–1932) Canadian
* *Gleam on the Hills*, 1921

Oil on canvas. 81.5 × 87.1 cm
National Gallery of Canada, Ottawa

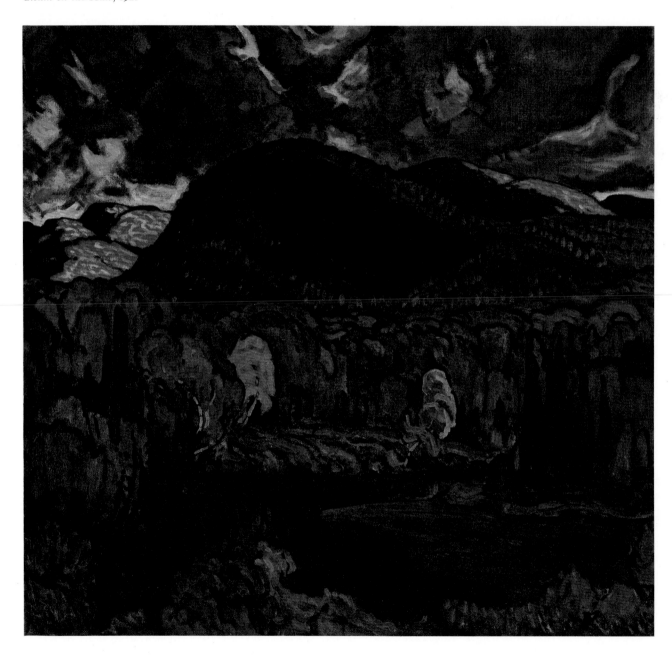

123
Franklin Carmichael (1890–1945) Canadian
* *Autumn Hillside*, 1920
Oil on canvas. 76.2 × 91.4 cm

Gift from J.S. McLean Collection. On loan to Art Gallery of Ontario, Toronto, from the Ontario Heritage Foundation, 1970

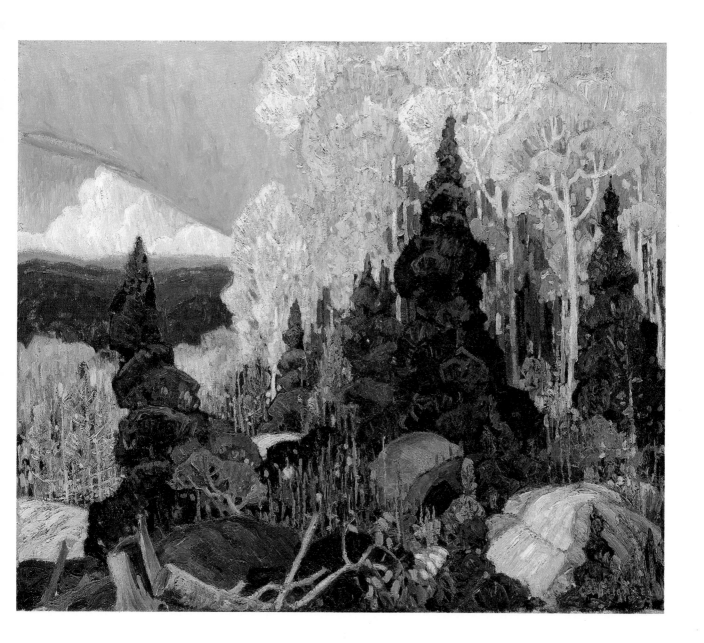

wilderness. But such relationships must be understood, not as a result of specific influences, but as evidence in the Canadians of a common conception of the "spirit" of nature, a kind of undercurrent flowing beneath the technical boldness and the torrent of colour that has sources in their Impressionist and Post-Impressionist backgrounds.

These affinities occur also between Harris's urban scenes and earlier European ones. The aggressive, even garish colours of his street scenes, especially when seen under snow, are perhaps better understood in relation to Sohlberg's justification for the "disharmonious" palette of Røros house paintings (no. 71) – that northern colours were

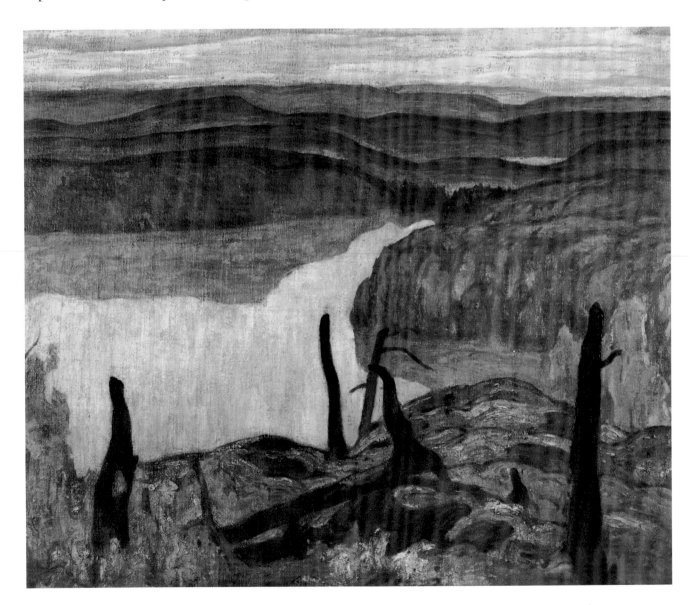

124 (opposite)
A.Y. Jackson (1882–1974) Canadian
* *October Morning, Algoma*, 1920
Oil on canvas. 123.2 × 154 cm
Hart House Permanent Collection, University of Toronto

125 (below)
Arthur Lismer (1885–1969) Canadian
* *Old Pine, McGregor Bay*, 1929
Oil on canvas. 82.5 × 102.2 cm
Art Gallery of Ontario, Toronto.
Bequest of Charles S. Band, 1970

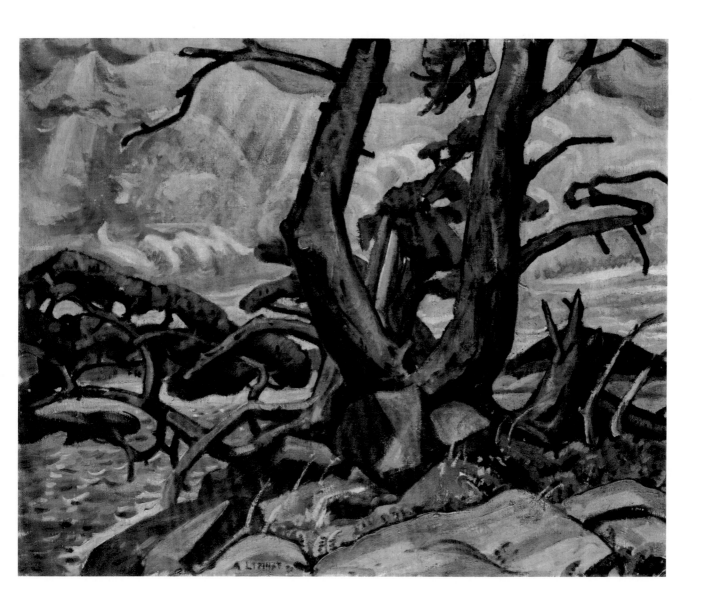

190　126

Lawren S. Harris (1885–1970) Canadian
* *Elevator Court, Halifax*, 1921
Oil on canvas. 96.5 × 112.1 cm
Art Gallery of Ontario, Toronto. Gift from the Albert H.
Robson Memorial Subscription Fund, 1941

pure, clear, and strong and sounded like a brass band. Harris's *Elevator Court, Halifax*, 1921 (no. 126), despite the fact that it drew its subject matter from the dreariest of urban slums, is as ambivalent as Jansson's *The Outskirts of the City* (no. 50) about its attitude to poverty and human misery. Finally Harris chose to transcend social reality

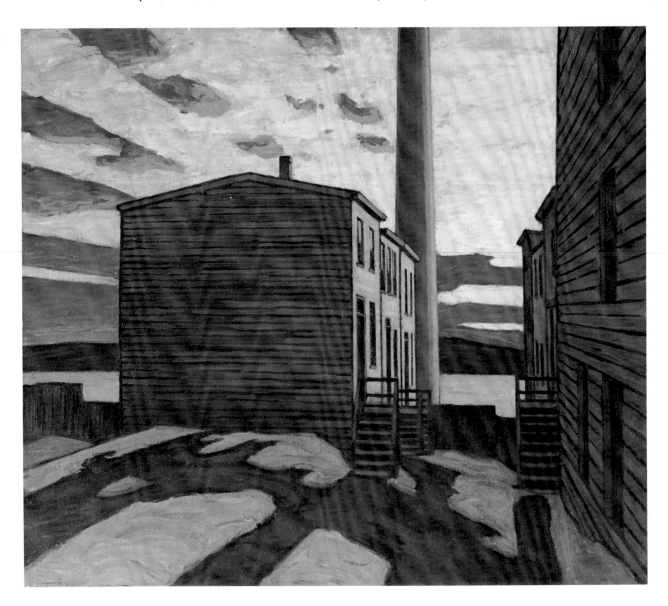

and produced an apocalyptic vision in which, because of the dramatic perspectival recession with which the space of the painting is constructed, the last light of the sun seems to be sucked away along the converging orthogonal lines to a vanishing point low on the horizon and hidden from view. There is a feeling of visual denial in Harris's painting in another sense, comparable to Sohlberg's equally tightly structured *Night* (no. 72), in the way that the subject matter of both pictures seems to back onto the viewer, filling major central portions of their respective picture surfaces with blank and featureless walls.

The subject of mountains, pursued in Europe with various results by Willumsen, Sohlberg, and Hodler, did not emerge among the members of the Group until the 1920s and was then driven to ultimate transcendent heights by Harris and Varley. Harris had already laid the foundations for a severely reductive and abstracted style in his paintings from the north shore of Lake Superior, which he discovered in 1921. In comparison to *Above Lake Superior* (no. 114), however, in *Maligne Lake, Jasper Park*, 1924 (no. 127), one of the first paintings to result from his trip to the Canadian Rockies in 1924, he has gone even further in stripping the subject matter of a sense of its locale and its material texture. The mountain subject matter has been reduced to a series of simplified angular planes, perfectly mirrored in the water of the lake, and transformed into flattened triangles centred on a horizontal axis, and interpenetrating and interlocking across a vertical axis running down the centre of the painting. With its timeless order and hieratic design the composition is especially reminiscent of Hodler's *Lake Thun*, 1909 (no. 86), or perhaps even more so of his more severe *Lake Thun Seen from Därlington*, 1905 (Musée d'art et d'histoire, Geneva), both of which work with near monochromatic colour schemes and have observed biaxial symmetry even more strictly. Hodler, however, even under his structural austerity, has not found it necessary to sever relations with the feel and touch of nature in order to reveal its underlying truths. This contact was clearly incompatible with Harris's idealist ambitions to burrow through to the spiritual forces inherent in his lofty motif. As a reviewer of the first exhibition of Harris's Rocky Mountain canvases remarked, Harris "has put these piles of granite into a powerful metal press and squeezed out of them every ocular property of mountains, leaving only their cold austere sublimity. He does not give you a mountain, but the platonic idea of a mountain."[53]

Lake and Mountains, 1927–8 (no. 128), is even more a landscape of the mind and a dwelling place for ascetic gods. This hauntingly barren scene was no doubt based on a motif in nature, but it has been so transformed that there is little here that can be explained by the action of natural forces alone. The hardened sculptural forms and the cold supernatural light, whatever explanations may be offered for them from Harris's Theosophical reading and speculation, also stand in direct line of descent from turn-of-the-century northern Symbolism, as indeed does the kind of mystical insight that frozen places inspired. In Harris's Rocky Mountain works, and later in his Arctic landscapes, we have finally entered the imaginary and physically inaccessible realm of the mountain peaks above the clouds which Willumsen (and Sohlberg) aspired toward, but were able only to glimpse from afar. Stylistically Harris's paintings from this period are the culmination of a sequence of Symbolist mountainscapes beginning with Willumsen's *Jotunheim* (no. 6) and passing through *Mountains under the Southern Sun* (no. 88) and the various versions of Sohlberg's *Winter Night in Rondane* (no. 69), All are rooted in visionary experiences which cast a stern cerebral eye on nature and had little patience with her sensuous outer garments.

In contrast, the mountain paintings that Varley executed in British Columbia, where he settled in 1926, can be positively hedonistic in their range and richness and colour and in their luxuriating in the physicality of paint. As with most of the members of the Group, there is some difficulty in knowing what visual sources Varley may have encountered or been informed about. Perhaps his most significant images of mountain motifs date to a period soon after he arrived on the west coast, *The Cloud, Red Mountain* (no. 129) to around 1928, and *The Open Window* (no. 130) to 1932. The latter was first conceived in a more detailed version in 1928–9, before the arrival from Vienna in 1931 of Harry Täuber, a stage designer who also gave classes in German Expressionism,[54] and presumably could have conveyed information about Hodler, as well as Munch,

127 (below)
Lawren S. Harris (1885–1970) Canadian
* *Maligne Lake, Jasper Park*, 1924
Oil on canvas. 122.8 × 152.8 cm
National Gallery of Canada, Ottawa

128 (opposite)
Lawren S. Harris (1885–1970) Canadian
* *Lake and Mountains*, 1927–8
Oil on canvas. 130.8 × 160.7 cm
Art Gallery of Ontario, Toronto. Gift from the Fund of the
T. Eaton Co Ltd for Canadian Works of Art, 1948

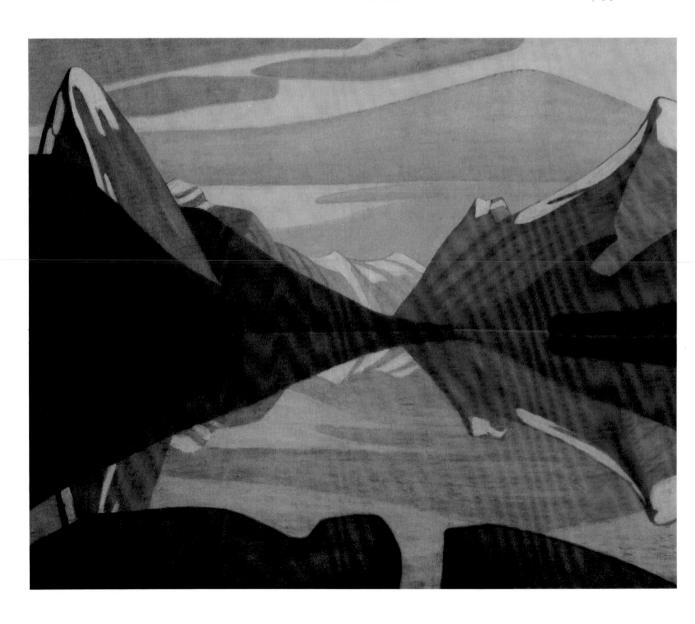

whose example hovers behind later 1930s work such as *Night Ferry, Vancouver*, 1937 (private collection, Toronto). If Varley was aware of Hodler's work, his information must have preceded his departure from Toronto. As Charles C. Hill has suggested, there may also be a debt to Chinese landscape painting, which Varley admired a great deal, in these two pictures, especially in the mist-shrouded space of *The Open Window.*[55] Nevertheless, these paintings stand at the tail-end of the northern Symbolist landscape tradition and partake of its basic compositional schemes. The massively sculptured forms of the tops of the mountain range in *The Cloud, Red Mountain,* so severely cropped, are resonant echoes of Hodler's comparably concentrated Alpine pinnacles from 1909–11,

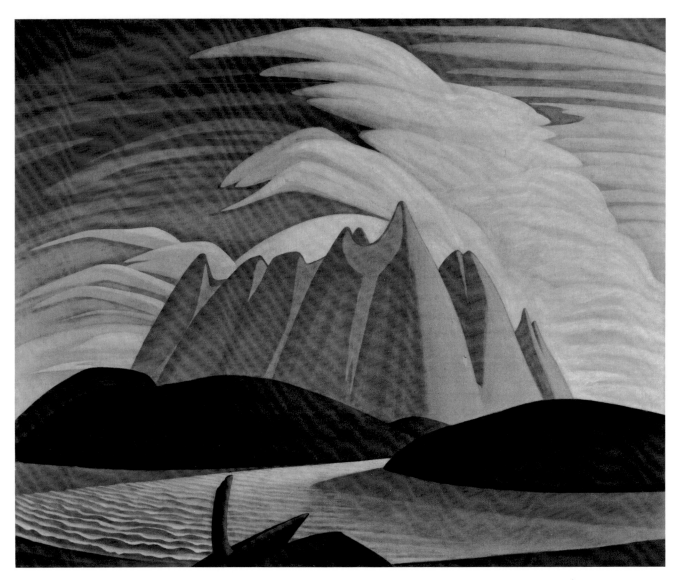

129 (below)
F.H. Varley (1881–1969) Canadian
* *The Cloud, Red Mountain*, ca 1928
Oil on canvas. 86.8 × 102.2 cm
Art Gallery of Ontario, Toronto. Bequest of Charles S.
Band, 1970

130 (opposite)
F.H. Varley (1881–1969) Canadian
* *The Open Window*, 1932
Oil on canvas. 102.3 × 87 cm
Hart House Permanent Collection, University of Toronto

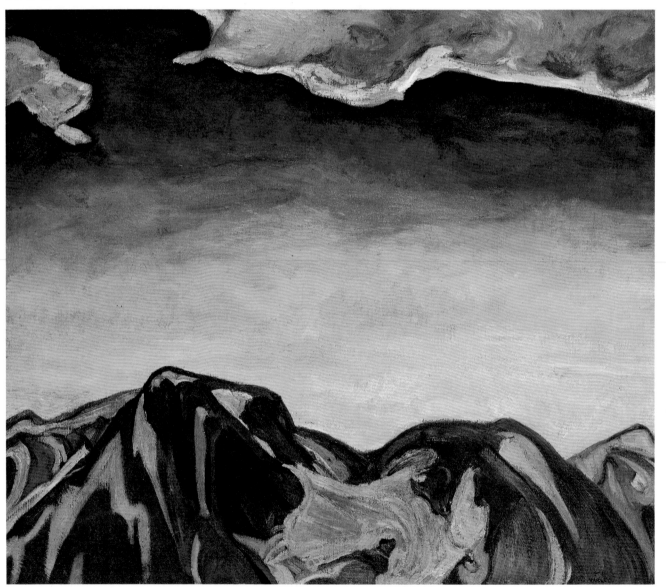

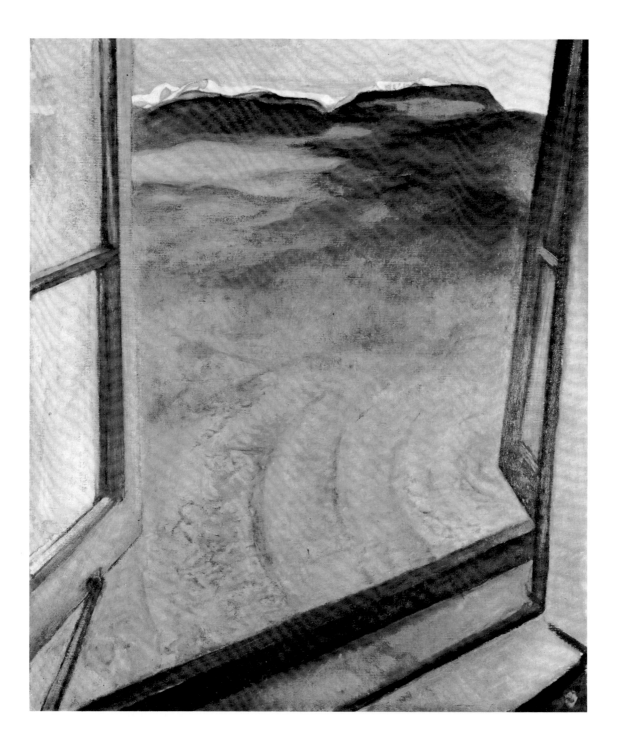

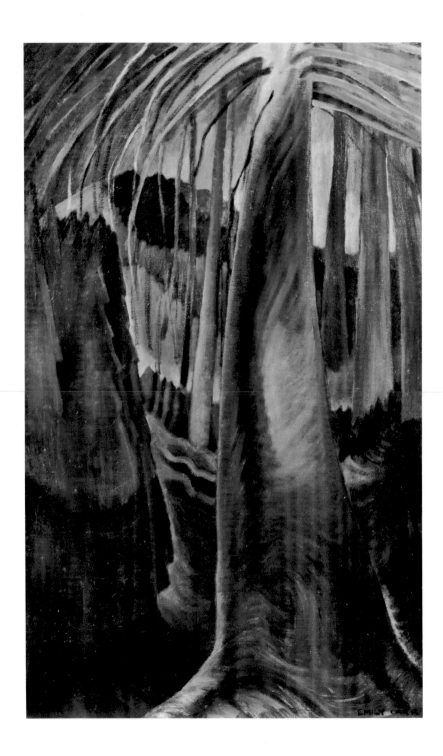

also often surmounted by powerful cloud structures which play an important role in the decorative design of the painting. Varley is, however, not as interested in mountain portraiture *per se* as in defining the upper limits of the world beyond which we can look past the clouds into depths of shimmering light. *The Open Window*, which, as the title tells, borrows an iconographic theme that dates back at least to Friedrich, juxtaposes the near and far, the private and the universal, and metaphorically swings open the windows of the soul onto the infinity of nature focused in the long white snow-covered mountain ridge. Caught by the sunlight, it rises with undiminished clarity, like Hodler's *Eiger, Mönch and Jungfrau* (no. 89), above a sea mist.

The work of Emily Carr may also be considered within this context. Carr, though older than all the members of the Group of Seven, is perhaps their most important progeny. It was not until she finally, after years of artistic isolation on the west coast of Canada, met the Group on a trip east in 1927, when she was fifty-six, that her work blossomed. She had studied in France in 1910–11 and had had contact with Fauvism, but during the fifteen years after her return she produced little of importance. The members of the Group not only impressed her with the visionary grandeur of their work and the boldness with which they handled their subjects, but they inspired in her a new regard for the wilderness, not only as identifiable with the Canadian spirit, but as an untrodden place where she could pursue her pantheistic beliefs, "always looking for the face of God, always listening for the voice of God in Nature."[56] A picture she defined as "a glimpse of God interpreted by the soul,"[57] reflecting the transcendent content of her work, which links it spiritually with the tradition of Symbolist landscape and suggests that she, even in the 1930s, will continue to find reiterations

131
Emily Carr (1871–1945) Canadian
* *Old Tree at Dusk*, ca 1936
Oil on canvas. 112 × 68.5 cm
McMichael Canadian Collection, Kleinburg, Ontario.
Gift of Col R.S. McLaughlin

of the long-standing themes, subject matters, and compositional types that we have been examining.

Upon her return to Victoria, with the example of Harris foremost in her mind, Carr launched a totally new departure for her work. Her painting quickly attained the largeness of scale that she had observed in the works of the Group, but she never adapted their decorative approaches or Harris's silent clean-lined sculptural reductions. On the contrary, her new work throbbed with a vital energy that required rapid changes in her technique and style in order to be accommodated with the greatest freedom. Her first forest paintings were composed of strangely stylized shapes, somehow Cubo-Futurist, with branches and foliage built up of heavy, swelling, and sharp-toothed solid forms, which swoop and swing among one another, transforming the forest interior into a frighteningly chaotic and impenetrable maze. In *Indian Church*, 1929 (no. 132), such a forest threatens to engulf from all sides a frail little white church centrally placed and flanked by groups of crosses. Like Sohlberg in *Night*, Carr achieved her simple, effective frontal symmetry by eliminating from her motif some surrounding outhouses, elongating and simplifying the church itself, and borrowing the crosses from an adjacent churchyard.[58] She has created a poignant juxtaposition between an isolated symbol of Christian faith, pointing toward heaven, and an overwhelmingly indifferent or terrible nature, and thereby has contributed significantly to a family of such images, to which the American artist Georgia O'Keeffe would soon add her variation, in the way of a simple giant cross starkly silhouetted against an infinite expanse of ocean, in *Cross by the Sea, Canada*, 1932 (no. 152).

When Carr penetrates the forest itself, as in *Old Tree at Dusk*, around 1936 (no. 131), it not surprisingly looms large and close up, its depths shrouded in mysterious shadows, and the way through unmarked and confused. Such pictures too join a long list of earlier Symbolist forest images beginning with Prince Eugen and running through Munch and Ernst Ludwig Kirchner. It has been suggested that the way Carr often blocks the inward view by the broad trunk of a foreground tree and her close cropping of images were influenced by O'Keeffe, whose work she saw at Stieglitz's gallery, An American Place,

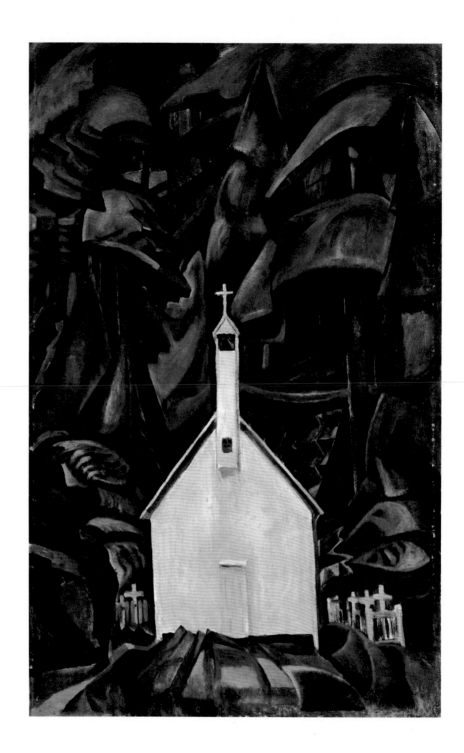

132 (opposite)
Emily Carr (1871–1945) Canadian
* *Indian Church*, 1929
Oil on canvas. 108.6 × 68.9 cm
Art Gallery of Ontario, Toronto. Bequest of Charles S. Band, 1970

133 (below)
Emily Carr (1871–1945) Canadian
* *Overhead*, 1935–6
Oil on panel. 61 × 91.6 cm
Vancouver Art Gallery, Vancouver, BC

in New York in 1930.[59] According to Maria Tippett, Carr was especially impressed by O'Keeffe's *Lawrence Pine Tree, with Stars*, 1929 (collection of Georgia O'Keeffe), in which the crown of a tree is seen from underneath, looking upwards through its branches into a starry blue sky, and may have been influenced by it in such skyward-gazing paintings as *Above the Trees*, 1935 (no. 134).[60]

Carr, however, never shared O'Keeffe's smooth and flattened style, and by 1932 she began exploring the ex-pressive liberties possible with her newly developed technique of oil paint thinned down to the consistency of watercolour, using large standard-sized sheets of cheap manilla paper for support. It was easy to use and light to carry on her sketching trips and, as she wrote, "allows great freedom of thought and action. Woods and skies out west are big. You can't squeeze them down."[61] The new fluid material dispelled the heavy sculptural forms that characterized the first forest interiors in favour of

134 (opposite)
Emily Carr (1871–1945) Canadian
* *Above the Trees*, 1935
Oil on panel. 91.6 × 61 cm
Vancouver Art Gallery, Vancouver, BC

135 (below)
Emily Carr (1871–1945) Canadian
* *Study in Movement*, 1936
Oil on canvas. 68.6 × 111.8 cm
Art Gallery of Ontario, Toronto

long flowing expressing sweeps and swirls that transform her paintings into fields of rhythm and movement. The range of subjects grows accordingly and opens up to include not only the head-on forest interiors but also tree tops (no. 134), tangled undergrowth (no. 135), and wide shorelines and open expansive skies (no. 133), themes that are familiar to us from the Symbolist landscape repertoire but that now speak less through decorative spatial structures than through unified and all-pervasive painterly movement. Her new principle became "unity of movement," an idea that she was quick to point out she had realizied by herself before she discovered that it was also van Gogh's.[62] Movement as embodied in a spontaneous and flowing technique became at once a vehicle of personal expression, a pictorial equivalent of the universal life force, growth, and spiritual energy that nature radiated, and her method for uniting herself with the God that "filled all the universe."[63] By her Expressionist rather than Synthetist outlook Carr puts herself stylistically distant from Harris, her principal mentor among the Group of Seven, and completes another line of northern Symbolist landscape painting, of which van Gogh was the precursor and Munch the principal protagonist, and in which she occasionally will find contemporary echoes during the 1920s and 1930s in the work of the former members of Die Brücke.

For the thirty years after 1913 it is possible to draw meaningful parallels between Canadian and preceding northern European works. Occasionally it is possible to account for direct influences, such as those Harris and MacDonald brought back from the Scandinavian exhibition in Buffalo. But more often, as with Thomson and Jackson in the years immediately after 1913, the full implications of the lessons the Scandinavians could have taught were realized without firsthand knowledge of their work. Stylistic analysis shows that, throughout the next decades, the principal works of the Group of Seven and Emily Carr abide by the basic compositional ground rules that were established in Europe during the 1890s, as if they were in unconscious but continuous dialogue with a set of inherited principles. The closest affinities are in pictorial structure, not in colour schemes, in which the Group drew perhaps more directly from advanced French sources. Structural principles could also be conveyed meaningfully from illustrations, and Symbolist ones could be deduced from the decorative designs of art nouveau, in which most of the Canadians were well versed. If the Canadians wanted to wrest meanings from nature similar to those of the Symbolist landscapists of the 1890s, their pictures would have to compose themselves in related decorative ways, despite inevitable stylistic differences that must come about because the time, place, and people were different. From this perspective it would seem clear that the Scandinavian exhibition, while offering some real practical assistance, in the long run was most significant for the example it presented of the viability of a national art rooted in specific characteristic subject matter and paintable in a modern decorative way, that is, not according to the Barbizon school or Hague school or other shopworn Realist formulas then available in Canada. For an artist such as Jackson, who did have a feeling for more advanced styles, the examples of the Scandinavians potentially pointed him away from the pastoral landscape to which he was most accustomed to the challenges of a different, native one, a redirection that also required rethinking of the fundamentals of his style.

It was no more essential for all the Canadians to have shared specific sources and models than it was for the northern Europeans at the beginning of the 1890s, when they developed what subsequently emerged as a common style despite the fact that they did not necessarily know one another during the initial stages of its formulation. By the same token it can also be better understood why the Group of Seven played down its foreign influences and insisted that its work developed directly in accordance with the character of the land. To some extent this was pure obfuscation, but the members of the Group did not simply derive a style from the Scandinavians, or anyone else, but had to learn it from basic principles in front of untested subject matter and make it their own. That they could sustain it so long, and develop upon it, is an indication of the authenticity of their personal commitment to it. That it was late on the larger international stage and that the Group increasingly retreated into dogmatic isolationism are separate problems.

The United States: Marsden Hartley, Arthur Dove, Georgia O'Keeffe, and Augustus Vincent Tack

This quality of nativeness is coloured by heritage, birth and environment, and it is therefore for this reason that I wish to declare myself the painter from Maine.
Marsden Hartley[1]

The major proponents of the northern Symbolist landscape tradition in the United States are Marsden Hartley, Arthur Dove, and Georgia O'Keeffe. They have in common their long association with Alfred Stieglitz and his galleries – 291, the Intimate Gallery, and An American Place – and they were all seminal contributors, between 1910 and 1920, to the development of abstract art in the United States. Nevertheless, in their respective ways – and Hartley's career runs somewhat differently from Dove's and O'Keeffe's – the land and things of nature remain, with few exceptions, essential reference points for their work.

Before the First World War Hartley developed, especially in Germany, a reputation as an equal among the European pioneers, of abstract painting. Yet his abstract period seems almost an interlude in his career, though an exceptionally productive and significant one. On either side of it he painted monumental landscapes, which echo many of the subjective concerns of northern Symbolist landscape painting from turn-of-the-century Europe and of his contemporaries in Canada. The work of his last years, from Nova Scotia and Maine, was motivated by a regionalist cult of wild, northern places, and it vies with his Synthetic and Cubist German military paintings of 1914–15 as his most brilliant work.

Hartley's absorption of modernist principles, especially Cubist space, makes it possible to differentiate between his abstraction, which has a strong European base, and his landscape painting, which with few exceptions was rooted in American subjects. Such a distinction, however, is meaningless in discussing Dove and O'Keeffe, for the principles of their work changed little once their course was set. For them the polarities of abstraction and realism were not absolute, merely relative ranges within which their work swings throughout their careers.

Only rarely did Dove and O'Keeffe, and also Hartley, attempt completely non-referential abstraction on the model of Mondrian or Kandinsky during the 1920s and 1930s. There is little of the absolute in their work, which always, even at its most abstract, is tied to, and expressive of, the force of experience. For all three artists landscape painting is a major preoccupation, and their work grows out of a deep sensitivity to specific places, upstate New York for Dove, Lake George and the stark deserts of the southwest for O'Keeffe, and New England and Nova Scotia for Hartley. This mystical bonding with the landscape infuses their art with transcendent meaning and ultimately ties them to the Symbolist landscape tradition of the North.

Unlike their stylistically more conservative Canadian counterparts, the Americans' participation in that tradi-

tion cannot be accounted for through any direct transmission of influence. It arises instead from a confluence of ideas and attitudes drawn from American subjectivist traditions rooted in Transcendentalism, and from European Symbolist literary theories, coupled with the application to American subjects of the Modernism of the European avant-garde, for which Alfred Stieglitz had been an early propagandist.

All three had launched their work in Stieglitz's gallery 291 (O'Keeffe married Stieglitz in 1924). But though Stieglitz was one of the most influential disseminators of European Modernism in the United States, it was also his stated objective to provide an atmosphere for the development of an indigenous American modern style, an attitude that, after the Armory Show of 1913, caused him to concentrate on American artists, "not in the name of Chauvinism, but because one's own children must come first."[2] By the time of the opening of the Intimate Gallery in 1925 Stieglitz had abandoned the developments of European Modernism and turned his interest to the ways in which simplification and abstraction could be turned to creating meaningful expression of the American environment. Ultimately Stieglitz's purpose, as he wrote to the critic Paul Rosenfeld, became to promote "America without the damned French flavor."[3]

This point of view became prevalent with the new conservative and isolationist attitudes which flourished in the general mood of disenchantment that pervaded the United States after the First World War. In the arts it was manifested in the retreat from Modernism and abstraction and the development of American-scene realism as represented in the work of Hopper, Burchfield, and the Precisionists, and which in the Depression years would reach new heights in the socially conscious painting of Benton, Craven, and Shahn. Both conservative and liberal circles believed in the need to identify with the American character, and its spirit and history as the way to build cultural and aesthetic values for the future. They often speak in terms that echo the sentimental feelings for native country that motivated the Scandinavian retreat from France in the 1880s. Thus Hartley in 1921 argues, citing Vlaminck, that "intelligence is international, stupidity is national, art is local ... That art is likewise just as true of America as of any country, and despite the judgement of stodgy minds, there is a definite product which is peculiar to our specific temper and localized sensibility as it is of any other country which is nameable ... art is an essential local affair and the more local it becomes by means of comprehension of the international character, the truer it will be to the place in which it is produced."[4] Writers such as Van Wyck Brooks, Waldo Frank, and Paul Rosenfeld urged artists to stay at home to establish native roots and to render an American perception of place. Rosenfeld felt that it was Hartley's special ability to be able "to record the genius of a place," though he doubted that Hartley would be able "to lose himself in his object" and bring his art into full flower until he returned to his original roots in New England.[5]

When Hartley eventually did declare himself as the painter of Maine in a catalogue introduction of 1937 entitled "On the Subject of Nativeness – a Tribute to Maine," it was with a kind of possessiveness that excluded other contenders, because only he has the requisite "quality of nativeness," which "is coloured by heritage, birth and environment."[6] O'Keeffe, who except for a trip to the Gaspé in 1932 did not go abroad until 1953, recalls looking somewhat askance, during the early 1930s, at her literary contemporaries. While they spoke of writing the Great American Novel, the Great American Play or Poetry, they were all living abroad. "They didn't even want to live in New York – how was the Great American Thing going to happen?" The Great American Painting was not even conceived of, so intimidating was the continual presence of Cézanne. "I knew the middle of the country – knew quite a bit of the South – I knew the cattle country – and I knew that the country was lush and rich. I had driven across the country many times. I was quite excited over our country ... So ... I thought to myself," while working on *Cow's Skull – Red, White and Blue*, 1931 (Metropolitan Museum of Art, New York), "I'll make it an American Painting. They will not think it great with the red stripes down the sides – Red, White and Blue – but they will notice it."[7]

If it is true that the thinking around Stieglitz's galleries

increasingly set up America against Europe, 291 had also been the transmission point for subjective and Symbolist ideas, both North American and European. As Sasha M. Newman summarizes it: "Various currents of Symbolist origin – neo-Mallarmism, Neo-Impressionism, Synthetism, fascination with a fantasy of the outcast's life and a striving for social and intellectual non-conformity – thrived in Stieglitz's 'laboratory.' So too did the ethos of transcendentalism, undergoing a renascence at the hands of ... young literary radicals."[8] The collective body of ideas around Stieglitz stressed imagination and subjectivity, and his own writings echo and re-echo the ubiquitous Symbolist concepts of Idea, Soul, Beauty, Truth, Reality, and so on as code words for artistic expression dedicated to spirit over matter and intuition over intellect.[9] There is, of course, some risk in drawing more than the most generalized parallels between the ingredients of national aspiration and Symbolist insight of the northern European artists in the 1890s and those that motivated the Americans between the wars. Nevertheless there are reverberations that strike familiar chords, particularly in their regionalist commitment to place and their celebration of the indwelling spirit of native localities, often valued particularly for their remoteness and wildness.

Hartley was born and grew up in Lewiston, Maine. In the last years of his life, between 1937 and 1943, after many years of wandering, he finally returned to Maine and painted what are among his most powerful works. These late Maine paintings of figures, still lifes, and especially the landscapes, were a fulfilment in every sense of Hartley's first independent landscape painting from 1906 to 1909. These early works were developed first under the influence of Segantini's Divisionist palette (no. 136), and a year later under the shadow of the much more sombre one of Albert Pinkham Ryder who, after Hartley discovered his work in 1909, would become his true spiritual predecessor in New England.

Hartley's relation to his native Maine was ambiguous for much of his career. While he was in Europe, he wrote and spoke continually about the country of his childhood. In 1924 he executed in his Paris studio a group of Maine landscapes that are pure recollections of the "Dark Landscapes" he had painted under Ryder's influence in 1909 (no. 137). When Hartley returned to the United States in 1930 and declared himself a New England painter, it was perhaps as much a matter of strategy as of real conviction, in face of an art community that was entirely committed to American subjects and that looked with some suspicion on his European paintings. As we have seen, Paul Rosenfeld had suggested in 1923 that Hartley would have to return to Maine for his painting to regain the inner cohesion that it seemed to have lost. But even if Hartley's regionalist interests were to some degree motivated by pressures from critics and colleagues, he hardly capitulated, as Gail R. Scott argues, to the call to paint the "American scene."[10] The site Hartley selected in 1931 at Dogtown in Massachusetts was remote, bleak, barren, and neither attractive nor typical of New England. But it was typical of Hartley, who always preferred subjects that were forbidding and primitive. As it had in the Karelian forests, on the Norwegian and Swiss mountain peaks, and at the edge of the North Sea, so too in New England, in the stark glaciated rocks of Dogtown, nature revealed itself in its essential symbolic garb:

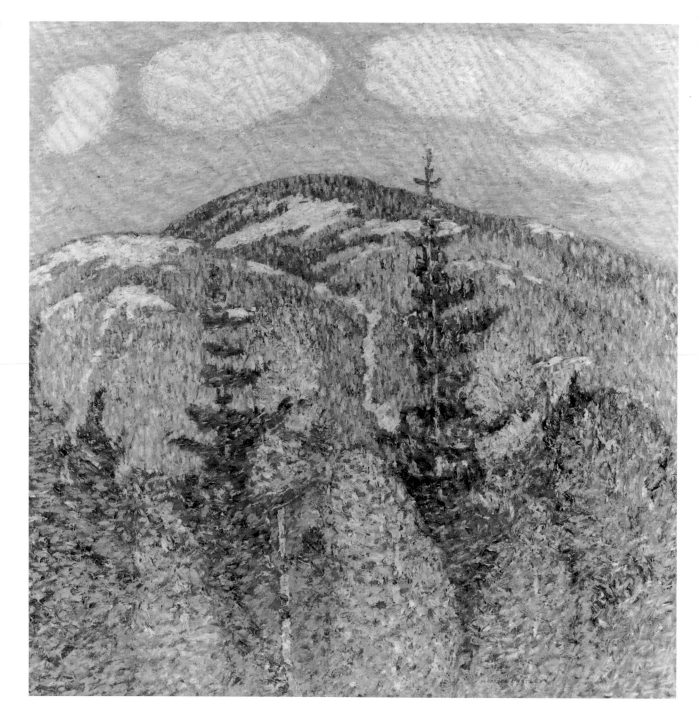

The place is forsaken and majestically lovely as if nature had at last found one spot where she can live for herself alone. It takes someone to be obsessed by nature for its own sake – one with a feeling for austerities and the intellectual aloofness which lost lonesome areas can persist in ... No triviality enters such places as these ... [It is] a cross between Easter Island and Stonehenge – essentially druidic in its appearance – it gives the feeling that an ancient race might turn up at any moment and renew an ageless rite there.[11]

Beginning with his first mature paintings, Hartley's view of the landscape of Maine is surprisingly new in American painting, and his coloristic vigour and compositional boldness seem to have few roots in either American Impressionism or the crepuscular moodiness of Tonalism, which dominated landscape painting at the beginning of the century. On the contrary, in *Cosmos*, 1908–9 (no. 136), we are carried out of the pastoral twilight and up into the clear air of a sunlit autumn mountainscape, our view cast across the tree-tops onto the opposite mountainside with its newly fallen snow and into a blue sky in which float self-assured solid Hodlerian clouds. We seem to have crossed the threshold from the quietist reverie of the *fin de siècle* into the new century's open-eyed optimism, which will similarly constitute the essential mood of the works of the Group of Seven. The sense of rebirth after a period of enervation and decadence was fully realized by Hartley himself, who felt he had "come back to the original child within, the romanticist," and described his new work as "little visions of the great intangible ... Some will say he's gone mad – others will look and say he's looked in at the lattices of Heaven and come back with the madness of splendor on him."[12] As its title implies, *Cosmos* is not untouched by a note of mysticism.

Hartley's lifelong faith in intuitive experience and his

136
Marsden Hartley (1877–1943) American
* *Cosmos*, 1908–9
Oil on panel. 76.2 × 76.5 cm
Columbus Museum of Art, Columbus, Ohio.
Gift of Ferdinand Howald

spiritual and mystical interests, which are reflected throughout his writing and art, had their roots in Emerson's *Essays* to which he was introduced in 1898 while he was studying at the Cleveland School of Art. He carried the book with him for five years and attributed to it "all the things I was made to know and out of which the substance of my being was fed."[13] The transcendental inclinations aroused by Emerson were further fed by Hartley's readings of Thoreau and Whitman, and his early letters abound with references to the restorative powers of nature and to his understanding of nature as an embodiment and glorification of the divine. To the American Transcendentalist tradition was added a formal introduction to Eastern religion in 1907 during a summer spent at Green Acre, a retreat in Maine dedicated to the exchange of mystical and philosophical views. Sarah Farmer, the founder, had also been a patroness of the art teacher Arthur Wesley Dow (a major influence on O'Keeffe), who purportedly had painted with Gauguin in Pont Aven and who taught a Synthetist approach based on Oriental art. Barbara Haskell suggests that, though Dow had stopped attending Green Acre by 1907, Hartley could still have picked up his theories from Sarah Farmer, or from the paintings themselves, which hung in the guest lodge.[14]

Hartley had studied Japanese prints since student days and may have developed his interest in the decorative quality of all-over surface patterns from American Impressionists such as Twachtman or from Maurice Prendergast, who in 1908, apart from Hartley, was the only Neo-Impressionist working in the United States. Certainly the Synthetist organization of parti-coloured planes in *Cosmos* gives it its high-spirited freshness. In this respect Hartley's work of 1908 also differs essentially from that of Segantini, who always retained a basic faith in naturalistic form. Hartley, however, had taken his Divisionist technique from Segantini, but had adapted it to Synthetist compositions.[15] Hartley would later give Segantini credit for giving him insight into mountains, especially his own Maine mountains, as a subject matter for art, teaching him not only about their appearance, but also suggesting other penetrations of meaning. Above all, however, as he said in the late 1920s, it was to "Segantini, the impressionist, not Segantini the symbolist" to whom

he was indebted "for what I have learned in the times past of the mountain and a given way to express it."[16] This comment no doubt refers to the liberating advantages of Segantini's Neo-Impressionist "stitch" technique, which allowed Hartley, not only to separate his individual brush stroke from formal description, but also to use its interwoven fabric of discrete dabs of brilliant colour to give luminosity to shadows as well as areas of sunlight, an essential factor in laying out a flattened decorative pattern.

From an early stage Hartley's work has close parallels with northern European Symbolist landscapes: *Cosmos*, with the Gauguin-inspired Synthetist patterns of Osslund's *Autumn Day, Fränsta* (no. 51) and with Munch's decorative landscapes from around 1900 (nos. 58 and 59), which also use a strong pattern of cropped foreground trees as a foil for more expansive landscape elements that lie further in the distance. The "Dark Landscapes" from 1909, whose mood and style would later be repeated in a group of recollections from Maine painted in France in 1924, find a counterpart in Sohlberg's *Winter Night in Rondane* (no. 69). *Paysage*, 1924 (no. 137), is composed in a similar way, with close-up groups of primitive trees which have been crowded to the sides of the frame so as to open up a central view onto distant mountains. Hartley's vision is, however, quite different from Sohlberg's. His mountains are dark and solemn, and his clouds heavy and oppressive, forcing the eyes downward onto the little farmhouses below, which are quite overwhelmed by a brooding and threatening landscape. Both the 1909 and 1924 series were, according to Hartley, painted "solely from memory and the imagination"[17] and reflect his deeply felt sympathy with older American Romantic traditions represented especially by Ryder, under whose influence Hartley came in 1909. Ryder's work deeply touched Hartley's own Romantic and imaginative spirit, and the older artist's dark palette and formal austerity joined forces well with the Synthetism Hartley had developed in the paintings of 1908. The result was a brooding Expressionist style that suited the mood of loneliness and artistic isolation by which Hartley was then possessed. From his later perspective as the regional painter of Maine, Hartley would record his pride in these "Dark Landscapes," "as

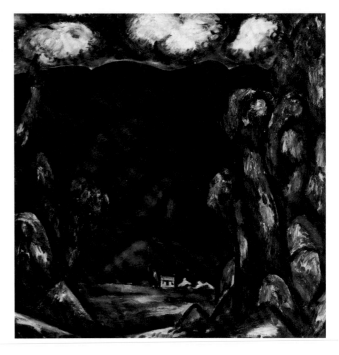

137
Marsden Hartley (1877–1943) American
* *Paysage*, 1924
Oil on canvas. 80.9 × 80.9 cm
Grey Art Gallery and Study Center, New York University
Art Collection. Gift of Leo M. Rogers, 1972

they bear witness to devout and lasting influence as if the great spirit of Ryder had wrapped its folds about me, and made me if possible more inviolably Yankee than ever."[18]

As a result of his first one-man show at 291 in 1909 Hartley soon discovered Matisse, Picasso, and Cézanne, and for a while his landscape-inspired mystical concerns gave place to more formal problems. It would be a decade before he turned to landscape subject matter again, two decades before he returned to New England, and more than two and a half before his period of wandering finally ceased and he found himself back in Maine. He began his first European stay in 1912 in Paris and like the Scandinavians earlier on, he did not feel comfortable with the

French and formed his closest friendships among the German artists in Paris. "I turn to the Germans with more alacrity for they are more sturdy like ourselves," he wrote to Rockwell Kent.[19] His introduction to Kandinsky's *On the Spiritual in Art* and to *Der blaue Reiter* generated the interest in primitive cultures that may have underscored his later espousal of American Indians, an attitude shared by Dove, for the sense of integrity in work by the Indians which stemmed from the seamless unity between their art and their way of life. Such unity, Hartley would later maintain, could be recovered only by cultivating the "nativeness" of the regional painter, whereby the spirit of the land became, through heritage, birth, and environment, instilled in the artist's being. The German contacts also revived Hartley's interest in intuitive and spiritual expression, but despite his sympathy with the mystical programmes of Kandinsky and Marc, he was always careful to develop his own interests as an American and in continuation of the landscapes of 1908–9, which, as he wrote to Stieglitz in 1913, "were so expressive of my nature – and it is the same element I am returning to now with a tremendous increase in power through experience."[20]

In the late 1910s Hartley began to distance himself from avant-garde issues, and for the next decade he did not find any sure artistic direction. His most powerful landscapes during the 1920s were often painted from memory in his studios in New York, Berlin, and Paris. They referred back to earlier experiences in New Mexico and Maine (no. 137) and stressed nature in its bleaker and more desolate moods. In 1927, in Aix-en-Provence, in emulation of Cézanne, he executed a series of Mont Sainte-Victoire paintings, perhaps as a corrective to what he considered previous excessive indulgences in personal expression and to his undue pursuit of the life of the imagination at the expense of intellectual and aesthetic problems.[21]

Hartley returned to New England in 1930, and in 1931 he turned to the scenery of Dogtown, outside Gloucester, Massachusetts. In Scott's words, he then "first penetrated through to his radical notion of place."[22] This step in regionalist identification, soon to be formulated in his concept of nativeness, also joined him with the community of thought heretofore represented by Bergh and

Nordström, Gallen-Kallela, and the Group of Seven, who all sought authenticity in their work through an intimate spiritual bonding with the land of their birth or adoption.

Hartley ultimately tied his nativeness specifically to Maine. His principal manifesto, "On the Subject of Nativeness – A Tribute to Maine," however, was published as the foreword in a catalogue for an exhibition of paintings from Nova Scotia.[23] This was in April 1937; Hartley began to paint in Maine later in June. In his text Hartley argued that even within New England itself it was necessary to speak in terms of regions: Vermont, for example, represented a New England different from New Hampshire, and Boston could not be identified with Massachusetts. Nevertheless he seemed quite prepared to let the Nova Scotia pictures in the exhibition support his theory of nativeness, because they derived from "my own native country – New England – and the country beyond to the north – geologically much the same thing." Nova Scotia may even offer an "added tang because it is if anything wilder still, and the people that inhabit it, fine types of hard boned sturdy beings have the direct simplicity of these unique and original places."

Hartley thus subtly boosts his aesthetic theories with an ethical belief that people whose character is shaped by hard and primitive places (presumably like his own) are also morally superior: "The opulent rigidity of this north country, which is a kind of cousin of Labrador and the further ice-fields, produces a simple, unaffected conduct and with it a kind of stark poetry exudes from their behaviour, that hardiness of gaze and frank earnestness of approach which is typical of all northerners." In the North contact and trust are established in silence: "Silence is the enriching channel by which you make social contact, or at least to say, brief speech and much meat in it." Hartley had discovered a similar directness, and an unwillingness or inability to deceive, in the Indians of the southwest; only in cities was lying not detested. For Hartley the virtue of life in the wilderness was that, however hard it was, or rather because it was hard, it was lived with almost unconscious harmony with nature, whether its moods were beneficent or malevolent. The fisherman drowned at sea, "pretty much as children often go to their death without murmur and without reproach."[24]

Hartley mythologized and raised to heroic proportions his New England paradise in "archaic" single and group portraits and in monumentalized landscapes. He usually kept the two genres strictly apart, never depicting the interaction of man and nature. In this he was in agreement with the tradition of northern Symbolist landscape painting, and also joined it in the rejection of narrative or illustration, tendencies that he disapproved of in Charles Burchfield, and that would trivialize his wilderness myth.

In reality Hartley's relationship to stark and lonely places was ambivalent, an irony he remarked on from Gloucester in 1931: "What an anomaly it is anyhow that I for simple human reasons prefer city sophistication – and for the purposes of work I am always driven to the wastes, where little or nothing moves but the speechless progress of geological structures of the earth."[25] His conception of the nobility of simple hard-working people was also severely tested by experience. Except for two brief idyllic stays with a fishing family in Eastern Points, Nova Scotia, in 1935 and 1936, which was the subject matter for the "archaic" portraits that followed in the next years, he failed to establish any meaningful contact with the common people in the communities in which he worked, and they treated his painting either with disregard or with hostility. Their speech, filled with the "bucolic platitudes of people who never think above the surface," he found discouraging enough to make him contemplate discontinuing his summers in Maine: it is "all right to be sentimental about the homeland and all that – but it provides no stimulus."[26]

To a large extent Hartley's longings for the far reaches of New England and Nova Scotia were probably motivated by nostalgia for a way of life that had hardly been his own in Maine. Haskell suggests that, although Hartley had declared himself a New England painter as early as 1931, and linked his return to Maine with a restoration of earlier faiths and ideals so as to "make what was broken whole,"[27] it was perhaps bitter childhood memories that postponed the return for another five years. Maine nevertheless became the final geographical focal point for the ideal of transcendental union with nature which had its roots in Hartley's artistic youth before his years of international travel. Maine became an anchor in periods of exile and artistic confusion, and eventually the philosophical cornerstone for the heroic art of his last years.

Hartley, whether referring to New England, Nova Scotia, or Maine, speaks of "country." It is a matter not of nation, Canada or the United States, but of locality. A country is a man's place of origin, "bounded on every side by its people, its place and its ideas." "Country" is an "abstract yet definite reality," whose quality is "nativeness," which in relation to Maine appears in art most strongly and powerfully in Ryder and in Winslow Homer, and in literature is exemplified by E.A. Robinson and Edna St Vincent Millay. Nativeness is built of "primitive things," the eternal and solemn flow of the rivers, "the numberless inland lakes [which] harbour the loon, and give rest to the angles of geese making south or north according to the season." Whatever modernizations civilization will invent, "the gulls remain the same and the rocks, pines, and thrashing seas never lose their power and their native tang." Nativeness, furthermore, never lets go of one; as with Strindberg, writing in the 1880s,[28] it is in one's bones, and however far afield one travels, one cannot shake it off. As Hartley argued, because his education had begun in his native hills, they never left him but looked even more wonderful to him when he was away in Paris, Berlin, or Provence. His return, with the will to become "the painter from Maine," would reunite him with the "heritage, birth and environment" to which he had always been subject.[29]

The appeal of Dogtown, as the first motif of his return to New England, was its stark and archaic quality. Its "druidic" appearance seemed to recall the earliest of times and had "the air of being made for no one – for nothing but itself ... A sense of eeriness pervades all the place therefore and the white shafts of these huge boulders mostly granite – stand like sentinels guarding nothing ... the place is forsaken and majestically lovely as if nature had at last found one spot where she can live for herself alone."[30] Hartley's pictorial conceptions of Dogtown, as in *Rock Doxology, Dogtown*, 1931 (no. 138), are as severe as his verbal description of his subject's primitiveness and agelessness. He has subjected the parts of his landscape to monumental abstraction, wiping out details of texture and substance. The powerful compressed forms that re-

sult push and shove one another with a primeval energy all the more sluggish and earthbound under a pale, tranquil sky. The reduction to essential form is reminiscent of Harris's procedure in his pictures from north of Lake Superior (no. 114), as is the sense of eternal order that underlies the surface chaos. Harris, however, simplified in pursuit of pure idea, whereas Hartley retained a sense of organic life as pervasive in nature.

In 1933 on a European visit Hartley painted a series of monumental mountainscapes in Garmisch-Partenkirchen

138
Marsden Hartley (1877–1943) American
* *Rock Doxology, Dogtown*, 1931
Oil on board. 47.5 × 61 cm
Private collection

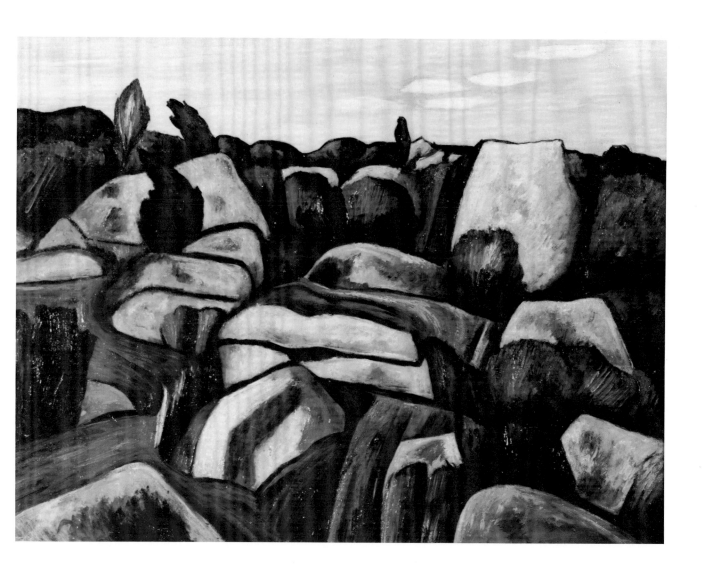

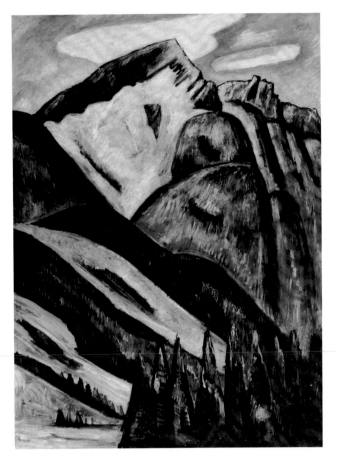

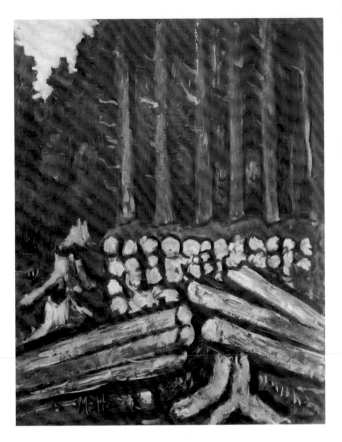

139
Marsden Hartley (1877–1943) American
* *Garmisch-Partenkirchen*, 1933
Oil on composition board. 75.1 × 56.6 cm
Mr and Mrs William J. Poplack, Birmingham, Michigan

140
Marsden Hartley (1877–1943) American
* *Wood Lot, Maine Woods*, 1938
Oil on panel. 71.1 × 55.9 cm
Phillips Collection, Washington, DC

in the Bavarian Alps, which impose on the Alps the kind of solid grandeur of the Dogtown paintings. These pictures join the ranks of the line of Symbolist mountainscape painting initiated by Willumsen forty years before, something of which Hartley was well aware, in so far as he understood his own mountain painting to follow in the tradition of Segantini and Hodler. Though a relatively

small work, the vertical format of *Garmisch-Partenkirchen*, 1933 (no. 139), enhances the height of Hartley's snowclad mountain peaks, their pointedness echoed in the staccato rhythms of the tops of the foreground trees in a manner reminiscent of the Alpine pictures done by Ernst Ludwig Kirchner late in the First World War (no. 157). Hartley's palette is, however, much more subdued and naturalistic,

centred on bold black and white contrasts, which contribute to the sense of mass and permanence of structure. Though produced in Germany, such a painting does not suffer from any lack of feeling of nativeness; on the contrary it already contains the essentials of the great landscape style that would flower in Maine.

The Maine paintings resume the subject matter of the "Dark Paintings" from 1909. They deal with the relationship between man and nature, usually in tragic terms, and often on the edge of a merciless sea (*Rising Wave, Indian Point, Georgetown, Maine*, 1937–8, no. 141), with waves crashing relentlessly on a raw and rugged shoreline. With Hartley's return to Maine he also returned to Ryder, plumbing both his subject matter and his brooding lonesome moods. Hartley's pervasive sense of personal melancholy is underscored by a style dominated by thick paint, heavy black outlines, and chunky shapes that stress the weight and density of things. At the same time, however, there is in his heavily bodied paint a sense of substance and texture, not just of the paint surfaces *per se*, but also of the things of nature (no. 140). In this way Hartley speaks also of his love for nature and succeeds in holding in balance the dual aspects of tragedy and regenerative divinity that it embodies.

If Hartley found a point of peaceful equilibrium, it was in the peak of Mount Katahdin in Maine, which he first visited in October 1939: "I have achieved the 'sacred' pilgrimage to Ktaadn. I feel as if I had seen God for the first time – I find him so nonchalantly solemn."[31] By 1 February 1940 he had finished eighteen paintings of the mountain, all of the same view but under different conditions and moods.[32] He would continue the subject for the next two years, noting that "after all Hisroshigi did 80 woodblocks of Fujiyama, why can't I do 80 Katahdins – and each time I do it I feel I am nearer the truth, even more so than if I were trying to copy nature from the thing itself."[33]

A new kind of spiritual calm resides in these paintings, realized in *Mount Katahdin, Autumn No. 1*, 1939–40 (no. 142), in a brief succession of cleanly outlined and simplified forms: the oval curve of the foreground lake, a few trees, the gentle rise of the autumn-coloured hill in middle ground, and the dark conic form of the mountain itself silhouetted against a blue sky with familiar stylized clouds. Hartley has also heightened the visionary impact of his mountain peak by juxtaposing its abstracted shape against comparatively agitated foreground detail, a device common to northern Symbolist mountainscapes, from Sohlberg to Harris's *North of Lake Superior*, but in sharp contrast to Hartley's own Cézannesque paintings of Mont Sainte-Victoire from the late 1920s, which are evenly built across their entire surface by a uniform structural brush stroke. It is curious that these late manifestations of northern Symbolist landscape painting should find their resolution in mountains peaks, the subject that from the very start, fifty years before, Willumsen had isolated as the seat of superhuman values. It is furthermore ironic that the site of the subject matter of these paintings, the meaning of which derives ultimately from the Transcendentalist belief in nature as the embodiment of divine presence, should be the one place of true wilderness in which Thoreau, almost a century earlier, was defeated in his attempts at transcendence. Clinging to its craggy ascent, he lost sight of the symbolic significance of nature's objects and could no longer perceive the correspondence between outward form and inward vision. Mount Katahdin was wilder than anything he had experienced, and he returned home with a much greater respect for civilized places:[34]

It was vast, Titanic, and such as man never inhabits. Some part of the beholder, even some vital part, seems to escape through the loose grating of his ribs as he ascends. He is more lone than you can imagine. There is less of substantial thought and fair understanding in him, than in the plains where men inhabit. His reason is dispersed and shadowy, more thin and subtile, like the air. Vast, Titanic, inhuman Nature has got him at disadvantage, caught him alone, and pilfers him of some of his divine faculty. She does not smile on him as in the plains. She seems to say sternly, Why came ye here before your time ... Why seek me where I have not called thee, and then complain that you find me a stepmother ... ?[35]

Marsden Hartley (1877–1943) American
* *Rising Wave, Indian Point, Georgetown, Maine*, 1937–8
Oil on board. 55.9 × 71.1 cm
Edward Joseph Gallagher III Memorial Collection,
Baltimore Museum of Art

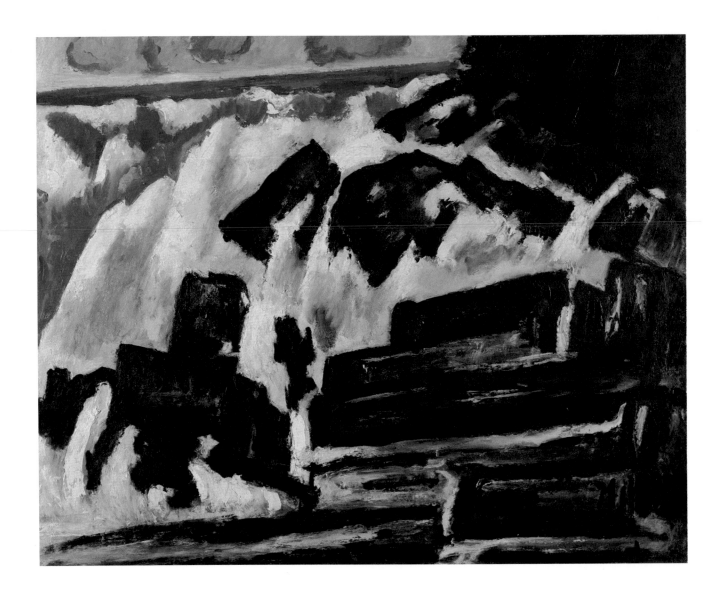

142
Marsden Hartley (1877–1943) American
* *Mount Katahdin, Autumn No. 1*, 1939–40
Oil on canvas. 76.2 × 101.6 cm
F.M. Hall Collection, Sheldon Memorial Art Gallery,
University of Nebraska – Lincoln

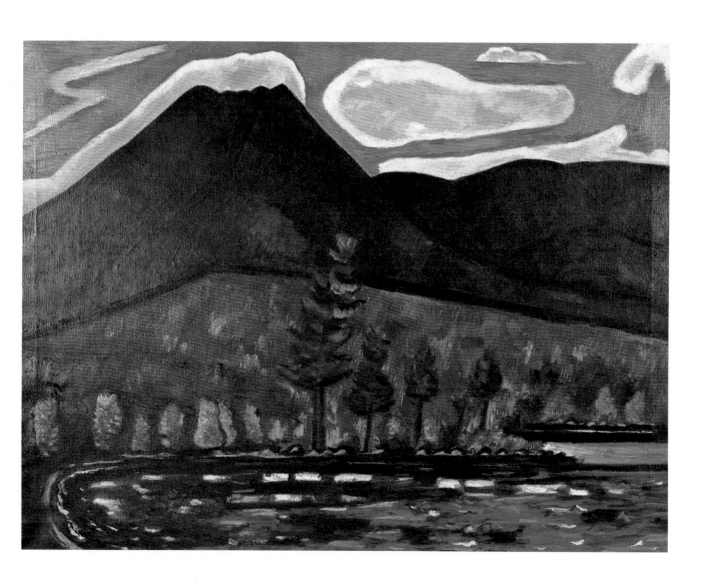

The unexplainable thing in nature that makes me feel the world is big beyond my understanding – to understand maybe by trying to put it into form. To find the feeling of infinity on the horizon line or just over the next hill.
Georgia O'Keeffe[36]

But, for instance, to feel the power of the ground or sea, and to play or paint it with that in mind letting spirit hold what you do together rather than continuous objective form, gaining in tangibility and actuality as the plane leaves the ground, to fly in a medium more rare and working with the imagination that has been built up from reality rather than building back to it.
Arthur Dove[37]

Arthur Dove came to admire European Modernism, especially Cézanne and the Fauves, during his 1908–9 visit to France. Permanently back in the United States in 1909, he executed, between 1910 and 1912, with the added influence of Cubism, a remarkable array of abstract works, as advanced as their contemporary European counterparts. Georgia O'Keeffe, on the basis of purely American experience, particularly the teaching of Arthur Wesley Dow,[38] had by 1915–16 developed a powerful personal abstract style applying the simplest and most economical means. Her work too remains among the most original manifestations of native American Modernism. Abstraction continued to be potent force for both artists, but it was always a relative abstraction, a means for imaginatively probing into the spirit of natural things, which were never far out of sight or mind. Because theirs is basically a pantheistically motivated art, it probably would have foundered had it ventured into the realm of pure abstraction such as was developed in Europe in the years between the wars. As Dove announced to Stieglitz in 1913, after the period of extreme abstraction that had commenced in 1910, his line had gone dead with the effort of having to work with pure form. The only way to keep his art alive, he felt, was to go back to nature and build his art on experience.[39]

Hartley, who described O'Keeffe as "a mystic of her own sort," said of her work that her "struggle is always toward a glorification of the visible essences and semblances of earth." O'Keeffe also quickly recognized the mutual affinity between herself and Dove based on their shared passion for nature. As she observed of him, "Dove comes from the Finger Lakes region. He was up there painting, doing abstractions that looked like that country, which could not have been done anywhere else."[40] She also noted: "Dove is the only American painter who is of the earth. You don't know what earth is, I guess. Where I come from the earth means everything. Life depends on it. You pick it up and feel it in your hands."[41] Out of such comments developed the myth of Dove as a twentieth-century Thoreau, working in poetic seclusion, immersed in the cycles of nature, who had quickly upon his return to the United States detached himself from European influence and needed only the forms of nature as his dictionary.[42]

The myth is, of course, false, as was the contemporary claim of the Group of Seven to visual innocence in front of nature. The affinities that can be discerned, especially between the early work of both Dove and O'Keeffe and the pre-First World War work of Kandinsky, are surely not entirely fortuitous, certainly not for Dove, though there was no opportunity for O'Keeffe to have direct contact with Kandinsky's painting.[43] What, however, distinguishes the work of the two Americans, regardless of how freely and intuitively it may have been conceived, is its faithfulness to the space and the relationships of nature. The spatial principles of representational painting control their compositions. If pictorial space is not always rational and sometimes assumes the character of the imaginary space of dreams, and if the pictorial shapes of Dove and O'Keeffe cannot sometimes be translated into something that we can name, they nevertheless evoke things, or their movements and energies, and they retain the colours and smells of the world of objective reality.

143
Arthur Dove (1880–1946) American
* *Waterfall*, 1925
Oil on panel. 25.4 × 20.3 cm
Phillips Collection, Washington, DC

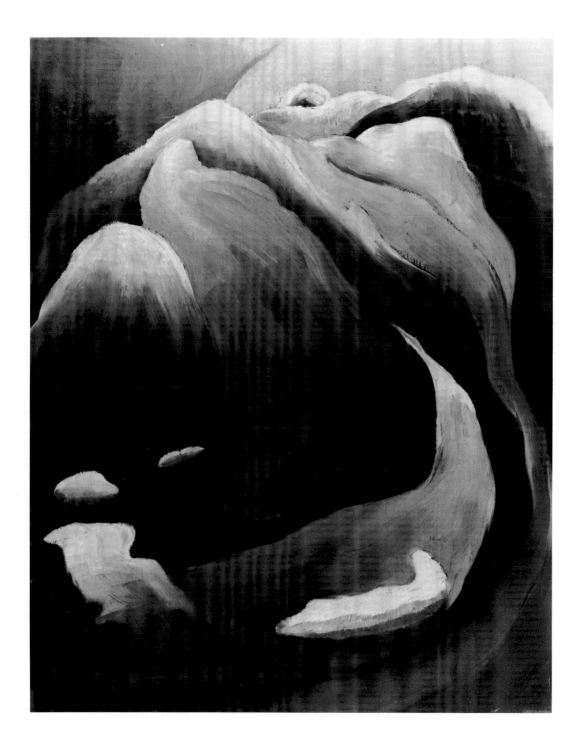

"Actuality!" wrote Dove, "At that point where mind and matter meet. That is at present where I would like to paint. The spirit is always there. And it will take care of itself. We can tear our imaginations apart, but there is always the same old truth waiting."[44]

Hartley would state the problem of the relationship between subjectivity and the material world differently, as he did in an article of 1928 in which he discussed his anxiety about work emanating from emotion and personality and the need to anchor the imaginative life in

144
Arthur Dove (1880–1946) American
* *Snow Thaw*, 1930
Oil on canvas. 45.7 × 61 cm
Phillips Collection, Washington, DC

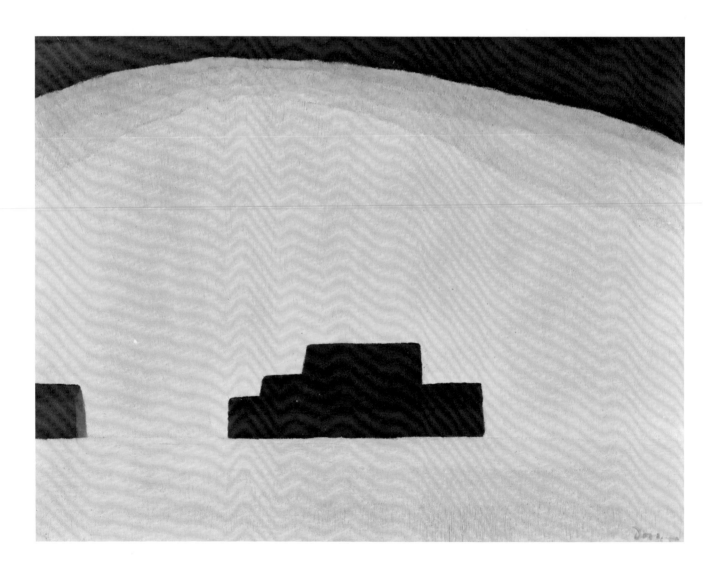

145
Arthur Dove (1880–1946) American
* *Morning Sun*, 1935
Oil on canvas. 50.8 × 71.1 cm
Phillips Collection, Washington, DC

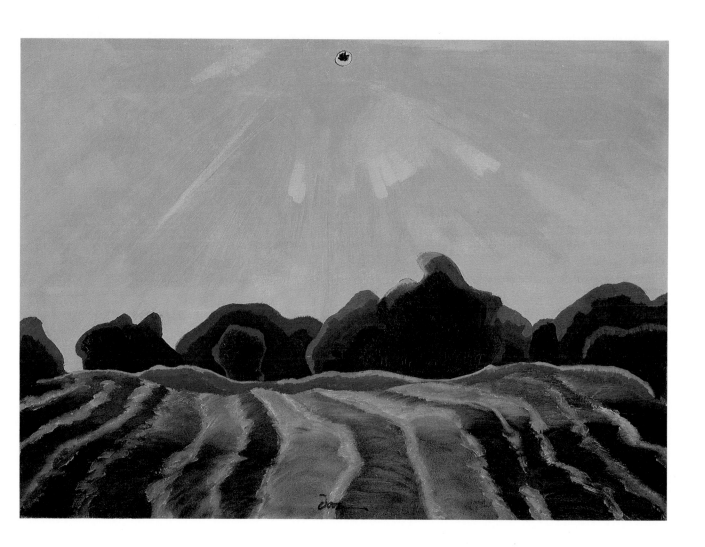

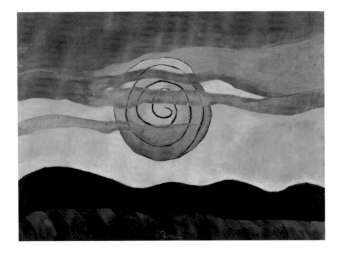

146
Arthur Dove (1880–1946) American
* *Red Sun*, 1935
Oil on canvas. 51.4 × 71.1 cm
Phillips Collection, Washington, DC

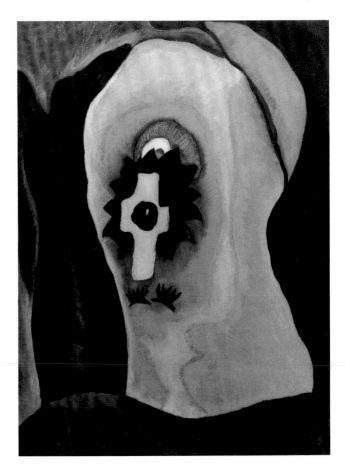

147
Arthur Dove (1880–1946) American
* *A Cross in the Tree*, 1935
Oil on canvas. 71.1 × 51.4 cm
Terry Dintenfass Gallery, New York

concrete experience: "I have made the complete return to nature, and nature is as we all know, primarily an intellectual idea, and that the laws of nature as presented to the mind through the eye – and the eye is the painter's first and last vehicle – are the means of transport to the real mode of thought: the only legitimate source of esthetic experience for the intelligent painter."[45]

Despite the contrasting intuitive and intellectual drifts of the two programmatic statements by Dove and Hartley, they reiterate the common bond of the three Americans we are discussing here. However much they wanted to fly to imaginative heights, each wanted (and this is as true for Hartley despite his occasional retreat to intellectual foundations), "to be sure the balloon of experience was anchored to the fact, even if by a very long cable."[46] In this they were, of course, remaining faithful to their deep roots in the American philosophical traditions of Transcendentalism and Pragmatism, which did not conceive of essential distinctions between subjective and objective experience, but maintained that the ideal and the

transcendental truths were coincidental with the stuff of reality and flow directly and inseparably from it.[47] The belief in the immanence in nature of subjective and spiritual truth is also the shared experience of northern Symbolist landscape painters throughout Europe and North America.

As we have observed, the work of both Dove and

O'Keeffe throughout their careers flows unimpededly back and forth between near-abstraction and near-realism. The work at the realist end of the scale most tellingly underscores the fact that both artists belong to the Symbolist landscape tradition, not only philosophically, but also visually. Dove's subjects, except for his assemblages from the 1920s, are predominantly unpeopled landscapes or landscape-derived abstractions. He occasionally descends

148
Georgia O'Keeffe (b 1887) American
* *Lake George*, 1922
Oil on canvas. 41.2 × 55.9 cm
San Francisco Museum of Modern Art.
Gift of Charlotte Mack

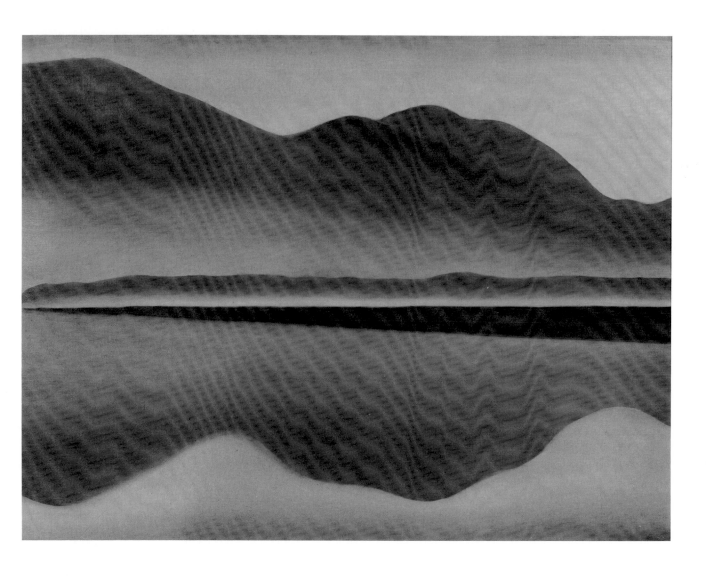

149 (below)
Georgia O'Keeffe (b 1887) American
* *Red Hills and Sun, Lake George*, 1927
Oil on canvas. 68.6 × 81.3 cm
Phillips Collection, Washington, DC

150 (opposite)
Georgia O'Keeffe (b 1887) American
* *East River from the Shelton*, 1927–8
Oil on canvas. 63.7 × 55.8 cm
New Jersey State Museum Collection, Trenton. Purchased
by the Association for the Arts of the New Jersey State
Museum with a Gift from Mary Lee Johnson, 1972

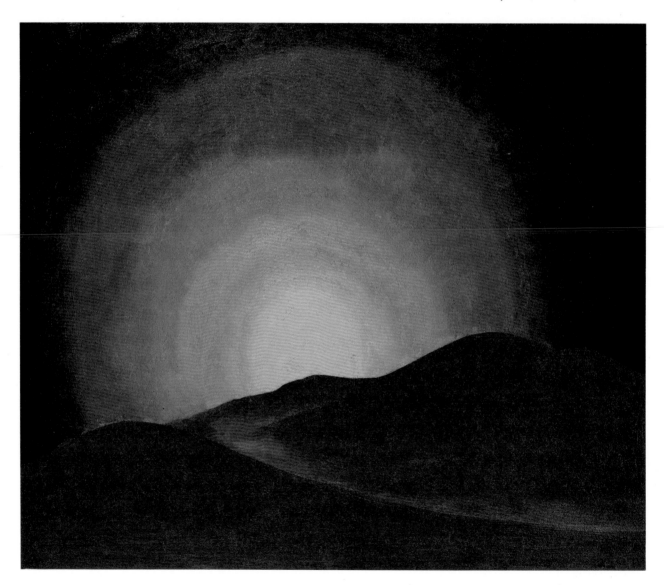

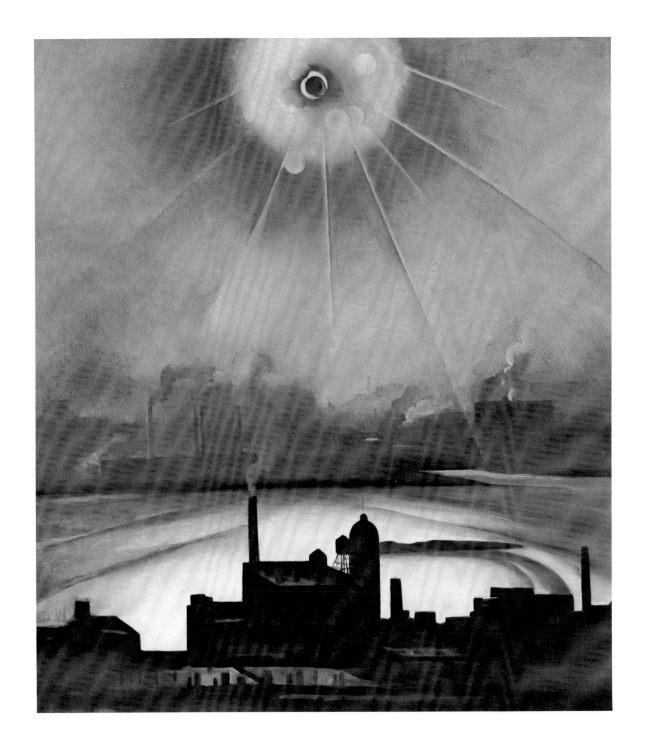

into quaintness, but at his best he infuses even his relatively pastoral surroundings in upper New York with awesome splendour. He never seems to have deliberately sought exceptional scenery, but he was able to work with what was readily around him and discover in it deep emotional and visionary content. He did not need to

work in a large format; most of his paintings are small in comparison to the work of the other artists we have considered. But even his tiny *Waterfall*, 1925 (no. 143), suffers nothing from its scale and flows with something of the elemental force that we can imagine to have shaped the original contours of the earth.

151 (below)
Georgia O'Keeffe (b 1887) American
* *Lake George Barns*, 1926
Oil on canvas. 53.7 × 81.3 cm
Walker Art Center, Minneapolis.
Gift of T.B. Walker Foundation

152 (opposite)
Georgia O'Keeffe (b 1887) American
* *Cross by the Sea, Canada*, 1932
Oil on canvas. 91.4 × 61 cm
Currier Gallery of Art, Manchester, New Hampshire

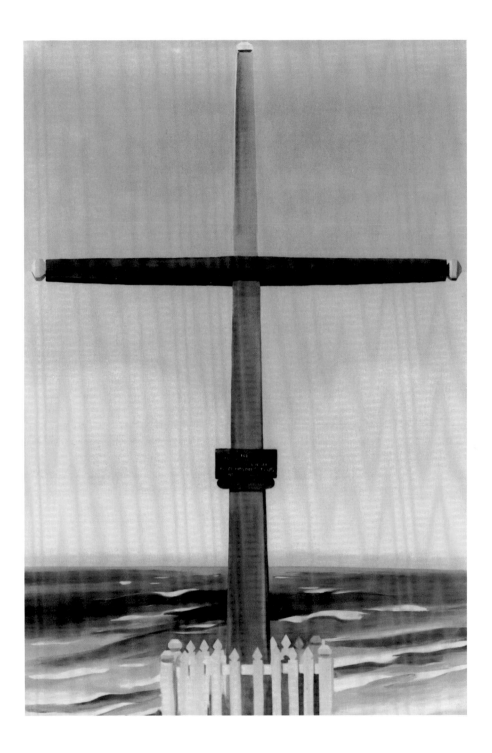

Often Dove's landscapes pulsate with organic life and are rich with growth and decay. At other times his subjects face us with a frontal solemnity, like the small farm buildings in *Snow Thaw*, 1930 (no. 144), desolately isolated in the unbroken white of winter nature and dark like the still-slumbering earth emerging at the edge of the receding snowline. Like Munch and Willumsen, Dove is a pantheist sun worshipper peering into the glare of fresh morning sunlight over newly ploughed furrows, as in *Morning Sun*, 1935 (no. 145), or into its dull orange-red evening glow as it hangs large and pensive in a cloudy sky above a stark and primitive landscape, as in *Red Sun*, 1935 (no. 146). *A Cross in the Tree*, 1935 (no. 147), is typical of Dove's more intuitive insights into the forms and meanings of nature; scale becomes ambiguous, and nature looms with demanding intimacy.

O'Keeffe, more than Dove, was attracted to landscapes that stretched beyond the edge of habitation: "I lived on the plains of North Texas for four years ... That was my country – terrible winds and a wonderful emptiness."[48] There is a persistent quality of emptiness to her landscapes, much more so than in Dove's, and quite unlike Hartley's work, which is filled with the presence of nature. O'Keeffe's subject matter is usually seen either at a sufficient distance or so close up that, because her art is devoted to essential form and not to analytical detail, much of the surface of her paintings is given over to broad, relatively undifferentiated planes of colour. Her work is strangely spacious and monumental, and her style much simplified, with an emphasis on strong rhythmic outlines.

As critics have remarked, not without surprise, her work dealt with "a kind of nature poetry that few modern artists of the time would have attempted; who among the modernists would dare to paint a sunset?"[49] Her Lake George landscapes, even more than those she would later paint in the southwest, were pervaded by a kind of northern sobriety and severity which is familiar to the northern Symbolist landscape tradition, whether represented by her twilight reflections of hills on a far shore (*Lake George*, 1922, no. 148), or a brilliant setting sun hovering on the edge of the horizon at Lake George, transformed into a landscape more awesome and primordial than those imagined by Munch or Willumsen (*Red Hills and Sun, Lake George*, 1927, no. 149). Her landscapes are usually devoid of human presence, as are her rural farm buildings, stark grey and severly frontal (*Lake George Barns*, 1926, no. 151). Even her cities, alongside those of Sohlberg, Hammershøi, and Jansson, stand stark and empty, bathed in supernatural light, equally eerie whether its source is electric or heavenly. O'Keeffe's New York City paintings of skyscrapers at night, or looking across to the bleak industrial bank of the East River (*East River from the Shelton*, 1927–8, no. 150), suggest that comparable Precisionist pictures of barns, grain elevators, and cityscapes belong within the same landscape tradition.

As in preceding northern Romantic and Symbolist painting, there are startling contrasts of close-up and distance from work to work or within individual paintings. The latter is especially true of O'Keeffe's juxtapositions of broad desert landscapes and animal bones and skulls hovering monumentally in the foreground, or of pictures of crosses from New Mexico and Canada, in which a single stark, wooden, centrally placed cross fills the foreground pictorial plane, backed up against an endless sea or a vast landscape of rolling hills stretching toward the final glow of a sunset (*Cross by the Sea, Canada*, 1932, no. 152). These are strange inversions of the more traditional uses of cross images, from symbols of promise at the end of the road of life into stark declarations of the finality of death. In the same vein O'Keeffe's myopic close-ups of flower, of the voluptuous interiors of petals and stamens, are counterparts of the fascination of earlier northern European Symbolists with the undersides of snow banks and the stony bottoms of stream beds or their need to turn lonely sand dunes into monumental mountains.

Hartley, O'Keeffe, and Dove, as well as other American landscapists active in the 1920s and 1930s, are increasingly credited with providing strong foundations for the development of painting in the United States after 1945. Another interesting painter is Augustus Vincent Tack, whose work received no art historical attention until a circulating exhibition in 1972 presented it as a connecting link between Abstract Expressionism and earlier American traditions; subsequently Tack's paintings were also noticed by Robert Rosenblum, who saw them as per-

153
Augustus Vincent Tack (1870–1949) American
* *Storm*, 1920–3
Oil on canvas mounted on construction board.
94 × 121.9 cm
Phillips Collection, Washington, DC

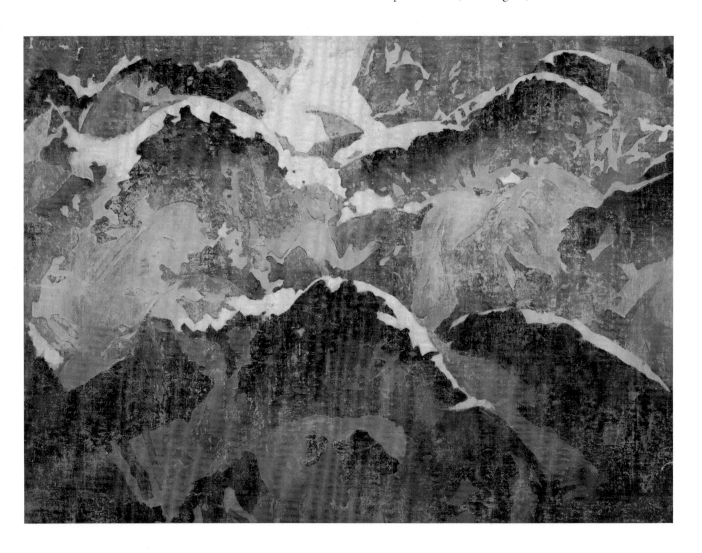

petuating in an American context a number of forms and intentions that stemmed from the more general northern Romantic tradition.[50]

Indeed if Tack's paintings of flattened, interlocking shapes of colour (nos. 153–155) can be seen on the one hand as "a harbinger of later radical painting" and on the other as sublime landscapes in the Romantic tradition, beginning with Turner and Friedrich, they also have a specific context, by the very nature of their formal treatment – how the landscape is framed and its features abstracted – within turn-of-the-century Symbolist landscape painting, from Vallotton's Alpine views and Willumsen's *Jotunheim* from 1892, to Hodler's mountain tops and Mondrian's sand dunes from a decade later. For all their radical modernity, Tack's pictures, often restricted to a palette of predominantly blue and yellow in juxtaposition, seem to repeat in the shifting tonalities of their jagged, irregular shapes many of the basic earlier Symbolist landscape themes. The vocabulary of their abstraction unwittingly is shared with Willumsen's *Jotunheim* and Mondrian's *Dune v* and describes a similarly stripped down and elemental world of being. In the summer of 1920, on a visit to the Canadian Rockies, Tack recorded experiences that echo many that we have already witnessed. He wrote at length about a "valley ... walled in by an amphitheater of mountains as colossal as to seem an adequate setting for the Last Judgment, glacial lakes lay like jewels on the breast of the world – malachite and jade-greens of every variation. Battlements and pinnacles of rock close to the clouds and on the mountain slopes great white glaciers seem motionless and slumbering, but terrible in their potentialities."[51]

Duncan Phillips, who was Tack's principal patron, in several instances addressed the sublime and Symbolist content of the works. About *Storm*, 1920–3 (no. 153), he wrote: "We behold the majesty of omnipotent purpose

154 (above)
Augustus Vincent Tack (1870–1949) American
* *Voice of Many Waters*, 1924
Oil on canvas mounted on construction board.
194.3 × 121.9 cm
Phillips Collection, Washington, DC

155 (opposite)
Augustus Vincent Tack (1870–1949) American
* *Flight*, ca 1930
Oil on canvas mounted on construction board.
111.8 × 91.4 cm
Phillips Collection, Washington, DC

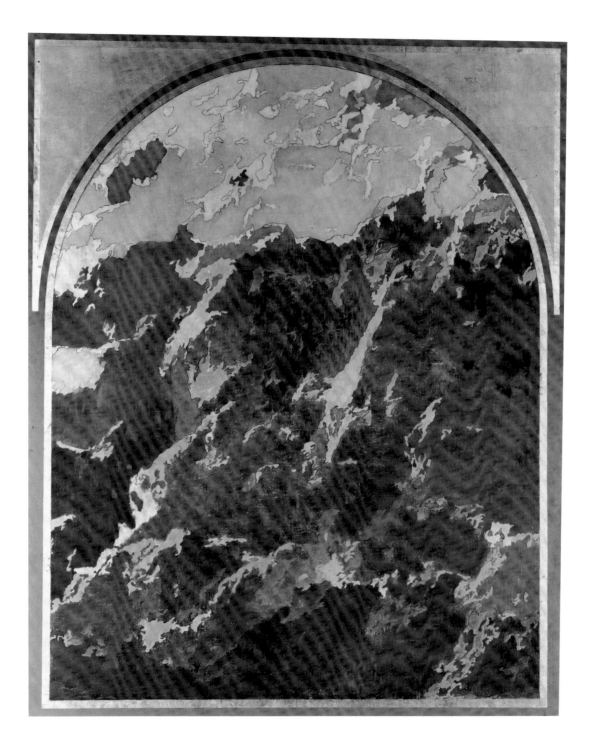

emerging in awe-inspiring symmetry out of thundering chaos ... It is a symbol of a new world in the making, of turbulence stilled after the tempest by a universal God."[52] And in describing a series of 1928 paintings ordered as wall decorations for the Phillips Collection gallery, he spoke of "universal emotions and cosmic conceptions" and "elemental patterns conveying the idea of the outposts of Time, the borderlands of Eternity."[53] Tack was better known as a portraitist and an executor of mural commissions, and he produced church decoration with specific Christian subjects. He was brought up a strict Catholic but later explored universal spiritual values learned from oriental religions and perhaps Theosophy. He was in Paris in 1893 and later would enunciate Symbolist principles from Denis, Jacques Maritain, Baudelaire, and Cézanne.[54] It was probably the working out of these beliefs, in conjunction with "his personal, mystical variation on the belief that God pervaded all nature," that demanded of his most personal art a monumental and Synthetist stylization of remote and elementary landscape motifs.[55]

Tack, like Dove and O'Keeffe, may have provided strong foundations for the development of abstract painting in the United States in the 1940s. But none of these artists ever crossed the threshold that would have severed their links with natural reality. They may have participated in the same historical continuum of which Abstract Expressionism too is a part – and which Rosenblum has defined as the "northern Romantic tradition" – and broached similar cultural and spiritual problems. Crossing that threshold would have required them to redefine their understanding of the foundations of the expressive power of their art: that subjectivity does not require embodiment in the physical forms of nature but could as well be charted in the processes and materials of the painting medium. That discovery required northern artists to rejoin forces with Modernist developments from Paris, with which they seem to have retained a love-hate relationship.

11

Epilogue

These artists [the Scandinavians in Buffalo in 1913] seemed to be a lot of men not trying to *express themselves* so much as trying to express something that took hold of *themselves*. The painters began with *nature* rather than with *art*.

J.E.H. MacDonald[1]

In Europe the course of northern Symbolist landscape came to an end shortly after 1910, at least symbolically, when Mondrian abandoned study from nature and began to reconsider his art in purely formal terms. In North America it had more or less run its course by the end of the 1930s, and after the Second World War, in both Canada and the United States, the problems of abstraction came to dominate painting. The balance between objectivity and subjectivity, between faithfulness to the natural motifs on which a painting was based and the urge to fill them with feeling and spirituality, was broken.

Individual artists, of course, continued to work creatively within their personal styles well beyond such convenient termination dates. This was as true of Hodler as it was of Munch and Willumsen; and Georgia O'Keeffe is still active today. In addition, there were second- and third-generation followers on both sides of the Atlantic for whom the lonely landscape continued to provide artistic sustenance. In general, however, the torch of progressive art in northern European countries passed into younger Modernist hands, and Symbolist landscape subjects themselves, especially when patriotically charged, or useful to tourism, entered common currency, their meanings debased through excessive reuse.

One must not, however, wrap up too neatly a movement so broadly international and so internally unorganized as the one we have been trying to define. The transition from the Naturalist to the Symbolist landscape in the early 1890s often proceeded through subtle stages, and the northern Symbolist landscape, because of its profound commitment to nature, was in many ways a creature, if a rebellious one, of Naturalism. In the same way, certain aspects of northern Symbolism resurface in later northern art, the Surrealist landscapes of Max Ernst, the Cubist ones of Lyonel Feininger, the work of Paul Klee, and in German Expressionist art. This is true not just because Munch, Gallen-Kallela, and Hodler were conspicuously exhibited in Germany around the turn of the century, but as an inevitable outcome of their shared commitment to subjective and spiritual experience. By the same token Kandinsky was avidly read in the circles of the American and Canadian landscape painters we have discussed.

The closest parallels occur in the work of the artists of Die Brücke, including Ernst Ludwig Kirchner and Emil Nolde, who banded together in Dresden in 1905. Nolde's paintings, of the bleak low-lying plains of his native Schleswig-Holstein or of more exotic locations (*Tropical Sun*, 1914, no. 156) scan the endless expansions of the earth and the sky and are transported by ecstatic colours and

156
Emil Nolde (1867–1956) German
Tropical Sun, 1914
70 × 106 cm
Ada and Emil Nolde-Stiftung, Seebüll

157
Ernst Ludwig Kirchner (1880–1938) German
* *Sand Hills in Engadine*, 1917–18
Oil on canvas. 85.7 × 95.2 cm
Museum of Modern Art, New York. Purchase, 1949

dramatic weather effects into realms of mysterious nature worship as primitive as the barbaric personages of his figure paintings.[2] Kirchner also, especially during the several years following his arrival in Switzerland in 1917 to recuperate from the war, turned his attention with renewed interest to nature. The period after the war was generally a time of relaxation from the demands of artistic revolution that had dominated the pre-war years, and, as Kirchner remarked: "I longed so much to create works from pure imagination, the kind one sees in dreams, but the impression of reality is so rich here that its representation consumes all my strength."[3] These years are rich in landscapes that revive the subject matter of symbolist landscape painting: panoramic vistas and mountain tops (*Sand Hills in Engadine*, 1917–18, no. 157) and forest interiors and rushing mountain streams (*Forest Interior*, 1919–20, no. 158), seen monumentally and intimately, respectively. The jagged forms and the often high-keyed colour schemes of these paintings link them with his personal anxiety-ridden Expressionism of the earlier Berlin years,

but their dependence on natural observation tones down their private subjectivity and speaks of what Kirchner himself, echoing sentiments that date back to early-nineteenth-century Romanticism, described in 1917 as "the great mystery that lies behind all events and objects of the environment."[4]

Such subject matter, as well as the way it is painted, strikes earlier common chords in Europe, and contem-

158 (opposite)
Ernst Ludwig Kirchner (1880–1938) German
* *Forest Interior*, 1919–20
Oil on canvas. 120 × 90 cm
Staatliche Museen Preussischer Kulturbesitz,
Nationalgalerie, Berlin. Extended loan from a private
collection

porary and later ones in North America. It is, however, only part of a much larger Expressionist repertoire of subjects and did not demand the same commitment that it did for the northern Symbolist landscape painters.[5] Even during his Swiss years Kirchner did not confine himself to sublime landscapes, but produced these alongside pastoral subjects and paintings devoted to Swiss peasant life, which comfortably integrate human activity into an awe-inspiring Alpine environment. He seems to have transformed his mountain refuge into a kind of Gauguinesque paradise in which man lived in noble and idyllic harmony with nature,[6] and he had no essential need to imagine the landscape as empty of human presence, although that had been almost *de rigueur* for northern Symbolist landscape painting (with the exception of Munch).

In fact, one of the most compelling characteristics of northern Symbolist landscape painting is the uncanny absence of the human figure. The banishment of human figures from the landscape has precedents in earlier Romantic painting in both Europe and North America, most poignantly in the work of Friedrich, whose views of distant misty panoramas or close-up lonely crosses do not always need mediation by a contemplative surrogate, but lie directly at the end of our vision. However, Carus's point of view prevailed more commonly, that the unity of a work of art demanded the inclusion of man "because man is indeed the most beautiful product on earth and the earth without man is imperfect."[7] Thus within the visual compass of even the most remote and primeval Romantic landscapes we shall invariably discover somewhere, although dwarfed and scarcely discernible, some tiny explorer enraptured by the magnificence of God's creation.

The totally uninhabited landscape, especially in America, therefore had special moral and religious poignancy because, as for Bierstadt, these landscapes were both the original Eden and the future Paradise and could not be entered by mortals except through the mediation of God. No human surrogate licenses physical entry, the experience is purely for the eye, and looking, in the words of Barbara Novak, "is a spiritual act composed of wonder and purification."[8] Visual contemplation of nature as a sacred and devotional act and a way to discover the unity of mind, nature, and God also became the programme of American Luminist painting, in which landscape space was often devoid of human beings, but as often projected an easy integration of man and nature. The philosophical underpinnings of the Luminists were provided by the Transcendentalists, especially Emerson and Thoreau, who in turn would transmit, across the intervening Naturalist interlude, a Romantic belief in the divinity of nature to modern-day Americans and Canadians, as a parallel to the rediscovery in Europe in the 1890s of early-nineteenth-century idealist attitudes.

The depreciation of narrative and anecdote in Barbizon and Impressionist painting made human figures less imperative components of landscape painting in the second half of the century in France. Only, however, in northern Symbolist landscape painting does the absence of figures become a consistent characteristic, and one made even more striking by the accompanying transformation of pictorial space, which denies Realism's traditional implication of physical access and allows entry only to the eye and the mind.

Northern landscape painters say little about this themselves. In the transition from bold daylight Naturalism to crepuscular mood painting, to Symbolism, the figure simply vanishes, and a kind of solitude, which is also loneliness and even alienation in relation to the natural world, emerges. Prince Eugen remarks simply that he wants to inhabit his landscapes himself and "reign supreme there." His comment corroborates the transformation of the landscape from a record of fact to a reflection of the individual soul, which finds truth only in its own reading of nature, a truth that in turn is a product of private and not common experience. His other comment on the problem, that "Oddly enough my landscapes have nearly always peculiar, actually wrong proportions in which a figure could never fit,"[9] implies that he has quite unconsciously framed his views, creating viewpoints or symmetries with an integrity that would be spoiled by concessions to invasion from other minds or eyes. His world is individually apprehended.

The sense of absence is most pregnant in those paintings with human habitation, such as Jansson's, Sohlberg's, or Harris's cityscape pictures, where people seem

159
Ferdinand Hodler (1853–1918) Swiss
Wilhelm Tell, 1896–7
Oil on canvas. 256 × 196 cm
Kunstmuseum, Solothurn, Switzerland

160
Jens Ferdinand Willumsen (1863–1958) Danish
The Mountain Climber I, 1904
Oil on canvas. 210 × 170 cm
Hagermanns Kollegeum, Copenhagen

to have been deliberately shunned or told to go away so as not to get into the picture. Here, as well as in nature, artists have grander designs on their subject matter than depicting human activity, and on its inherent and eternal characteristics, which, as Hodler argued, would, in relation to landscape, be dissipated by as transient a trespasser as a human being. Exceptions are rare. Where figures and landscape are combined, as they are in Munch's

"Frieze of Life" during the 1890s, they are not, however, seen in interaction. The landscape lies behind or alongside the figures, and it is, as Goldwater has observed, "not the figures who give substance to the landscape, but rather the landscape which projects the inner world by which the figures are obsessed."[10] Munch's contemporary unpeopled landscape paintings are as pregnant with resonant mood as those that include figures, though they may

not be as interpretable in terms of specific human psychology.

Usually northern Symbolist landscape painters make sharp distinctions between figure and landscape painting. Many – Sohlberg, Nordström, Jansson, Eugen, Fjaestad, Thomson, MacDonald, Carr, Dove, O'Keeffe – rarely engaged in figure painting, including portraits. Artists for whom the figure in the landscape was a central preoccupation, as it was for Willumsen, Gallen-Kallela, Hodler, and Hartley, monumentalized their figures as startlingly as they did their independent landscape motifs. Their figures assume heroic proportions and fill the whole height and breadth of the canvas, blocking out the natural surroundings which lie behind and which are often, especially in Hodler, reduced to mere emblems of landscape. The consistency of this practice may be observed by comparing Gallen-Kallela's *Kullervo's Curse*, 1899 (no. 24), to

Hodler's *Wilhelm Tell*, 1896–7 (no. 159) or Willumsen's *The Mountain Climber I*, 1904 (no. 160), and Hodler's *Emotion*, 1902 (Kunsthistorisches Museum, Vienna); and in principle it applies equally to Hartley's "archaic" portraits from his Maine years. These Nietzschean heroes and heroines by their sheer proximity dominate the whole range of our vision in a way that curiously parallels the effect of the close-up views of Hodler's mountain streams and O'Keeffe's flower portraits. Both the figure paintings and the close-up views, particularly as exemplified by Hodler and O'Keeffe, deny a normal integration of the

161
Harald Slott-Møller (1864–1937) Danish
Primavera, 1901
Oil on canvas. 69 × 119 cm
Nordjyllands Kunstmuseum, Aalborg, Denmark

central subject matter with its natural context.

The matter of the absence of human figures is brought to a head in the juxtaposition of two pictures that quite complement one another: Sohlberg's *Summer Night*, 1899 (no. 68), and the almost contemporary *Primavera*, 1901 (no. 161), located in Italy, by the Danish painter Harald Slott-Møller (1864–1937). Both pictures are set in evening twilight and both are concerned with matters of courtship; tradition maintains that *Summer Night* commemorates the evening of Sohlberg's engagement. Otherwise they stand as far apart in meaning as their respective settings in the north and the south. *Primavera* takes immediate joy in the pleasures of food and drink and human companionship and love. *Summer Night* seems almost to regret the joys of life or, at best, after they have been tasted, to prefer recollecting them in sweet melancholy. Slott-Møller tells his story in the action of his foreground plane. Sohlberg, in contrast, has so structured his picture that, however much joy we may take in the profusion of sensuous details of the flowers and the table setting on the verandah, we cannot linger there. We have been stood, to borrow a phrase from Novalis, "on the threshold of the distance." The perspective recession on the left side of the painting, in the house and the verandah, is so sharp that our eyes are caught in it and overshoot, until we find ourselves in rapt contemplation of the silent mysterious blue hills far beyond in the light of the setting sun. The door on the left allows no escape into the world of the present. Its glass panels do not open to the inside but reflect back to us the distant view.

Sohlberg's painting seems to focus on the choices made in northern landscape painting, which were designed to draw our attention away from the immediate world of sense gratification, across the edge of the present, over the tree-tops, and out toward the stillness and eternity of the horizon. A work of art, to paraphrase Richard Bergh, is an atmosphere, a world where the artist can live his spirit's hidden needs, where he can experience such sensations as his spirit longs for and such emotions as his soul desires. Bergh would have disagreed with Willumsen, who felt the obligation to make his content in *Jotunheim* more precise by adding frames composed of symbolic human figures. Bergh upheld the superior value of pure landscape because it was *not* precise. In thoughts that echo Mallarmé's injunction – "To *name* an object is to suppress three-fourths of the enjoyment ... ; to *suggest* it, that is the dream" – he maintained that the landscape was the only form of art, along with music, that at the end of the nineteenth century could say something new: "The mental states of our century, its uncertain longings, its brooding and pining ... have in music and landscape art found just that impalpable and indefinite expression which is necessary in order to become alive and emotionally sensitive in our consciousness."[11]

NOTES

1 THE NORTHERN SYMBOLIST LANDSCAPE

1 From "Scandinavian Art," a lecture given by J.E.H. MacDonald at the Art Gallery of Toronto (now the Art Gallery of Ontario), 17 April 1931; reprinted in *Northward Journal*, no. 18–19 (1980), p 18.

2 Lawren Harris, "The Group of Seven," talk delivered at the Vancouver Art Gallery, April 1954; cited in Jeremy Adamson, *Lawren S. Harris: Urban Scenes and Wilderness Landscapes 1860–1930* (Toronto: Art Gallery of Ontario 1978), p 44.

3 MacDonald, *Northward Journal*, p 9.

4 Lawren Harris, "The Group of Seven in Canadian History," *The Canadian History Association, Report of the Annual Meeting at Victoria and Vancouver, June 16–19, 1948*, ed A. Preston (Toronto: University of Toronto Press 1948), pp 30–1.

5 Albright Art Gallery, Buffalo, *Exhibition of Contemporary Scandinavian Art*, exhibition catalogue by Christian Brinton, 1913.

6 *Tidens Tegn* (Oslo), 13 March 1912.

7 "De norske kunstverker i Chicago," *Aftenposten* (Oslo), 13 April 1913.

8 For example, *The Sacred and the Profane in Symbolist Art* (Toronto: Art Gallery of Ontario 1969); Edward Lucie-Smith, *Symbolist Art* (New York: Praeger 1972); *French Symbolist Painters* (London: Arts Council of Great Britain, 1972); Philippe Jullian, *The Symbolists* (London: Phaidon 1973).

9 Cited in Robert Pincus-Witten, *Les Salons de la Rose + Croix 1892–1897* (London: Picadilly Gallery 1968).

10 Allan Bowness, "An Alternative Tradition," *French Symbolist Painters*, pp 14–20.

11 See especially Jullian, *The Symbolists*.

12 "Peinture et mysticisme: les Rose + Croix," *Le Chat noir*, 18 March 1892, reprinted in Félix Fénéon, *Au-delà de l'impressionisme*, ed Françoise Cachin (Paris: Hermann 1966), p 131.

13 See Robert Goldwater, *Symbolism* (New York: Harper and Row 1979), p 1.

14 Paul Gauguin, *The Writings of a Savage*, ed Daniel Guérin, trans E. Levieux (New York: Viking 1978), pp 23–4.

15 See Goldwater, *Symbolism*, pp 4–11; and John House and Maryanne Stevens, *Post-Impressionism: Cross-Currents in European and American Painting 1880–1906* (Washington, DC: National Gallery of Art 1980), pp 15–19.

16 See Robert Rosenblum, *Modern Painting and the Northern Romantic Tradition* (New York: Harper and Row 1975), p 121.

17 Ibid.

18 Brooklyn Museum, New York, *Northern Light: Realism and Symbolism in Scandinavian Painting 1880–1910*, catalogue by Kirk Varnedoe, 1982.

2 FROM NATURALISM TO SYMBOLISM

1 Cited in Tate Gallery, London, *Caspar David Friedrich 1774–1840: Romantic Landscape Painting in Dresden*, exhibition catalogue, 1972, p 102.

2 Cited in Ragna Stang, *Edvard Munch*, trans G. Culverville (New York: Abbeville Press 1979), p 11.

3 Julius Lange, "Studiet i Marken. Skilderiet. Erindringens Kunst," *Bastien Lepage og andre afhandlinger* (Copenhagen: P.G. Philipsen 1889), pp 57–75.

4 See Trygve Nergaard, "Despair," in National Gallery of Art, Washington, DC, *Edvard Munch: Symbols and Images*, exhibition catalogue, 1978, pp 119–20.

5 Lange, "Erendringens Kunst," p 62.

6 Ibid, p 69.

7 Ibid, p 63.

8 The term *mood painting* is an inadequate translation for *stemningsmaleri* (Danish and Norwegian), *stämningsmaleri* (Swedish), or *stimmungsmalerei* (German) and does not fully capture the sense of evocative tension of the mood landscapes of the Symbolist period, the silence of which is attentive to and resonant with the spiritual forces hidden beneath the surface of the commonplace.

9 See Leif Østby, *Fra naturalisme til nyromantik: En studie i norsk malerkunst i tiden ca. 1888–1895* (Oslo: Gyldendal 1934), chap 5. The participating artists included Erik Werenskiold (1855–1938), Christian Skredsvig (1854–1924), Kitty Kielland (1843–1914), and Eilif Peterssen (1852–1928).

10 Stang, *Munch* p 74.

11 Arne Eggum, "The Landscape Motif in Munch's Art," in National Museum of Modern Art, Tokyo, *Edvard Munch*, exhibition catalogue, 1981, p 248.

12 See National Gallery of Art, Washington, DC, *Edvard Munch*, p 36.

3 WILDERNESS AND THE CHALLENGE OF GAUGUIN

1 J.F. Willumsen, as told to Ernst Mentze, *Mine Erindringer* (Copenhagen: Berlinske Forlag 1953), pp 92–3.

2 Yrjö Hirn, "Kalevalaromantiken och Axel Gallen-Kallela," *Lärt Folk och Landstrykare i det finska Findlands Kulturliv* (Helsinki: Wahlström & Widstrand 1939), p 205.

3 Cited in Sixten Strömbom, *National-romantik och radikalism: Konstnärförbundets historia 1891–1920* (Uddevalla: Albert Bonnier 1965), p 43.

4 Wayne Anderson, *Gauguin's Paradise Lost* (New York: Viking 1971), p 134; Paul Gauguin, *The Writings of a Savage*, ed Daniel Guérin, trans E. Levieux (New York: Viking 1978), pp 47–8.

5 Anderson, *Paradise*, pp 147–8.

6 From the original text of Gauguin's letter to Willumsen in Sven Loevgren, *The Genesis of Modernism: Seurat, Gauguin, van Gogh, & French Symbolism in the 1880's* (Bloomington: Indiana University Press 1971), p 195.

7 Karl Madsen cited in Roald Nasgaard, "Willumsen and Symbolist Art 1888–1910," PHD dissertation, New York University, 1973, p 167.

8 H. Abels Kunsthandel, Kristiania, *Katalog over Willumsens Udstilling*, no. 14; cited in Nasgaard, "Willumsen," p 198.

9 The exhibition ran from 16 September to mid-October 1892; Munch's first one-man show after 1889 took place from 14 September to 4 October 1892. The two artists met.

10 Willumsen to Johan Rohde, dated at Paris, 17 November 1891; cited in Nasgaard, "Willumsen," p 192.

11 Willumsen to Hannover, 9 April 1892; cited in ibid, p 193.

12 Kristiania, *Willumsen Udstilling*, no. 13; cited in Nasgaard, "Willumsen," p 193.

13 See Salme Sarajas-Korte, *Vid symbolismens källor: Den tidiga symbolismen i Finland 1890–1895* (Jacobstads Tryckeri 1981), p 256.

14 Willumsen, *Mine Erindringer*, p 92.

15 Ibid, pp 99–100.

16 J.F. Willumsens Museum, Frederikssund. I am indebted to Leila Krogh for bringing this notebook to my attention.

17 Willumsen, *Mine Erindringer*, p 102.

18 Catalogue of Den frie Udstilling, 1895, no. 8; translation in J.F. Willumsens Museum, Frederikssund, *Catalogue*, 1962, p 22.

19 See Nasgaard, "Willumsen," p 270.

20 Richard Bergh, "Svenskt konstnärskynne," *Om Konst och annat* (Stockholm: Albert Bonnier 1908), p 150. As further indication of the persistent power of the Gauguinesque dream throughout the period we are considering, and the need for northerners to subvert it, we might refer to the American artist and writer Rockwell Kent. In his autobiographical novel of 1930, *N. by E.* (Middletown: Wesleyan University Press 1978), he formulates his account of a journey northwards to Greenland as a quest for paradise, which originates in a dream of the South Seas but finds its reality in the stern climate of the far North.

21 Emil Hannover, "Willumsen og hans sidste arbejde," *Politiken* (Copenhagen), 17 December 1893; cited in Nasgaard, "Willumsen," p 209.

22 Willumsen to Rohde [Paris, summer 1893]; cited in Nasgaard, "Willumsen," p 210.

23 The listing does not appear in the illustrated catalogue to the first Salon de la Rose + Croix, but in the broadside listing, a separate brochure: no. 220, "Cadre contenant deux sujets originaux sur bois; – Hautes Alpes (gravure sur bois)"; information courtesy Robert Pincus-Witten.

4 NORTHERN SYMBOLISM AND NATIONAL ROMANTICISM

1 From an 1892 notebook, cited in Sixten Strömbom, *National-romantik och radikalism, Konstnärsförbundets historia 1891–1920* (Uddevalla: Albert Bonnier 1965), p 43.

2 Richard Bergh, *Om Konst och annat* (Stockholm: Albert Bonnier, 1908), p 150. The article "Svenskt konstnäskynne" was originally published in 1899.

3 Strömbom, *National-romantik*, p 72.

4 Bergh, *Om Konst och annat*, p 148.

5 See Bo Lindwall, "Artistic Revolution in Nordic Countries," in Brooklyn Museum, New York, *Northern Light: Realism and Symbolism in Scandinavian Painting 1880–1910*, 1982, pp 35–42.

6 Strömbom, *National-romantik*, p 388.

7 Cited in Bo Lindwall and Gösta Sandblad, *Bildkonsten i Norden, III: Nordiskt friluftsmåleri, Nordiskt sekelskifte* (Stockholm: Prisma 1972), p 241.

8 Strömbom, *National-romantik*, p 42.

9 Ibid, p 46.

10 Karl Wåhlen, *Svenska Dagbladet*, 7 December 1886; cited by Anders Hedval, "Karl Nordström," *Svenskt Konstnärs Lexicon*, IV (Malmö: Allmeim 1953), p 252.

11 Strömbom, *National-romantik*, p 47, 48.

12 Ibid, p 141.

13 Ibid, pp 47, 49, 187.

14 Ibid, pp 65, 75, 80, 91.

15 Rohde's van Gogh painting was *Mountainous Landscape behind St Paul's Hospital, Saint Rémy*, June 1889 (de la Faille no. 611); see Johan Rohde, *Journal fra en Rejse i 1892* (Copenhagen 1955), p 111. Rohde also acquired a drawing from Père Tanguy (de la Faille no. 1450).

For works by van Gogh in Copenhagen in 1892 see Merete Bodelsen, *Gauguin og Impressionisterne* (Copenhagen, 1968), p 182, note 87.

16 Strömbom, *National-romantik*, p 193.

17 Bergh, *Om Konst och annat*, p 122.

18 Ibid, pp 121–2.

19 J.F. Willumsen, "Fransk Kunst," *Politiken* (Copenhagen), 4 June 1905; cited in Nasgaard, "Willumsen," pp 257–8.

20 Ibid, pp 258–9.

21 Cited in Anders Hedvall, *Bohuslän i konsten* (Stockholm: Sveriges Allmänna Konstförening 1956), p 201.

22 Ibid, p 192.

23 Strömbom, *National-romantik*, p 43.

24 Both articles are reprinted in Bergh's *Om Konst och annat*: "Karl Nordström och det moderna stämnings landskabet," pp 110–29; "Svenskt konstnärskynne," pp 146–64.

25 Bergh, *Om Konst och annat*, pp 146–7.

26 Ibid, p 148.

27 Salme Sarajas-Korte, *Vid symbolismens källor: Den tidiga symbolismen i Finland 1890–1895* (Jacobstads Tryckeri 1981) p 229.

28 Prins Eugen, *Breven berätta* (Stockholm: P.A. Norstedt 1942), p 101.

29 Bergh, *Om Konst och annat*, 148.

30 Nordström to Fürstenberg, 12 November 1899; cited in Strömbom, *National-romantik*, p 205.

31 Cited in Jan Askeland, *Norsk Malerkunst: Hovedlinjer gjennom 200 år* (Oslo: Cappelen 1981), p 89.

32 Østby, *Fra naturalisme til nyromantik: En studie i norsk malerkunst i tiden ca. 1885–1895* (Oslo: Gyldendal 1934), p 58.

33 Karin Hellandsjø, *Monet in Norway* (Høvikodden: Sonja Henies og Niels Onstaads Stiftelser 1974), p 5.

34 See Hedvall, *Svenskt Konstnärs Lexicon*, IV, p 252.

35 See chap 2, p 24.

36 Østby, *Fra naturalisme*, p 53.

37 Eugen, *Breven berätta*, p 91.

38 Ibid, pp 91–2.

39 Ibid, p 28.

40 "Indledning," *Svensk konstkrönika under 100 år*, ed Ragnar Josephson (Stockholm: Natur och Kultur 1944), p xxviii

41 J.E.H. MacDonald, "Scandinavian Art," *Northward Journal*, no. 18–19 (1980), p 14.

42 Bergh, *Om Konst och annat*, p 117.

43 Ibid, p 115.

44 Strömbom, *National-romantik*, p 32.

45 Birgitta Rapp, *Richard Bergh, Konstnär och kulturpolitiker* (Stockholm: Rabén & Sjögren 1978), p 40.

46 Staffan Björk, *Heidenstam och sekelskiftets Sverige* (Stockholm: Natur och Kultur 1946), p 38.

47 Cited in Hedvall, *Bohuslän i konsten*, p 194.

48 Bergh, *Om Konst och annat*, p 147.

49 Ibid, p 112. For Carus's original statement see Lorentz Eitner, *Neoclassicism and Romanticism 1750–1850*, Sources and Documents in the History of Art Series, ed H.W. Janson (Englewood Cliffs, NJ: Prentice-Hall 1970), II, p 50. For Aubert's paraphrase (originally published in 1894) see his *Maleren Johan Christian Dahl. Et stykke av forrige aarhundredes kunst- og kulturhistorie* (Kristiania: H. Aschehoug 1920), p 379.

50 Bergh, *Om Konst och annat*, p 112.

51 Ibid, p 127.

52 Ibid, p 112.

53 Ibid, p 126.

54 In this choice of phraseology Bergh may well have had in mind Henri-Frédéric Amiel's "Un paysage c'est un état d'âme," as cited by the Danish poet Johannes Jørgensen in "Symbolisme" (published in November 1893 in the Copenhagen-based Symbolist journal *Taarnet*), the first article comprehensively to introduce Symbolist ideas to the North in a Scandinavian language. See *Taarnet: En Antologi af Tekster of Illustrationer*, ed Carl Bergstrøm-Nielsen (Copenhagen: Gyldendals Uglebøger 1966), p 57.

55 See note 49.

56 Bergh, *Om Konst och annat*, p 127–8.

57 Lange, "Erindringens Kunst," pp 65, 72.

5 FINLAND

1 Statement from 1897 cited in Salme Sarajas-Korte, *Vid symbolismens källor: Den tidiga symbolismen i Finland 1890–1895* (Jacobsdads Tryckeri 1981), p 327.

2 Ibid, p 101.

3 Yrjö Hirn, "Kalevalaromantiken och Axel Gallen-Kallela," *Lärt Folk och Landstrykau* (Helsinki: Wahlotröm & Widstrand 1939), p 205.

4 Matti Klinge, "Finland efter 1809," Nationalmuseum, Stockholm, *Finsk sekelskifte*, ed Eva Nordenson (Stockholm: Rabén & Sjögren 1971), p 11, trans p 131.

5 Ibid, p 11.

6 Sarajas-Korte, *Vid symbolismens källor*, p 19.

7 Eva Mannerheim Sparre, *Konstnärsliv: Sparre-Minnen från gåmla tider til 1908* (Helsinki: Holger Schildt 1951), p 81. Gallen-Kallela was born Gallén (the Swedish form of Kallela), after the farm on which his father was born. This is the form often used by writers, including Sparre, Hirn, and Sarajas-Korte, when discussing his early life and work. In 1905 he added the old farm name to his own and dropped the accent. See Hirn, "Kalevalaromantiken," p 192.

8 Sparre, *Konstnärsliv*, p 105.

9 Sixten Ringbom, in *Konsten i Finland: från medeltid till nutid*, ed S. Ringbom (Helsinki: Holger Schildt 1978), p 205.

10 Sarajas-Korte, *Vid symbolismens källor*, p 354, note 1.

11 Ibid, p 234.

12 Ibid, p 234.

13 Ibid, p 235.

14 Gallen-Kallela to K.A. Tavaststjerna, 26 April 1892; cited in ibid, p 235.

15 Nationalmuseum, *Finsk sekelskifte*, p 132.

16 Sarajas-Korte, *Vid symbolismens källor*, p 235.

17 Ibid, p 235.

18 *Boken om Gallen-Kallela* (Helsinki: Holger Schildt, 1947), p 100.

19 Ibid, pp 101–2.

20 Hirn, "Kalevalaromantiken," p 204, Sarajas-Korte, *Vid symbolismens källor*, p 236.

21 Hirn, "Kalevalaromantiken," p 198.

22 Ibid, p 199.

23 Sarajas-Korte, *Vid symbolismens källor*, p 236.

24 Ibid, p 238, Bo Lindwall and Gösta Sandblad, *Bildkonsten i Norden III* (Stockholm: Prisma 1972), p 166.

25 Sarajas-Korte, *Vid symbolismens källor*, p 241.

26 Ibid, p 241, and Onni Okkonen, *A. Gallen-Kallela: elämä ja taide* (Porvoo: Werner Söderström 1961), pp 268–9.

27 Sarajas-Korte, *Vid symbolismens källor*, p 242.

28 *Boken om Gallen-Kallela*, p 184.

29 Ibid, p 182.

30 Okkonen, *Gallen-Kallela*, p 175.

31 The subject for *Kullervo's Curse* is taken from poem 33 of the *Kalevala*. See *The Kalevala*, prose translation by F.P. Magoun jr (Cambridge: Harvard University Press 1963), pp 236–40.

32 Sarajas-Korte, *Vid symbolismens källor*, p 255.

33 *Boken om Gallen-Kallela*, p 125.

34 Brooklyn Museum, New York, *Northern Light: Realism and Symbolism in Scandinavian Painting 1880–1910*, 1982, p 120.

35 *Boken om Gallen-Kallela*, p 105.

36 Okkonen, *Gallen-Kallela*, p 260, suggests national and personal interpretations for the work of this period.

37 Symbolic single-tree images are unusual at the turn of the century, except in Hodler, whose trees, however, do not strive for the heroic stature of those of earlier Romantic painters, i.e. Friedrich, Dahl, and Fearnley (no. 118). Images of lonely but staunch trees bent by the onslaughts of a malevolent nature become common in the work of Tom Thomson and the Group of Seven (no. 117).

38 Brita Ysabel Gustafson, "Vision och öde: Akseli Gallen-Kallela och Juselius-mausoleet i Björneborg," *Ord och Bild*, LI, p 196.

6 SWEDEN

1 Prins Eugen, *Breven berätta* (Stockholm: P.A. Nordstedt 1942), pp 91–2.

2 Gunnar M. Silfverstolpe, *Prins Eugens Konst* (Stockholm: Nordisk Rotogravyr 1935), p 18. The generally warm admiration of Böcklin's work wore off later in the decade. In 1897 when Bergh visited the Böcklin exhibition in Basel he found the work "pretentious, coarse, the drawing bad, the colour repulsive ... ," Sixten Strömbom, *National-romantik och radikalism Konstnärförbundets historia 1891–1920* (Uddevalla: Albert Bonnier 1965), p 144, note 8.

3 Eugen, *Breven*, p 86 (1 May 1889).

4 The painting was inspired by Verner von Heidenstamm's *Hans Alienus* (1892) but does not refer to any specific scene or moment in the novel. See Silfverstolpe, *Prins Eugens Konst*, p 20.

5 John Conron, *The American Landscape: A Critical Anthology of Prose and Poetry* (New York: Oxford University Press 1973), plate 27.

6 Strömbom, *National-romantik*, p 84.

7 Axel Gauffin, *Konstnären Prins Eugen* (Stockholm: P.A. Norstedt & Söner 1947), p 27.

8 Robert Goldwater, *Symbolism* (New York: Harper and Row 1979), p 249.

9 Bo Lindwall and Gösta Sandblad, *Bildkonsten i Norden III* (Stockholm: Prisma 1972), p 206.

10 Eugen, *Breven*, p 146.

11 Ibid, p 150.

12 From a lecture delivered in Lund in 1935, cited in Eric Wennerholm, *Prins Eugen: Människan och konstnären. En biografi* (Stockholm: Bonniers 1982), p 95.

13 Cited in *Tidskrift för konstvetenskap*, XXIII, 1940–1, p 102; and Brooklyn Museum, New York, *Northern Light: Realism and Symbolism in Scandinavian Painting 1880–1910*, 1982, p 100.

14 Eugen, *Breven*, p 181.

15 *The Portable Thoreau* (Harmondsworth: Penguin 1977), p 435.

16 Thomas Carlyle, *Sartor Resartus; On Heroes, Hero-worship and the Heroic in History* (London: E.P. Dutton 1908) pp 23–4. *Sartor Resartus* was well known by Symbolist writers and artists. Gauguin included it in his 1889 portrait of Meyer de Haan, and Merete Bodelsen has persuasively argued that the book contributed to Willumsen's programme for the frames of *Jotunheim*. See her *Willumsen i halvfemsernes Paris* (Copenhagen: G.E.C. Gad 1957) pp 36–46.

17 Eugen, *Breven*, p 279.

18 A. Gauffin, cited in *Svensk konstkrönika*, year 1902.

19 Sixten Ringbom ed, *Konsten i Finland: från medeltid till nutid* (Helsinki: Holger Schildt 1978), p 197.

20 MacDonald, *Northward Journal*, p 14.

21 Osvald Sirén, *Varia*, 1905; cited in *Svensk konstkrönika*, year 1895.

22 J.E.H. MacDonald, "Scandinavian Art," *Northward Journal*, no. 18–19 (1980), p 18.

23 Strömbom, *National-romantik*, p 154, suggests that Fjaestad's Pointillism was influenced by Segantini whose work aroused lively interest when it was first shown in Stockholm in 1897, but he was already applying it in 1895.

24 Cited in *Northern Light*, p 205.

25 Tor Hedberg, 1927; cited in *Thielska Galleriet*, collections catalogue, 1979, p 54.

26 See Roderick Nash, *Wilderness and the American Mind*, 3rd edn (New Haven: Yale University Press 1982), p 3.

27 Nils G. Wollin, *Eugene Janssons Måleri* (Stockholm: Sveriges Allmänna Konstförening 1920), p 86.

28 *Northern Light*, p 140, draws attention to French Neo-Impressionist precedents for this kind of subject matter and to later affinities with views of Milan suburbs by Boccioni from around 1908.

29 *Svensk konstkrönika*, year 1905.

30 Nils Palmgren and Herje Granberg, *Helmer Osslund* (Stockholm: Svensk Litteratur 1937), p 35.

31 Ibid, p 43, and Bo Wennberg, "Osslunds maleri, ett försök till grupperingar," Nationalmuseum, Stockholm, *Helmer Osslund – Norrlands målare*, 1971, p 16.

32 Wennberg, *Osslund*, p 16.

33 Agnes Branting, "Modern Tapestry-work in Sweden," *The Studio*, LVIII, no. 240 (March 1913), p 108.

34 Nils-Göran Hökby, "Helmer Osslunds brev om 'Hösten'," Stockholm, *Nationalmuseum Bulletin*, V, no. 2 (1981), pp 72, 73.

35 August Anian in *Helmer Osslund – Norrlands målare*, p 8.

36 Erik Osslund in ibid, p 14.

37 City Art Museum, St Louis, Missouri, *The Swedish Art Exhibition*, 1916; *Autumn Evening, Nordingrå* was exhibited under the title *Summer Evening, Häggviken*.

7 NORWAY

1 Munch to Rolf E. Sternesen, cited in Ragna Stang, *Edvard Munch*, trans G. Culverville (New York: Abbeville Press 1979) p 169, who also remarks, p 297, on how faithful Munch was to his landscape sources: "To this day we can recognize every stone in the painting of *Inger on the Beach*."

2 National Gallery of Art, Washington, DC, *Edvard Munch: Symbols and Images*, exhibition catalogue, 1978, p 3.

3 See Arne Eggum, *Edvard Munch og hans billeder fra eventyrskoven*, exhibition catalogue (Copenhagen: Kastrupgårdsamlingen 1979), n.p.

4 Ibid.

5 Ibid.

6 See Roald Nasgaard, "Willumsen and Symbolist Art 1888–1910," PHD dissertation, New York University, 1973, p 323.

7 Ibid, p 325.

8 Robert Goldwater, *Symbolism* (New York: Harper and Row 1979), p 232.

9 Henning Asvik and Leif Østby, *Norges Billedkunst i det nittende og tyvende århundrede*, I (Oslo: Gyldendal 1951), p 431.

10 Østby, *Fra naturalisme til nyromantik: En studie i norsk malerkunst i tiden ca. 1888–1895* (Oslo: Gyldendal 1934).

11 Cited in Arne Stenseng, *Harald Sohlberg: En Kunstner utenfor allfarvei* (Oslo: Gyldendal 1963), p 177.

12 Leif Østby, *Harald Sohlberg* (Oslo: Gyldendal 1936), p 7.

13 Andreas Aubert, *Nyt Tidskrift*, April 1894, p 531; cited in Stenseng, *Sohlberg*, p 178.

14 Stenseng, *Sohlberg*, p 49.

15 Ibid, p 62.

16 This was not for want of trying. Although he applied for travelling scholarships for several years, it was only ten years later that he was successful; Magne Malmanger, typewritten essays compiled in conjunction with the organization of the exhibition *Northern Light* at the Brooklyn Museum, New York, 1982.

17 Østby and Stenseng published the painting dated 1891, but Malmanger's redating in his essays for *Northern Light* cannot be disputed.

18 Stenseng, *Sohlberg*, p 69.

19 Ibid, p 74.

20 Ibid, p 78, suggests that the blue tonalities of the painting may be explained in a way comparable to Wollin's explanation of the deep blues of Jansson's paintings which were executed at night from an illuminated room. Sohlberg's studies in front of the subject were executed by the light of lanterns and bonfires.

21 Kristiania, 7 November 1914; courtesy Magne Malmanger.

22 Sohlberg to Byron L. Smith, 27 January 1915. The purpose of the letter was to request the loan of *Fisherman's Cottage* for the Panama-Pacific International Exhibition, San Francisco, 1915; courtesy Edward Byron Smith, Chicago.

23 Stenseng, *Sohlberg*, p 129.

24 Ibid, p 129, note 12.

25 Ibid, p 132.

26 *Verdens Gang* (Oslo), 29 November 1919.

27 Ibid.

28 Sohlberg to Byron L. Smith, 13 January 1915; courtesy Edward Byron Smith, Chicago.

29 Stenseng, *Sohlberg*, p 104.

30 Sohlberg to Smith, 27 January 1915.

31 Malmanger, typewritten essays.

32 Ibid. Andreas Aubert, "Der Landschaftsmaler Friedrich," *Kunstchronik*, VII, 1895–6, pp 282ff.

33 Malmanger, typewritten essays; see also Stenseng, *Sohlberg*, pp 101–2, 183, 218.

34 Cited in Stenseng, *Sohlberg*, p 87.

35 Tate Gallery, London, *Caspar David Friedrich*, fig xvi.

36 Cited in Magnhild Ødvin, "Nikolai Astrups Brever," *Kunst og Kultur*, XV (1928), p 227.

37 See Ole Rønning Johansen, "Astrup hjemme og ute," *Bergen Tidende*, 22 December 1956.

38 Inger Alver Gløersen, *Nikolai Astrup* (Oslo: Gyldendal 1967), p 74.

39 Ødvin, "Astrups Brever," pp 235, 236.

40 Einar Lexow, "Nikolai Astrup," *Kunst og Kultur*, XV (1928), p 193.

41 Gløersen, *Astrup*, p 88.

42 Jan Askeland, *Norsk Malerkunst: Hovedlinjer gsennom 200 år* (Oslo: Cappelen 1981), p 254.

43 Hans Ernst Kinck, "Litt om Nikolai Astrup," *Kunst og Kultur*, I (1910–11), p 238.

8 OUTSIDE SCANDINAVIA

1 Wilhelm Hausenstein, *Deutsche Kunst und Dekoration*, July 1918; cited in Jura Brüschweiler, *Ferdinand Hodler: Anthologie critique* (Lausanne: Editions Rencontre 1971), p 109.

2 Piet Mondrian, "Natural Reality and Abstract Reality: An essay in dialogue form," 1919 / 1920, in Michel Seuphor, *Piet Mondrian: Life and Work* (New York: Harry N. Abrams 1956), p 304.

3 Margit Hahnloser-Ingold, "Hodler et ses amis alémaniques vers 1900," in *Hodler, Die Mission des Künstler / La Mission de l'artiste*, exhibition catalogue, Friburg, 1981 (Bern: Benteli), p 63.

4 Franz Servaes, "Hodler, peintre monumental," *Neue Freie Presse* (Vienna), 19 January 1904; cited in Brüschweiler, *Hodler*, p 70.

5 Hugo Wagner in *Ferdinand Hodler: 1853–1918*, exhibition catalogue (London: Hayward Gallery 1971), p 13.

6 Louis Vauxcelles, *Gil Blas*, 15 November 1913; cited in Brüschweiler, *Hodler*, p 94.

7 Felix Vallotton, "A propos de Hodler," *La Suisse et les Français* (Paris: Crès 1920), p 252; cited in Brüschweiler, *Hodler*, p 89. Munch fared little better when he tried out his luck in Paris during 1896 and 1897. Although he exhibited under favourable circumstances, in the Salon des Indépendants in both years, as well as in Bing's Salon de l'Art nouveau for which Strinberg wrote a poetic review in *La Revue blanche*, his work seems to have left only the slightest impression. As Frederick B. Deknatel, *Edvard Munch* (New York: Museum of Modern Art 1950), p 34, notes: despite Munch's strong representation in the 1897 Indépendants, Gustave Coquiot, in his history of that organization, makes the mere comment that 1897 was notable for the paintings of the Douanier Rousseau and Signac. "The few writings in French on Munch are more an indication of the curiosity and taste of individual Frenchmen than of any general awareness among writers or artists of Munch's significance."

8 Brüschweiler, *Hodler*, p 86.

9 C[arl] G[ebart], *Frankfurter Zeitung*, 3 August 1910; cited in Brüschweiler, *Hodler*, p 100.

10 Robert Goldwater, *Symbolism* (New York: Harper and Row 1979), pp 248–9.

11 On the relation of Hodler and Puvis de Chavannes see Richard J. Wattenmaker, *Puvis de Chavannes and the Modern Tradition* (Toronto: Art Gallery of Ontario, 1975), pp 144–9.

12 Franz Zelger, *Der Frühe Hodler: Das Werk 1870–1890*, exhibition catalogue, Pfäffikon, 1981 (Bern: Benteli), p III. In a similar way the composition of *Autumn Evening* may be compared to and distinguished from Hobbema's *The Avenue of Middelharnes*, 1689, National Gallery, London.

13 Sharon L. Hirsh, *Ferdinand Hodler* (New York: Braziller 1982), p 80.

14 Notice in *Journal de Genève*, 21 September 1892; information courtesy Sharon L. Hirsh.

15 Brüschweiler suggests that Hodler painted the figure out around 1894 after being subjected to criticism concerning it. See University Art Museum, Berkeley, *Ferdinand Hodler*, exhibition catalogue, 1972, p 112, note 1.

16 See Friburg, *Hodler, Die Mission des Künstler*; English translation in Berkeley, *Hodler*, pp 119–25.

17 Berkeley, *Hodler*, p 123.

18 Cited in Hahnloser-Ingold, "Hodler et ses amis," p 68.

19 Hodler to Richard Bühler, 23 March 1909, cited in ibid, p 82.

20 Jura Brüschweiler, "La datation du 'Bois des Frères' de F. Hodler et la naissance du parallelisme," *Musées de Genève*, nos. 103 and 105, Geneva, March–May 1970, p 2.

21 Ibid.

22 Ibid, p 3. From a drawing for *Beech Forest* (reproduced, Zürich, Kunsthaus, *Ferdinand Hodler*, exhibition catalogue, 1983, no. 14) it appears that the painting looked even more realistic before the painting out of the woodcutter figures, the scale and placement of the figures measuring spatial recession as well as introducing variety into the visual regularity of the forest.

23 Ibid, p 14, note 5.

24 Reprinted, ed Brüschweiler, in Berkeley, *Hodler*, pp 111–12.

25 Ibid, p 112, note 1.

26 Hirsh, *Hodler*, pp 27, 62.

27 See Hans A. Lüthy, *Hodler, Die Mission des Künstlers*, pp 93–5.

28 The 1893 participation was not commonly known until Hirsh, *Hodler*, p 30, and note 31.

29 Cited in Berkeley, *Hodler*, p 62.

30 Ibid, p 62.

31 Fritz Schmalenbach, *Das Werk* XXV, no. 7 (1938), pp 193–9; cited in *Expressionismus in der Schweitz 1905–1930*, exhibition catalogue (Winterthur: Kunstmuseum 1975), p 34.

32 Wilhelm Wackenroder, "Effusions from the Heart of an Art-Loving Monk," Elizabeth G. Holt ed, *From the Classicists to the Impressionists: A Documentary History of Art*, III (Garden City, NY: Doubleday 1966), p 63.

33 Carl Carus, "Nine letters on Landscape Painting," Holt, *A Documentary History of Art*, III, pp 89–90.

34 Carlyle, *Sartor Resartus* (London: E.P. Dutton 1908), p 116.

35 Ibid, pp 135–6.

36 Sarajas-Korte, *Vid symbolismens källor*, p 247.

37 Honoré de Balzac, *Seraphita*, trans K.P. Wormeley (New York: Arno 1970).

38 Hirsh, *Hodler*, p 104.

39 Berkeley, *Hodler*, p 119.

40 J.F. Willumsen, *Mine Erindringer* (Copenhagen: Berlinske Forlag 1953), p 93.

41 Berkeley, *Hodler*, p 123.

42 Robert Rosenblum, *Modern Painting and the Northern Romantic Tradition* (New York: Harper and Row 1975), p 81.

43 Robert Rosenblum, "Notes on Mondrian and Romanticism," Art Gallery of Toronto, *Piet Mondrian: 1872–1944*, 1966, exhibition catalogue by Robert P. Welsh, p 20.

44 Robert P. Welsh, *Piet Mondrian's Early Career: The "Naturalist" Periods* (New York: Garland 1977), p xiv.

45 Welsh, Art Gallery of Toronto, *Mondrian*, p 44.

46 See Welsh, *Mondrian's Early Career*, p 2; Herbert Henkels, Centro Di, Florence, *Mondrian et l'Ecole de la Haye*, exhibition catalogue, 1982, p 21.

47 Herbert Henkels, in Royal Academy of Arts, London, *The Hague School*, exhibition catalogue, 1983, p 151.

48 Mondrian, in Seuphor, *Mondrian*, p 306.

49 Ibid, p 309.

50 Ibid, p 308.

51 Berkeley, *Hodler*, p 117.

52 Mondrian in Seuphor, *Mondrian*, p 303.

244

53 Welsh, in Art Gallery of Toronto, *Mondrian*, p 106.
54 Rosenblum, in Art Gallery of Toronto, *Mondrian*, p 21.
55 Ibid, p 18.

9 CANADA

1 Richard Bergh, "Den nationalla konsten," 1902, *Om Konst och annat* (Stockholm: Albert Bonnier 1908), p 168.
2 Arthur Lismer, "Art in Canada," *The Twentieth Century*, II, no. 1 (Nov 1933).
3 F.B. Housser, *A Canadian Art Movement: The Story of the Group of Seven* (Toronto: Macmillan 1926), p 63.
4 Housser, "The Amateur Movement in Canadian Painting," *Yearbook of the Arts in Canada*, 1928–9, p 83–4.
5 A.Y. Jackson, Introduction to *Exhibition of Paintings by the Late Tom Thomson* (Montreal: The Arts Club 1919); cited in Peter Mellen, *The Group of Seven* (Toronto: McClelland and Stewart 1970), p 45.
6 Ann Davis, "An Apprehended Vision: The Philosophy of the Group of Seven," PHD dissertation, York University, Toronto, 1973, p 184.
7 Robert Stacey, "A Contact in Context: The Influence of Scandinavian Landscape Painting on Canadian Artists before and after 1913," *Northward Journal*, no. 18–19 (1980), p 53.
8 Reprinted in *Northward Journal*, no. 18–19 (1980), pp 9–35.
9 C.W. Jefferys, "MacDonald's Sketches," *The Lamps* (Dec 1911); cited in Dennis Reid, *The Group of Seven* (Ottawa: National Gallery of Canada 1970), p 29.
10 Lawren Harris, "The Group of Seven," Talk delivered in The Vancouver Art Gallery, April 1954, cited in Mellen, *The Group of Seven*, p 23; and "The Group of Seven in Canadian History," *The Canadian Historical Association: Report of the Annual Meeting Held at Victoria and Vancouver June 16–19, 1948*, ed A. Preston (Toronto: University of Toronto Press 1948), p 31.
11 Dennis Reid, *A Concise History of Canadian Painting* (Toronto: Oxford University Press 1973), p 136.
12 Cited in Stacey, "Contact," p 40.
13 Ibid, p 41.
14 Ibid, pp 43–4.
15 Ibid, pp 36, 37.
16 Reid, *Concise History*, p 137.
17 Lawren Harris, "The R.C.A. Reviewed," *The Lamps* (Dec 1911), p 9.
18 See p oo.
19 Cited in Mellen, *The Group of Seven*, p 14.
20 Reid, *Concise History*, p 138.
21 Harris, "Art in Canada: An Informal History," part 3, lecture delivered on *CBC Wednesday Night*, 21 June 1950, p 1; mimeographed typescript, Reference Library, Art Gallery of Ontario, Toronto.
22 Cited in Reid, *The Group of Seven*, p 128.
23 A.Y. Jackson, *A Painter's Country* (Toronto: Clarke Irwin 1964), p 16.
24 Jackson to his mother, 28 March 1910; private collection.
25 Jackson to Charles B. Clement, 1 October 1910; private collection.

26 Cited in Reid, *Group of Seven*, p 34, and Davis, "Vision," p 154.
27 Cited in Davis, "Vision," p 155.
28 Jackson, *A Painter's Country*, p 31.
29 Ibid, p 31.
30 Jackson to Albert Laberge, 25 April 1914; Art Gallery of Ontario, Toronto.
31 Harris, Vancouver Art Gallery, 1954.
32 Housser, *A Canadian Art Movement*, p 13.
33 Arthur Lismer, "Canadian Art," *Canadian Theosophist*, V, no. 12 (15 February 1925).
34 Jackson to Laberge, 25 April 1914.
35 MacDonald, cited in Davis, "Vision," p 234.
36 Bergh, *Om Konst och annat*, p 157.
37 Lismer, "Canadian Art."
38 Harris, "Revelation of Art in Canada," *Canadian Theosophist*, VII, no. 5 (15 July 1926), pp 85–6.
39 Jack Bush, "Reminiscences," in Art Gallery of Ontario, Toronto, *Jack Bush: A Retrospective*, 1976, n.p.
40 Harris to Carr, June [1930]; Public Archives of Canada, Ottawa.
41 See Jeremy Adamson, Art Gallery of Ontario, Toronto, *Lawren S. Harris, Urban Scenes and Wilderness Landscapes 1906–1930*, exhibition catalogue, 1978, p 207, note 61.
42 Robert H. Hubbard, *The Development of Canadian Art* (Ottawa: National Gallery of Canada, 1963), pp 88–9; see also Davis, "Vision," p 181, and Stacey, "Contact," p 52.
43 MacDonald, *Northward Journal*, p 18. Stacey, "Contact," p 51, also remarks on the visual similarities between Fjaestad's snow paintings and Tom Thomson's *Snow in October*, around 1915 (National Gallery of Canada, Ottawa).
44 Adamson, *Harris*, p 89.
45 Hubbard, *Development*, pp 87–8.
46 MacDonald, *Northward Journal*, p 26.
47 See p ooo (Arne Stenseng, *Harold Sohlberg* [Oslo: Gyldendal 1963], p 129.) The bracketed quotations are from Sohlberg's restatement of similar principles in a letter to the acquisition committee of Nasjonalgalleriet, Oslo, 1 November 1914.
48 Adamson, *Harris*, p 89.
49 *Studio*, LVII, no. 238 (January 1913), pp 337–8; LVIII, no. 240 (March 1913), p 108.
50 Hubbard, *Development*, suggests as one of Thomson's sources a Swedish tapestry, *Spruce Coppice*, designed by Henrik Kröh, reproduced in colour in *Studio* (March 1913).
51 Harold Town and David Silcox, *Tom Thomson. The Silence and the Storm* (Toronto: McClelland and Stewart 1977), pp 152–3.
52 Davis, "Vision," p 189, remarks on the use of the single-pine-tree image as the symbol for the Association of American Painters and Sculptors, the organizers of the Armory Show in 1913, and its appearance on the cover of *Art and Decoration* in March 1913 with the legend "The new Spirit." She notes also that Ruskin in *Modern Painters*, well read by the Group, imputes nationalistic characteristics to the pine tree. As well, single-tree images with symbolic meaning

recur in sentimental realist painting; see William Ritschel's *The Fallen Comrade*, reproduced in *Studio*, LVIII, no. 241 (April 1913), p 254.

53 " 'School of Seven' Exhibition Is Riot of Impressions," *Toronto Star Weekly*, cited in Adamson, Harris, p 168. Harris's stylistically severe work of the 1920s and 1930s is often compared to that of the American artist Rockwell Kent (1882–1971), who was drawn to northern subject matter for comparable spiritual reasons. If the writings of the two artists often follow similar directions, Kent's perception of nature, and consequently his painting, remain thoroughly realist and therefore fall outside the present discussion. See Ann Davis, *A Distant Harmony: Comparisons in the Painting of Canada and the United States of America* (Winnipeg: Winnipeg Art Gallery, 1982).

54 Charles C. Hill, *Canadian Painting in the Thirties* (Ottawa: National Gallery of Canada, 1975), p 157.

55 Ibid, p 155. See also Christopher Varley, *F.H. Varley: A Centennial Exhibition*, Edmonton Art Gallery, 1981, p 94.

56 Emily Carr, *Hundreds and Thousands: The Journals of Emily Carr* (Toronto: Clarke Irwin), p 42.

57 Ibid, p 57.

58 Maria Tippett, *Emily Carr* (Toronto: Oxford University Press 1979), p 170.

59 Ibid, p 182.

60 Ibid, p 294, note 16.

61 Cited in Doris Shadbolt, *The Art of Emily Carr* (Toronto: Clarke Irwin 1979), p 114.

62 Carr, *Hundreds and Thousands*, p 106.

63 Shadbolt, *Emily Carr*, p 60.

10 THE UNITED STATES

1 Marsden Hartley, "On the Subject of Nativeness – A Tribute to Maine," 1937, reprinted in Marsden Hartley, *On Art*, ed and intro Gail R. Scott (New York: Horizon 1982), p 115.

2 Cited in Barbara Haskell, *Arthur Dove* (San Francisco: San Francisco Museum of Art 1974), p 13.

3 Cited in Sasha M. Newman, Phillips Collection, Washington, DC, *Arthur Dove and Duncan Phillips: Artist and Patron*, 1981, p 31.

4 Hartley, "Modern Art in America," in Hartley, *Adventures in the Arts* (New York: Boni and Liveright 1921; facsimile reprint New York: Hacker Art Books 1972), pp 59–60.

5 Gail R. Scott, "Marsden Hartley at Dogtown Common," *Arts Magazine*, LIV, no. 1 (Oct 1979), p 160.

6 See note 1.

7 *Georgia O'Keeffe* (New York: Viking 1976), opp pl 58.

8 Newman, *Dove*, p 14.

9 See ibid, p 14.

10 Scott, "Hartley at Dogtown Common," p 161.

11 Hartley, *Somehow a Past*, unpublished autobiography written in late 1930s or early 1940s, Beinecke Rare Book and Manuscript Library, Yale University, New Haven, Connecticut; cited in Barbara Haskell, *Marsden Hartley* (New York: Whitney Museum of American Art 1980), p 82.

12 Hartley to Seumas O'Sheel, 19 October 1908; cited in Haskell, *Hartley*, p 17.

13 Hartley, *Somehow a Past*; cited in Haskell, *Hartley*, note 11.

14 Haskell, *Hartley*, p 14.

15 See ibid, p 13. Haskell also suggests the influence of other European Neo-Impressionists such as Richard Pietzsch, who was reproduced in *Jugend*, 1906.

16 Hartley, "Art – and the Personal Life," in Hartley, *On Art*, p 72.

17 Hartley, *Somehow a Past*; cited in Haskell, *Hartley*, p 18.

18 Hartley, "New England Painting and Painters," n.d., carbon copy typescript in Collection of American Literature, Beinecke Library, Yale.

19 Hartley to Kent, 12 August 1912; cited in Haskell, *Hartley*, p 52.

20 Hartley to Stieglitz, February 1913; cited in ibid, p 30.

21 See Hartley, "Art – and the Personal Life," pp 70–3.

22 Scott, "Hartley at Dogtown Common," p 165.

23 See note 1.

24 *On Art*, p 113. Rockwell Kent had earlier in the 1930s discovered in Greenland, an even more naked and majestic land, "people who were good. Who lived, each man, by his labor. Who gave to others, without thought, as they had need. Who obeyed the unwritten golden rules of their simple society without coercion. Who worshipped God by how they lived"; Kent, *This Is My Own* (New York: Duell, Sloan & Pearce 1940), p 150.

25 Hartley to Adelaide Kuntz, 16 July 1913; cited in Scott, "Hartley at Dogtown Common," p 161.

26 Hartley to Hudson Walker, 8 October 1938; cited in Haskell, *Hartley*, p 115.

27 Hartley, "The Return of the Native," 1932; cited in Haskell, *Hartley*, p 83.

28 See p oo.

29 Hartley, *On Art*, pp 114–15.

30 Hartley, *Somehow a Past*; cited in Haskell, *Hartley*, p 82.

31 Hartley to Adelaide Kuntz, 2 February 1940; cited in Haskell, *Hartley*, p 117. Hartley uses the Indian spelling for Katahdin, "Ktaadn," as did Thoreau.

32 Ibid, p 118.

33 Cited in Museum of Modern Art, New York, *Feininger / Hartley*, exhibition catalogue, 1945, p 82.

34 See John Conron, *The American Landscape: A Critical Anthology of Prose and Poetry* (New York: Oxford University Press 1973), p 233; Roderick Nash, *Wilderness and the American Mind*, 3rd edn (New Haven: Yale University Press 1982), p 91.

35 Henry David Thoreau, "Ktaadn," cited in Conron, *Landscape*, p 249.

36 *Georgia O'Keeffe*, opp pl 100.

37 Statement by Dove in exhibition catalogue, *The Intimate Gallery*, 1929; cited in Haskell, *Dove*, p 135.

38 See Lloyd Goodrich and Doris Bry, *Georgia O'Keeffe*, exhibition catalogue, Whitney Museum of American Art, New York, 1970, p 8.

246

39 Haskell, *Dove*, p 20.

40 Cited in ibid, p 77.

41 Cited in ibid, p 118.

42 See Newman and Duncan Phillips in Newman, *Arthur Dove*, pp 25, 52.

43 She seems, however, early to have read Kandinsky's *On the Spiritual in Art*; see *Georgia O'Keeffe*, opp pl 12.

44 Cited in Haskell, *Dove*, p 135.

45 Hartley, "Art – and the Personal Life," in Hartley, *On Art*, p 72.

46 Scott, Preface to Hartley, *On Art*, p 26.

47 See ibid, pp 24–7, and Haskell, *Dove*, p 20.

48 Goodrich and Bry, *O'Keeffe*, p 9.

49 Ibid, p 16.

50 See Robert Rosenblum, *Modern Painting and the Northern Romantic Tradition* (New York: Harper and Row 1975), p 197; and University Art Museum, University of Texas at Austin, *August Vincent Tack*, exhibition catalogue, 1972, text by Eleanor Green (reprinted in *Artforum*, October 1972, pp 52–63).

51 Cited in Green, *Artforum*, p 59.

52 Cited in Rosenblum, *Northern Romantic Tradition*, p 198.

53 Cited in Green, *Artforum*, p 61.

54 Ibid, p 56.

55 Ibid, p 61.

II EPILOGUE

1 From "Scandinavian Art," a 1931 lecture by J.E.H. MacDonald; reprinted in *Northward Journal*, no. 18–19 (1980) p 18.

2 Robert Rosenblum, *Modern Painting and the Northern Romantic Tradition* (New York: Harper and Row 1975), p 136, discusses Nolde as perpetuating the vision of C.D. Friedrich and J.M.W. Turner.

3 Statement by Kirchner from 1919, cited in Donald E. Gordon, *Ernst Ludwig Kirchner* (Cambridge, Mass: Harvard University Press 1968), p 114.

4 Kirchner, 1 December 1917, cited in ibid, p 110.

5 This is also true for other members of Die Brücke such as Erich Heckell and Karl Schmidt-Rottluff, as well as Oskar Kokoschka, all of whom on occasion produced landscapes that perpetuated northern Symbolist attitudes and compositional characteristics.

6 Donald E. Gordon in *Ernst Ludwig Kirchner: A Retrospective Exhibition*, exhibition catalogue (Boston: Museum of Fine Arts 1968), p 32.

7 Carl Carus, "Nine Letters on Landscape painting," Elizabeth Holt, *A Documentary History of Art*, III (Garden City, NY: Doubleday 1966), p 93.

8 Barbara Novak, *Nature and Culture: American Landscape and Painting 1825–1875* (New York: Oxford University Press 1980), p 189. Novak observes that one type of figure could be introduced into this landscape without disrupting its virgin purity, namely the Indian, who represented nature, not culture.

9 Cited in Brooklyn Museum, New York, *Northern Light: Realism and Symbolism in Scandinavian Painting 1880–1910*, 1982, p 102.

10 Robert Goldwater, *Symbolism* (New York: Harper and Row 1979), p 59.

11 Bergh, *Om Konst och annat* (Stockholm: Albert Bonnier 1908), p 127.

BIOGRAPHIES

NIKOLAI ASTRUP (1880–1928) Norwegian
Astrup studied with Harriet Backer in Oslo 1899–1901. He toured Germany and spent 1901–2 in Paris with Christian Krogh at the Académie Colarossi. He was especially impressed by the work of Böcklin, Constable, Gauguin, and the Douanier Rousseau. For the rest of his life he worked as an artist and farmer in Jølster on the Norwegian west coast and had a few short trips abroad. He was also one of Norway's most important graphic artists.

FRANKLIN CARMICHAEL (1890–1945) Canadian
Carmichael commenced study at the Ontario College of Art, Toronto, in 1911 and went to the Académie Royale des Beaux-Arts, Antwerp, Belgium, in 1913. His activities as a designer restricted his landscape painting. He produced a number of important canvasses around 1920. In 1925 he went on a major sketching expedition to the north shore of Lake Superior and helped found the Canadian Society of Painters in Water Colour.

EMILY CARR (1871–1945) Canadian
Carr commenced three years of study at the California School of Design in 1890 and received art instruction in England in 1899 and France in 1910. Early in her career she became committed to making a visual record of the vanishing British Columbia totem poles. Her most important work was produced after 1927, the year she met members of the Group of Seven in Toronto. Around 1930 her subject matter came to be dominated by the British Columbia forest. She turned to views of open vistas in the mid-1930s.

ARTHUR DOVE (1880–1946) American
After working as an illustrator in New York, he went to France in 1907 to devote himself to painting. He exhibited at the Salon d'Automne of 1908 and 1909. Upon his return to New York, his work was exhibited by Arthur Stieglitz at 291 and over the next few years he produced a group of highly abstract paintings. He nevertheless stressed the importance of nature as the primary inspiration of his subsequent work. During the 1910s he attempted to support himself and his family by farming near Westport, Connecticut, and through the 1920s he lived and worked on a houseboat.

PRINCE EUGEN (1865–1947) Swedish
Eugen Napoleon Nicholas was the youngest son of King Oscar II of Sweden and Norway. He studied in Paris 1887–9 with Bonnat, Gervex, Roll, and Puvis de Chavannes. He was sympathetic to the Artists' Union and exhibited with it. His most important Symbolist landscapes date from the 1890s; his later work was more impressionistic. He executed important monumental frescos.

GUSTAF FJAESTAD (1868–1948) Swedish
Fjaestad studied at the Royal Academy of Fine Arts in Stockholm 1891–2 and under Bruno Liljefors and Carl Larsson. He was an enthusiastic sportsman and a propagandist for competitive sports. In 1897 he left Stockholm and settled at Lake Racken, near Arvika in Värmland, where a small artists' community, Rackengruppen, formed around him and his wife. In his paintings Fjaestad usually confined himself to winter subjects; he practised almost all the decorative arts.

AKSELI GALLEN-KALLELA (1865–1931) Finnish
He began his studies in Helsinki but spent 1884–90 mostly in Paris and was strongly influenced by Bastien-Lepage. In the 1890s he became the focus of the Finnish national Romantic movement, drawing his subject matter from the *Kalevala*. In 1895 he exhibited with Munch in Berlin and contributed to *Pan*. Inspired by William Morris, he helped develop the decorative arts in Finland. He decorated the Finnish Pavilion at the 1900 Universal Exposition in Paris, was invited by Kandinsky to participate in the Phalanx IV exhibition in Munich in 1902, and achieved wide acclaim over the next decade.

PEKKA HALONEN (1865–1933) Finnish
Halonen attended the Fine Arts Association in Helsinki 1886–90. In 1891 he went to Paris, studied at the Académie Julian, and was drawn to Naturalism. He was early committed to Finnish national Romanticism and in the summer of 1892 first went to Karelia. The lessons of Gauguin in Paris in 1894 and Giotto's frescos in Italy in 1896–7 were applied to the monumental style he developed at the turn of the century. He helped decorate the Finnish Pavilion at the 1900 Paris Universal Exposition.

VILHELM HAMMERSHØI (1864–1916) Danish
Hammershøi studied at the Royal Academy of Fine Arts in Copenhagen 1879–84 and from 1883 under Peder Severin Krøyer. The formative influence of Whistler appears as early as 1886. In the 1890s he experimented with overt Symbolism, but his typical subjects, reminiscent of the Danish tradition and Vermeer, are simple interiors inhabited by single contemplative figures. Their evocation of loneliness recurs in his cityscapes and landscapes. He travelled widely, and his work found an international audience.

LAWREN S(TEWART) HARRIS (1885–1970) Canadian
Harris was the theorist and prime organizer of the Group of Seven. After receiving academic art training in Berlin 1904–7, he returned to Toronto and quickly became committed to the development of a Canadian school of landscape painting. In 1918 he discovered the important Group painting site, the Algoma region of northern Ontario, and arranged a number of trips into the area over the next few years. During the early 1920s, when his commitment to Theosophy was deepening, he developed a particular affinity for the austere landscape of Lake Superior's north shore. Later in the 1920s he painted the Rockies, and he travelled to the Arctic in 1930. After the mid-1930s, his work moved into pure abstraction.

MARSDEN HARTLEY (1877–1943) American
Hartley commenced his studies in 1898 at the Cleveland School of Art and spent 1900–4 at the National Academy of Design in New York. In 1909 he met Alfred Stieglitz, who gave him his first solo exhibition. That year he also discovered the Romantic landscape painting of Albert Pinkham Ryder. From 1910 he travelled widely, and his style and subject matter fluctuated greatly. In the late 1920s he returned to nature for inspiration, and during the last decade of his life he painted and poeticized the New England landscape, most notably in a series of paintings of Mt Katahdin in Maine.

(JOHAN) OTTO HESSELBOM (1848–1913) Swedish
From 1882 Hesselbom studied independently and copied paintings in Stockholm's Nationalmuseum, and he studied 1888–95 at the Royal Academy of Fine Arts. His work is primarily devoted to the landscape of Dalsland in central Sweden, but his monumental panoramas, Jugendstil stylizations, and nature lyricism were internationally popular.

FERDINAND HODLER (1853–1918) Swiss
Hodler commenced a three-year apprenticeship in 1867 with Ferdinand Sommer, a painter of picturesque mountain views, and studied at the École des Beaux-Arts in Geneva for six years under Barthélemy Menn. He painted *Night*, his first monumental Symbolist figure composition, in 1889–90. At this time he formulated his theory of Parallelism and later applied it to his landscapes and figurative works. His principal landscape subjects were Lake Geneva and, especially after 1900, the Alps.

A(LEXANDER) Y(OUNG) JACKSON (1882–1974) Canadian
Jackson attended evening classes at the Art Institute of Chicago in 1906 and in 1907 enrolled at the Académie Julian in Paris. He returned to paint in Europe 1911–13. Of all the members of the Group of Seven, he was most familiar with current European art trends. In 1913 he moved from Montreal to Toronto where he joined the emerging school of nationalist painters and began painting northern Ontario. During the 1920s he painted farther and farther afield, from the Maritimes to the Rockies and the Arctic.

EUGÈNE JANSSON (1862–1915) Swedish
Jansson studied at the Royal Academy of Fine Arts in Stockholm 1881–2. He became acquainted with the radical Swedish artists returning from France and joined the Artists' Union in 1886. He was especially close to Nordström and was influenced by Munch. He was plagued by ill health and poverty and first travelled abroad in 1900. He painted Stockholm at twilight or night almost exclusively until 1905 when he turned to male nudes.

ERNST LUDWIG KIRCHNER (1880–1938) German
Kirchner commenced study at the Technical High School in Dresden in 1901, earning a degree in architecture in 1905. In 1903–4 he also attended art classes in Munich. With fellow architectural students Fritz Bleyl, Erich Heckel, and Karl Schmidt-Rottluff, he formed Die Brücke (Bridge) in 1905. The group moved from Dresden to Berlin in 1911, and there Kirchner produced his famous Expressionist city street scenes. In 1917, following a breakdown while in military service, he moved to Davos, Switzerland. His alpine environment became an important subject in his later work.

ARTHUR LISMER (1885–1969) Canadian
Lismer grew up in England and studied as a teenager at the Sheffield School of Art. In 1906–7 he attended the Académie Royale des Beaux-Arts in Antwerp, Belgium. His limited success as a photo-engraver in Sheffield led him to move to Canada in 1911. He joined the commercial art firm Grip Ltd and met a number of the nationalist landscape painters with whom he would form the Group of Seven in 1920. He began painting northern Ontario and developed a particular affinity for Georgian Bay. He also became a respected children's art educator, lecturing widely.

J(AMES) E(DWARD) H(ERVEY) MACDONALD (1873–1932) Canadian
MacDonald was the first of the future Group of Seven to envisage a
Canadian school of painting. His formal art education was limited, and
he began work as a commercial artist. In 1911, he left Grip Ltd, Toronto,
to devote himself to painting. His paintings of the Algoma region of
northern Ontario, dating from around 1920, are among his most ac-
complished. His chief subject later was the Rockies.

PIET MONDRIAN (1872–1944) Dutch
Mondrian was trained first as a public school drawing instructor and
enrolled in 1892 at the Rijksakademie in Amsterdam to study painting
and drawing. In his early career he concentrated on landscape subjects,
working in a style influenced by the Hague school. By 1900, however,
his landscapes were distinguished by their frontality and axial symmetry.
He produced 1905–8 his late evening landscapes, which began the tran-
sition to abstraction. In 1916–17, with Theo van Doesburg, he founded
De Stijl, but withdrew in 1925. In 1940 he moved to New York.

EDVARD MUNCH (1863–1944) Norwegian
Munch attended Christiania Royal Academy of Drawing (1880–2) and
the open-air academy of Fritz Thaulow in Modum (1883). In the mid-
1880s he became involved with Christiania-Bohème, a group of young
radicals. He visited Paris in 1885, 1889, and 1891 and was influenced by
Gauguin and the Symbolists. In 1893, spending much of his time in
Berlin, he began "The Frieze of Life," a large series of works devoted
to the themes of love and death. Especially after 1900, he produced
landscapes, primarily inspired by Aasgaarstrand on the Oslo fjord, where
he spent most summers between 1889 and 1908. Following a nervous
collapse, he retreated to a small village in Norway in 1909 and led an
increasingly reclusive life.

EJNAR NIELSEN (1872–1956) Danish
Nielsen studied at the Royal Academy of Fine Arts in Copenhagen
1889–93 and with Kristian Zahrtmann 1895–6, but his most important
model was J.F. Willumsen. From 1894 to 1900 he worked alone in Gjern
in central Jutland, where he produced his most important monumental
landscapes and figure paintings, the latter in an austere linear style
dealing with poverty, sickness, and death. He did not travel abroad
until after 1900, but was then attracted by Puvis de Chavannes, the
Nabis, and Quattrocento painting.

KARL NORDSTRÖM (1855–1923) Swedish
Nordström studied at the Royal Academy of Fine Arts in Stockholm
1875–8. He worked in Paris 1881–6, mostly in the Scandinavian artists'
colony at Grèz-sur-Loing. Unsuccessful at the Paris Salon, he returned
home to devote himself to the Swedish landscape. In 1886 he helped
found the Artists' Union, becoming the first president. In 1892 he moved
to his native Bohuslän; in 1893 he joined Richard Bergh and Nils Kreu-
ger in Varberg and became the principal exponent of national Romantic
landscape painting.

GEORGIA O'KEEFFE (b 1887) American
O'Keeffe studied at the Art Institute of Chicago in 1905 and The Art
Students League, New York, in 1907–8, following which she worked
as a commercial artist in Chicago. She studied with Arthur Wesley Dow
at Teachers College, Columbia University, in the mid-1910s. In 1916,
Alfred Stieglitz, later her husband, first exhibited her work at his gallery,
291. She took up residence in New York in 1918, spending summers at
the Stieglitz family estate at Lake George, NY, a locale that inspired
many of her landscapes. In 1929 she began spending summers at Abi-
quiu, New Mexico, and has lived there since 1949.

HELMER OSSLUND (1866–1938) Swedish
On a trip to London in 1891, while working as a decorator for the
Gustavberg porcelain factory, Osslund discovered Constable and Turner
and decided to become a painter. In Paris 1893–4 he studied at the
Académie Colarossi and with Willumsen and Gauguin. After a period
as a portrait painter in various European cities, he returned to Sweden
in 1898 and the next year sought out the Artists' Union school and
Richard Bergh. For the rest of his life he devoted himself to the land-
scape of Norrland and Lappland.

HARALD SOHLBERG (1869–1935) Norwegian
Sohlberg commenced formal studies in Oslo in 1885. His education was
unsystematic. During his early years he developed within the circle of
the Norwegian Naturalists. In 1891–2 he worked under Kristian Zahrt-
mann in Copenhagen, where he was also attentive to avant-garde Dan-
ish art. A travelling scholarship took him to Paris in 1895–6 and Weimar
1896–7. He spent 1901–5 in the mountains of central Norway and in
Røros and 1907–9 at Kjerringvik on the Oslo fjord and lived from 1910
in Oslo.

AUGUSTUS VINCENT TACK (1870–1949) American
After completing his degree in fine arts in 1890, he studied with artists
John La Farge and John Twachtman in New York and travelled to
France in 1893 and 1895. From about 1900 he worked in New York and
Deerfield, Mass, primarily as a portrait painter. During the 1910s he
began producing a group of Pointillist-inspired landscapes and by 1924
had evolved a highly personal style of semi-abstract landscape painting.
He worked in this idiom for the rest of his career, continuing as a
successful society portraitist and muralist.

TOM THOMSON (1877–1917) Canadian
He was a pivotal figure in the emergence of the Group of Seven. His
early career was spent primarily as a commercial artist, and about 1908
he was hired by Grip Ltd, Toronto. By 1911 he was making regular
sketching trips. In May 1912 he made his first trip to Algonquin Park,
Ontario, thereafter his dominant painting site. By 1915–16, he was be-
ginning to synthesize a bold, colourfully patterned style with the rugged
landscape motifs of the North. He drowned in Canoe Lake, Algonquin
Park, in 1917, three years before the Group of Seven was formed.

FÉLIX VALLOTTON (1865–1925) Swiss-French
Vallotton moved from his birthplace, Lausanne, to Paris in 1882, attending the Académie Julian for three years. There he met future Nabis members Pierre Bonnard, Edouard Vuillard, and Maurice Denis, with whom he developed a close association. He began making woodcuts about 1891, under the influence of Charles Maurin and Japanese ukiyo-e masters, especially Hokusai and Utamaro. His major woodcuts, ranging from alpine landscapes, to portraits, to scenes of contemporary life, were produced 1891–8 and contributed much to the medium's subsequent revival.

F(REDERICK) H(ORSMAN) VARLEY (1881–1969) Canadian
Varley grew up in England and commenced studies at the Sheffield School of Art in 1892. He attended the Académie Royale des Beaux-Arts in Antwerp, Belgium. He moved to Canada in 1912 and was hired by the commercial art firm Grip Ltd. Unlike the other members of the Group of Seven, Varley concentrated on portraiture and figures in landscapes until 1926, when his experience of the Rocky Mountains led him to landscape painting. In British Columbia he became involved with Eastern mysticism and advocated the use of colour symbolism in painting. After 1936 he worked in Ottawa, Montreal, and Toronto.

VICTOR WESTERHOLM (1860–1919) Finnish
Westerholm received his first instruction in Turku and lived in Düsseldorf for eight years. In 1888 he went to Paris. He worked in an impressionistic style, with subjects drawn from the banks of the Seine, but changed to a firmer Realism, which after 1900 took on symbolistic features in landscapes devoted to northern, often winter subjects. He made important contributions as a teacher in the art school in Turku.

JENS FERDINAND WILLUMSEN (1863–1958) Danish
Willumsen was a student of the Royal Academy of Fine Arts in Copenhagen and the artists' "free schools" and made his début as a Naturalist. He was in Paris 1888–94 and quickly became immersed in Symbolist and Synthetist currents, meeting Gauguin in Pont Aven in 1890. He was a painter, sculptor, print-maker, architect, ceramicist, author, and artistic director 1897–1900 of Bing & Grøndal. From 1928 to his death he lived in the south of France.

INDEX

TYPESETTING
Q Composition

COLOUR SEPARATION AND PRINTING
Herzig Somerville Limited

PAPER
Warren Patina 140M

BINDING
T.H. Best Company Limited

DESIGN
William Rueter RCA